New York City Gardens

Veronika Hofer / Betsy Pinover Schiff (Photography)

Hirmer Verlag Munich

Contents

Introduction

The ancient Romans called their Rome quite simply "urbs," the city. Anyone saying "city" meant Rome. Today, it could mean New York: New York City, with its skyscrapers whose silhouettes are known throughout the world as "the Manhattan Skyline," is the epitome of the modern city and urban living. Iconic names can release a flood of associations: Broadway, Fifth Avenue, Greenwich Village, Soho, The Metropolitan Museum, MoMA, the Guggenheim, to name but a few. Even people who are not world travelers know New York from countless films. They are familiar with Central Park, the Statue of Liberty, the chic shops, bars and restaurants of Manhattan. All these associations with the city of cities revolve around concrete, steel and glass, streets, automobiles and noise. And: New York is usually thought of as only Manhattan. But, in addition to Manhattan, the boroughs of Brooklyn and the Bronx, Queens and Staten Island are also part of "the Big Apple." Eight million people from all over the world live in these five boroughs, and it is amazing how well they live together.

Just 20 years ago, even in Manhattan, there were dangerous neighborhoods, "no-go areas." At that time the economic situation was bad, and there was no money available for what was considered unnecessary investment in green spaces. The poorest areas were neglected, and existing gardens received no financial support or care. Vacant lots were magnets for drug dealers and centers of crime, which reflected on the reputation of the entire neighborhood. Recognition of the relationship between living conditions and behavior patterns in a neighborhood stimulated a number of private individuals to start clearing the vacant lots, planting grass and flowers. It may seem naïve to think that flowers can help in the battle against crime, but in the long run, the strategy worked. Today a few of these former no-go areas have become well-loved local recreational areas, for example Battery Park in southern Manhattan.

At the same time, the only formal garden in the north of Central Park also underwent a renaissance. In the 1880s Lynden B. Miller, a socially committed garden designer whose specialty was public gardens, took the risk of reorganizing a neglected area between Manhattan and Harlem. She was convinced that beautifying the environment would have a significant positive influence on the public, and her conviction was confirmed. When the garden was restored to its former glory, the dealers and their clients disappeared. Today the garden is enjoyed by strollers, newspaper readers, and mothers with children in their carriages. Every spring 45,000 bulbs are planted, and after they have bloomed, the beds are replanted. Thanks to a single private sponsor, the plants in the Conservatory Garden can be completely replaced several times each year.

That well cared for gardens have a positive influence on whole neighborhoods is borne out by initiatives and non-profit organizations such as the New York Restoration Project, which aim to make community gardens accessible to as many residents as possible. The famous actress Bette Midler launched this project and raised millions. This money is used to buy urban lots and

transform them into gardens with help from local people. Volunteers from this one organization have removed almost nine hundred tons of garbage and cultivated more than 400 acres of land since 1995. This was a massive achievement in a city like New York, where land prices are calculated almost by the square inch. Even well-known landscape architects are designing community gardens. In Manhattan, the Bronx, Brooklyn and Queens there are already more than six hundred of them. While these mainly give access to local residents, they must be open to the general public for a few hours a week. It all started with the "Green Guerillas" of the Lower East Side in 1973. Volunteers cleared away car wrecks, debris, and garbage from squalid vacant lots, brought in top soil, and planted flowers. These "seed-bomb" activities marked the beginning of Community Gardens. To put their activities on an official footing, in 1978 the city authorities created a specific department, known as "Green Thumb," and laid down rules and contractual requirements.

Various improvements have led to the recognition that well maintained gardens are amenities that increase the value of an area: Houses are renovated, façades are painted, social relationships are consolidated and, as a result, property prices rise. In Mayor Michael Bloomberg, the green initiators found a political supporter. Not long ago he declared a 300-yard section of 6th Avenue in front of the famous Macy's department store to be a pedestrian precinct and had trees planted. He also banned cars from Times Square between 42nd and 47th Streets, previously a traffic nightmare. Not long ago, nobody could have envisaged car-free zones in New York, or that it would be possible to cycle in the city. On the Manhattan Waterfront Greenway alone, cyclists can almost "circumnavigate" Manhattan Island along a twenty-mile cycle path. And there are other examples to illustrate the change in direction taken by the city planners: The overhead railroad through West Chelsea, previously the "High Line," is being transformed into "High Line Park." At present walkers can enjoy a 900-yard green walkway (the plan is for two

miles) immediately above heavily used roads. Or take the piers of the old New York docks: The sealed areas are disappearing and making way for the mile-and-a-half-long Brooklyn Bridge Park alongside the East River. Plans are in place to create artificial beaches and bays, canals, fishing platforms, playgrounds and gardens. This is the largest park project in Brooklyn since Prospect Park was built around the end of the 19th century.

Today there are public gardens in every borough, which, apart from the greenery, also offer training courses or the chance to be an active gardener: There are a few hundred people on the volunteer waiting list for The New York Botanical Garden alone. In a built-up city like New York, digging the soil, planting, deadheading or weeding is a sought-after privilege. All the gardens work with an established group of volunteers under the leadership of a qualified gardener. These volunteers allow the gardens to be maintained in a way that would not be possible using paid workers. So there are winners on both sides: On the one hand there are magnificent gardens, and on the other there are contented city-dwellers who not only enjoy their work with nature, but also profit from contact with their fellow residents. Many friendships have developed over the years among very different people who would otherwise have had no contact with each other.

All of these green initiatives, which give the general public greater access to more green spaces, and which give New York a more friendly face, are relatively new. However, it is surprising that the city of cities can look back on a long tradition of gardens which is more than a hundred years old. As early as 1891 The New York Botanical Garden was opened, made possible by sponsors such as the Vanderbilts, the Carnegies, the Morgans, and, above all, the Rockefeller family. Many of these original sponsors are still patrons and financial supporters of public gardens, which would not be there without their money. In the 1930s, during the Great Depression, John D. Rockefeller financed Fort Tryon Park, in which the Heather Garden is now situated. The

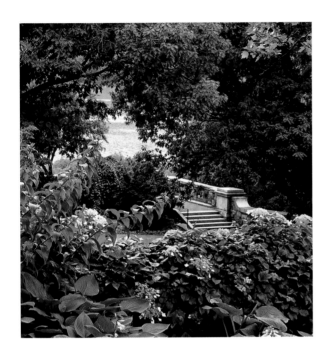

"pocket garden" Greenacre Park was also created thanks to the Rockefeller family. In the same era, John D. Rockefeller Jr. created a garden monument at Rockefeller Center in the form of four parallel Art Deco roof gardens, known as the Rockefeller Rooftops, and even today, these gardens are planted according to his original instructions. They were designed by the English landscape architect, Ralph Hancock, who became the founder of the classic New York tradition of "gardens for the view." This garden can be appreciated from more than one hundred thousand skyscraper windows.

Similar projects made New York a city of garden art. Many great designers have become immortalized as a result of their green projects, and any tour leads through many periods and trends. Dan Kiley, one of the most important landscape architects of the 20th century, developed the existing, basic Art Nouveau structure of the parks and combined the clear lines with a friendlier and more elegant arrangement. The proportions between buildings, green areas, and paths are perfect. Hideo Sasaki, a pioneer in integrating the locality into the garden design, created one of the most beautiful mini-urban parks in the world when he created Greenacre Park. He created the brilliant illusion of a skyscraper

continuing as a waterfall, with the water falling into a tank like a deluge.

Not unlike ancient Rome, New York is a city of many peoples: Influences from all over the world are evident in the green face of the metropolis, and the garden architects are not all from New York. They are, not least because of the projects which they have developed here, already part of the history of garden design, and their names can be found in the relevant textbooks. Present-day landscapers, such as Ken Smith, Brian Sawyer, Jeff Mendoza and Halsted Welles are already working hard to be included in this list; and they are making good progress. They have already won numerous awards and inquiries from all over the world. Artists come to New York to become famous, including garden artists. For example, Piet Oudolf came from Haarlem in the Netherlands, and he has influenced not only the visual aspect of New York with his sustainable planting plans. We have him to thank for the fact that people living in the city are becoming increasingly acquainted with the natural rhythm of plants, and are no longer obsessed only with the most spectacular blooms.

There are many opportunities in New York City for up-and-coming garden architects. The "Big Apple" is visibly changing into the "Big Green Apple," and the slogan "New York goes green" is the flavor of the month, but one cannot assert that this city is suddenly liberating itself from concrete and asphalt to become a city of lawns and a sea of flowers overnight. Viewed from above, Manhattan is still mainly one color, grayish black, with tar paper, chimneys and ventilation ducts as far as the eye can see. The airy heights of New York's upper story are a long way from a "Green Roof Movement": only gradually are we becoming aware of the potential for green roofs with regard to climate protection and quality of life. Until now rooftop gardens have been a privilege of the affluent.

Ken Smith, an artist and garden architect said, "The true luxuries in this city are light and soil." Anyone who has traveled the streets of Manhattan knows why they are referred to as canyons. Only at midday, when the

sun is at its zenith, does it shine on the asphalt and lighten the gray walls. At any other time, it is shady between all the skyscrapers. This is not true of other boroughs. The buildings are not so close to each other and the ground is not so completely sealed. Brooklyn, for example, has water on three sides and thus profits from a comparatively mild microclimate with more hours of sunshine. Many plants which would have no chance in the Bronx can make it through the winter out of doors in Brooklyn. However, you don't have to move from one borough to another to experience a variety of climate zones: You just have to take the elevator in a skyscraper. There can be many climate zones in one building and these can be calculated according to the number of days when the temperature is below freezing. Strong north winds cause the temperature to fall drastically and can be a big problem for roof terraces. New York is on the same latitude as Naples, but it does not have a Mediterranean climate. New York has the same very hot summers, but Naples is spared the harsh New York winters. For New Yorkers, the most stable and pleasant season is the fall. In September and October New York gardens are quite splendid.

Landscape gardeners planning gardens in New York must be familiar with these various microclimates. The choice of plants, and the technical measures which have to be taken for them to resist the strong winds, are dependent on these conditions. Trees must be well secured and furniture must be well anchored. And, of course, the weight of the garden must not exceed the load-bearing capacity of the roof. Planting in these extreme conditions is only a fraction of the total cost. In order to comply with structural requirements, it is often necessary to use customized constructions on which the real roof terrace "hovers." Drainage in the space between roof and garden must be guaranteed. In a few exceptional cases the weight of a roof garden is factored in at the construction stage, as, for example, in the Rockefeller Rooftops on Fifth Avenue. This is the only roof garden in all of New York which has a deep layer of earth, and where the plants grow directly out of the

soil and not in containers. The visual configuration of the garden is subject to the structural constraints, and not vice versa. The paths on some of the terraces are arranged so that the weight of the people is spread evenly. Serendipitously, this pragmatic requirement resulted in a pleasing aspect.

Apart from the structural factor, height is also a problem for roof gardens. The costs are enormous: not just for transporting all the materials up to the roof, but also for the future upkeep. If the service elevators are too small, then all the trees, bushes, plant containers, furniture, earth and stones must be lifted by crane. Sometimes, for safety reasons, whole streets have to be closed. For one office terrace, almost one hundred tons of material, over a period of six months, was delivered using a service elevator.

Quite apart from all these uncertainties, roof gardens on many highrise buildings have failed, often because they are condominiums or "condos" in which the individual apartment owners pay an annual sum for the

maintenance of the communal infrastructure. All of them must agree to the creation of a roof garden and it can take years before such an agreement is reached. Very often the residents are afraid that a roof garden could lead to roof damage, or that it could result in serious water damage to the building. Whether someone can become the proud owner of a garden depends on the goodwill of his or her fellow residents, and, not least, on their financial situation.

Roof terraces in Manhattan are luxurious retreats for rich New Yorkers, who can enjoy their few leisure hours amid bamboo groves, climbing hydrangeas, and maple trees. The spectrum ranges from the romantic Victorian dream to Bauhaus-inspired roof-garden architecture. As far as gardens are concerned, the famous New York toughness is a thing of the past. The word "garden" touches the heart of everyone: bankers, brokers, lawyers, designers, artists and businessmen. The garden provides a haven which compensates for the pressure of living in a city and the stress of business life. It symbolizes an island of retreat and a carefree existence.

The garden architect designing a garden for this privileged sector must take into consideration not only the lifestyle of his or her clients, but also their preference for certain plants, and also their artistic tastes. An art collecting family made available the works of famous sculptors, and commissioned the artist Ken Smith to create an atrium garden around the sculptures at Central Park South. The result is a *Gesamtkunstwerk* combining the sculptures with the garden design. One of the biggest problems here was to find plants which could survive with very few hours of sunshine. Ken Smith did his best to optimize the available light and used glass marbles on the ground, which multiplied the reflection of every sunbeam. This use of a seemingly absurd material for the floor of one of the most prominent roof terraces in New York made Ken Smith the talk of the town. He won the contract to build the roof garden on the extension of the Museum of Modern Art, but was not allowed to use either earth or living plants. This limita-tion, which would have driven others to resignation, gave him the freedom to create a garden just as he wanted. He used glass, rubber, stones and a lot of plastic. The MoMA Roof Garden is still controversial, but has not damaged his reputation.

Some garden owners such as Peter Schulz and Bruce L. Smithwick manage without garden architects. In the summer months they live in their roof garden, and for them the variety of flowers is paramount. Others can only enjoy the night hours outdoors and prefer white blooms and a good lighting design. In our world of luxury technologies everything is possible, so that a garden owner can even make the moon rise at a flick of a switch. Who in New York has time to wait for the real moon to appear, after all?

New York is not just made of steel, glass and concrete. The many gardens complete the city, and allow it to expand beyond the clichés. The luxury of having a garden, whether large or small, has just as great a role to play in the "urbs" as it did two thousand years ago in Ancient Rome. And now, as in years gone by, the craving for nature and a life without stress is satisfied by creating a harmonious reality.

Symphony in Green

The address of this roof garden, Central Park South, implies the southern boundary of the park in Manhattan. It is indeed one of the few streets looking on to a totally green sea of treetops, framed left and right by skyscrapers, which reach into the heights like canyon walls. On the horizon the green melts into the gray-blue sky, almost as if there were nothing behind it; no city, no houses, no streets. It is not surprising that for the owners this view was of the utmost importance. However, the landscape designer Jeff Mendoza was ambitious. He wanted the garden to be seen first, a garden which, as he said, "stands in the foreground." The owner Richard D. Rudder is proud to say, "In New York, this garden is unique. It stands alone and is still in harmony with Central Park."

Safety regulations meant the parapets on the park side had to be eight feet high, and they had to be made even higher after the ground level of the previously sunken terrace was raised in line with the interior. Jeff Mendoza found a solution: He created boxes which were mounted on the parapet and planted with creeping juniper. In this way the prescribed height was attained and the unwanted wall disappeared behind the junipers. Plants, bushes and trees thrive in containers of different depths and create a topographic gradation of four inches and a foot. Ground-covering plants only have four inches of soil; while the trees have a good foot. The ingenious aspect of this design is that none of the plant containers is visible so that the overall effect is that of a garden that was evolved under natural conditions.

The ground area of about eight square feet is a sheet metal tub in which there are containers of various heights. The soil and the roof of the house must never be in direct contact because this could lead to the building being damaged. Nevertheless, the designer must ensure that the water can run off; otherwise only marsh plants would survive. Drainage leaches nutrients; so roof terraces need regular and appropriate fertilizers. Mendoza not only takes into consideration the pragmatic requirements, but also, of course, his clients' wishes. Cynthia and Richard D. Rudder live in a Japanese ambience and say, "As is typical in Japanese design, the garden has a simple design, but a very complicated structure." Its charisma is immediately apparent, but the longer you look, the more you become aware of the beauty of the plants. The peace and tranquillity of the design are in harmony with the owners' vision of how the garden is to be used. They wanted it to be calm, modest and peaceful. Jeff Mendoza suggested using only one color, green. "I always thought that a colorful flower bed would be more interesting because it is always changing, but over a period of time I discovered that a well-designed green garden is just as rewarding." So the task was to orchestrate the size, shapes and surface structures of the leaves with olive, mint, dark and light shades. This roof terrace was, for him, a wonderful learning exercise, because every detail had to be perfect. The element which connects the whole is a carpet of light moss. Large level paving stones lead to the steps. On the wooden deck there is a glass table in which you

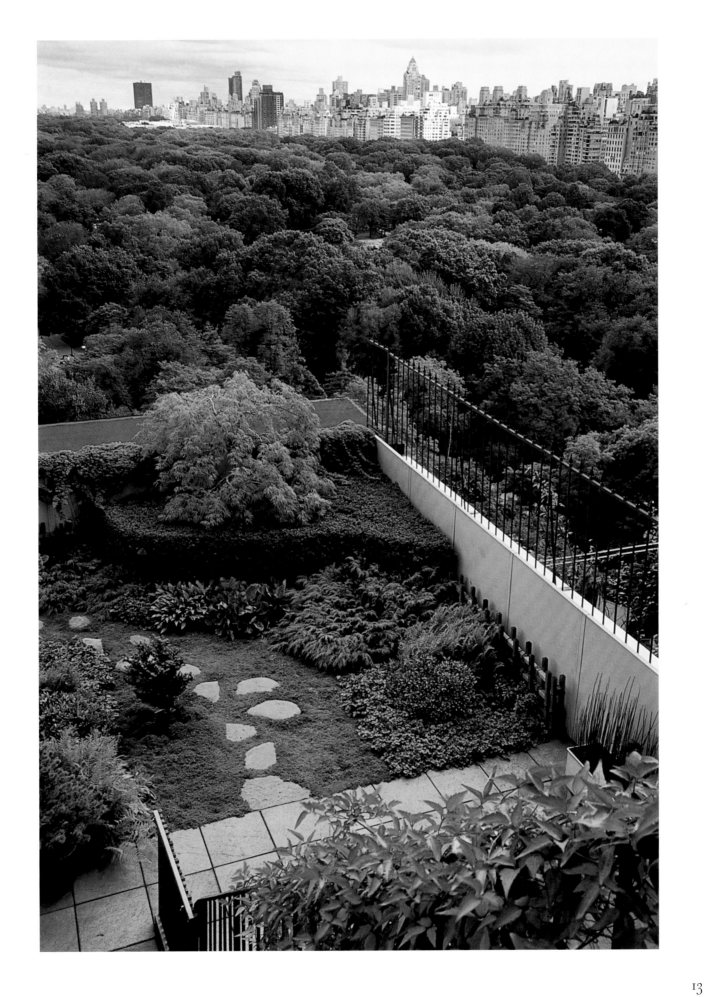

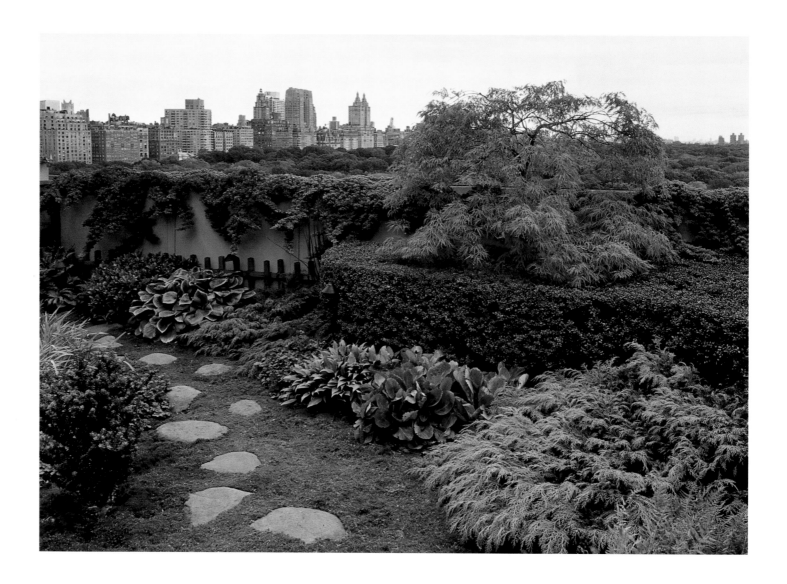

can see the sky or, looking to the side, down through the balustrade, the crowns of the trees in Central Park. Standing on the polished planks, feeling the stiff breeze blowing over the sea of green, it is like being on the prow of a ship. Jeff Mendoza says, "New York has many varied microclimates; it all depends on where you are and how high you are." There can be many climate zones in the same building, because the strength of the wind increases as you ascend. These zones are calculated according to the number of days when the temperature drops below freezing. The grasses on this exposed patio can withstand the cold and the strong wind. In fall, their light, feathery flowers fit in with the surrounding architecture.

In a sheltered, walled corner, with its back to the city, there is a fountain with a semi-circular trough, into which water ripples down from a vertical unit. Jeff Mendoza designed this himself; he studied stonemasonry, but his work has always been in landscaping. For him, designing gardens is an art. The trained eye taking in the whole picture, mentally staking out the many different spaces, understanding the total when positioning the individual items—these are all the elements in landscaping which he enjoys.

The fountain sculpture, a seated, contemplative imp, was supplied by the owner. Jokingly, Richard D. Rudder said, "It's his job to watch over the garden at night." Cradling his knees, he sits on the top of the

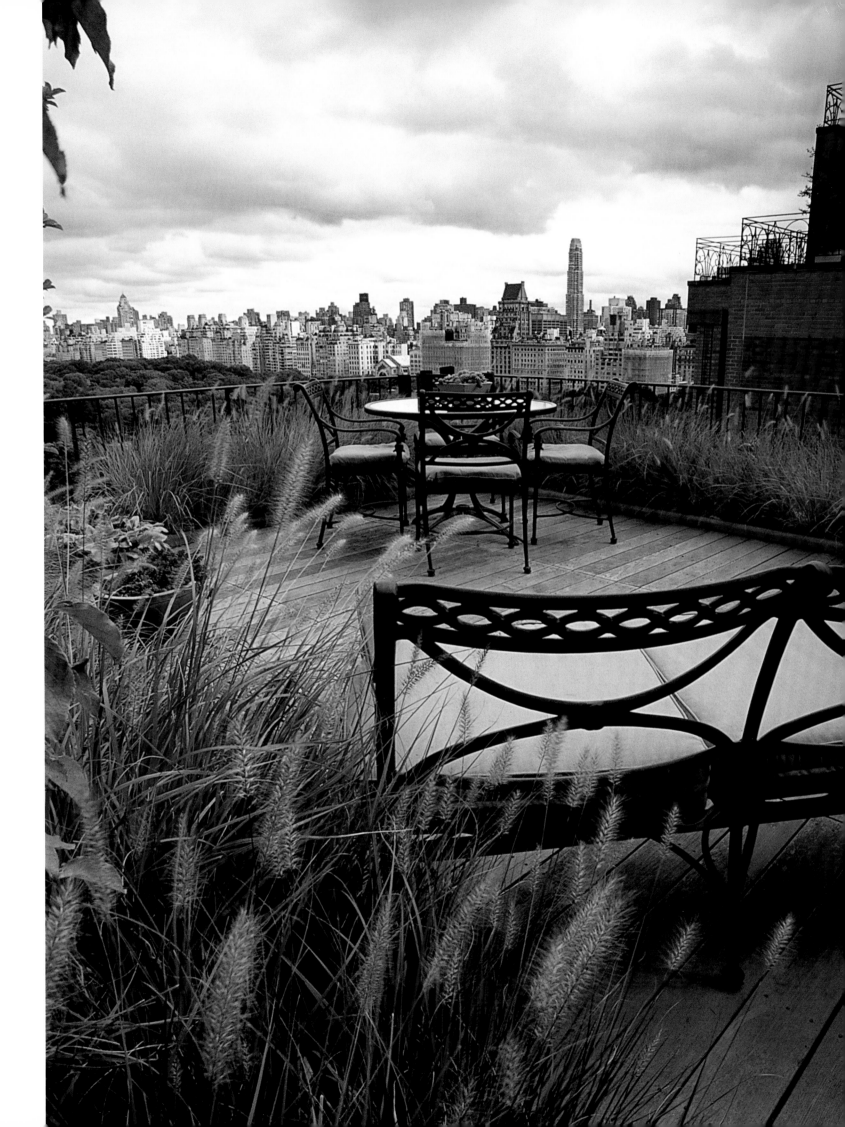

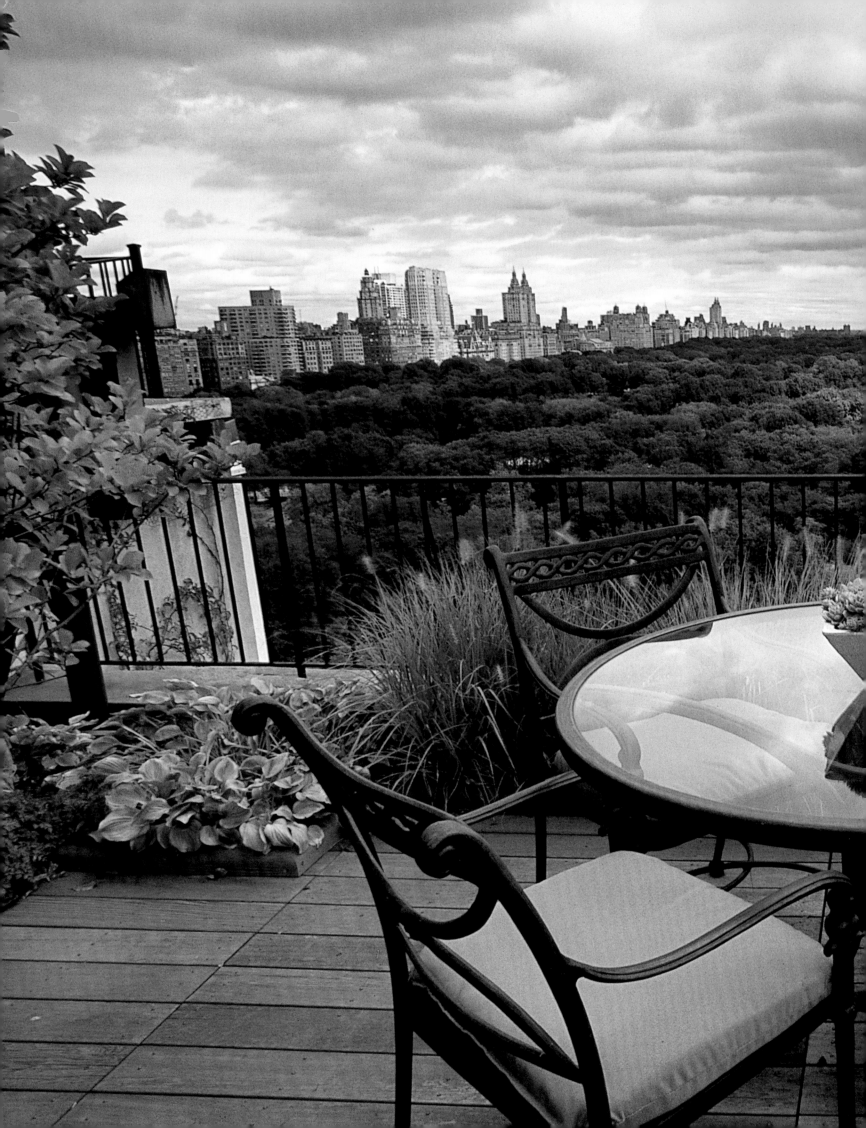

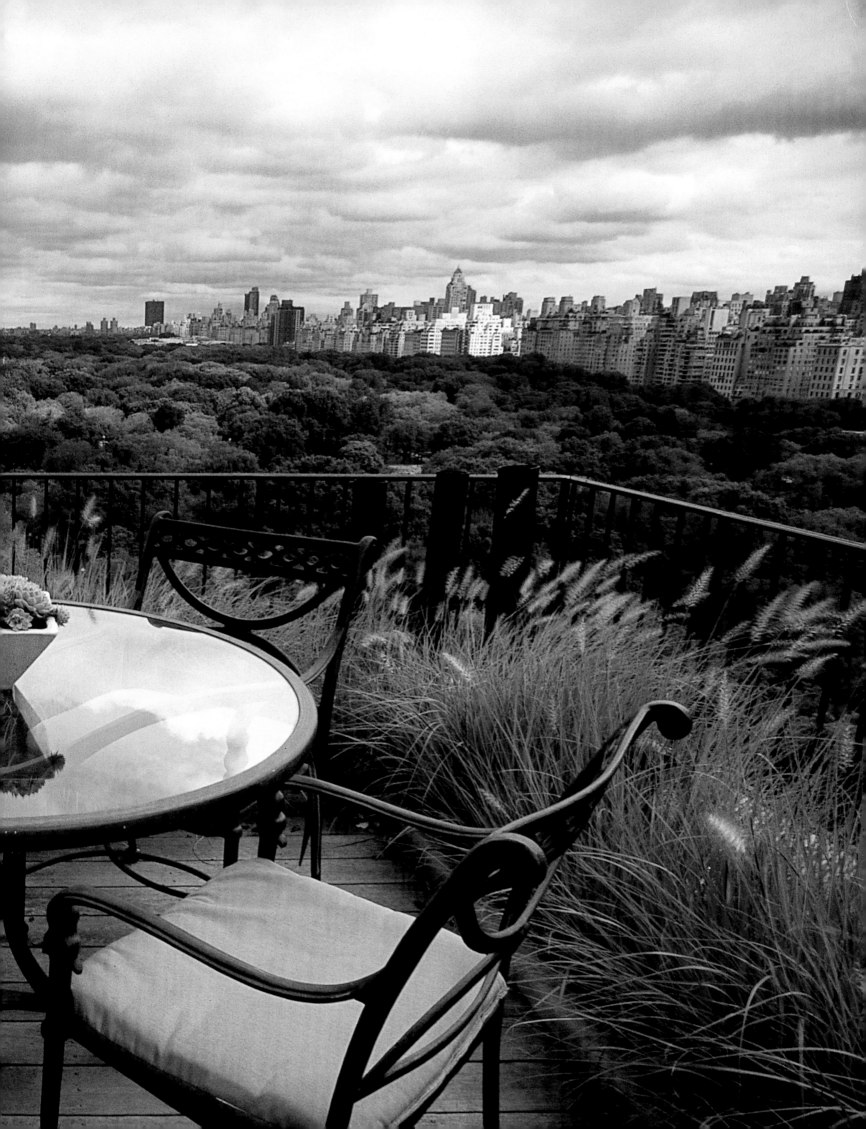

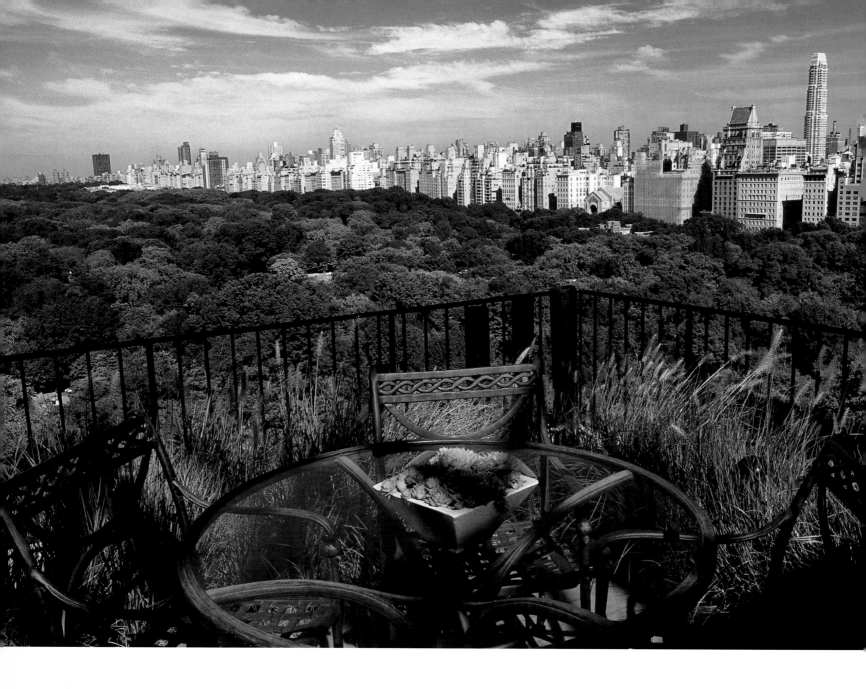

fountain, looking over Central Park like an alien from another planet. The little fellow could not have found a more suitable place to come to earth. From a garden hovering over Manhattan he has a truly otherworldly view of the park, and of the city of New York.

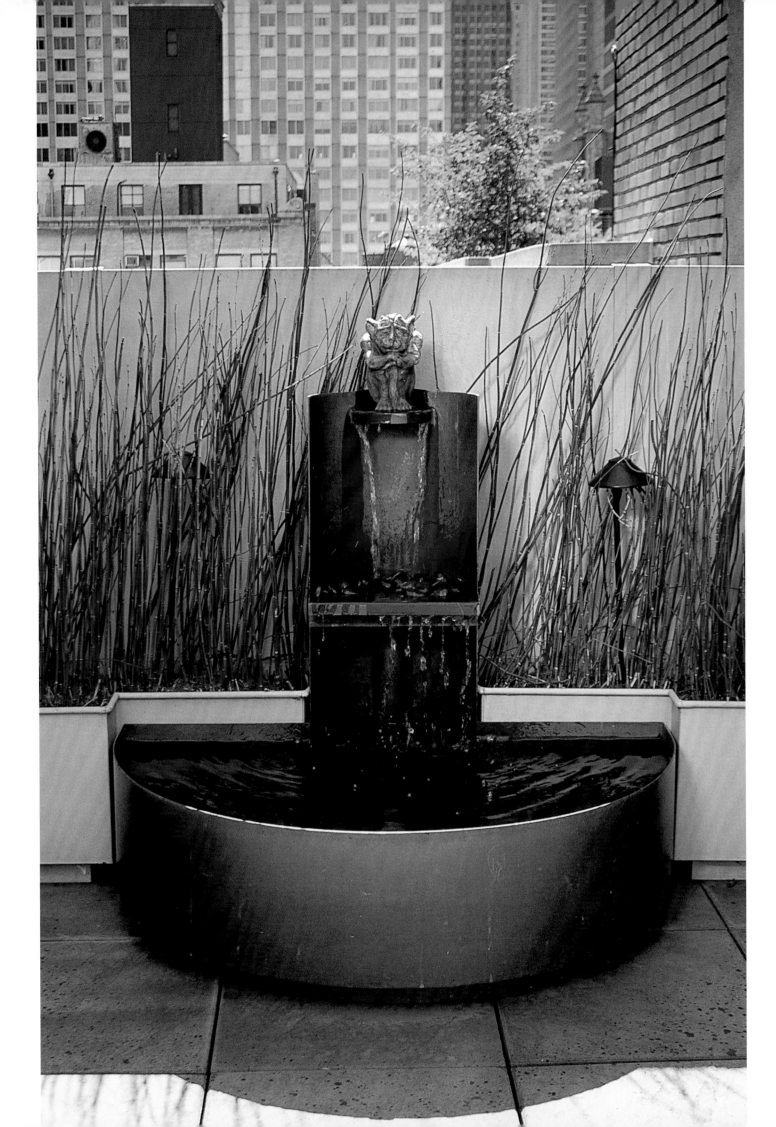

Garden Picture with Frame

"Brownstones" are town houses which have not been rendered or pebbledashed, but display their masonry structure. Richard J. Urowsky's brownstone house in the West Village dates back to the 19th century and is in a heritage zone. When the owner converted his house in 2006 he hired the landscape architect Brian Sawyer to create the garden. The plot behind the house is twenty feet wide by forty long. The only plant that he wanted to keep was the Norwegian maple in the south-west corner of the garden. Apart from this, Brian Sawyer was given a free hand. He designed an enclosed garden, which guaranteed maximum privacy for his client. Since the latter wanted to enjoy the garden from the windows, the landscape architect composed the garden like a painting. The positioning of each individual element is carefully chosen and fulfills its aesthetic function as a part of the complete concept. The view from every perspective is beautifully framed, and particular attention was paid to the surrounding fence: a painted mahogany trellis behind which there are bronze-colored acrylic mirrors designed to make the most of the available light. The ivy is cut so that it covers almost forty percent of the fence, and in this way you can glimpse, time and again, the light reflected by the mirror through the thick greenery. Crowning the pillars that support the trellis there are black zinc amphorae. Backlit, their silhouettes unfold to great ornamental effect. Fastened to the top third of the pillars there are also ornamental metal baskets holding gray Impruneta terracotta plant pots planted with variegated hanging ivy. The dark green

wall is thus endowed with a certain dynamic, since the light green areas look like miniature waterfalls. The natural stone paving is set in light green moss. This adds gentle contours and softens the austere architectural design. Evergreens, ferns, box shrubs trimmed into globes, and hostas are planted in the beds in front of the hedge. Terracotta plant pots planted with white-bordered hostas complete the exuberant impression, and create the desired effect of brightening the shaded garden. The center is furnished with elegant metal tables and chairs, like a stylized living room. And as is expected in a living room, there is of course a piece of art: a bronze, whose title is *Minister of Words* from Melissa Zink's *Guardians* series. To ensure that the sculpture can be viewed from all sides, it is mounted on a rotating plinth. The slender stele epitomizes the spirit of the garden, its introverted deliberateness which, at the same time, has room for a little playfulness. Two steps lead to the rear of the garden where there is a dining area including a barbecue. Because this is on a higher level this is an intimate area which is always shaded by the crown of the maple tree. Fenced on three sides it is protected from the view of the neighbors. A clever lighting system allows moonrise at the push of a button. Hidden between the highest branches of the maple, this artificial moon shines whenever you want. The tree trunk, the fencing, and the fountain can also be illuminated with varying effect. The constant babbling of the water has a calming effect and freshens the air. It also adds to the idea of a classical garden, in which the element of water

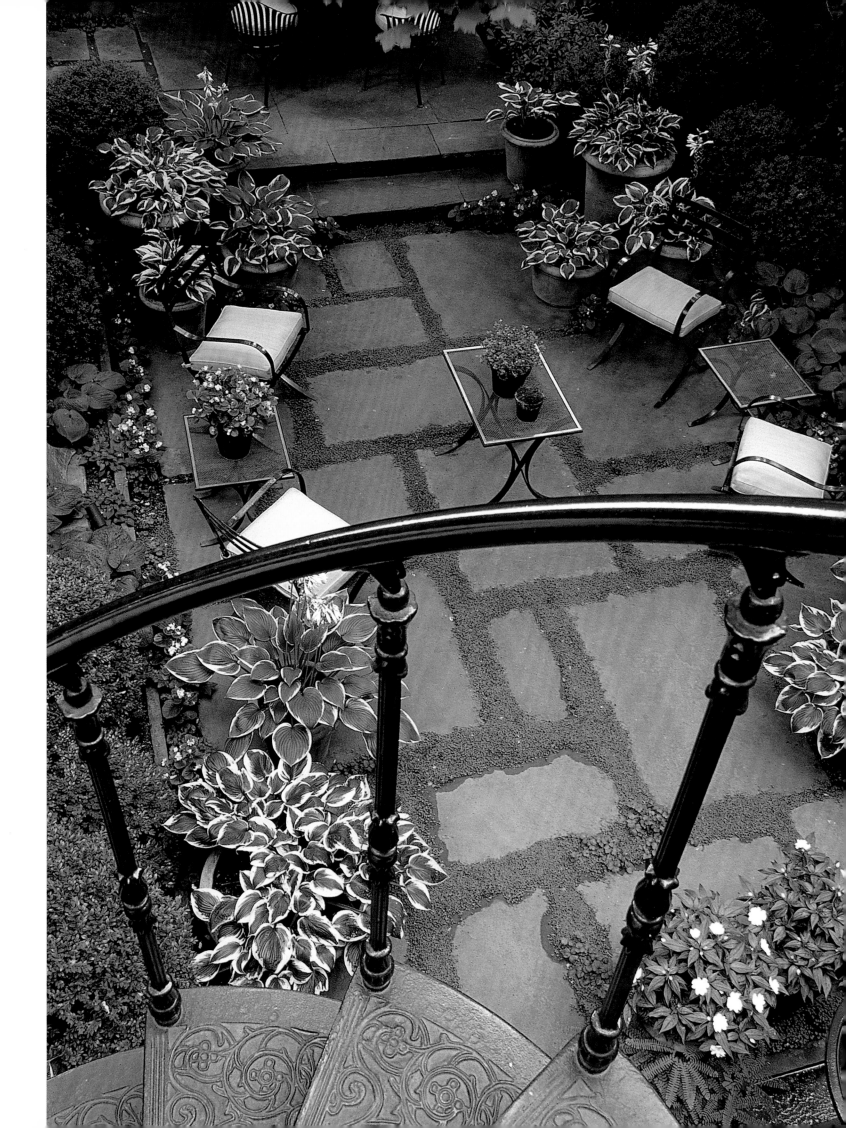

is always present. The wide bowl is also very beautiful when seen from above, just as, visually, the whole garden functions perfectly when seen from this aspect. The kitchen area was only added to the second floor during the most recent conversion. This now has a black spiral staircase connecting it to the garden. Under this there is a loggia. The mahogany trellis is also backed by bronze-colored mirrors. The whole complex gives the feeling that not a single detail has been left to chance, and the reward for these labors came in the form of the Honor Award 2007 from the American Society of Landscape Architects.

For Brian Sawyer, the garden in its present form is the culmination of a long period of development: Over twenty years he has taken it apart, re-created it and changed it. He knows every inch of the plot. His company, Sawyer and Berson, is on a twenty-first floor in southern Manhattan. It is a large open-plan office with many planners, draftsmen and landscape architects.

When asked about his own garden, Sawyer answers that he has the feeling of owning many gardens. It may be that this is the secret of his success—that he treats every garden as if it were his own. Inspired by his grandfather, he was only ten when he first designed a garden for his parents. He was given his first greenhouse when he was thirteen and started to grow vegetables. When he left school, he could not decide whether he should be a designer or a cook. For a year he worked for the only rich man in town, and for him he redesigned his enormous garden. After this he studied design and earned his money as a chef. During his time working in the office of the famous architect Robert M. Stern he got to know the world and supervised building sites in Europe, Asia, and the whole of America. He has said that

for his own garden he would like to have a roof terrace, but he would prefer a country house with old trees and a large, white oak. However, something modern with blue glass boxes would also be interesting. A sentence beginning with the words, "My ideal garden…" is broken off. He hesitates, falls silent and puts his head in his hands. He says that for years, no one has asked him such a difficult question. These are the words of an architect who has brought to fruition some of the most complicated building projects in the middle of Manhattan for which the traffic had to be brought to a standstill so that cranes, tons of steel, concrete and glass could be placed on the dizzy heights of roofs of buildings for which the load-bearing capacity had to be calculated anew and structural changes effected. With a smile, he finally says, "The only thing which I can imagine is that the garden must look like the one I knew as a child."

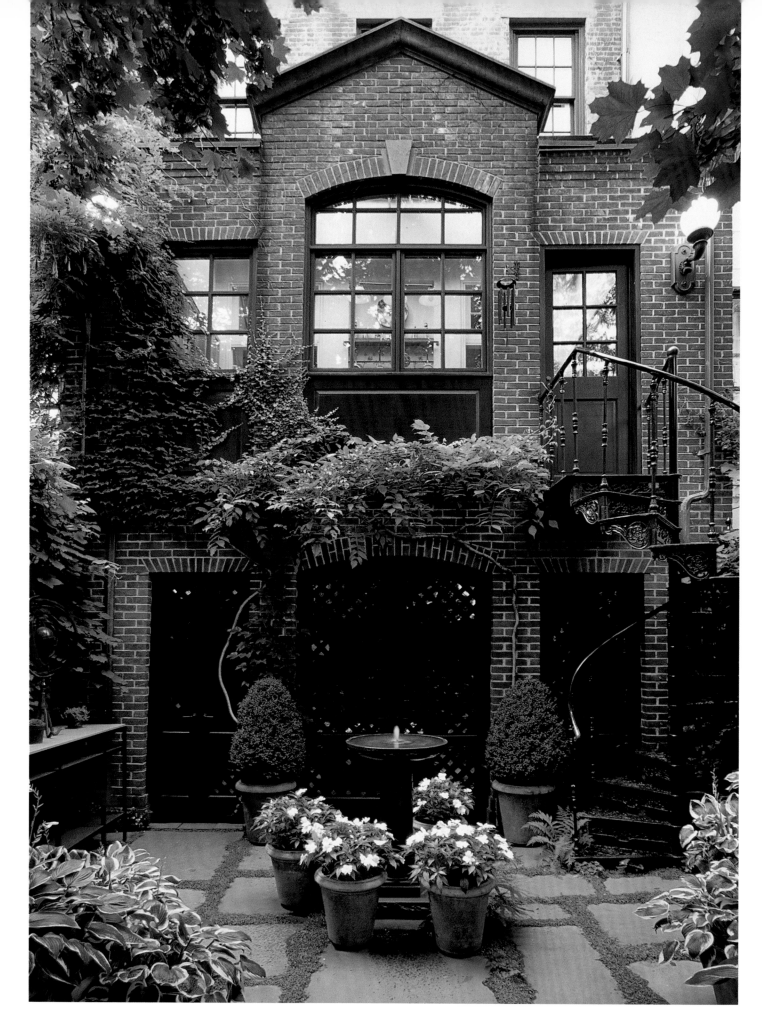

Barefoot Bliss at the End of Town

It is a long journey on the 1 from Manhattan to the Bronx. At some stage the subway train rattles above ground through an uninteresting, run-of-the-mill area, residential estates as far as the eye can see. It ends in an elevated station in the center of the Bronx. You go down metal stairs to the pedestrian level and spot the minibus with the sign "Wave Hill." The park provides its own free shuttle service, because the distance from the station to the park is too far to walk. You often hear it said that you should never walk alone in the Bronx. This may well be true of some areas, but not all. The bus climbs along a winding route, passing villas with park-like gardens in complete contrast to the popular image of the borough.

Wave Hill is on a plateau with a view of the Hudson sparkling at its feet. It is due to John D. Rockefeller Jr. that the other side of the river is not built up and constitutes a wild nature-conservation area. He bought up large areas to protect them from speculative building. You feel a long way from the city, which in reality is very close. The location of this park is beautiful, breathtaking. Gradually, you tear yourself away from the spectacular view and concentrate on the garden, which is almost 150 years old. There are eighteen designed gardens covering an area of more than twenty-eight acres grouped around four historic buildings and five glasshouses, among them the "Flower Garden," shown here in all the photographs.

Apart from the impressive numbers, the garden can look back on prominent names. In 1866 the publisher William Henry Appleton bought Wave Hill House and had a garden designed. He also built glasshouses. During the summers of 1870 and 1871 he let the house to the family of the future president Theodore Roosevelt. It is said that Wave Hill was the beginning of the then twelve-year-old Teddy's profound appreciation of nature. The result of this was that when he became president, he acquired millions of acres of land to protect them as parks. Another prominent friend of the Appletons was the author Mark Twain, who lived in Wave Hill from 1901 to 1903. He had a tree-house parlor built in a free-standing walnut tree, and obviously took great pleasure from his time in the garden. Referring to winter in Wave Hill, he wrote, "I believe we have the noblest roaring blasts here I have ever known on land; they sing their hoarse song through the big tree-tops with a splendid energy that thrills me and stirs me and uplifts me and makes me want to live always." Mark Twain was sixty-six when he came here and had already taken some hard knocks of fortune. So the Wave Hill garden must have already had a vibrant atmosphere.

Breakfast is served every Sunday morning in the Mark Twain Room, which has a view over the Hudson River. After breakfast, you make a tour of the park and the visit ends with a concert in the Armor Hall. Wave Hill is not simply a garden. It is also a cultural center, hosting concerts and exhibitions. The young artists exhibited must come from New York and must not have had any previous exhibitions. But they must have the potential to become famous.

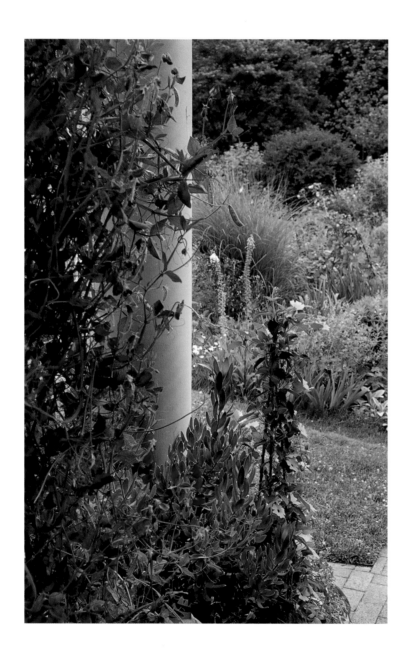

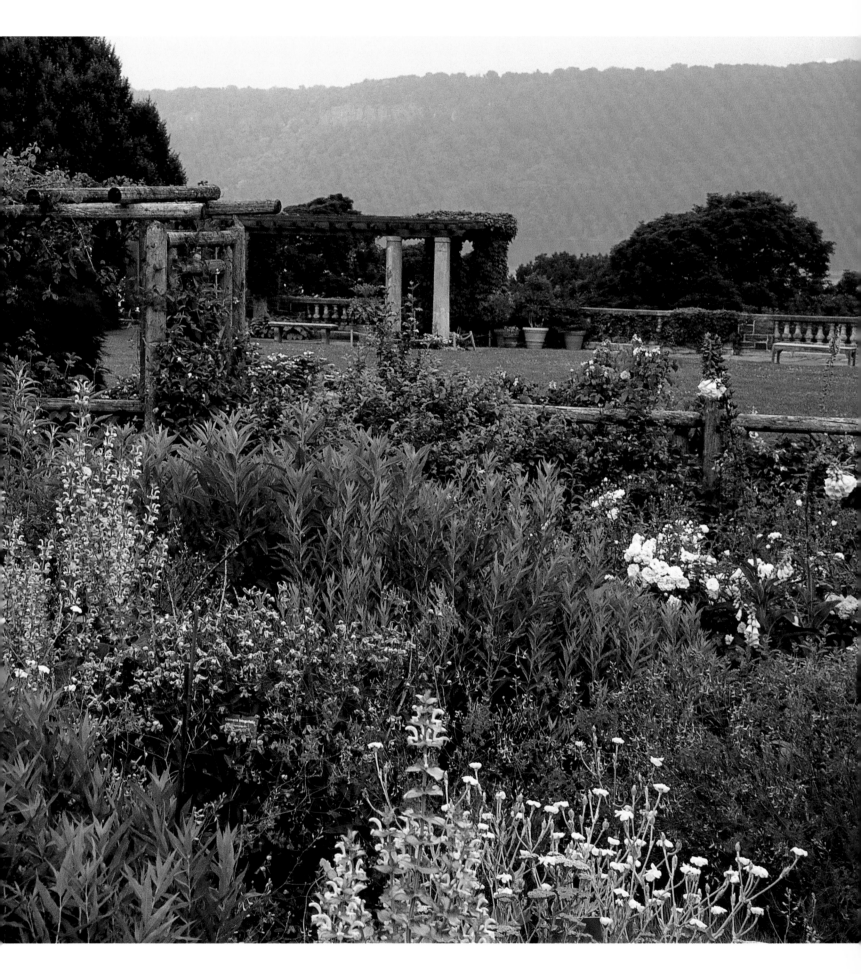

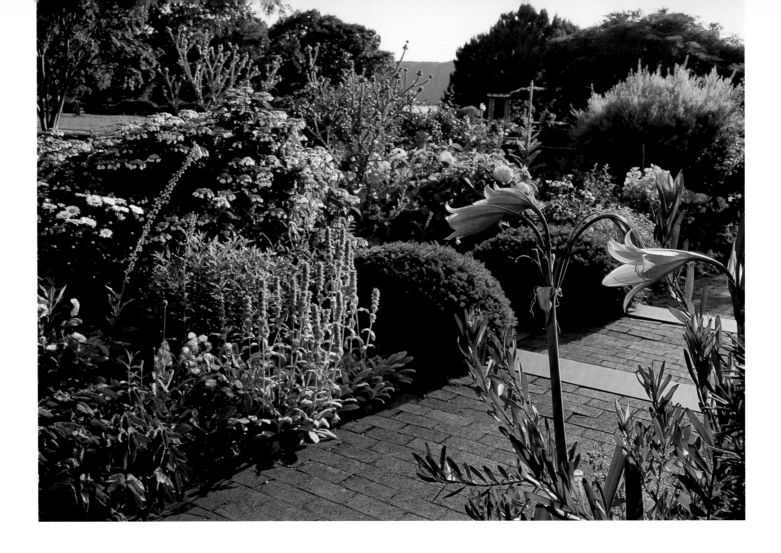

In 1903 the financier George Perkins bought the estate together with neighboring plots and extended the garden to its present area. Wave Hill is proud of its more than 3,000 species of plants, made possible only because it has special permission to import plants directly from overseas. In 1960 the Perkins family gifted Wave Hill to New York City. Five years later a nonprofit organization was founded which since then has made it its task to acquaint as many people as possible with nature at Wave Hill. In a megacity like New York children and young people often have no eye for nature. The thought of going into the country or finding out about nature never enters their head, because they know nothing about it or how interesting it could be. Wave Hill works together with educators and teachers. They guide the children and young people, making them aware of the smells, sounds, colors and shapes, as well as of the larger ecological picture and sustainable cultivation methods. Not least, these city children can literally feel the garden, because Wave Hill is the only garden in the whole of New York, with the exception of Central Park, where you can walk barefoot over the lawns and meadows and experience how grass tickles your toes, how rough or soft, bristly, velvety, dry or wet it is. On Sunday afternoons almost a hundred volunteers guide visitors through the garden. They show them the wild garden, the alpine garden, the herb garden and the water garden, and point out the more than 100-year-old copper beeches and lime trees. If they are lucky they might witness a wedding beneath the pergola on the Hudson River, which is overgrown with wisteria. Throughout the garden there are places to sit, and there are chairs which you can take to your favorite place. In this way, every visitor can imagine being in a private garden. Scott Canning, the head gardener, is proud that his garden is wonderful even in winter, but above all in fall. For, he says, it is easy to have a beautiful garden in spring. Wave Hill has deliberately made

the fall the most important season with asters, dahlias, sages, snowball bushes, seed pods, berries and dried grasses. In October the garden is filled with a magnificent display of waves of color. On its way to Mexico, the monarch butterfly flies over the Hudson River and thousands populate the garden. This is the last moment in the year when the garden radiates shimmering color. For Scott the view of the river is best in winter, when no foliage gets in the way. When he started in 2002 he had a hard act to follow: His predecessor was no less than Marco Stufano, who had been head gardener for more than thirty years. Wave Hill was his child, which he was reluctant to hand over. Marco Stufano succeeded in changing a private garden into a public garden without taking anything away from its charm and atmosphere. Scott recognizes the enormous task of doing justice to this legacy, and, at the same time, following his own path. Every year he plants the flower garden according to a theme; for example: "chocolate colors," "biting heat" or "ghost garden." People who love plants come here every year. Some New Yorkers come to see the many hundreds of plants in pots which the Wave Hill gardeners display to show how these visitors can enjoy a bit of greenery at home. But when their yearning for nature becomes overwhelming, subway line 1 leaves every few minutes and takes you from Manhattan to the Bronx and Wave Hill.

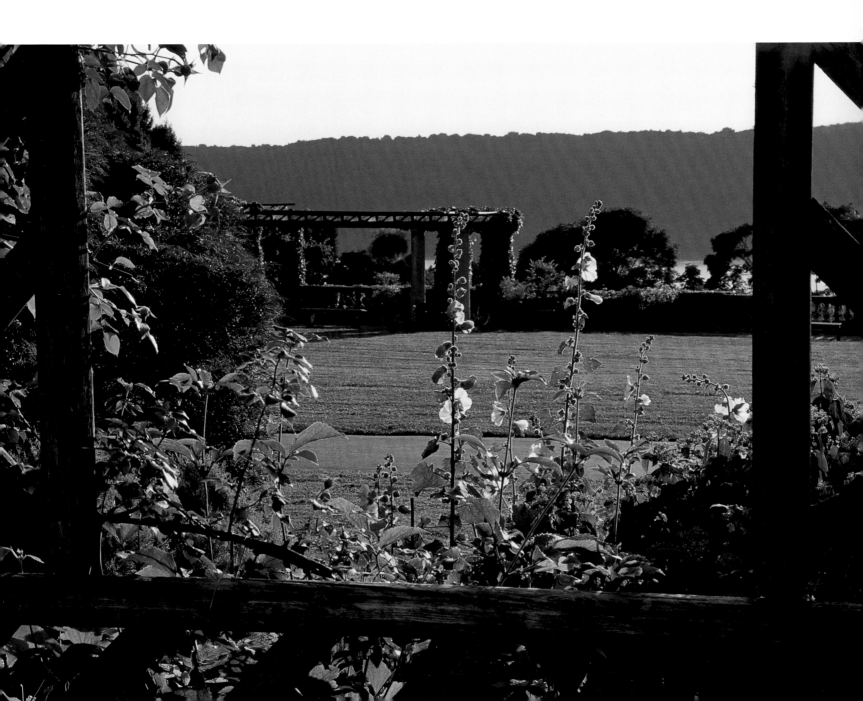

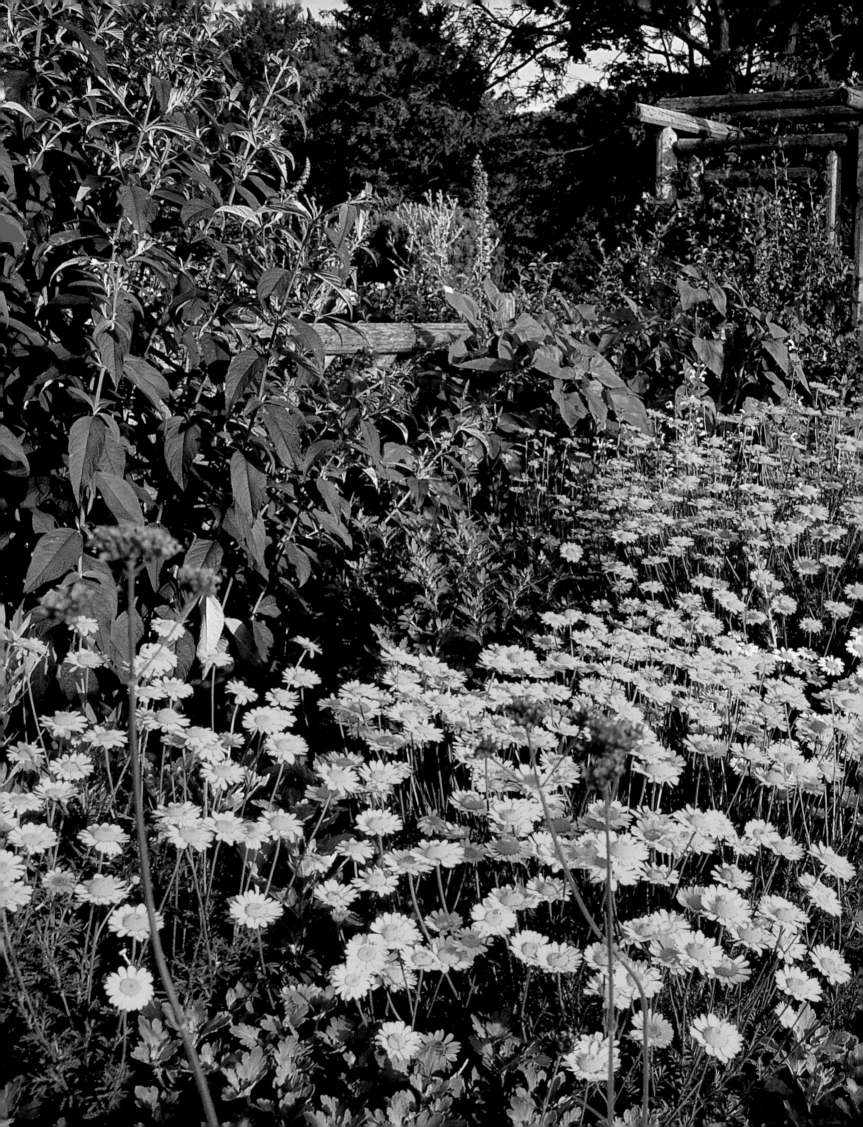

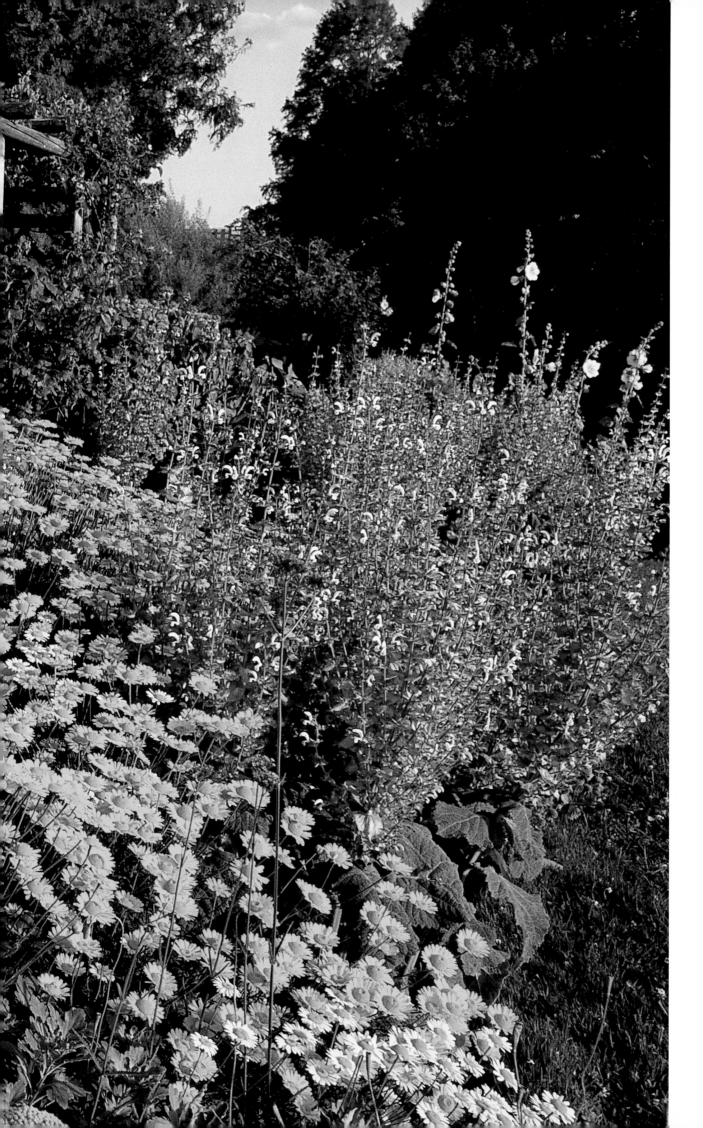

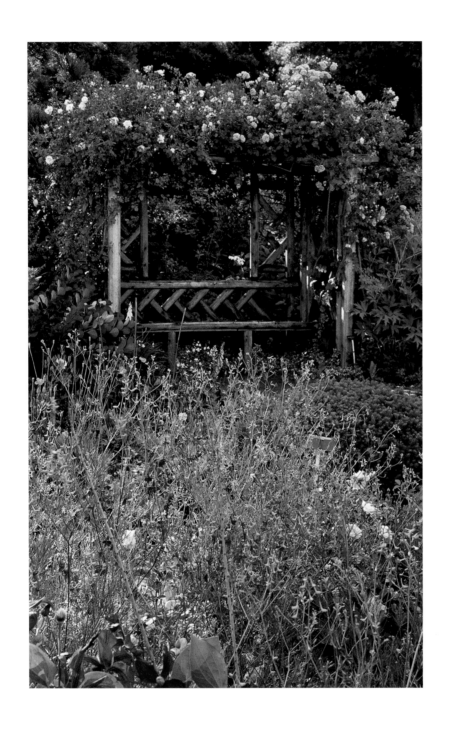

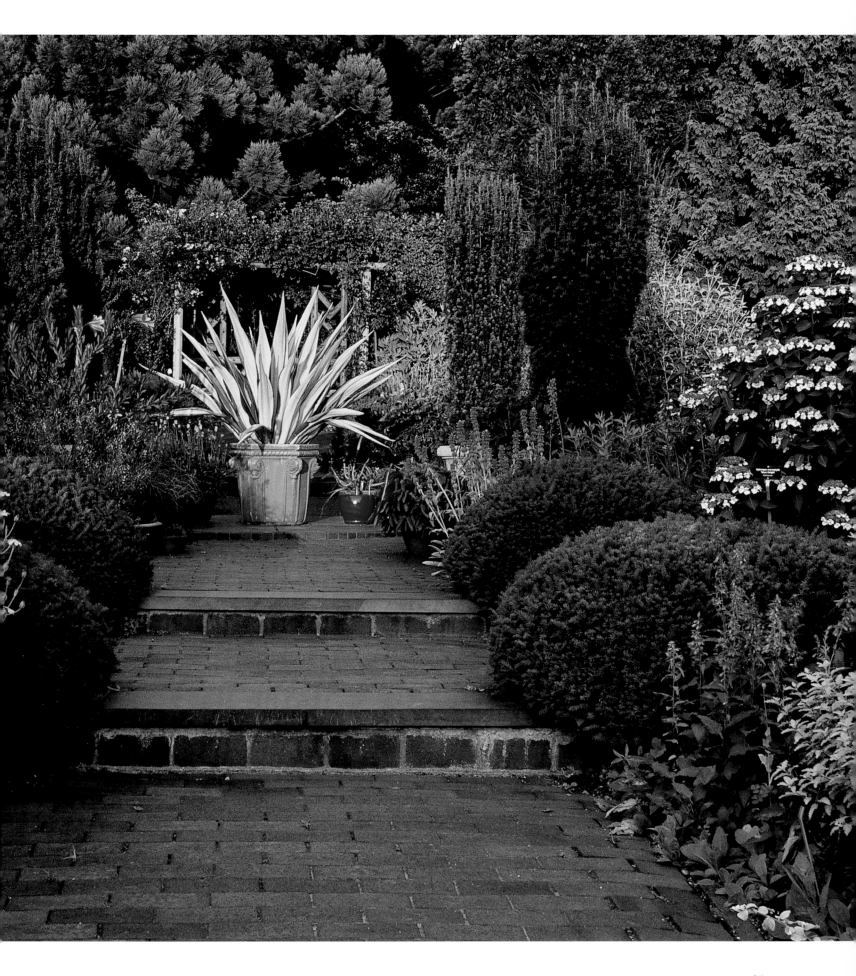

Scent of Roses at Vertiginous Heights

Ventilation ducts rise from the penthouse garden into the sky like metal mushrooms. They stand on an elevated plinth, so that the covering hood can turn without disturbing life in the garden. They seem like an inquisitive public spying on the romantically set table, which is decorated with yellow blooms from the adjacent flower bed. This oasis is one of many on the luxurious, five-thousand-square-foot terrace. The garden designer Halsted Welles, who has cared for it for more than twenty years, says, "It is among the most beautiful and largest in New York." Long before gardens became popular and a coveted status symbol in New York, the owners of this terrace, high above Central Park, had already discovered their love of plants. When they hired Halsted Welles to re-design the garden, he had to find a new place for every single flower, for every bush and every petunia, because it was out of the question to throw away even one plant. Given the wealth of plant material it was a blessing that the owners had just bought a second story and that Welles could create a two-story roof garden. The architecture provided the framework for the arrangement. Halsted Welles drew a parallel with Sissinghurst, Vita Sackville-West's English garden, which is known the world over for its garden "rooms": Here, as there, compartments merge into the whole multi-faceted creation.

The airy-blue wrought-iron vine-leaf pavilion commissioned by a former owner in the 1930s is unique. Positioned lengthways on a plinth it provides a shelter from the bright sunlight and creates a magical floral display of shadows on the orange Ludowici ceramic tiles. There is not a roof garden in Manhattan which has as many roses; they have been chosen not simply for color, but also for their scent. The owner enjoys them, above all, in early morning when the air is still fresh and the dew is glistening on the leaves. She feels at home in the world of perfume and says that her profession inspired her garden, and vice versa: "One rose, the *Double Delight*, has such a magnificent scent that we have been able to duplicate it and thus integrate it in one of our perfumes." Can you imagine that? Chemists on a roof in Manhattan have been able to capture and immortalize the scent of a rose!

No matter which window you look from, the view is of blooming roses and well cared-for flower beds. A regular gardener takes care that no fading leaves lie on the path and that every plant has everything it needs. The owner's love of gardens began in kindergarten in London. However, since her life now centers on New York and not southern England, together with her husband she developed a many-faceted blooming paradise at a dizzy height. Between birches, maples, poplars, cherry and apple trees, which were planted here decades ago, grow hydrangeas, wisterias, cosmea, zinnias, lilies, tulips and many other annuals and herbaceous perennials. There are flowers throughout the year.

The owners wanted Halsted Welles to create a Japanese garden on the upper level, which they could see from the gym when they were exercising. A narrow passage was framed with bamboo canes, although on

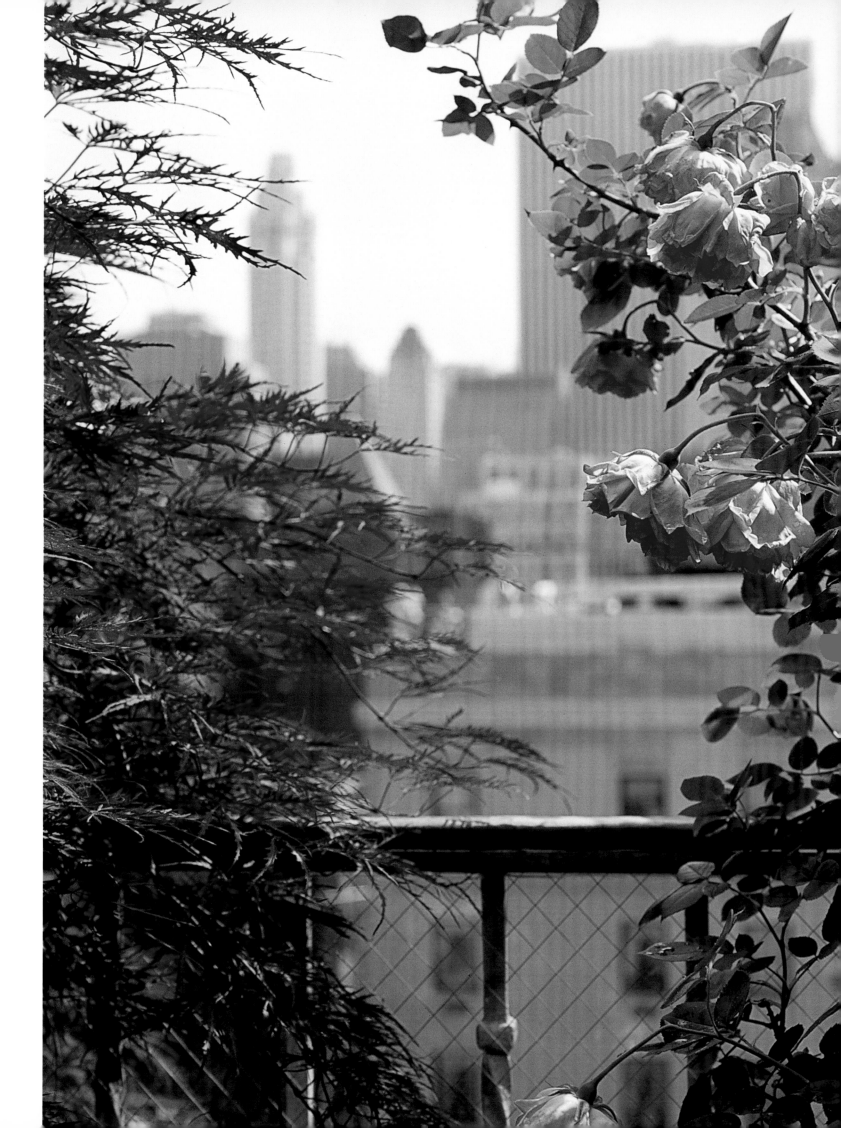

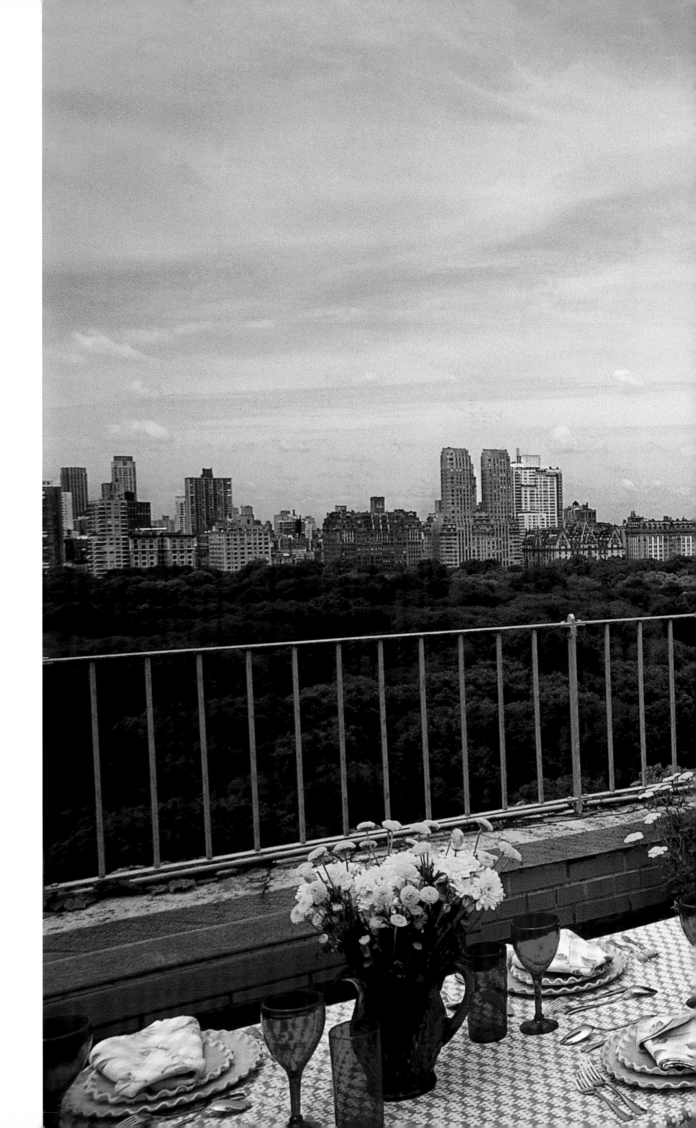

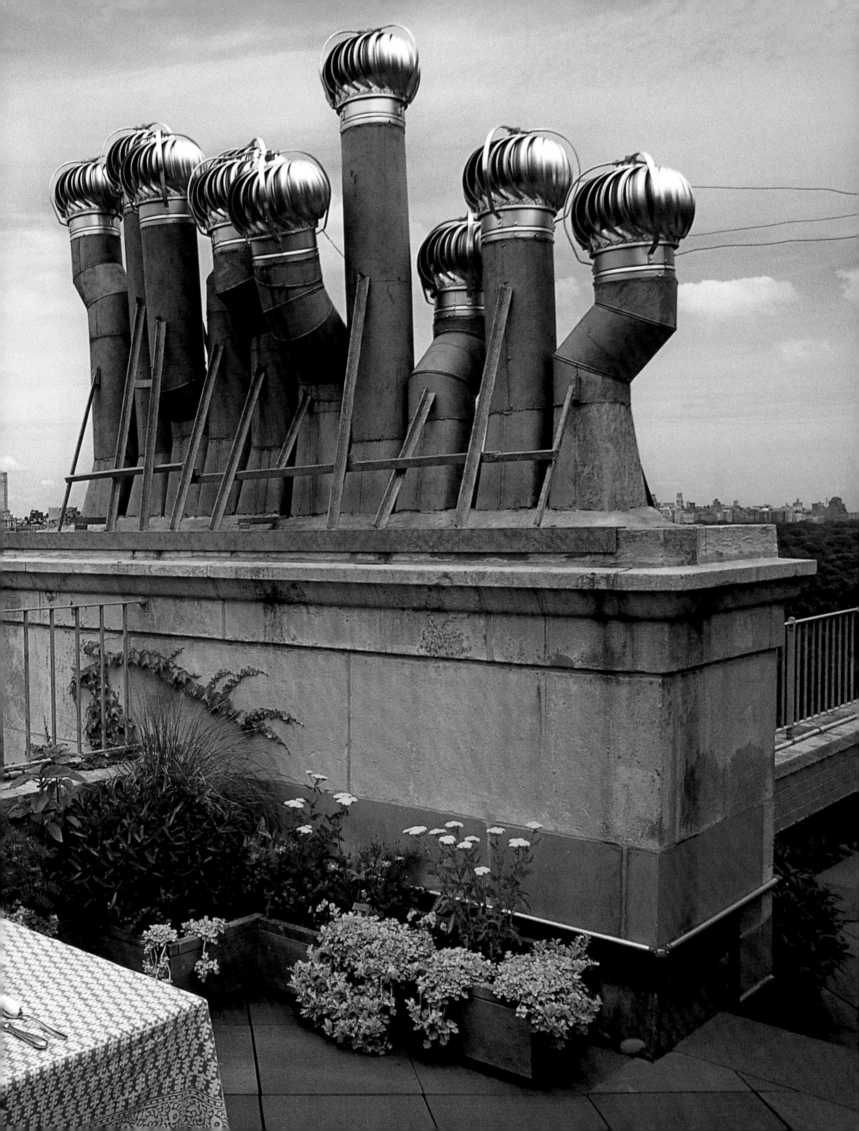

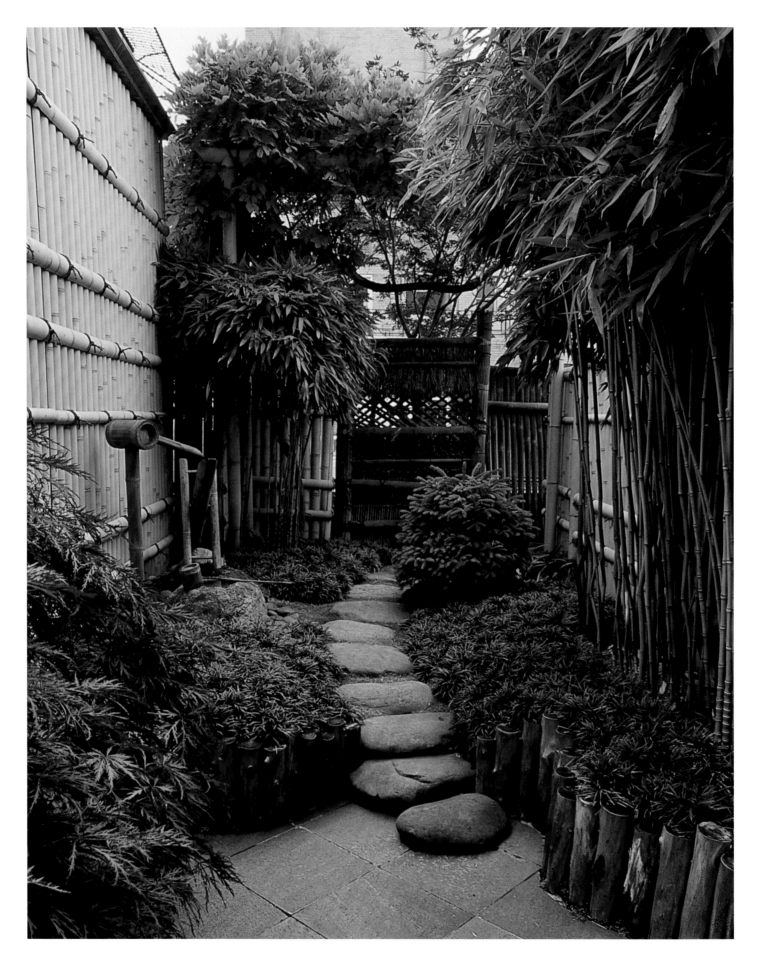

one side of the house Halsted Welles used a trick to hide the utilities: He clad the wall in aluminum pipes which looked like bamboo. The ground is covered in thick moss and strong, short grass, between which stepping stones are laid. A hollowed-out stone is used as a water tank, which is flanked by a bamboo construction and a water scoop. Bamboo is the dominant plant here. A fine red Japanese maple stands at the entrance. The result is an intimate garden room with an intensive aura, complete in itself, but without hiding the treetops of Central Park.

However, the roof terrace has larger areas too, which are framed all round by luxuriantly planted troughs. When, in the evening, friends are invited to dinner, or to a party, lanterns are hung in the trees. The owner says, "It is wonderful to see the city on a perfect night." The question of what a perfect night in New York means must, unfortunately, remain unanswered. Maybe she meant those nights when the stars twinkle more brightly than the lights of this great city.

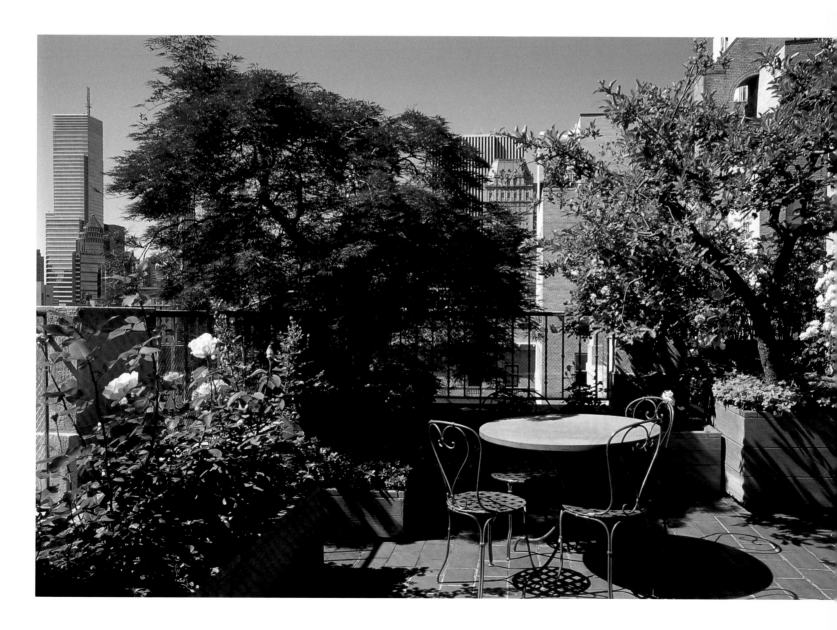

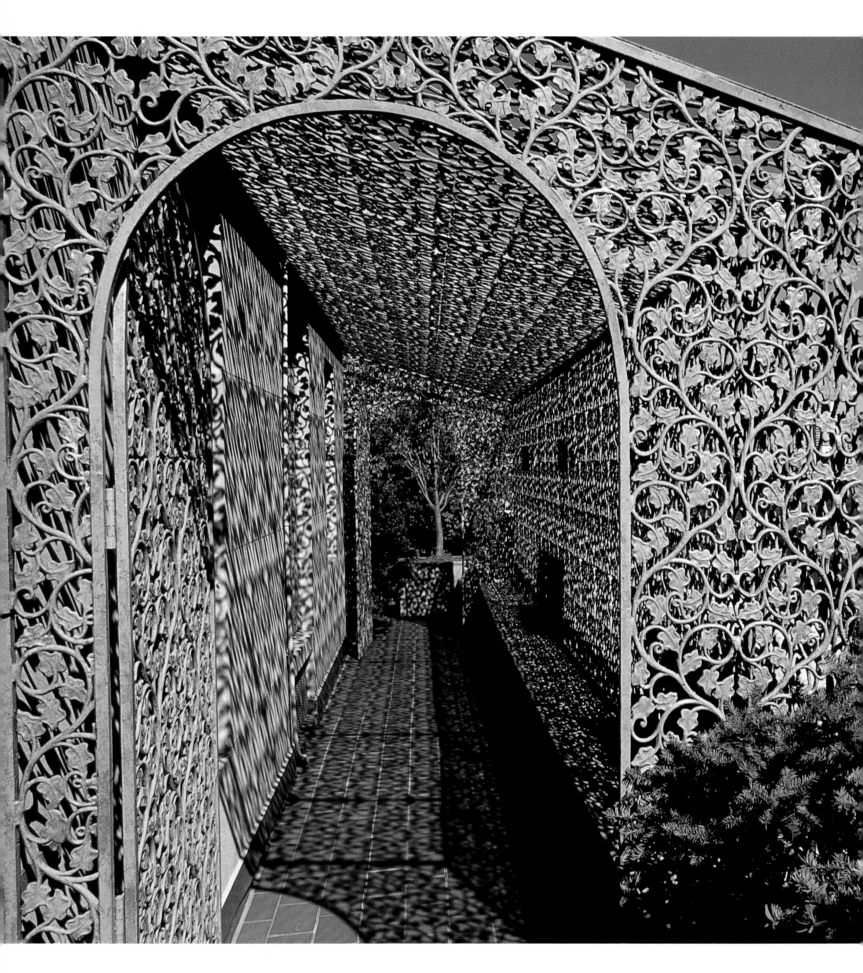

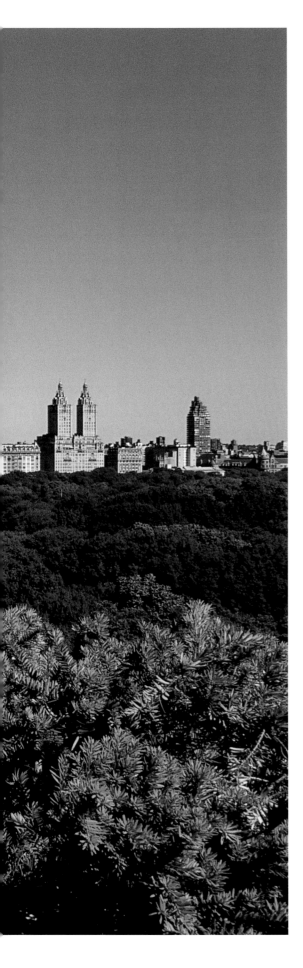

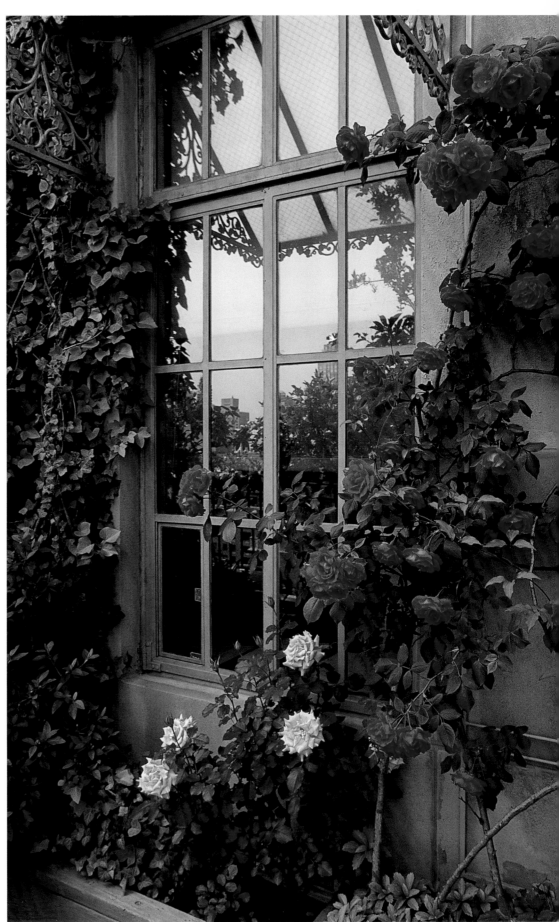

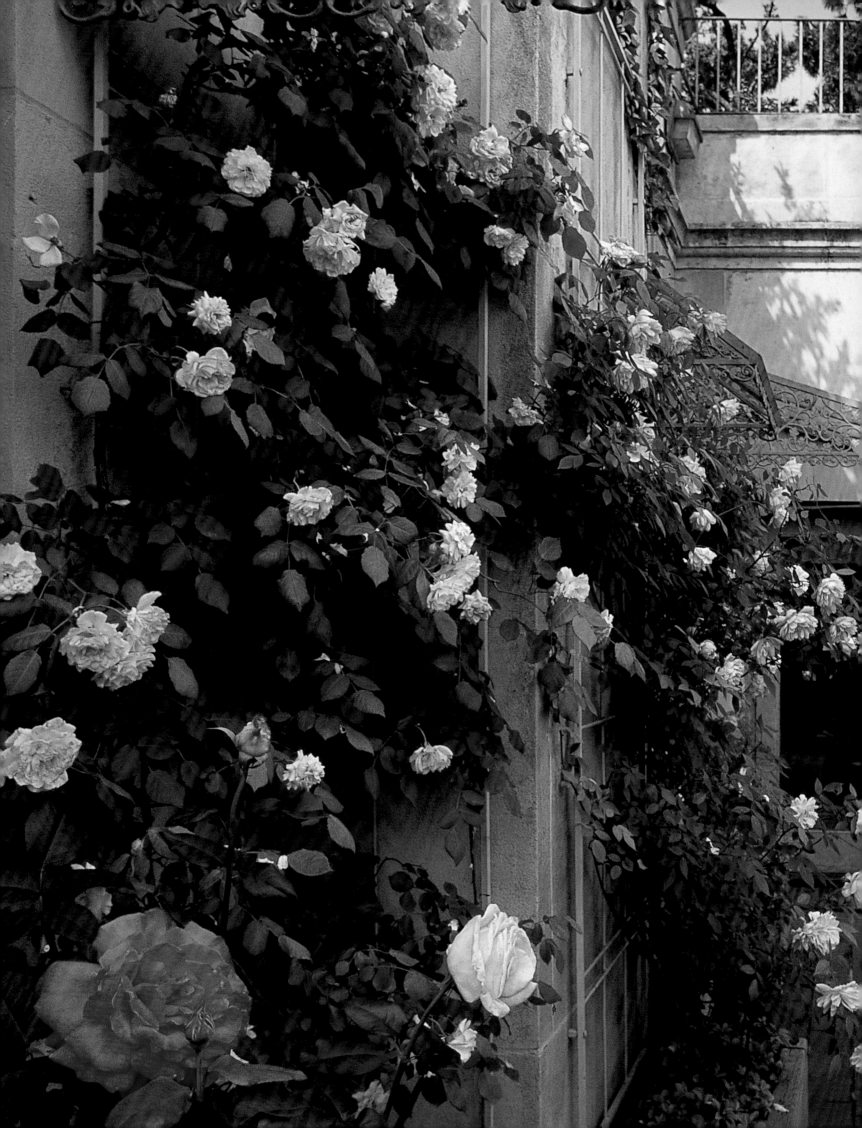

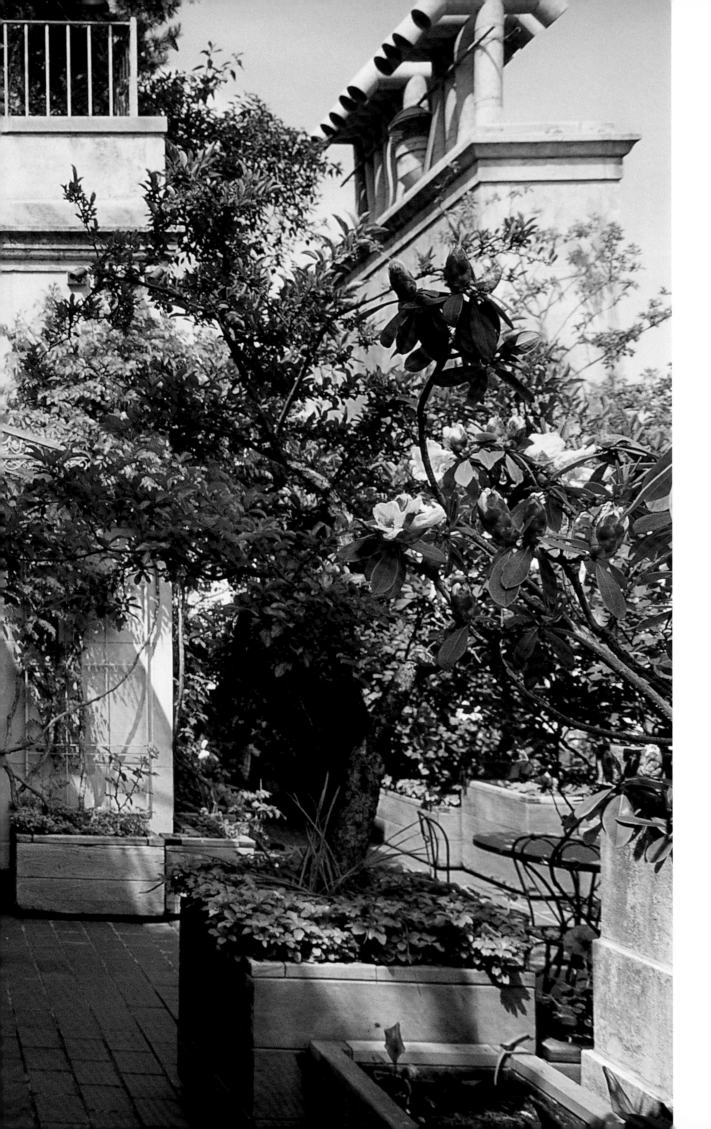

A Wonderful Transformation

When the garden designer Nigel Rollings drove over to a new client in Brooklyn Heights, the streets were covered in black ash. It was shortly after the attacks on the World Trade Center in September 2001 and the wind had brought ash from the collapsed buildings from Manhattan to Brooklyn. For weeks this dark layer lay over the city like a mourning veil. The backyard which Rollings was expected to turn into a garden was also black—a horrendous sight. It was a desolate plot which up to then had been mainly used by dogs for the usual purpose. Rollings' first reaction was very emotional. He felt a need to heal the place. During his conversation with the owners, Helena Lee and her husband Richard Klapper, he tried to discover their expectations. Rollings feels that as a designer, the most important thing is to adjust to the needs of one's clients. The garden, they said, was to be a private place of withdrawal but once a year had to be the venue for a party with sixty guests. Since the garden is only 700 square feet, this was a challenge. Today everyone is happy with the result: the gardener, the clients and the guests who come here once a year.

For Rollings a good garden is the result of successful co-operation between designer and owners, which also presupposes great trust; and, it must be added, if you know how Nigel Rollings works, great patience. He says that this garden cost him one year of his life; from the client's point of view, it meant a year spent waiting patiently. Many people are not willing to wait so long. They want an "instant garden," as Rollings calls it. But you need calm and contemplation to understand what is needed by a place in which something as sensitive as a garden is to be created. There was an ugly wall which Rollings wanted to hide, and in front of it, a beautiful maple tree with a curving bough. He suggested building a wall fountain in the shape of a circular disk, the universal symbol of holism and harmony. This disk is twelve feet in diameter and even before the water started to flow, Helena Lee and her husband began to appreciate the calming effect of the installation. The curving line of the maple bough reflects the curve of the circle, while the troweled blue surface reflects the shadows of the leaves and creates a graphic pattern.

Helena Lee loves English gardens such as those planted by the famous designer, Gertrud Jekyll. That is why she was excited when she heard that Nigel Rollings was English. He was recommended by a friend who had attended one of the courses on garden design which for years Rollings has been holding at the Brooklyn Botanic Garden. It may be true that in theory an English garden needs a large area, which the Lees did not have, but Rollings now knew what Helena Lee wanted and did everything possible to lend an English flair to this mini backyard garden in Brooklyn. The wooden shingles covering the walls and the flower containers give the feel of the countryside. The furniture and the steps which lead to the raised veranda, as well as the seating in front of the kitchen, are also made of wood. In the main garden there are various "rooms" resulting from the slightly different levels, an effect enhanced by

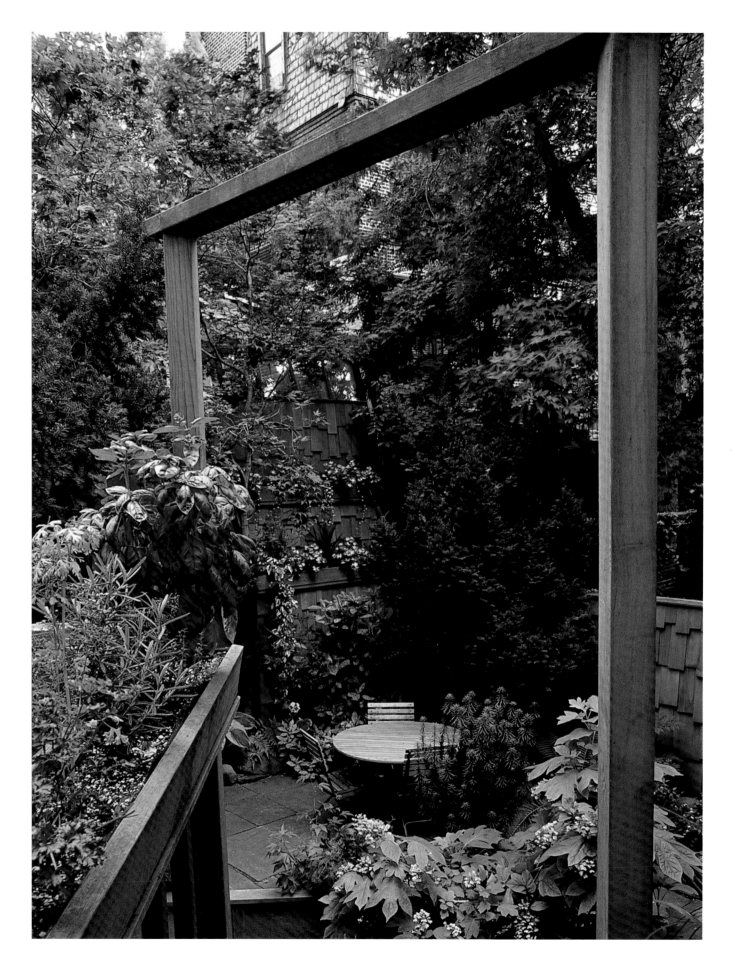

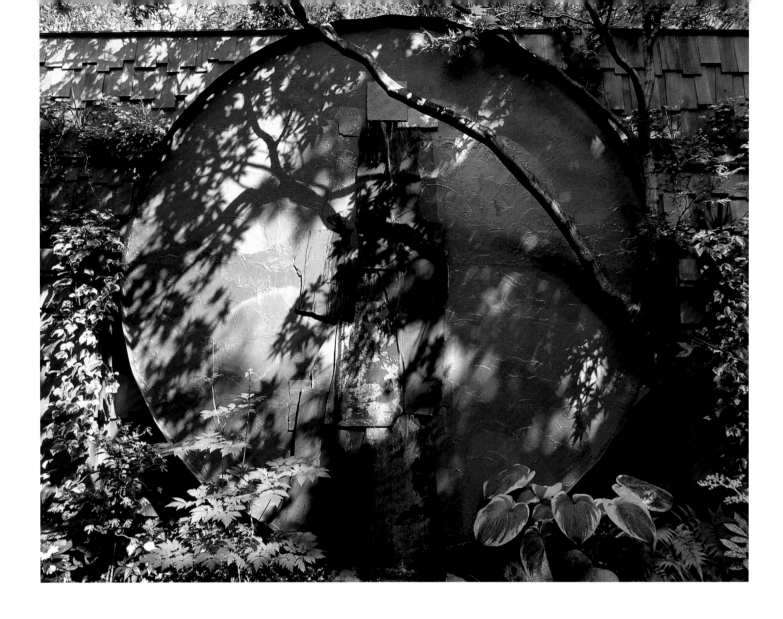

a very low dividing wall. The evergreen and flowering plants surrounding the open paved areas ensure a very natural appearance. The garden does not get a lot of sunlight and for this reason the designer chose shade-loving plants such as the white-bordered hostas around the fountain basin. Here and there he has omitted paving stones and put in plants instead. This has resulted in a good compromise between an area large enough for the annual party and a "look" for the garden which is as natural as possible. Rollings understands how to use ordinary materials to create very individual pieces of art, like the fountain disk. Here he troweled a layer of plaster on to a waterproof base to create an irregular surface. He then coated this with swimming-pool paint and shaped the line of the circle from a sheet of copper. In the middle, the water flows over an ensemble of real slates into a small basin which in reality is a fiberglass fake rock

turned upside down. The result is a water installation which radiates an atmospheric warmth.

Rollings has installed a herb trough on the kitchen terrace. Helena Lee tells of her pleasure when, in the middle of cooking, she goes out and quickly plucks fresh herbs. In the morning she takes her cup of coffee into the garden, even when she has very little time. The gentle splashing of the water relaxes her and always gives her day a good start—the garden as refuge from the chaos and constraints of the big city.

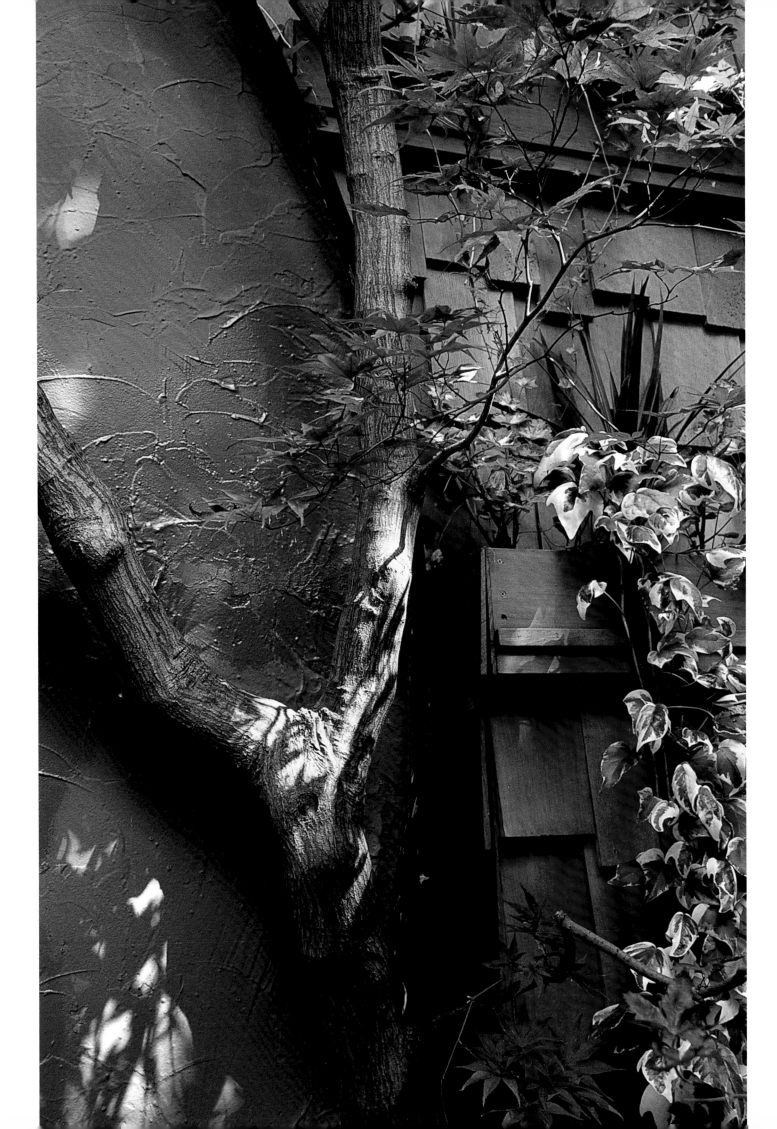

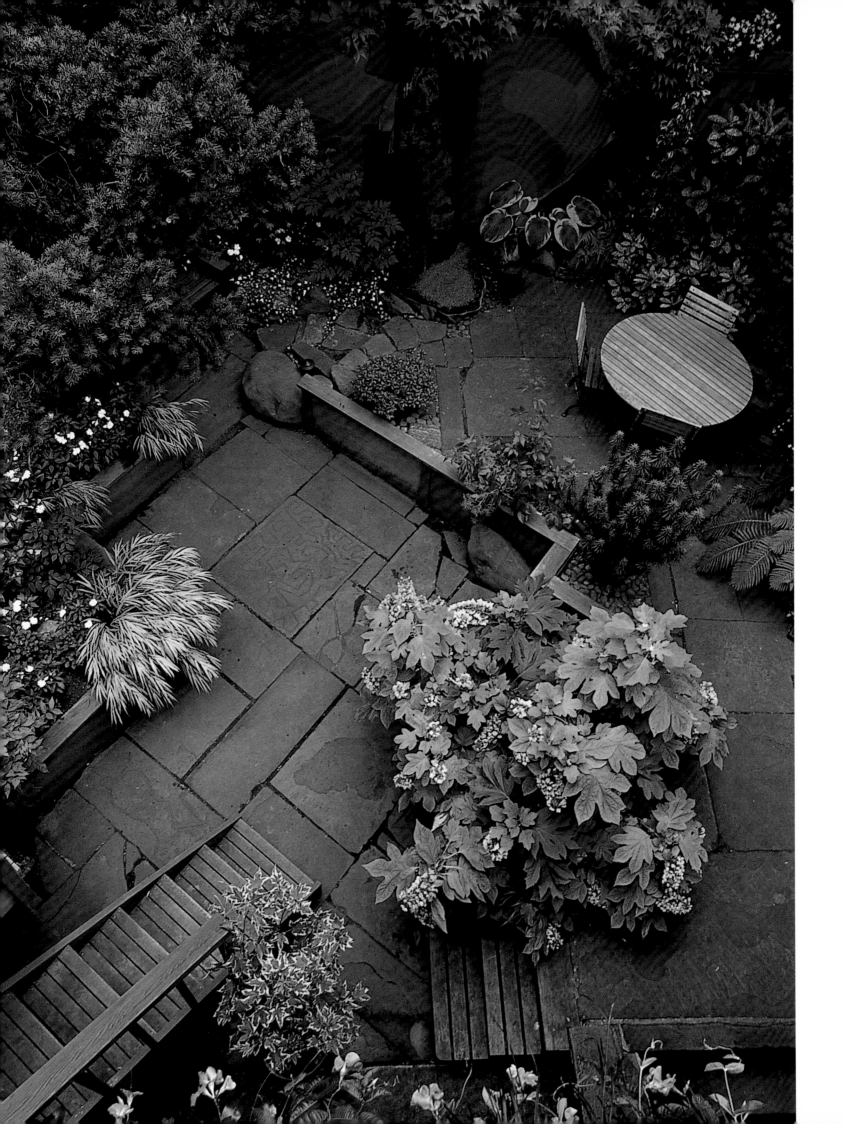

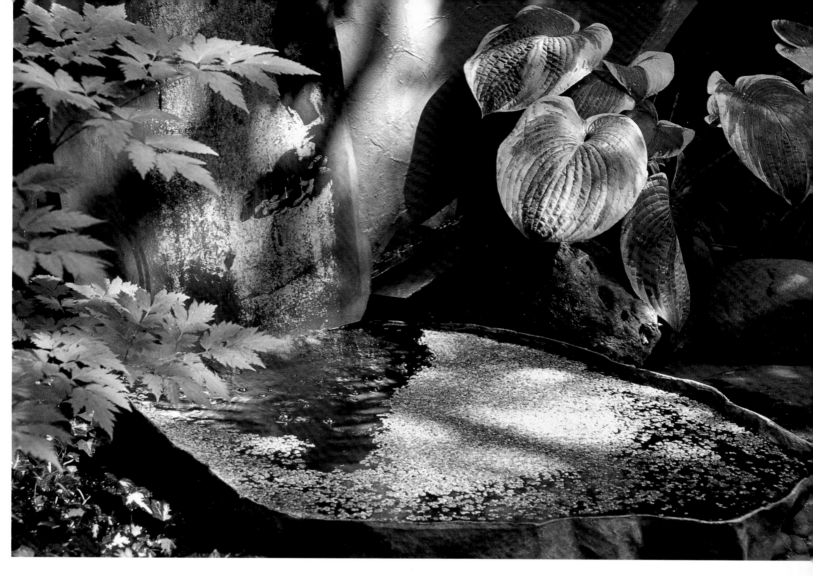
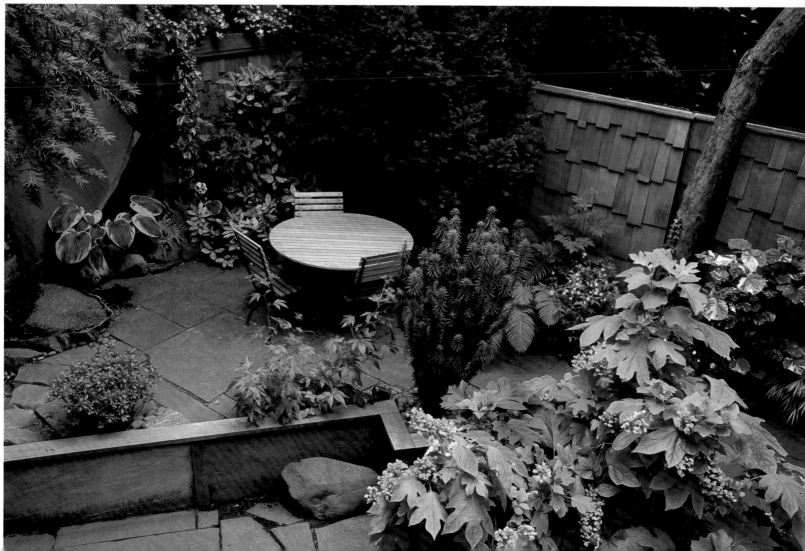

The Art Garden

The Museum of Modern Art in New York, the famous MoMA, is one of the most important collections of modern and contemporary art in the world. It houses a total of 150,000 paintings, drawings, sculptures, films, and works relating to architecture and design. One item in the collection does not fit any of these categories and, what is more, is not accessible to museum visitors.

Between 2002 and 2004, the Japanese architect Yoshio Taniguchi added the six-story New Gallery to the MoMA. On its roof you will find a work of art, that is the subject of heated discussions all over New York. It is called the MoMA Roof Garden, and critical voices argue about the use of the word "garden." Its designer, the landscape architect and artist Ken Smith, cannot understand what all the fuss is about. For him a garden is always artificial and many gardens pretend to be something which they are not. Smith explains how the MoMA Roof Garden came to exceed the criteria of artificiality currently valid for gardens. "Well, I was called and asked to undertake this project about which I knew nothing. That was very exciting. I went to the meeting and asked about the criteria. And they said: 'One: The roof cannot support any weight. Two: Because of the museum below, there can be no watering.' And that's why they allowed no living plants and no earth. And they had already bought black and white stones. It would be good if I could use them. Finally I asked them about the budget and it was pretty modest." Any other landscape architect would have thought that someone was playing a joke on him. Ken Smith did not. From the beginning it was clear to him that he could not design a normal garden, and he wanted to make use of this freedom. This was the reaction the curator Peter Reed had been hoping for when he called him. He knew Smith's P.S.19 project in Queens, where he had transformed a dreary public school. The huge orange, red, yellow or blue plant troughs on wheels were formerly garbage skips. Children and teachers now use them to plant herbs, vegetables, and decorative plants. Round colored circles brighten up the large asphalt areas and monotonous walls, while a fence is covered with foil printed with a lightly clouded sky. This depressing location became a cheerful urban space with a garden.

Ken Smith already had a reputation as an unconventional landscape architect when he was given the MoMA commission. The first design for the roof was playful, not to say real kitsch in the best sense: Smith planned a grid of fluorescent green PVC tubes over the approximately 16,000 square feet in which he wanted to "plant" six thousand plastic daisies, which would turn like windmills; a flower meadow moving with the wind on a roof in the middle of midtown-Manhattan. Smith presented this first design to the jury, who rejected it. The residents, who had a voice on the jury, were opposed. When MoMA planned a new building, designed by Yoshio Taniguchi, the neighbors suggested a roof garden. They proposed a classic "Garden for the View," of which there are several in New York. The prototype is the roof garden on the Rockefeller Center which dates from 1937. In the case of the MoMA, residents living on

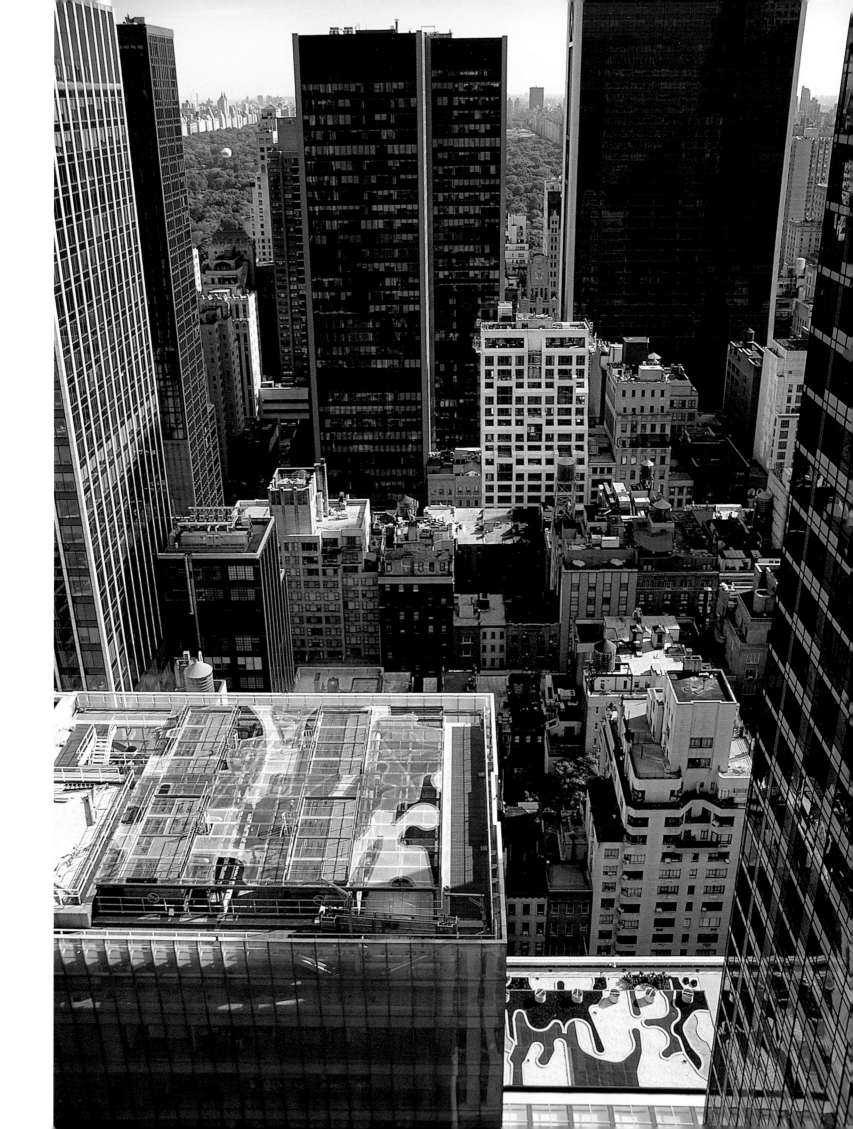

the sixth story and above of the neighboring Millennium Tower and in the immediate surroundings of 53rd Street between Fifth and Sixth Avenues were the particular beneficiaries of this idea. When Ken Smith's idea for a plastic flowering meadow was rejected, he started afresh. He came closer to the requirements when he thought of "camouflage," which as he understood it is always relevant to garden design, particularly in the center of a city. Camouflage means pretending to be something that one is not, and that can be achieved in various ways such as simulation. Thus, for Smith, Central Park simulates a pre-industrial Arcadia and covers a giant area of Manhattan with an imitation of nature. From this standpoint, it was necessary to formally establish what "imitating the surroundings" might mean for a Manhattan roof. Smith came to the conclusion that he must use rectangular forms and straight lines, which would fit in with the elevator shafts, ventilation ducts, and other technical facilities on the roof. The second possibility of camouflage is illusion: The roof would be changed so that it would appear to be something which it was not and which did not fit in with the surroundings. This is what Smith decided on. For his basic design he took flowing landscape forms, imi-

tating Central Park, which is only a few blocks away. For this he chose a camouflage pattern used in military clothing. His inspiration came from a pair of swimming trunks which were a present from his wife. In order to create a "landscape" which would remind the observer from above and at a certain distance of Central Park, Ken Smith worked with the following materials: One hundred and twenty-four artificial black and sixty-one white rocks, 560 plastic box trees, 306 pounds of recycled glass, thirty-five tons of white marble gravel, and nine tons of recycled black rubber, plus fiberglass grids and PVC tubes. He did not present his idea to the jury as a model, but built part of the garden in actual size on the roof. The jury could assess his intentions from a distance of forty to fifty feet, which matched that of the neighbors. Just by looking at it, it became clear that from a distance it was difficult to recognize the difference between what was artificial and what was natural. They voted for the design. The landscape design as developed was divided into simple units so that these could be prefabricated. They were numbered, taken up to the MoMA roof, and glued together. Ken Smith is a teaser and he never intended that visitors would see his garden as a natural landscape. No matter from what

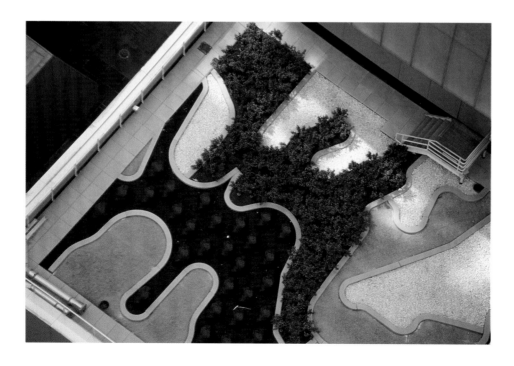

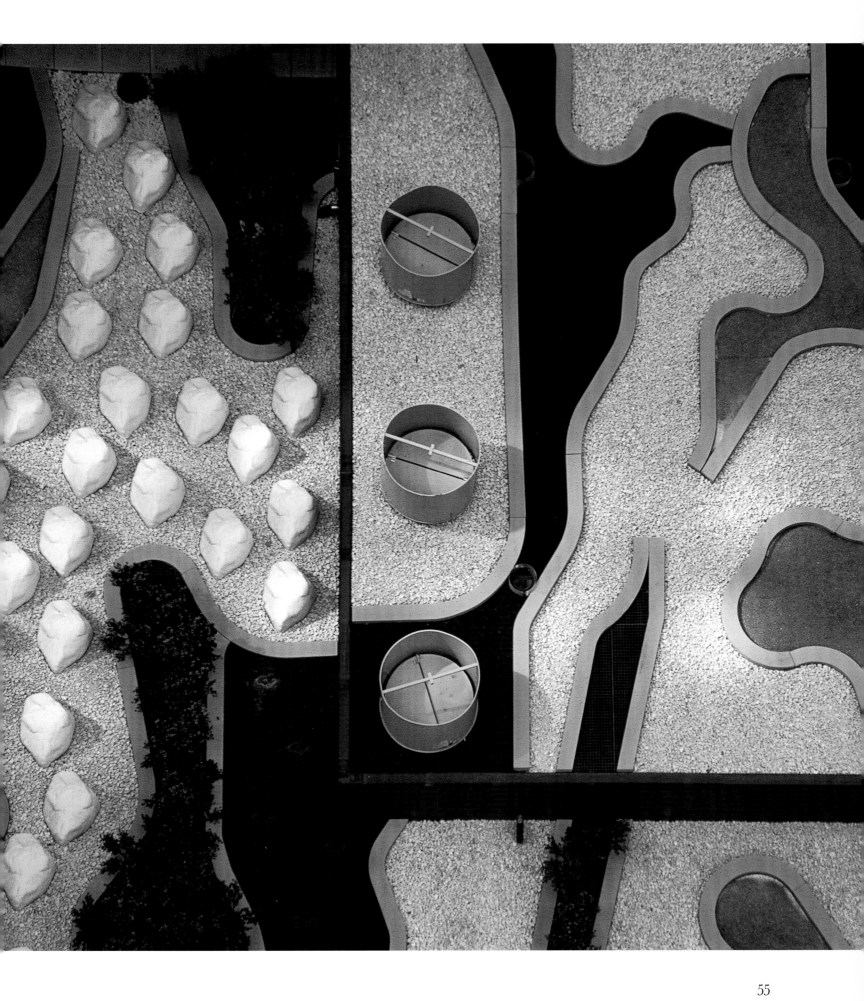

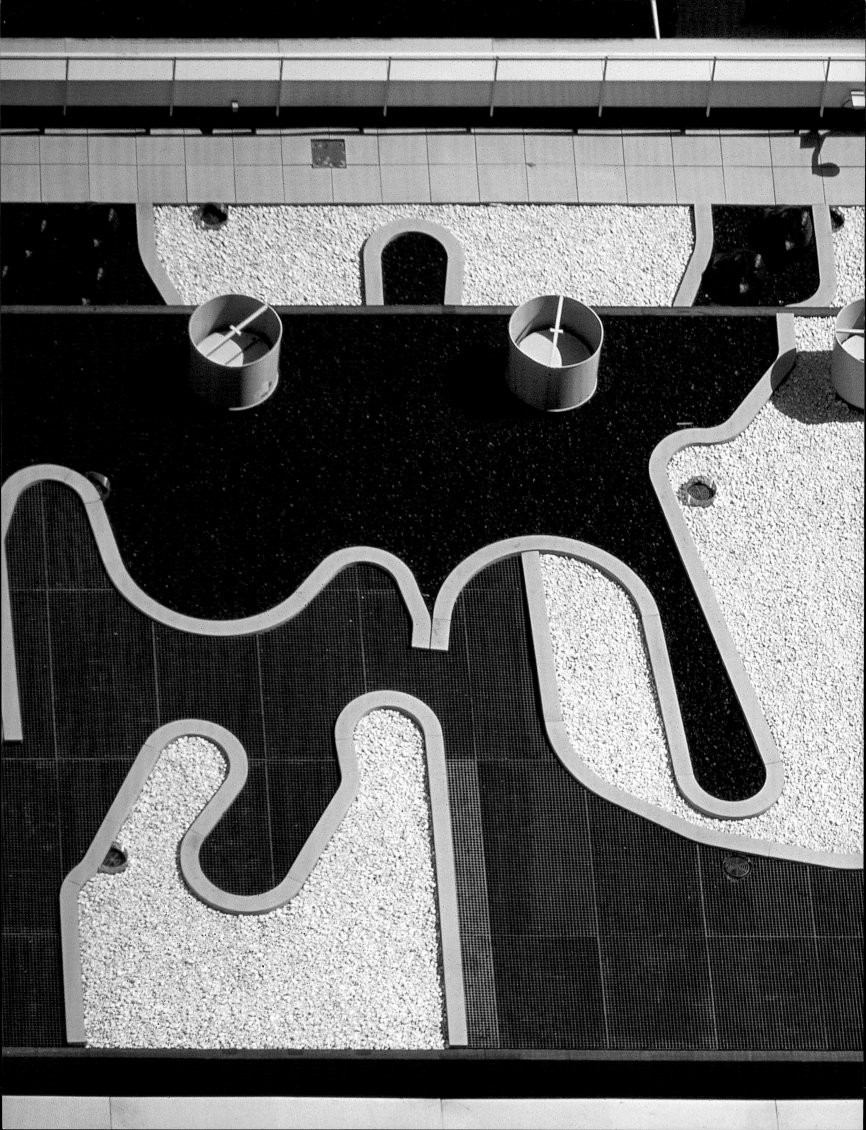

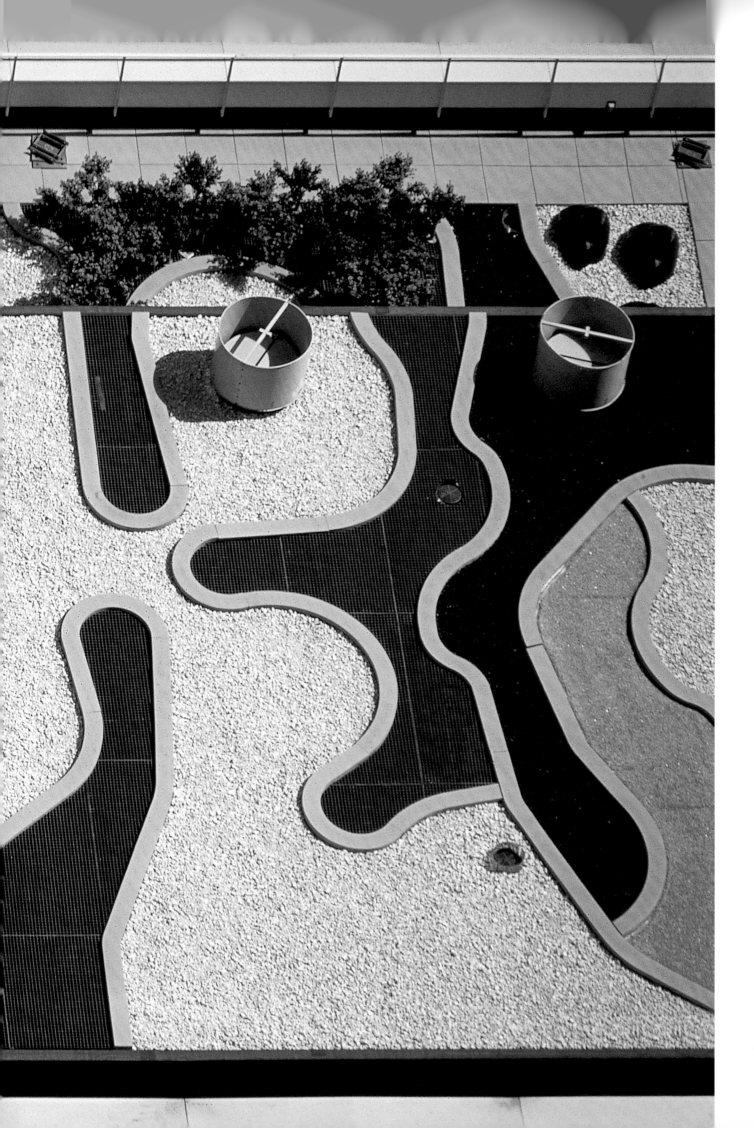

distance you see the MoMA roof, it is clear that what you see is an illusion, a landscape with graphically separated areas. Some, which are filled with crushed glass, glisten like water; others, covered in recycled rubber, resemble dark earth; the green fiberglass grids represent green meadows, and the white areas represent the stony foundation, which in this case, is real. The plastic box shrubs are amazingly realistic. Ken Smith says, with a hint of irony, that after a few years on the roof, they will look better than the real thing. Even the dimensions deceive the eye. You do not know whether you are looking at a tree or a bush, whether the stones are large or small. A camouflage pattern is normally used to hide something. However, when you look over the roofscape of Manhattan, then it is exactly the opposite: The garden is highly visible and, because it is obviously artificial, it shows how devoid of nature the city is. What is artificial here goes without saying, and the MoMA garden demonstrates this quite blatantly. It is a game with many ambiguities, into the spirit of which Ken Smith has entered with a great deal of humor and irony. At the same time, he has enriched MoMA with a work of art, whose seriousness sensitizes us to the degree to which the distinction between the artificial and the natural has become blurred.

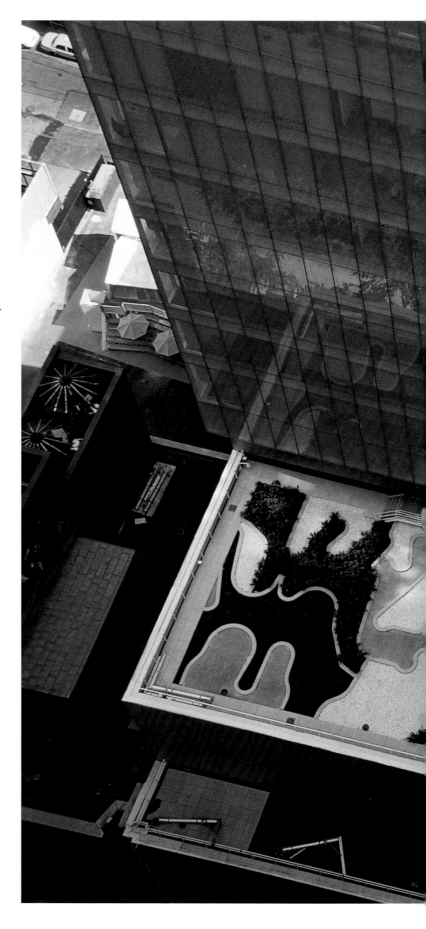

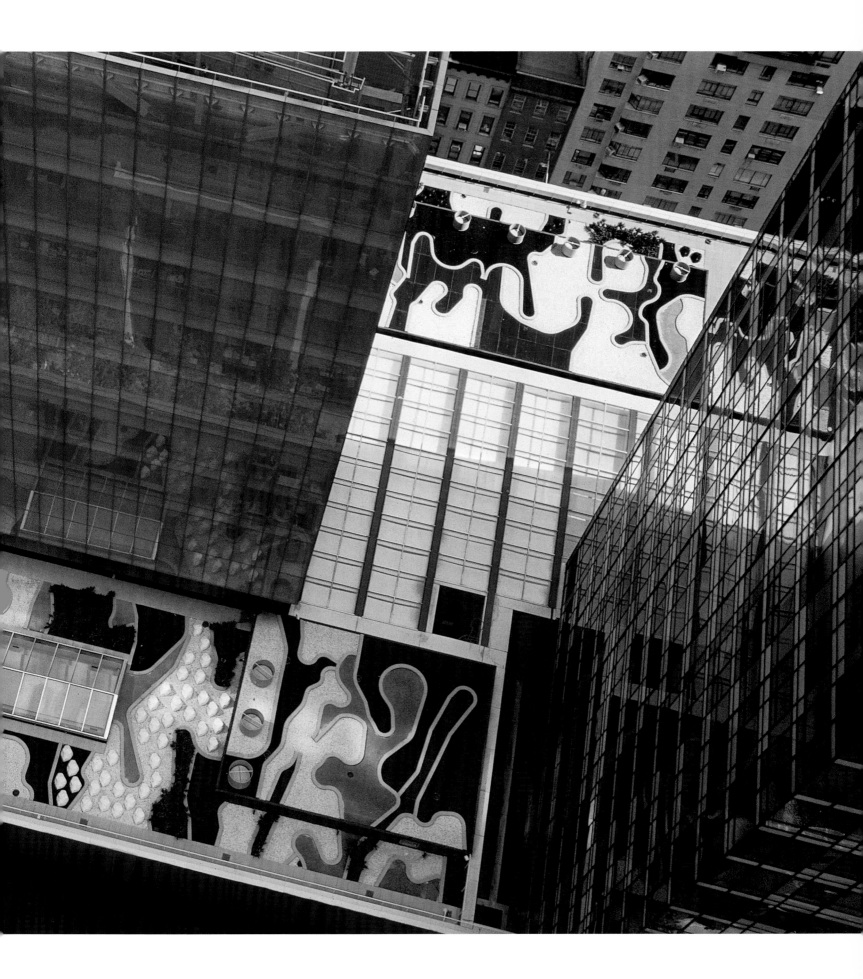

Exotic Erratics

Eve and Marco Havlicek's private miniature jungle even has a waterfall rippling over flagstones into a goldfish pond. It is amazing that in this area, which is as flat as a pancake, you can find a hill with a waterfall in a private garden. It is luxuriantly planted and well established. The Havliceks moved to Brooklyn twenty-five years ago and bought a house in the Fort Greene district, which was affordable because the area had a bad name. Few people dared to go there; these days Fort Greene is one of the best addresses in Brooklyn and you have to have a great deal of money to be able to buy a house here. The Havliceks had the courage to move in, and they have reaped the benefits. The houses in their neighborhood, most of which date from the 19th century, have been restored and the streets are cared for and quiet. They have profited from the gentrification of the area and have converted most of their house into rented apartments. The balconies are on the garden side. The Havliceks live on the ground floor and they are the only ones with direct access to the garden. Giant rounded boulders reinforce the natural appearance, but at the same time leave you wondering where these large stones came from. Believe it or not, the Havliceks found them here. The garden is located in the exact spot where the moraine of the last ice age left them. And there is a story behind the positioning of these stones in the garden, which is typical of Brooklyn. As she was going home one day, Eve Havlicek saw a young man with a lorry and lifting gear. She quite simply asked him if he would come with her to move some stones in her garden. He agreed, did the work and earned a few dollars. "That's how it is here," said Eve Havlicek, "there are so many young, skilled handymen in Brooklyn who are happy to do a job. You only have to ask them and tell them exactly what to do." It was just as uncomplicated when it came to the flagstones. People had thrown them out, and the Havliceks only had to organize transport and take them away. Eve now employs a gardener, because the work became too much for her to do alone. She recalls that she used to have a lot of vegetables and fruit, but the crop became too abundant. Now she just wants to enjoy the garden. It is not such hard work now, but she still has a need to change something every year. The herb garden is now closer to the house and the luxuriant pink hydrangeas are now planted where they can be enjoyed from the living room. But on the whole, she no longer wants to dig the earth and be a slave to her garden. Today she likes to watch the fish in the pond when they play with the water lilies, prod each other and hide. Nevertheless, she does not see the garden as a place to sit and contemplate for hours on end. On the contrary, she takes a great deal of pleasure in quickly recognizing what is not in order, or which plants have to be moved.

The beauty of her garden has obviously inspired her neighbors. Where twenty-five years ago there were only dreary backyards, today there are rows of gardens. They may not be so extravagant, but, one might say, at least they are green. Eve feels very much at home in Brooklyn. Previously, for a short time, she lived with her husband in Queens, where they felt totally out of place. In

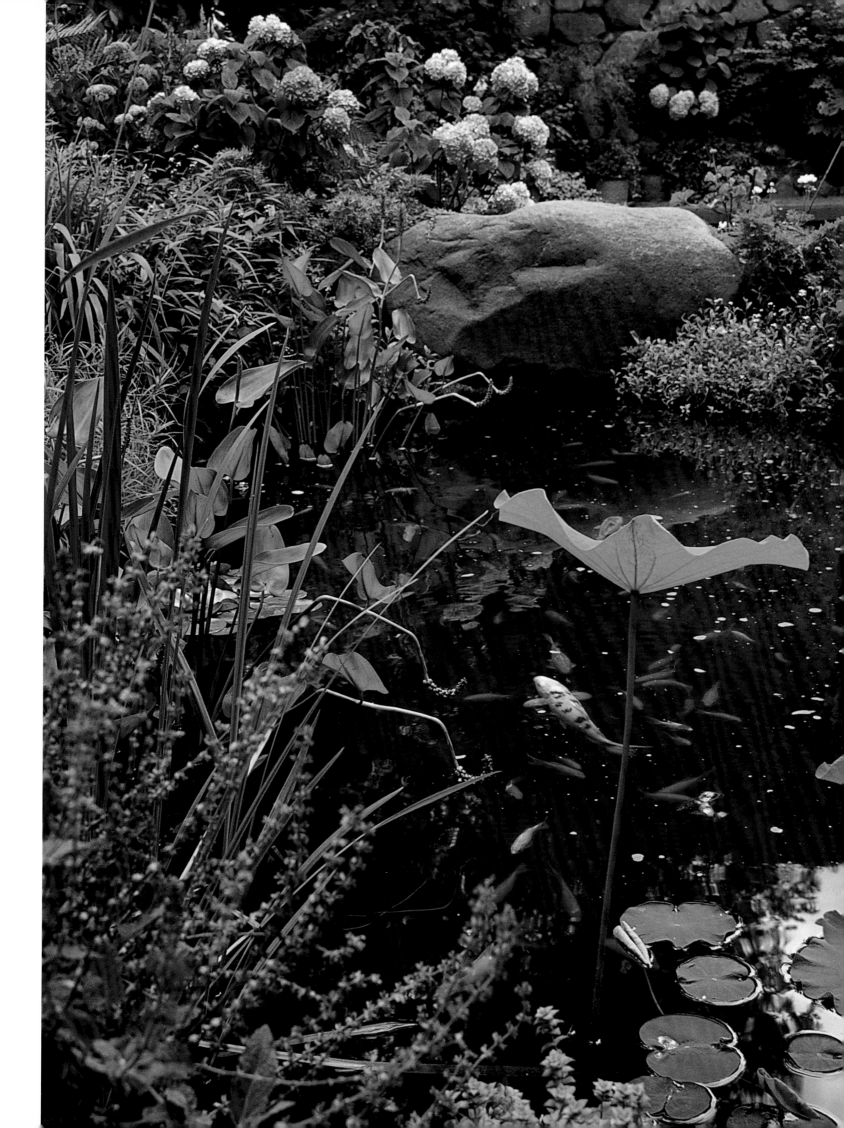

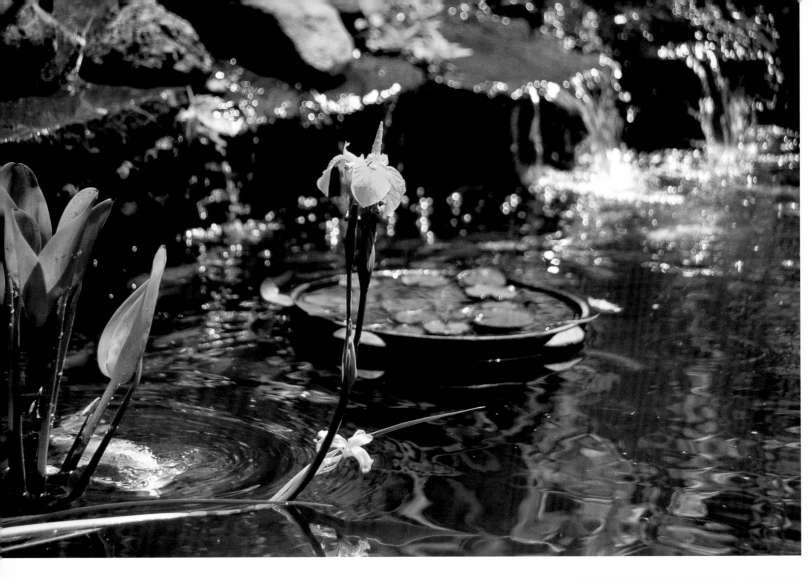

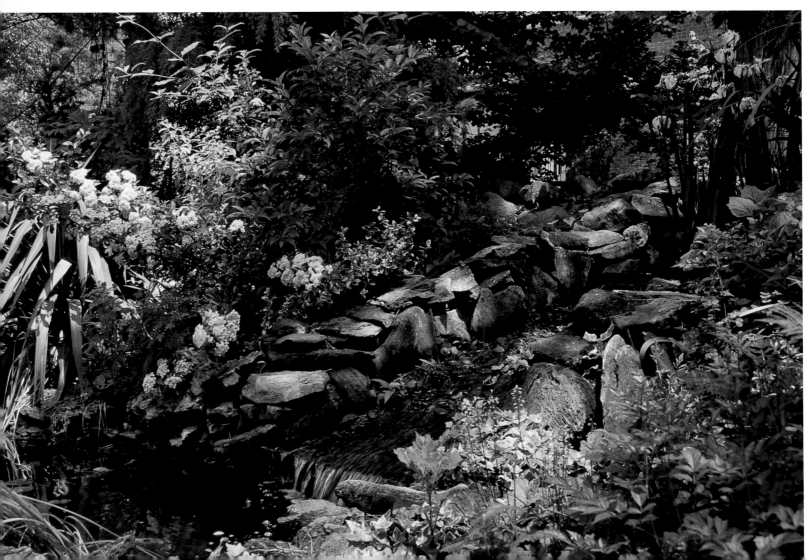

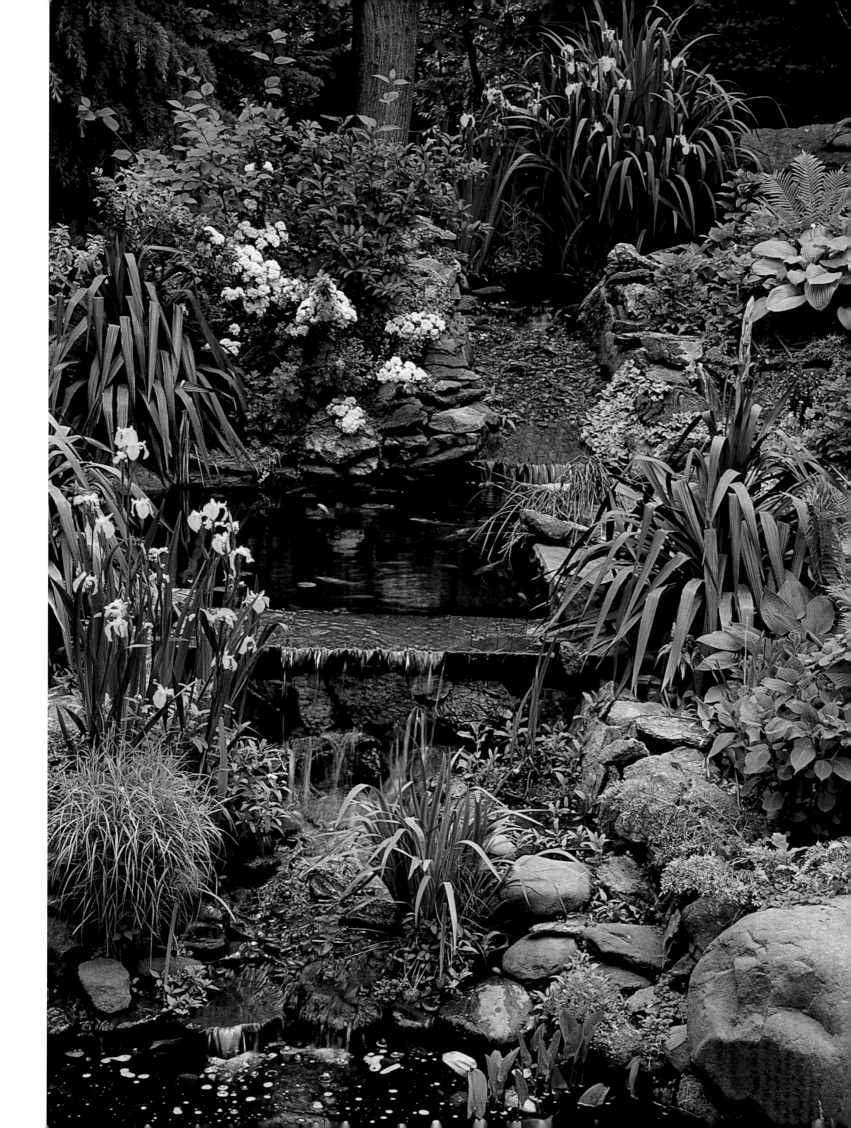

Brooklyn she does not have to wholly subscribe to the "American way of life;" she is just the way she is. She knows her neighbors, works together with clubs, and organizes viewing tours of apartments, houses, and gardens in Brooklyn. She recalls that you used to have to entice people to move to Brooklyn, but today that is absolutely unnecessary, because people are well informed. There is a very lively cultural scene, with museums such as the Brooklyn Museum. There are galleries, theatres and the famous Brooklyn Academy of Music, or BAM for short. The author Paul Auster lives here, Woody Allen got his nickname "Red" at Public School 99. The same team, Olmsted and Vaux, which planned Central Park for Manhattan was responsible for Prospect Park in Brooklyn. When the park was laid out, Brooklyn was still an independent town. It was not incorporated into New York City until 1898. Brooklyn is, in the best possible sense, a melting pot. Everyone can find a place here. Eve Havlicek is of mixed French and Czech descent, and her husband is Mexican. There are districts where they speak Italian and on Coney Island it is a good idea to be able to read the Cyrillic alphabet; most of the residents of Borough Park are Orthodox Jews, and Williamsburg is home to the largest Chassidic population in the world. Two and a half million people live in Brooklyn, the second most densely populated administrative district in the United States after Manhattan. This enhances the value of a fine jungle garden. The fact that the resident gardener is Mexican can be seen in the exotic plants and palms. They can only grow here because Brooklyn has a sort of microclimate. Surrounded by water on three sides, the climate is different from that in Manhattan. Winters are milder, and it enjoys more hours of sunshine. This may be why not only the exotic plants feel so much at home here, but also people from all over the world.

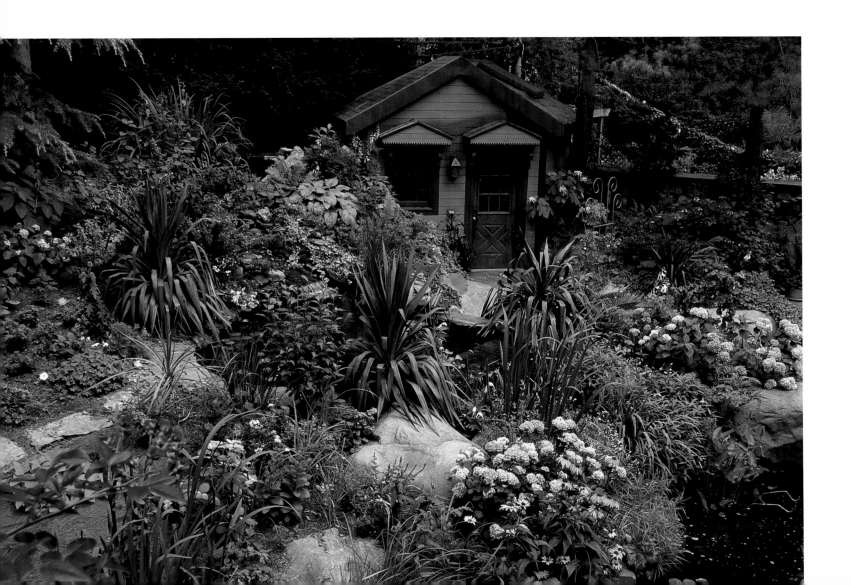

Brooklyn Heights

Harbor Garden with a History

DiAnne Arbour and Jay Bergen's roof garden is directly opposite Manhattan's southernmost tip in the Brooklyn Heights district. The piers which reached into the bay were once part of the harbor. From here, you can see the East River, and beyond this the Financial District, Governor's Island and the Statue of Liberty. During its 120 years, this garden has been witness to many changes. The house on which the roof garden is built is part of a row of three-story sandstone houses built in 1858. The original owner must have had a very strong design concept, since at the end of the 19th century he added two floors to the house and had a terrace wall and a 170-square-foot loggia with eight arcades built on the roof. Unfortunately there is no record of what the garden looked like then, but it is regarded as certain that there was one. Today, these structural changes would not be permitted: In 1974 Brooklyn Heights became the first New York neighborhood to be landmarked as a historic district; since then, no buildings in the area may be changed externally and no tall buildings may be erected. The plan for a highway to be built straight through the district also landed in the bin. When DiAnne and Jay bought the two-story apartment with the roof garden in 1996, the surrounding walls and loggia were in a sorry state and the garden could only be imagined. They restored the structure and put troughs and plants on the roof. There was plenty of sun, but unfortunately there was also salt in the wind from the sea. It took them a few years before they discovered which plants were best suited to these conditions. Their approximately 900-square-foot terrace is best seen in spring, when the weigelas, lilies, and irises are in flower. Fragrant lavender and sage take you through into the summer, with hydrangeas, hostas and daylilies. Annuals fill the gaps. In the fall asters and sedum bring color to the roof. For DiAnne and Jay, the loggia is a shaded summer room where they can read, listen to music, and eat. A light salty breeze drifts through the open glass doors and gives one the impression of being outdoors.

The landward part of the garden is abundantly planted with hostas, daylilies and grasses, and behind this there is a tall (for the district), architecturally striking brick building. The majority of the mainly three- to five-story buildings in the neighborhood are brick built. More then 250 of them date from before the Civil War. Many well-known authors have lived in this historic ambience, including Truman Capote, Norman Mailer, and Arthur Miller.

A wooden door in the surrounding wall looks like a rustic decoration, but originally had an important function: It guaranteed an escape route to the neighboring roof. When it is open you can see the grandiose Brooklyn Bridge, built in 1883. This was the first bridge to connect Manhattan with Long Island. The arcades on the loggia also offer spectacular views of the Manhattan skyscrapers and the bustling traffic on the East River. A permanent part of the background noise heard from the garden is the hooting of the Staten Island ferry when it leaves Manhattan.

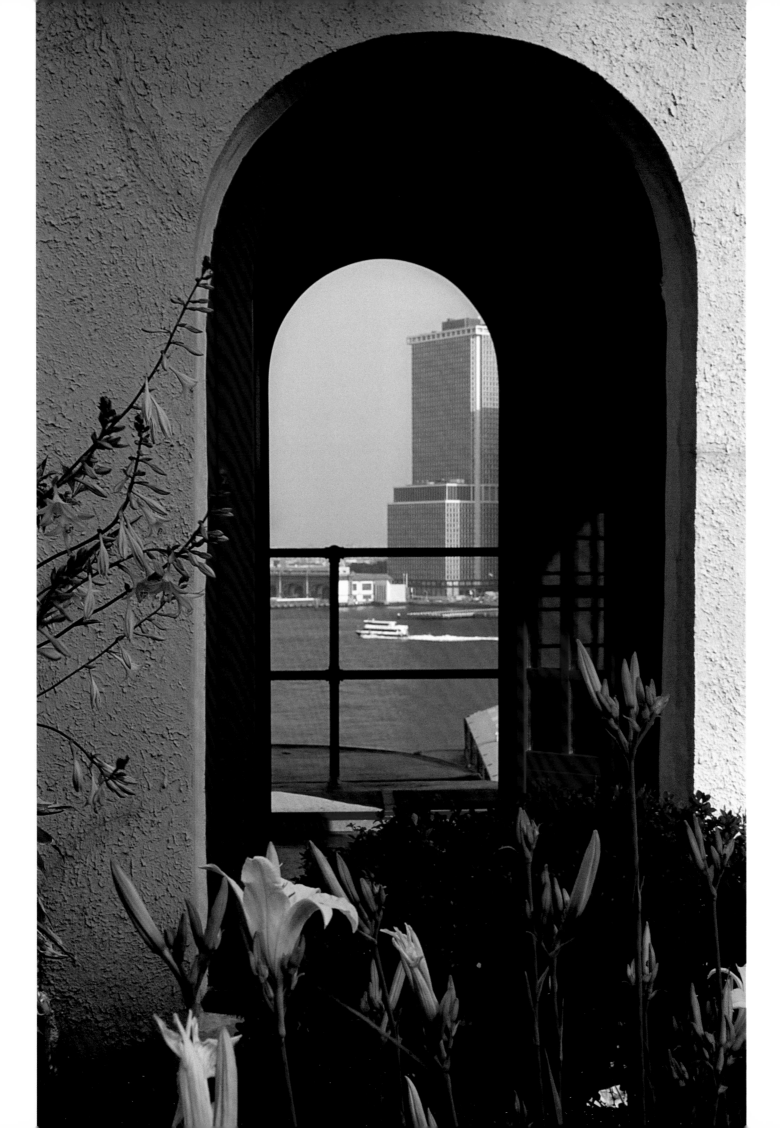

Directly below the secluded garden are the abandoned 19th-century piers. In the next few years these are expected to be changed into green areas: The renowned firm of landscape architects Michael van Valckenburgh Associates has been awarded the contract for the future Brooklyn Bridge Park, which will stretch for more than a mile along the waterside, and cover an area of more than 85 acres. This is the largest park project in Brooklyn in the 135 years since Olmsted and Vaux built Prospect Park, the twin of Central Park. The tarred areas of the piers will disappear and DiAnne and Jay will soon be able to see meadows, beaches, bays, playgrounds, and gardens when they look down over their garden wall.

Every day the garden affords a breathtaking view, and on certain days it is a royal box: On July 4, Independence Day, there is an incomparable firework display on the river right in front of their eyes. On this evening, every year, DiAnne and Jay invite friends to a

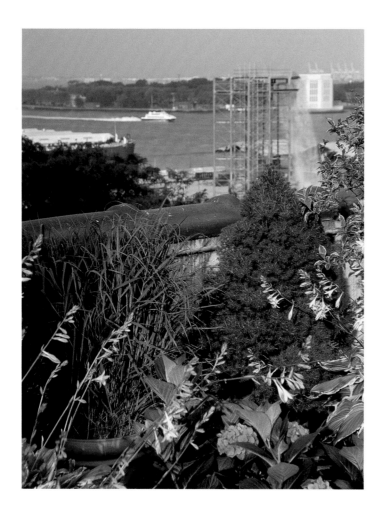

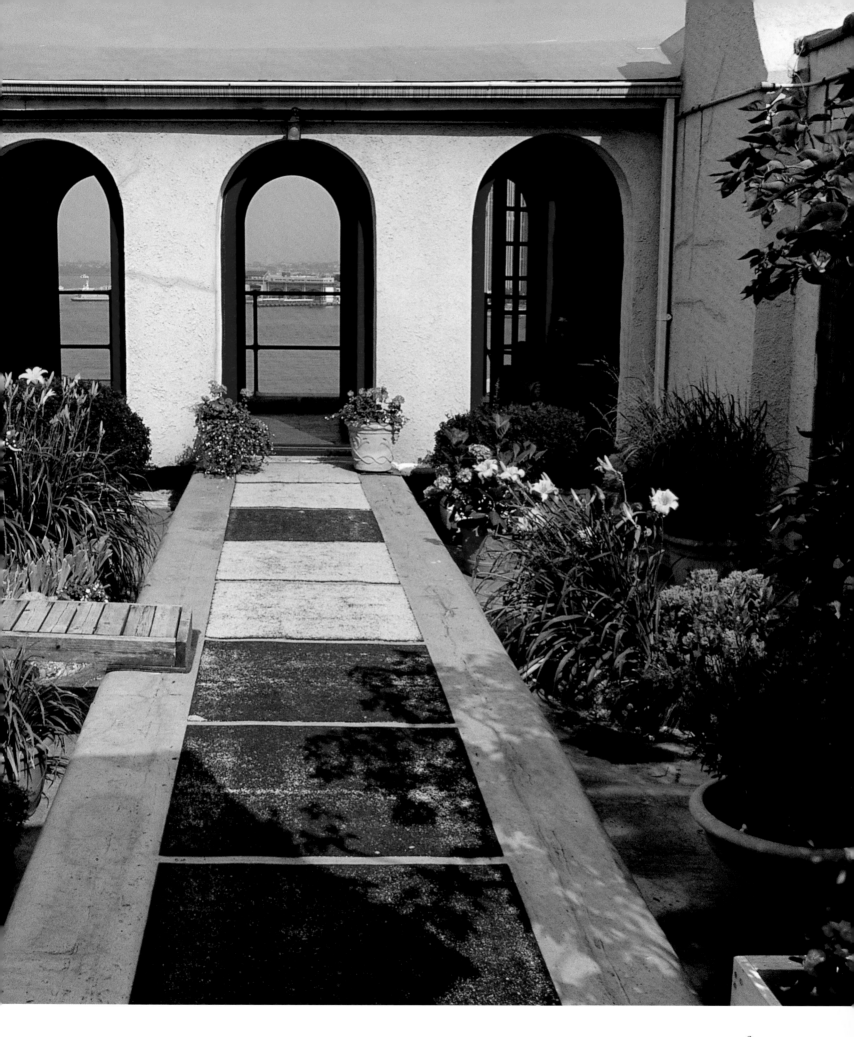

roof party where to many "oohs" and "ahs" they can watch the exploding pyrotechnics against the backdrop of the south Manhattan skyscrapers.

In 2008 the Danish artist Olafur Eliasson chose the East River as the location for his four waterfalls, one of which is very close to DiAnne and Jay's garden. The water was pumped up gigantic steel scaffolds and then allowed to fall back down again in a roaring cascade. Thousands of tourists came by boat to view this work of art from all sides. It was Olafur Eliasson's wish to make New Yorkers once more aware of the water, because for him, water is of the greatest importance. However, his main aim was to build an installation which entertained as well. Shafts of sunlight were refracted into rainbows by the drops of water, which the wind transported away like a wafting veil. Depending on the weather and the light, the water could almost disappear, or glow like a crystal curtain. It was an imposing game with the ele-

ments and nature. DiAnne and Jay were able to enjoy this spectacle and were among the privileged few to witness the changes daily. But sometimes they just want to look at their garden. They say it is simple and reflects their relaxed lifestyle. Everyone has his own opinion: Just by turning through 180 degrees, DiAnne and Jay can decide if they want to be a part of the big wide world, or simply a part of their own little realm: a walled roof garden above New York's old harbor.

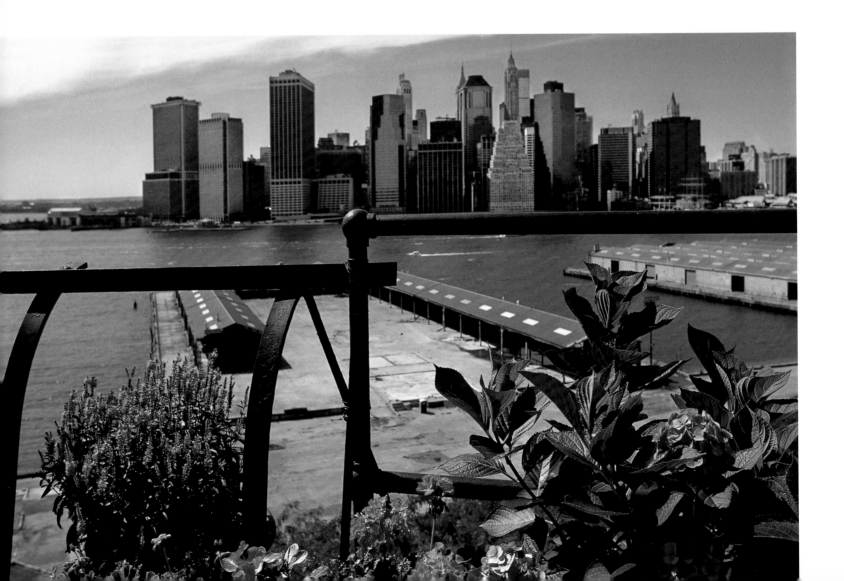

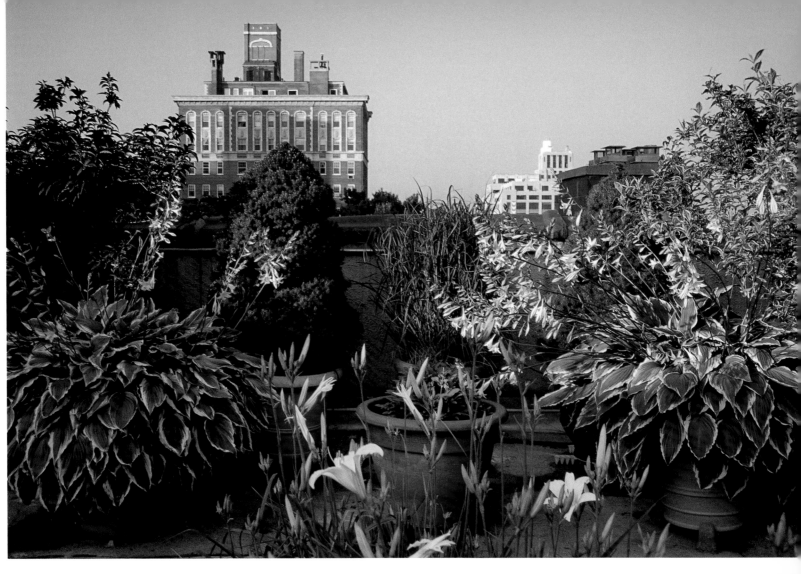

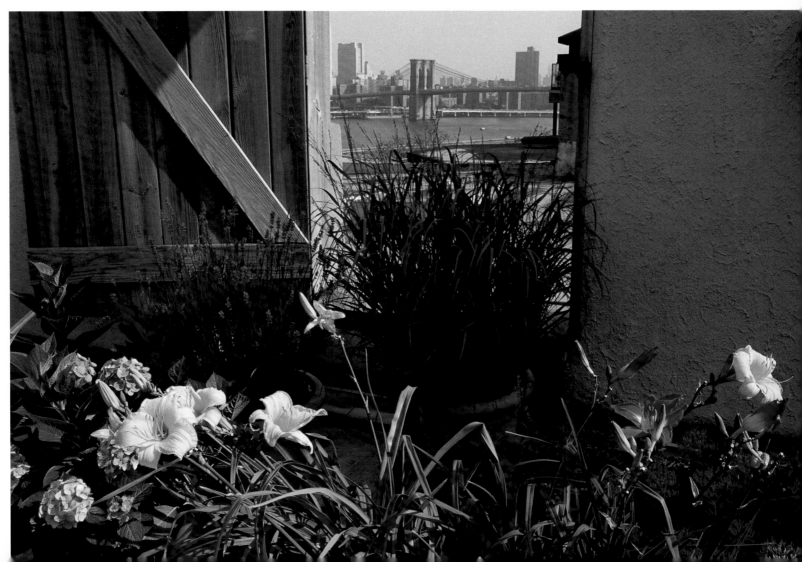

The Glory of the Shady Garden

Behind the reception desk stand liveried employees who greet visitors politely with a smile. The foyer is artfully designed. A large window looking out onto the street changes into a wall of water. The blurred contours of the passing yellow taxis look like a video installation. In Europe such entrances are normally only seen in hotels, but here you are in the entrance to an apartment building. If you want to visit a resident, you cannot simply take the elevator and go up to the apartment. You have to go to the reception desk and announce yourself. This is not the case everywhere, but only in buildings in exclusive areas, as at the southern end of Central Park. Close by there are luxury hotels, such as the Plaza and the Ritz-Carlton. Tourists treat themselves to a coach drawn by white horses, and they dream of catching a glimpse of a celebrity out shopping. This area, known as Central Park South, is the epitome of Manhattan, the focal point of parks, museums, and luxurious shops. Living here is the non plus ultra in New York.

Residents of the building in Central Park South have the privilege of a view not only of the park, but in the other direction, looking inwards, of a private sculpture garden established by the owners. It is a classical "garden for the view," which has a long tradition in New York, starting with the famous roof gardens on the Rockefeller Center. An art-collecting couple provided the sculptures and hired the artist and landscape architect Ken Smith to design a garden around them. The result is a garden and sculptures which blend in harmony. At first glance, the design appears geometrical: Various materials are ordered in clearly divided fields and strips. Finely shredded, dark matte rubber fragments contrast sharply with white marble pebbles. Next to these there are shining strips made of glass marbles, which reflect every beam of light. Between the twenty-two-story buildings, sunlight is rare. This makes Ken Smith's idea of using glass stones for the flooring even more plausible. At night they are lit from below and sparkle like small streams flowing through the garden. Seen from above, a rectangular glass area looks like a pool of water. Ken Smith loves to play with different materials and create illusions with them. Water is thus only an imaginary element in the garden. A band of blue on the wall is like an abstract waterfall, and the shadow play of bamboo leaves waving in the wind completes this trompe l'œil. These details encapsulate the poetic craft of Ken Smith's artistic talent. Something that at first seems cold develops, little by little, into a precise but at the same time warm and benevolent ambience. Smith was given the task of creating a green frame around three outstanding sculptures. Almost effortlessly, he has succeeded in bringing out each of the sculptures individually, without losing sight of the whole as an ensemble. The vertical aluminum-colored wooden trellises recall Japanese screens. They are elegant and structure the garden. When you walk along the windowed corridor on the ground floor of the building, these trellises certainly have a dramatic effect. One does not take in the whole inner courtyard at a glance,

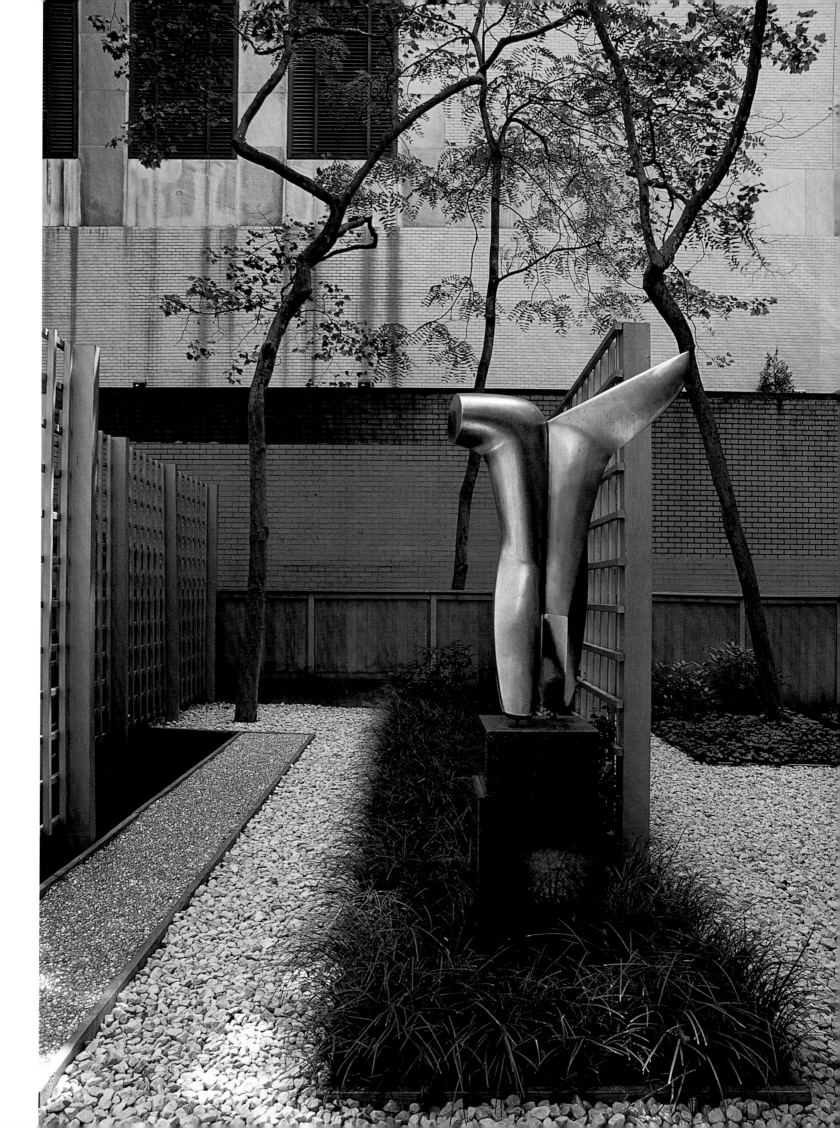

but in stages. In fact every step presents you with a different perspective. The very real challenge for a landscape architect is finding plants that can survive with little sunlight. This is a problem everywhere in Manhattan, unless the gardens are on the roof. The chasms between the skyscrapers are deep and the sun must therefore be high before it can reach ground level. Ken Smith decided on undemanding ivy, grasses and hostas for ground cover. Japanese maples, bamboos and magnolias reach up to the light. He originally wanted to plant climbing hydrangeas on the trellises, but it was really too dark for them.

Smith has a strong affinity for nature, and at the same time for rectilinear shapes. He has a surprising explanation for this seeming contradiction: "I grew up on a farm, and that is why I like geometric shapes. A farm has a large, geometric beauty, the grain is planted in well ordered rows, the orchard is clearly structured. But on the other hand, a farm also has a measure of ruggedness, it is not unduly tidy, the ditches are full of weeds, and the edges of the fields are not mown. That is why, in my projects, I try to introduce this kind of wilderness." Smith suffers when there is not enough light in a garden for the plants. Proper soil and sunlight are real luxuries in Manhattan, he says. Although the sculptures in the garden are not dependent on sunlight, they are enhanced by the effects of light and shade. If you are lucky enough to visit the garden when it is bathed in soft light, then you have the feeling of participating in a theater show: It is as though the sun wanted the tree to burst out, free its trunk from its rigid form, and spread its wings to heaven.

The New York artist Michele Oka Doner (b. 1945) transformed a Hellenistic statue, the *Winged Victory of*

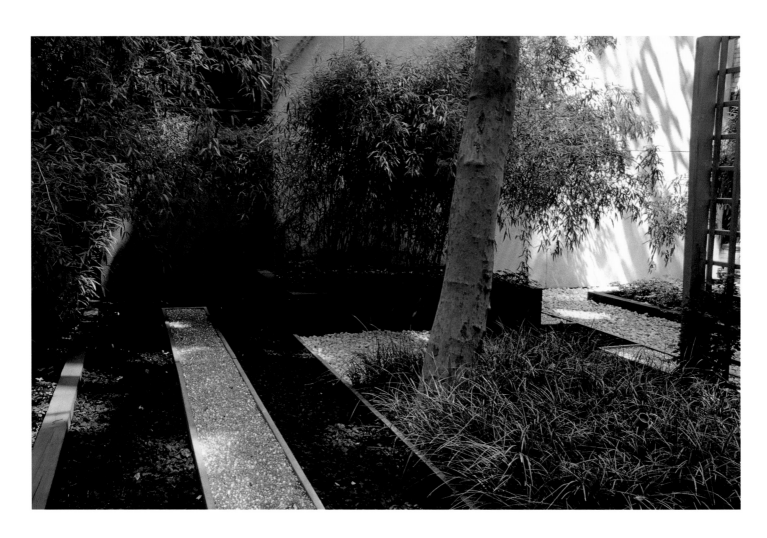

Samothrace, into an organic tree-like figure which on its fragmented surface appears to be alive. Her 2006 work is called *Guardian II*. A critic once said of her, "If Mother Nature were a smith, she would make things look like Doner's sculptures." The garden adds something wild and effervescent to the *Guardian*. It creates tension between it and the surrounding geometry. The torso entitled *Man Aviator* by Isamu Noguchi (1904–1988) is a complete contrast. In its perfect smoothness and silvery metal sheen it appears cold. Ken Smith was aware of this and planted at its feet dark green grass whose softness is almost visible. It takes this dark green fur to set off the sharp contours and humanize them.

The bronze by Chaim Gross (1904–1991) also portrays an abstraction of the human form and makes it clear that Ken Smith planned the garden on a human scale: a philanthropic garden without people. The high regard in which the art collector family holds him is evident from the labels on the sculptures, one of which proclaims the location itself to be an artwork. It reads: "Courtyard Garden by Landscape Architect Ken Smith, 2006."

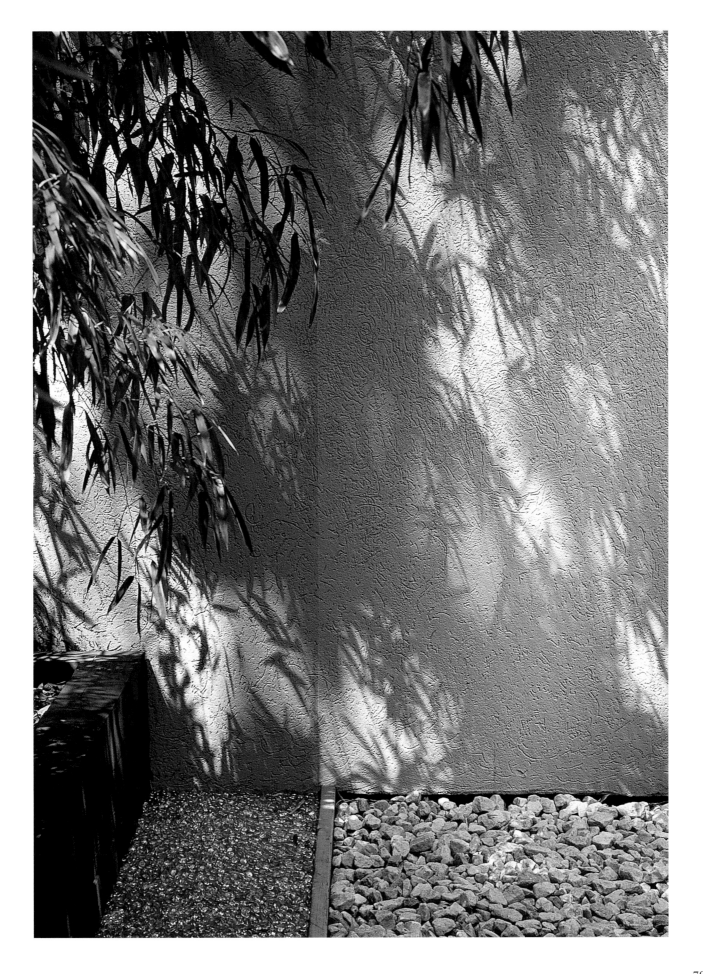

Far Eastern Flair in the City Hubbub

The inscription on the orange-painted *torii* or gateway to the Japanese Hill-and-Pond Garden in the Brooklyn Botanic Garden translates as "great illuminating light." In accordance with centuries-old Far Eastern tradition, this site of ponds and hills is where you become one with nature and thus a place of meditative enlightenment. This was the aim of its creator in 1915 and is still the aim of the gardeners today. In the midst of the noise and hubbub of Brooklyn, just a brief moment of quiet and awareness becomes a hopeful intimation of enlightenment. Sirens wail, the noise of countless cars becomes an acoustic maelstrom and overhead, planes take off and land minute by minute. And yet, in this oasis, you are far away from all that.

The impression is strongest when you stand on the wooden veranda above the water and the architecture of the viewing pavilion frames the garden. It is a very Oriental panorama with its imposing arch and curved bridges. The Far Eastern garden always symbolizes nature in which water, even if it is merely represented by gravel, is the most important element. The trimmed trees symbolize clouds, rocks represent a stony coast and the gentle hillocks the mountains. Stone is a material metaphor of timelessness and stability. One third of the Japanese Garden is given over to the 40,000-square-foot pond, which in spring reflects the flowering cherry trees, and can cause even the hardest-headed to dream. Then, for a few days, the paths are covered with a fine carpet of petals, which are swept away by the lightest of breezes. What could represent transience more vividly than these cherry blossoms?

There is nowhere outside Japan where you can see so many cherry trees in one place. People come from all over the world to celebrate the great festival of *Hanami*. Then it is as though an Impressionist painter had placed a vast canvas in the landscape covered with whirling dashes of paint in white, pink, green and blue. The spectacular flowering of the garden lasts for about ten days, after which it can sink back into its extraordinary tranquility, looking relaxed and very modest. Then only the hundreds of koi carp bring color to the garden.

On the softly modeled hills stand beautiful trees which the curator Brian Funk calls living sculptures. He frequently travels to Japan to perfect his gardening art. More than half of his working life is devoted to trimming trees. The ideal form is a cloud, but to achieve this you have to have a great deal of patience, precision and an eye for the end result. Correct trimming is good for the tree, since it brings light and air to the branches. Funk is particularly proud of his Japanese black pines. Careful trimming makes them look older than they are. The only thing which disturbs him about the principle of the Japanese garden is that plants are replaced if they do not fit in perfectly. Bamboos are an important part of this type of garden and he is always looking for suitable plants which do not spread uncontrollably. A ground-covering pale bamboo with fine leaves was very decorative under a pine tree, but could not be controlled and had to be removed.

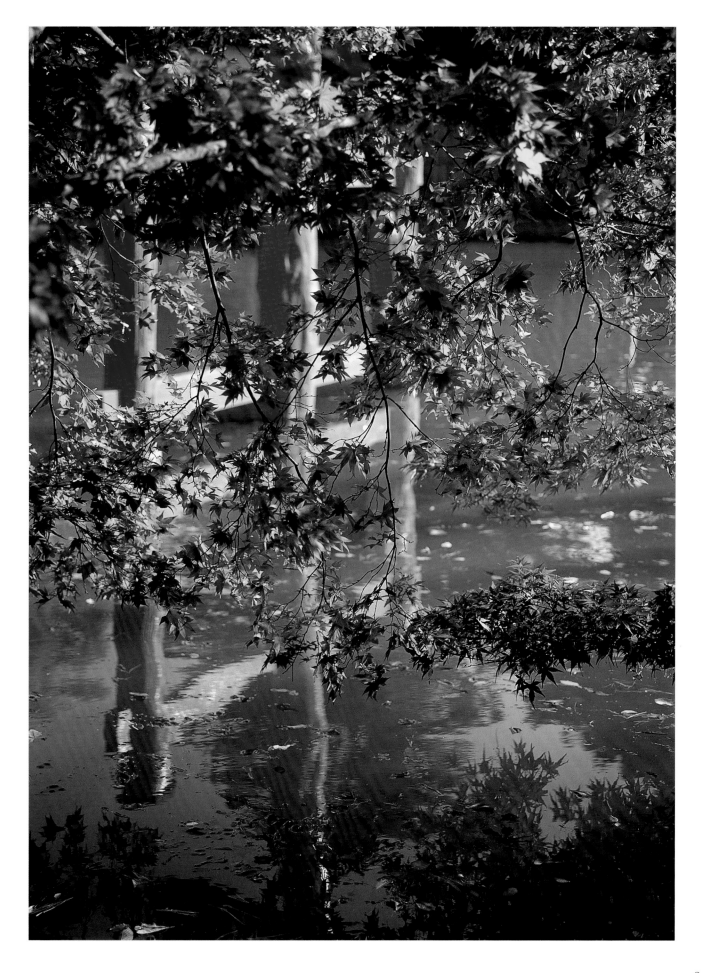

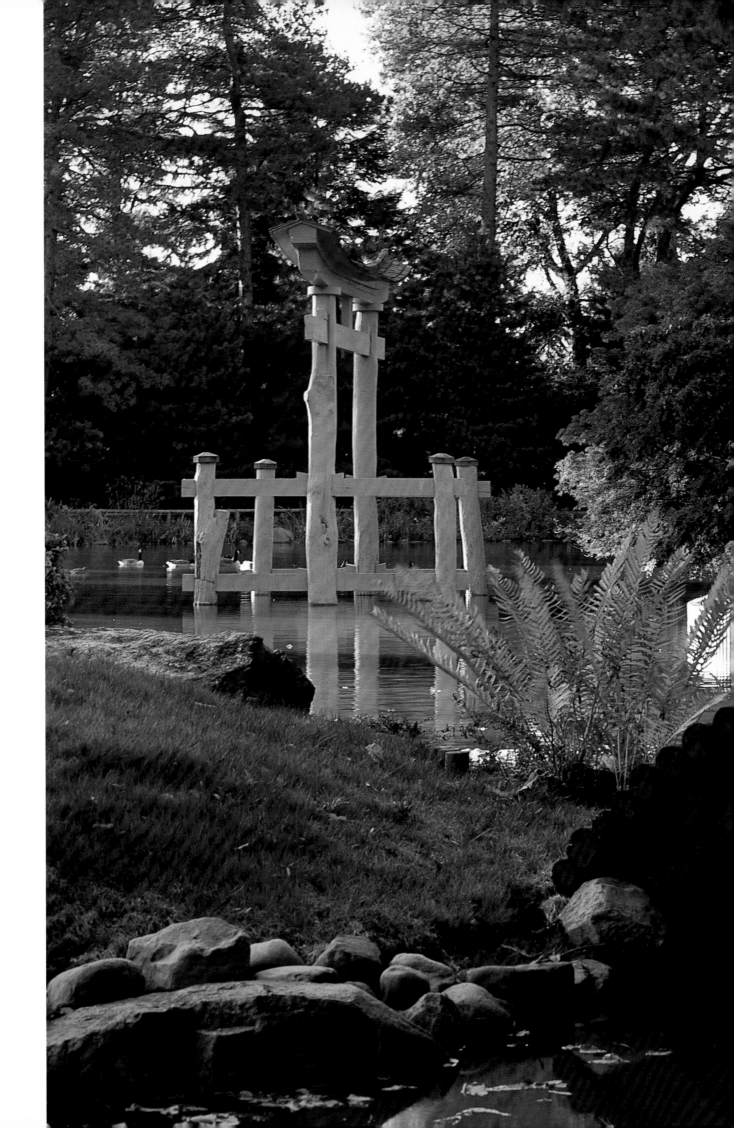

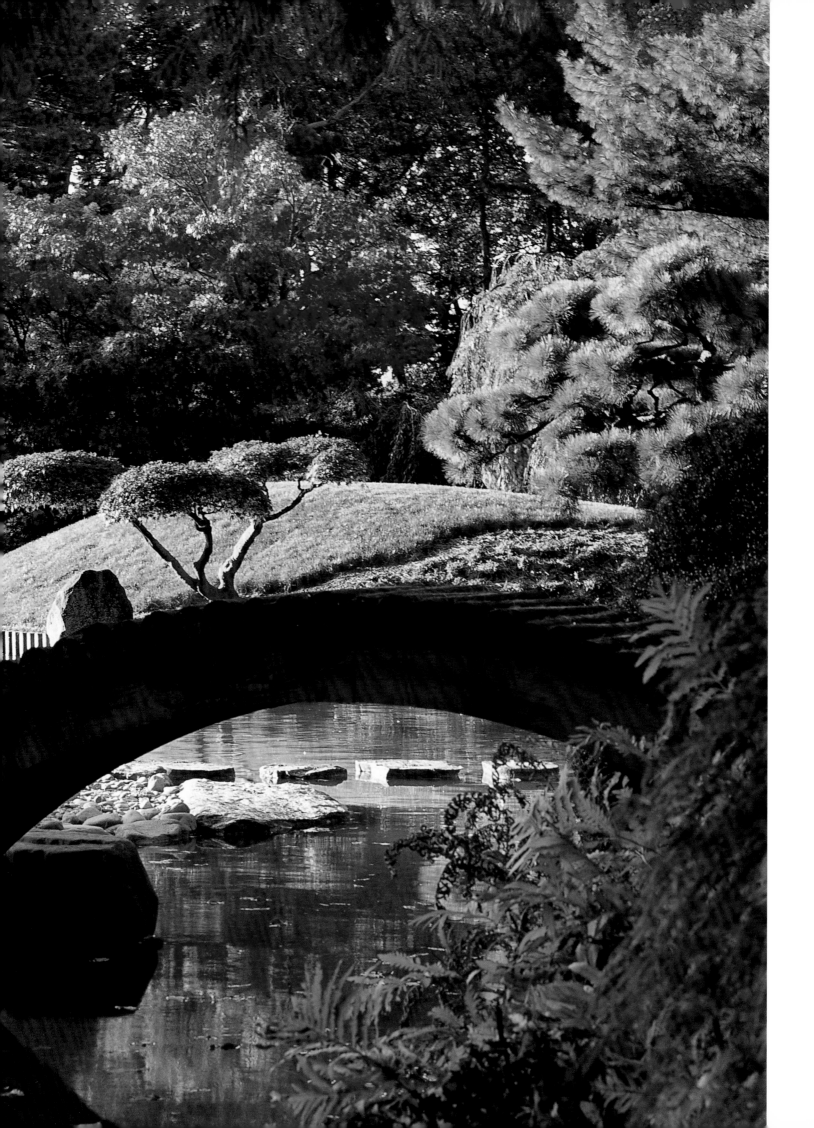

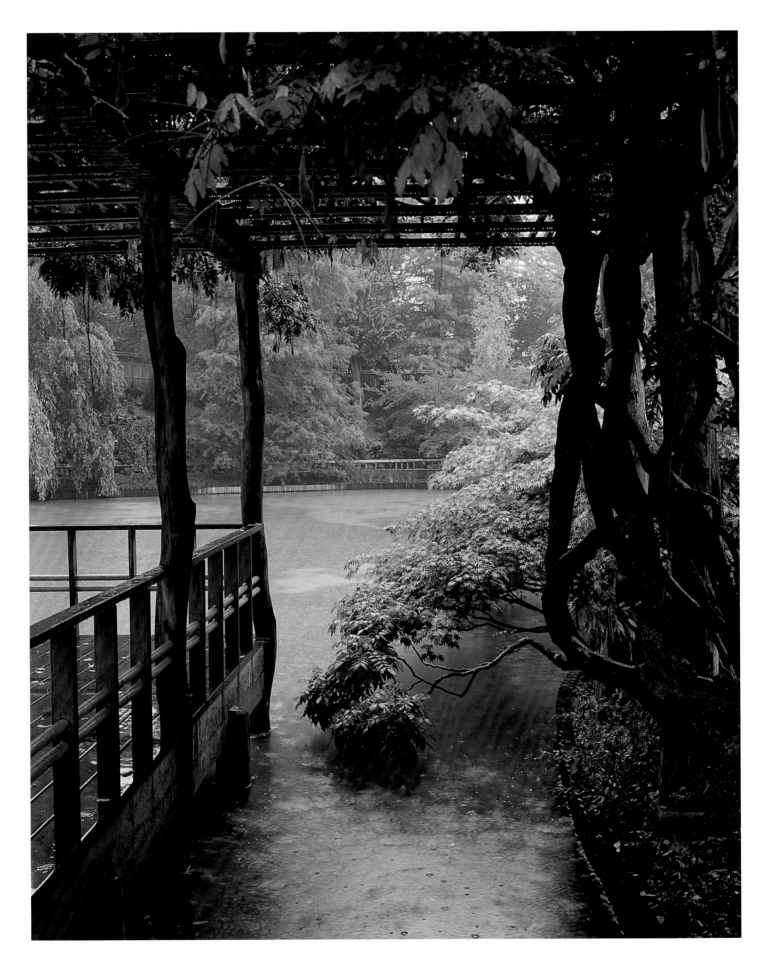

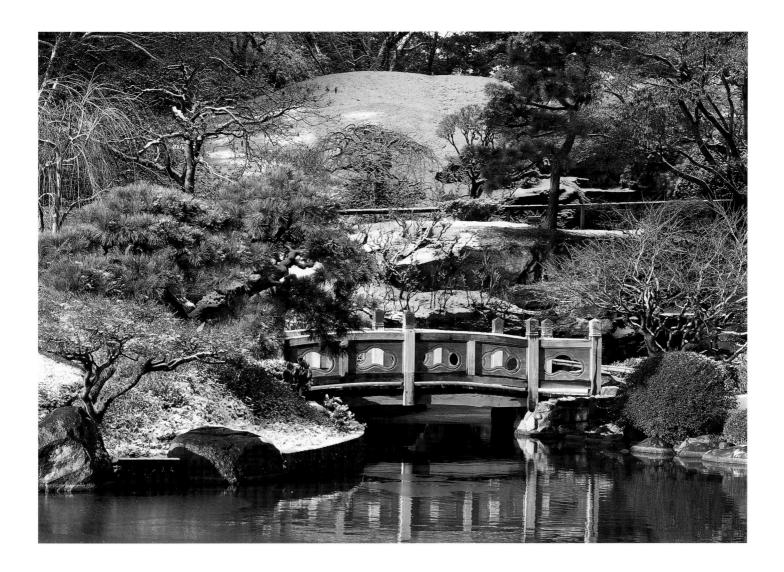

If the rules are followed to the letter, there can only be three types of plant in a Japanese garden. In Brooklyn this has never been so strictly adhered to. Takeo Shiota planted the first garden in 1914. He was not a qualified landscape gardener, but self-taught. He was recommended for the project by the Japanese Embassy. Japan opened up to the West at the point of a gun in 1868, but at the turn of the 20th century continued the process on its own terms. At this time Japanese gardens were rare in the West. San Francisco had had the Golden Gate Park since 1894, and London's Kew Gardens opened a Far Eastern section in 1910. Brian Funk states that the garden in his care is a blend of Eastern and Western elements, which is fitting for Brooklyn and its wide variety of cultures. Shiota, he says, created a

postcard image of a Japanese garden, because in his country of origin, the view could "hover" without being disturbed by such elements as the bright orange *torii*.

In a Japanese garden, the gateway is the entrance to the holy shrine; here in Brooklyn you would have to swim through it. The Shinto shrine itself stands hidden on a hill in a very natural-looking copse. You really have to discover it. The path to the shrine leads over the lotus bridge, uphill past a waterfall, the source of which it keeps to itself. Takeo Shiota built the waterfall using Italian workers, which probably explains why one is reminded of Italian grottos. In addition, he made no effort to use rounded stones as prescribed by Japanese tradition, but used available stones instead. It is this Brooklyn-Japanese mixture which gives the garden its

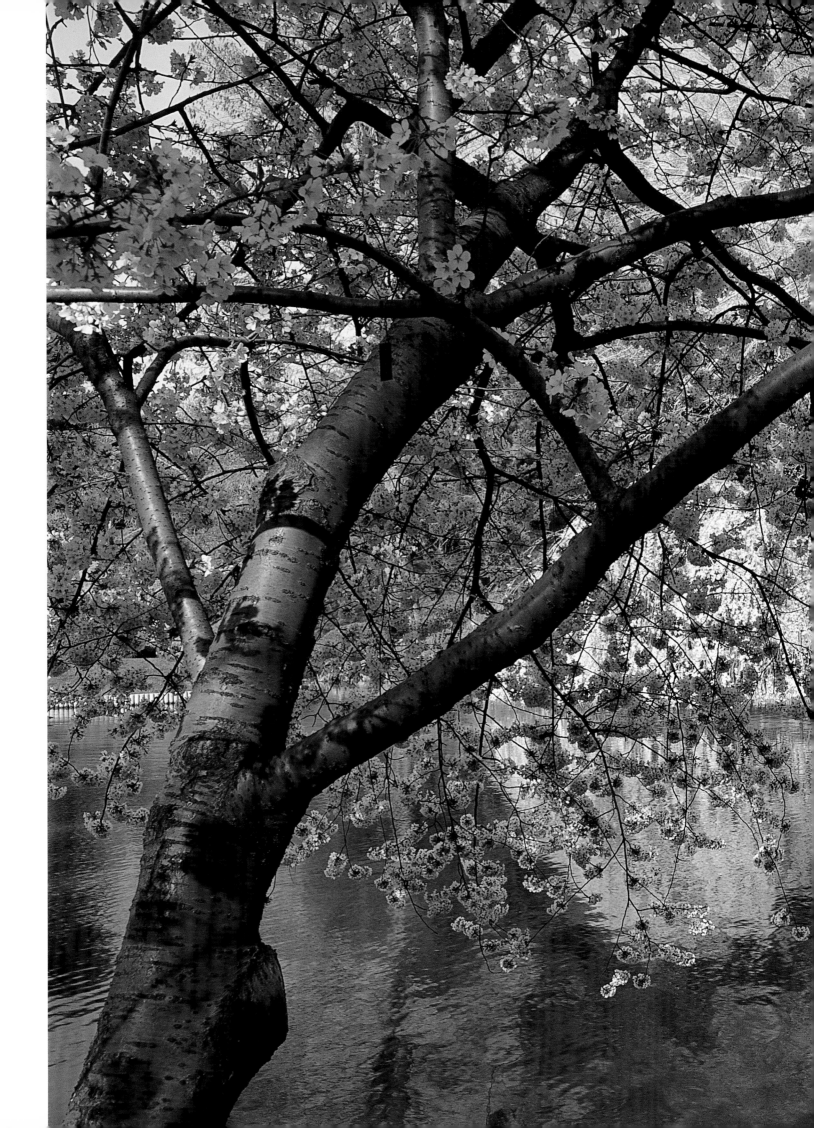

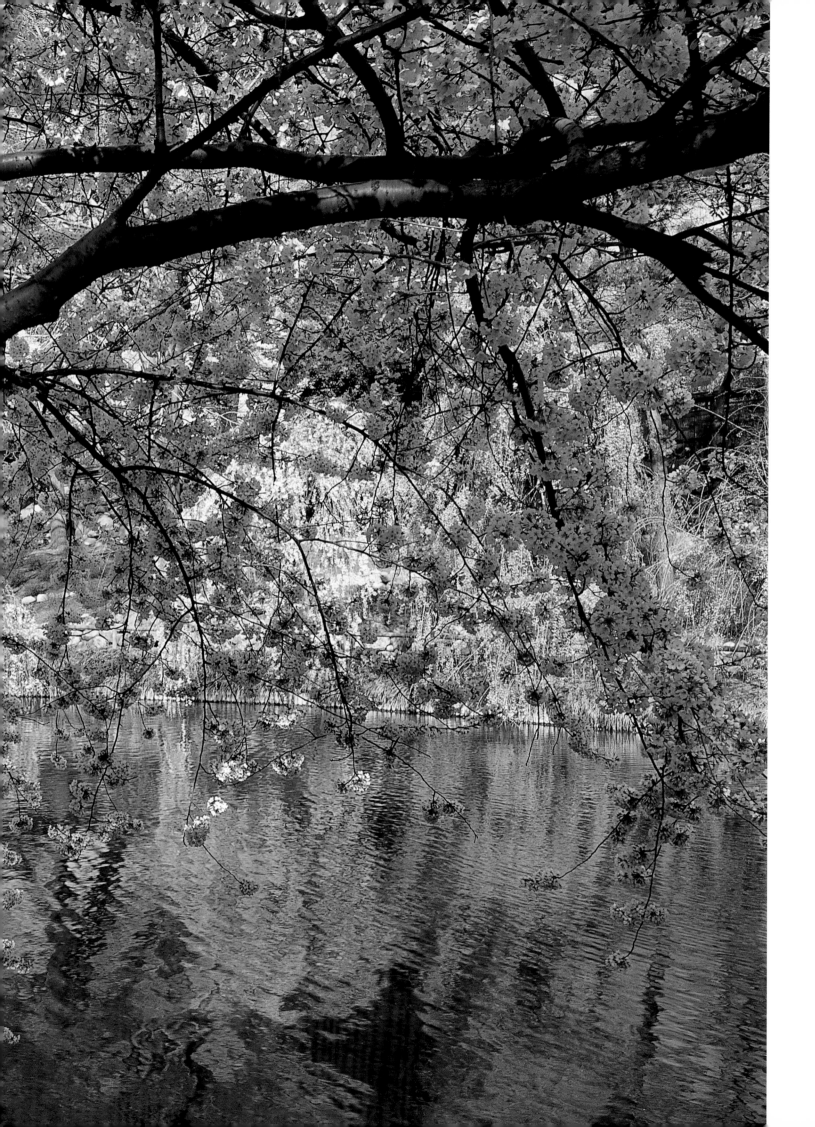

characteristic and sympathetic aura. Shiota constructed caves behind the waterfall, which increased the noise of the water and drowned out that of the city. Evidently Brooklyn was already a noisy district even at the beginning of the 20th century.

One great feature of the garden is its year-round beauty. Even in winter it is an experience: When a light covering of snow is lying on the lake, the hills are powdered and the silhouettes of the pines float like green clouds. In autumn, the red maple trees between the evergreen pines are veiled in the mist rising off the lake. Depending on the season, the lake can be milky or as clear as glass. It can absorb colors or reflect them. The moods are so varied that a visitor can go home every day with a different picture in his or her head.

It is a challenge for Brian Funk to find plants which flower in spring, have colored leaves in autumn and, because of their surprising structures, remain interesting in winter, such as azaleas. In 2001 he received the New York Landmark Conservancy's Preservation Award for his excellent choice of plants. Brian passes on the knowledge of Japanese garden art which he has acquired over the years to the garden guides, and they in turn pass on this knowledge to visitors, so that they may achieve a degree of enlightenment, be it ever so slight, in the Japanese Hill-and-Pond Garden in Brooklyn.

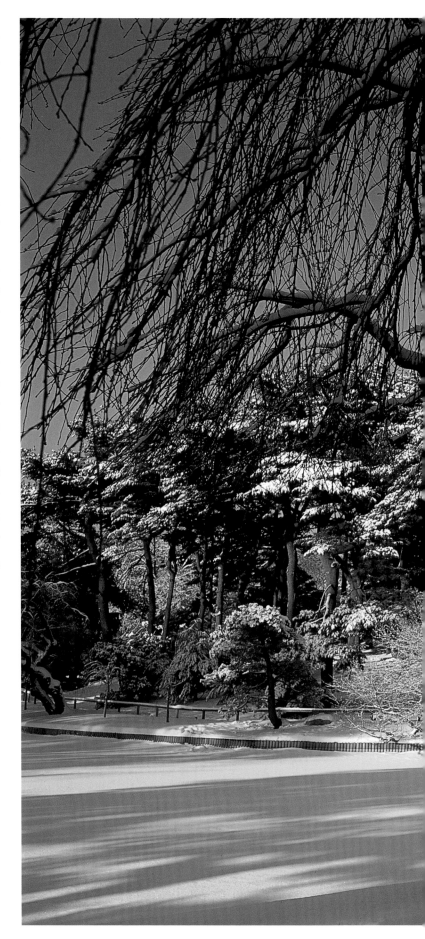

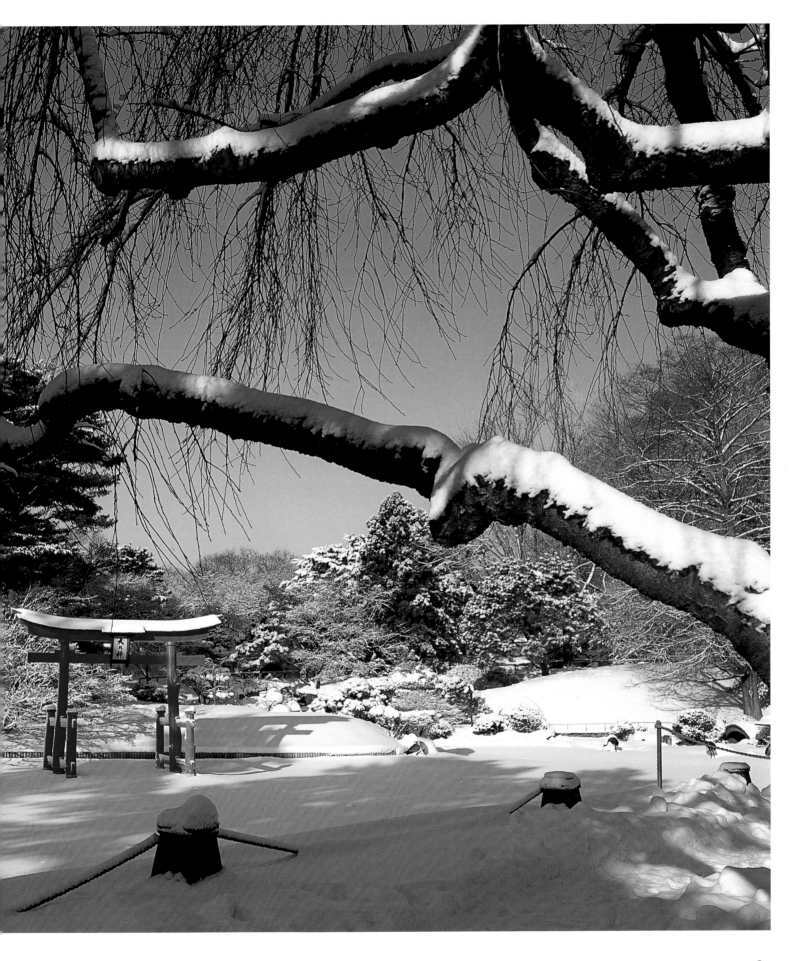

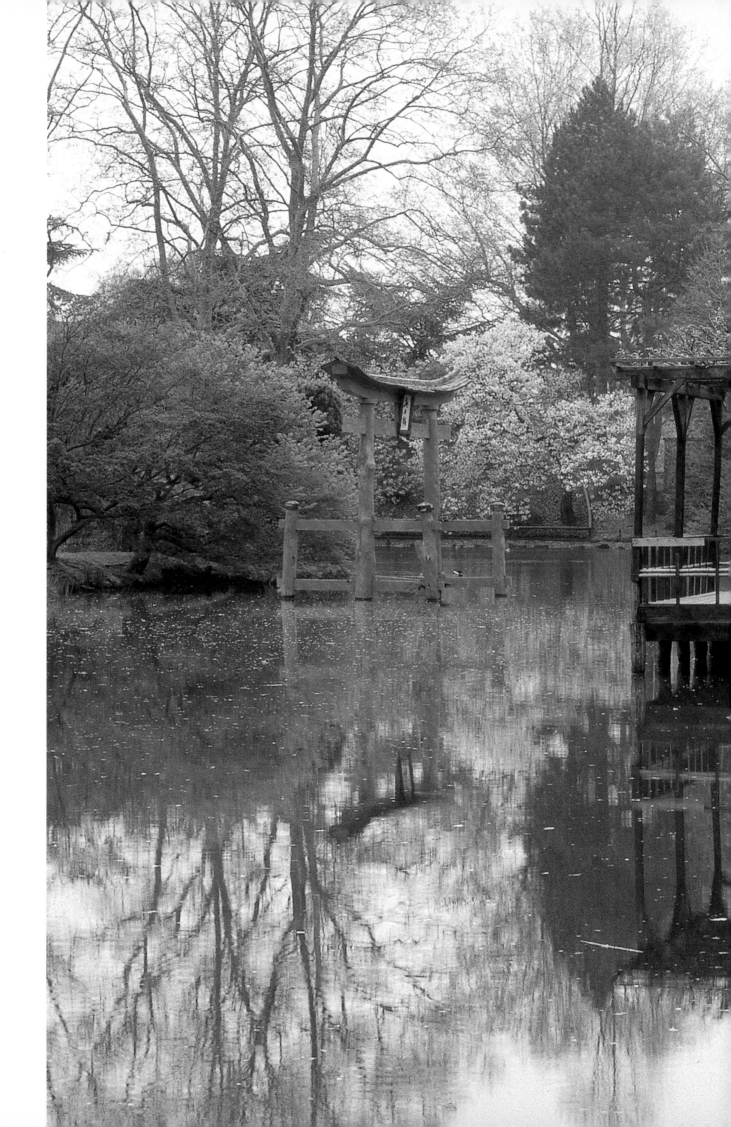

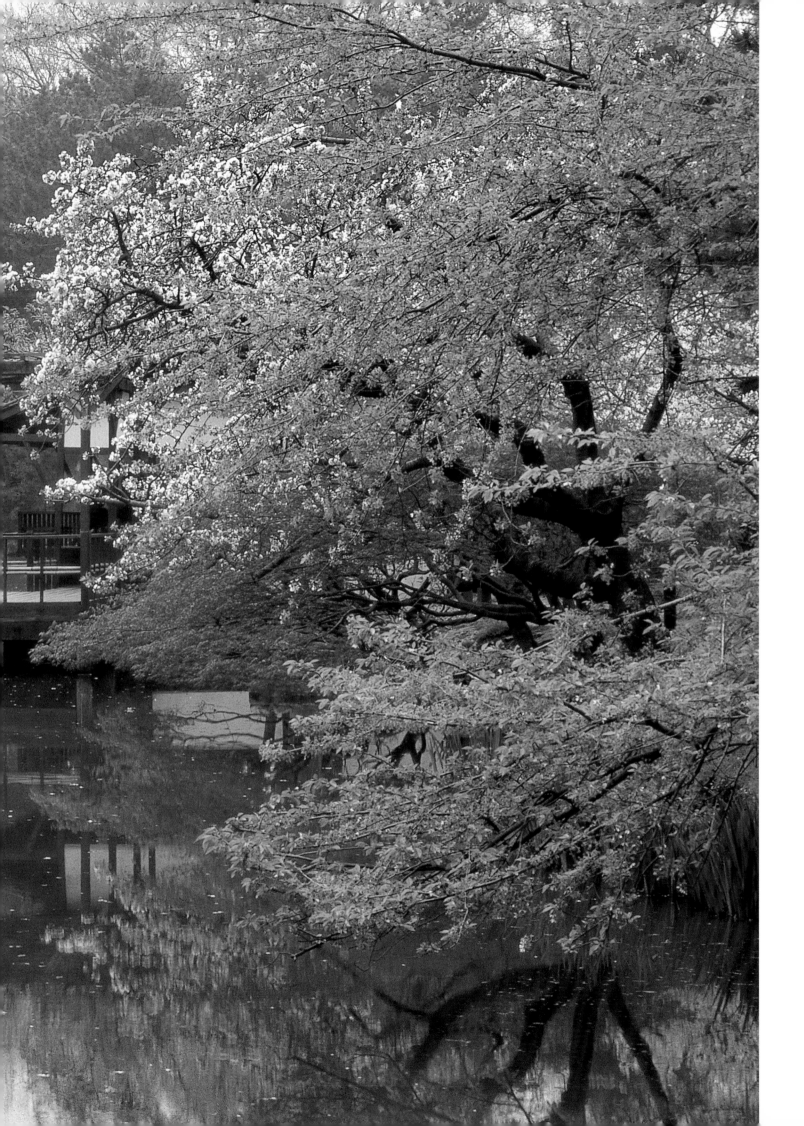

Romance with Neighborly Blessing

The district of Chelsea in southwest Manhattan takes its name from an erstwhile grand estate between 9th and 10th Avenues south of 23rd Street. It was surrounded by many gardens, which gave the district its countrified charm. The first town houses were not built until the middle of the 19th century, but they gradually displaced the gardens. When a railroad for goods trains was built, separating Chelsea from the Hudson River, the character of the district changed. Warehouses were built along the riverbank. Around 1900, most of the people who lived here were Irish longshoremen. Today, Chelsea is a favored district for artists and gallery owners who in the 1990s fled here from the high prices in Soho.

The heart of Chelsea is known as Chelsea Historic District. Along the tree-lined streets are three-story brick town houses with a few steps up to the front door, and next to them, a flight of steps down to the basement. This means that someone living on the middle floor is only a little above ground level. However, the Raffo Garden has other surprises. The living-room windows open onto the street. From here you go through an ad-joining room with an open fireplace and then you can hardly believe your eyes: The view is of a garden which appears to be far too large for the size of the house. Eileen Raffo explains the secret: The garden embraces an area normally allotted to one double-fronted and one normal brownstone house, and the owner of one had always also owned the other. In 1978 Eileen Raffo ac-quired the two properties, consolidated the plots and created the garden. No new garden could give this im-pression. The resident plants have proved themselves over three decades, nothing needs to be tested any more, everything has its place. The trees are now as tall as the houses, the treetops shade the plot, and the sun-light that penetrates the foliage covers the ground with a gentle green light. Three sides of the garden are en-closed by a fence consisting of horizontal wood board-ing appreciated by the dark green ivy as a climbing aid. The neighbor to the right is also a passionate gardener, so the green continues behind the fence. In the shadow of the dogwood trees, a small Japanese maple, a dwarf cypress, red-flowering azaleas, ferns, and, of course, many hosta varieties all flourish. Eileen Raffo does not just enjoy the view from her veranda, but often takes a walk through the garden, sitting on the stone bench next to a small pond where in spring purple irises bloom, and taking in the tranquility. She enjoys nothing more than hearing the bells of the neighboring General Theological Seminary. This was founded in 1836 and comprises more than twelve neo-Gothic buildings. Its garden is a huge surprise. It covers the area of a whole block and reminds Eileen Raffo of the colleges in Ox-ford. She often visits the seminary garden, and her gar-den too profits from these trips: Many of her plants started life as cuttings taken from there. She has the as-sistance of an English gardener; together they have found many shade-resistant plants which are well suited to life beneath her leafy roof in Chelsea. In this way Eileen has been able to create a 2,000-square-foot green oasis in which every spot is inexpensively planted. The

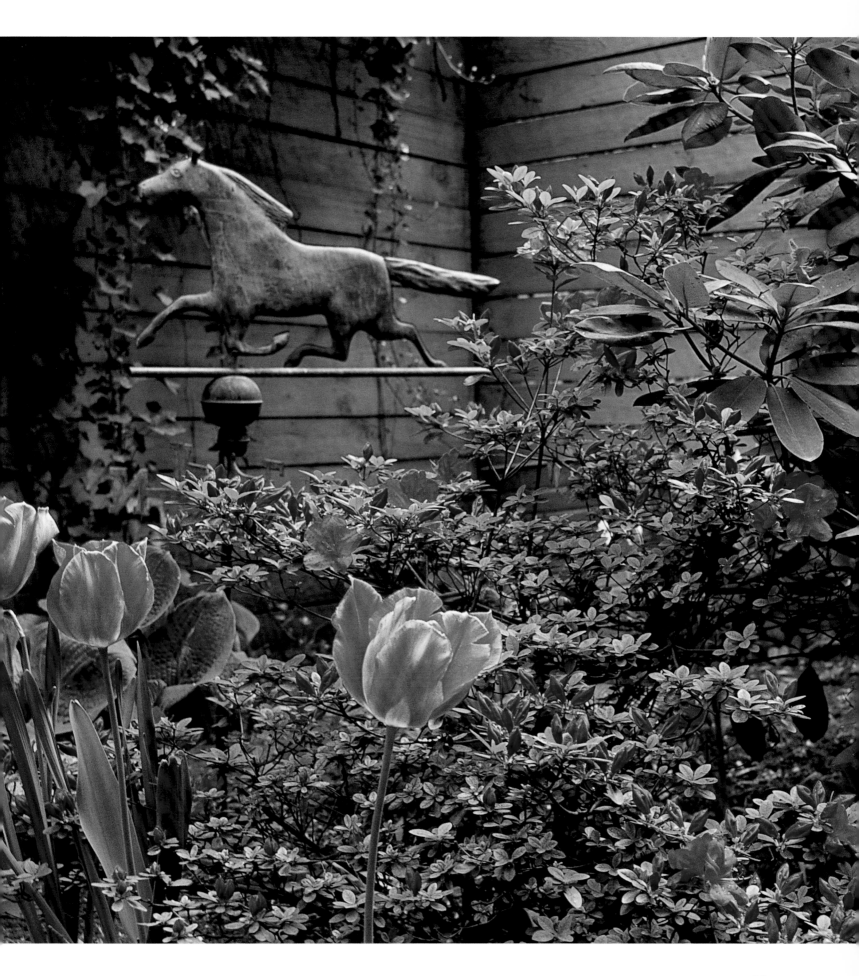

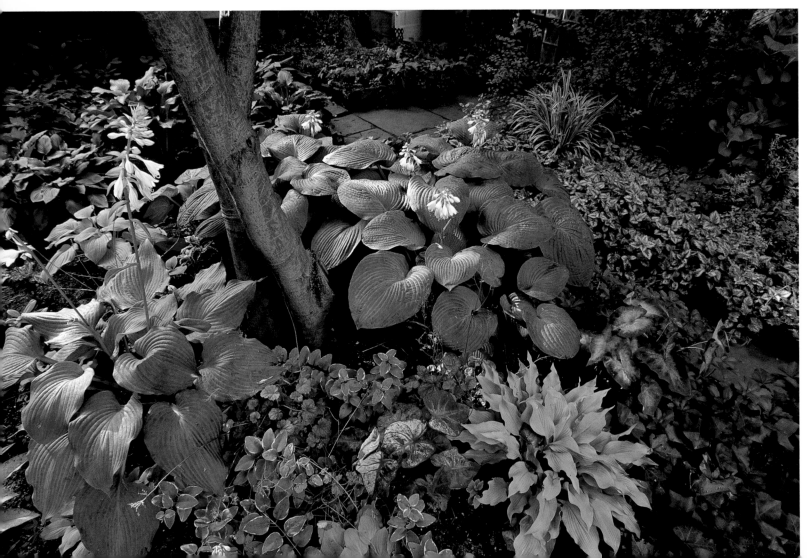

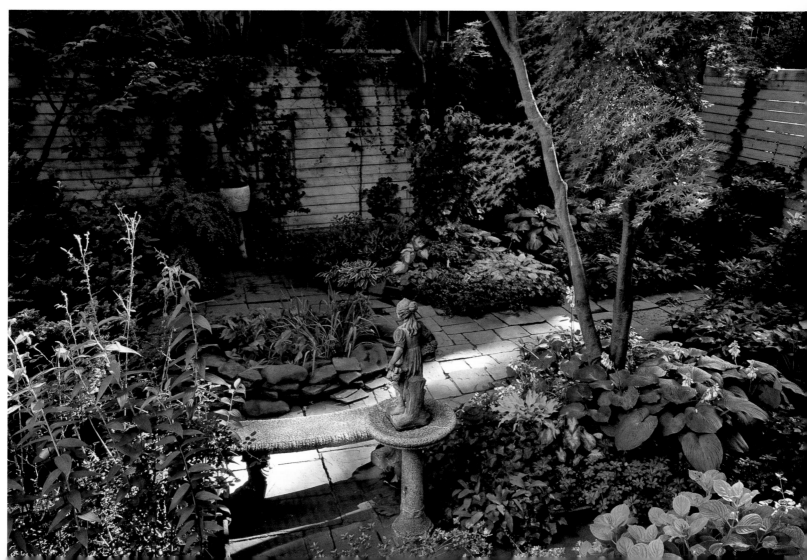

red corner with the bronze figure of a fleeing horse is amazing: It is clear that Eileen was able to find a late blooming, red tulip variety and a red azalea which flowers quite early, so that they combine, very unusually, to create a single pot-pourri of red petals. The Celtic-looking stone vessel contains a red-leafed plant which harmonizes with the stone ornament. The bench and the plinth, on which stands a romantic shepherdess holding a basket of flowers, are also made from the same pale stone. Eileen received the statue as a present. It serves as a background for the carol singers who come to all the gardens on Christmas Eve. They gather round the small pond, which in winter is overgrown with evergreens. Traditions are very important to Eileen Raffo. She often feels uneasy about the modern, cold, restoration work on the brownstone buildings in her neighborhood. She believes that they do not fit in with the original style of the houses whose enchanted and nostalgic character she treasures.

Incidentally, the seminary owes its existence to a noble patron: In 1818 Clement Clarke Moore planted an apple grove on the spot where it was later built. So when garden owners come here to look for cuttings for their gardens (after first asking, it goes without saying), the gardening tradition comes full circle. The seminary garden is open to the public so that New Yorkers and passing tourists can enjoy a little bit of nature in the center of historic Chelsea.

Ensemble of Balcony Seats

How is it that when you are on a 900-square-foot roof terrace on the sixth floor of a Beaux Arts mansion, a town house from the early 20th century on the corner of Fifth Avenue, you get the feeling of being in the middle of nature? This secret garden is not far from the architect Frank Lloyd Wright's Guggenheim Museum and the area could not be more urbanized or more elegant. Nevertheless, you sit up here and look at the airy foliage of the birch trees which are planted in containers beyond the perimeter of the terrace and grow high up through the gaps in the terrace roof. On the adjacent side a thirty-foot high bamboo grove blocks the view of the buildings behind. The roots of the bamboo are in a giant container on the floor below. The bamboo glints and sparkles at night, illuminated by lights placed between the plants. This prominent place is thus changed into a green oasis. In front of the rows of trees there is a long bench, big enough for an "entertaining area." The furniture is more organically shaped than strictly geometric. There was an interesting tension for the designer David Kelly, because the terrace was planned as an extension to the interior rooms, and objects had been placed on the roof which did not belong there.

The terrace can also be used when it is raining and if you want to enjoy the sun, the glass panes in the central area can be slid open. The area can therefore be enjoyed as a well-used family room. There is a barbecue area and an open fireplace, so that even on cool evenings you can stay outside.

When the residents have no guests and want to be alone, they use a 500-square-foot, intimate garden area, custom-built by architect David Kelly for his clients. Two loungers are placed next to each other and between them there is a low table, which looks like part of a tree trunk. In one direction there is a white-flowering climbing hydrangea; and lying down, there is a light green grass border stretching along the wall at eye level. The opposite view is of a white wall whose brick structure can still be guessed at. David Kelly uses plants very architecturally, but still recognizes the limitations. He knows that nature, over time, does not bow to architectural domination. The band of pale green grasses overgrows the precise contours of the plant containers, and that is good. On the ground in front of the green wall, there is a strip of glass tiles which can be lit from below. This means that at night the plants do not disappear into darkness, but are enveloped in a soft veil of light from underneath. In the dark, the illuminated water changes into a sparkling area of light on the black marble floor. The design does not reveal that for technical reasons, the basin is not deep. The floor of the terrace is placed on a fiberglass plinth, which "hovers" on the roof. However, all these technical details are quickly forgotten in this elegant ambience. A high point in this combination of relaxed and concentrated atmospheres is the sculpture at the center of the water basin by the artist Juan Asensio, who was born in Cuenca in Spain in 1959. There is no name for its geometric form, yet it still appears archaic, natural and familiar; the piece rises

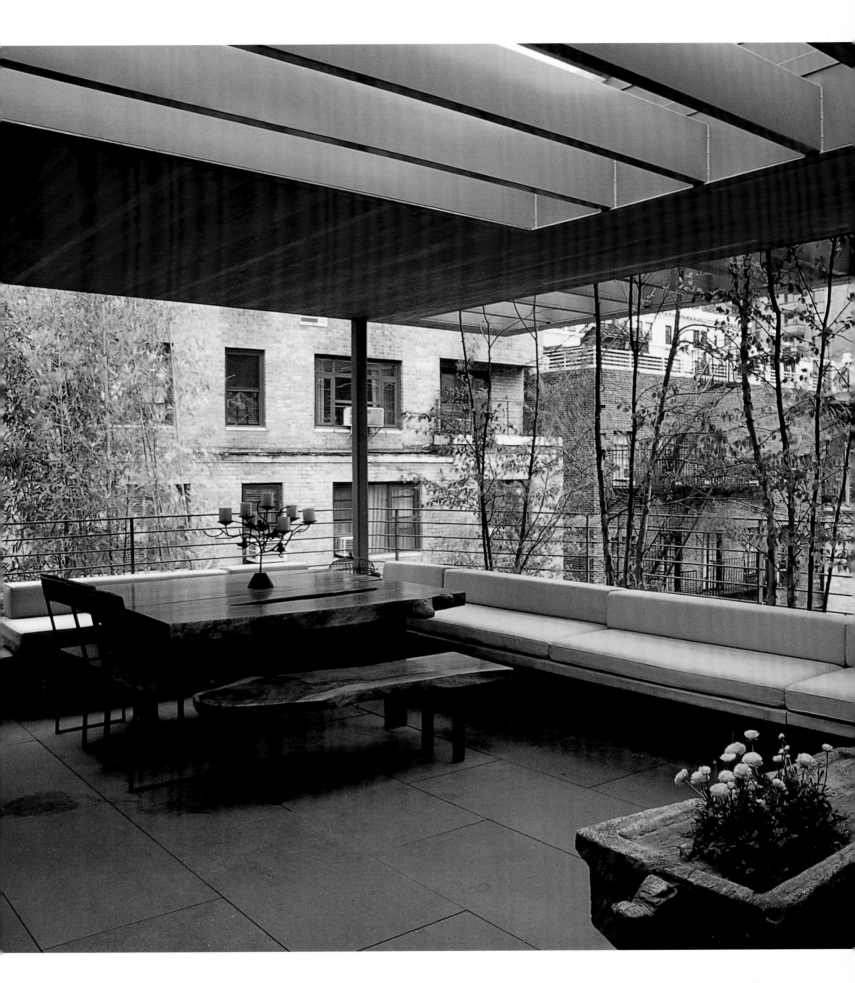

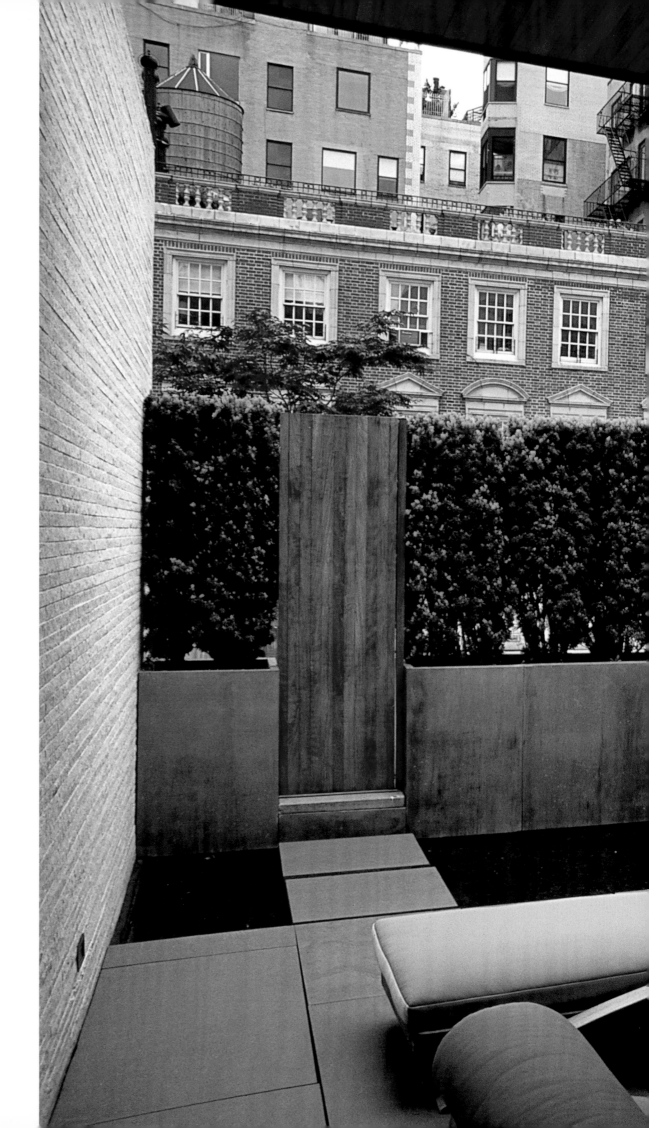

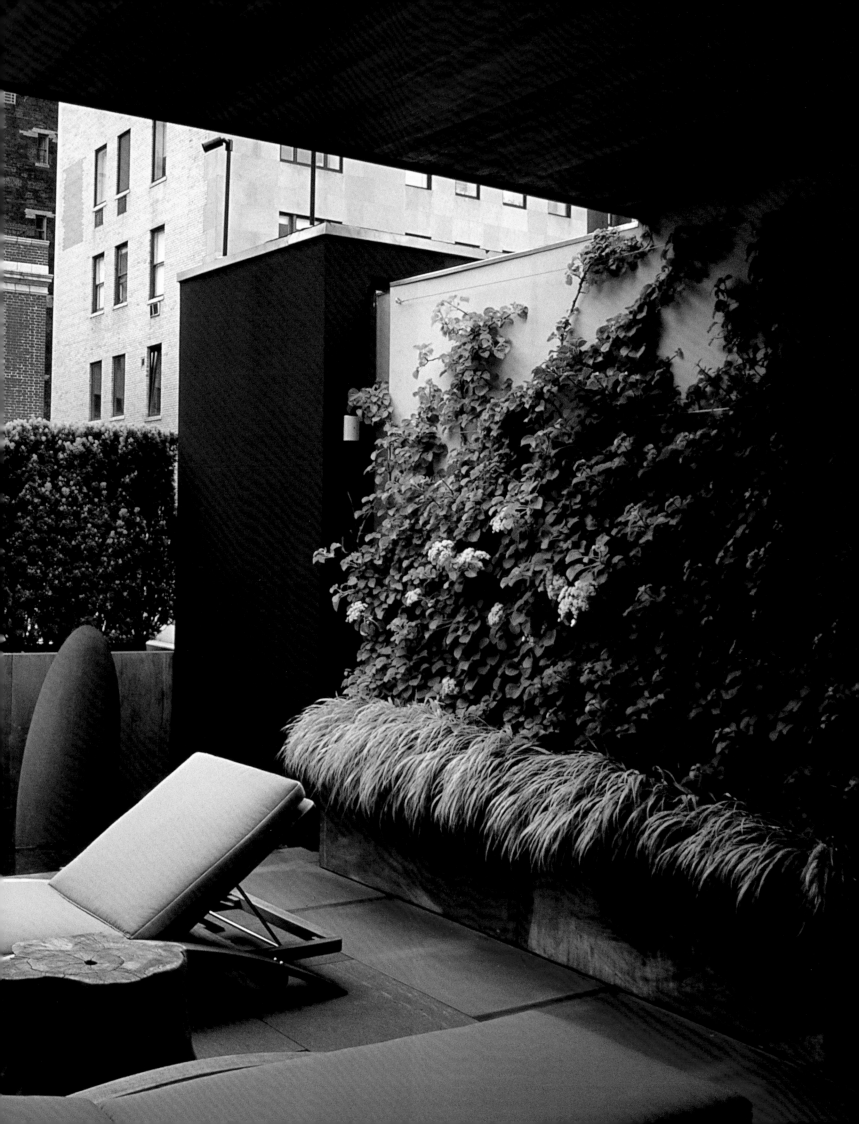

softly and harmoniously from uncompromisingly precise lines. The dark gray enhances its individuality. The influence of modern artists like Anish Kapoor and Isamu Noguchi is palpable. For this small space the sculpture is serendipitous and the total picture, with the architecture and the planting, would not be out of place in a museum.

Behind the basin there is a gray plinth on which a dark green yew hedge closes off the space. A simple wooden garden gate leads to the communal terrace. Others living in the building rarely enjoy the shade of the maple tree, even though from here you have won-

derful views of the Guggenheim Museum and Central Park. The garden gate is only opened when the owners of the roof terraces throw a party. And yet one might say that just the fact of living here is reason enough to celebrate.

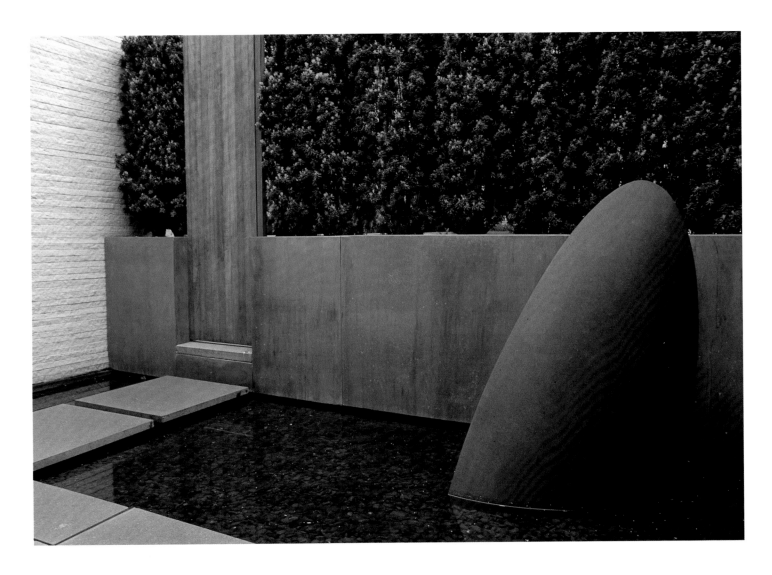

Village Idyll between Skyscraper Canyons

"We sit here, in a city of concrete and skyscrapers, and feel like we're in the country. At least we behave as though we were in the country." So says Carol, who lives on Pomander Walk, a private garden street of twenty houses on Manhattan's Upper West Side. She gets up and takes her red watering can to water the newly planted hydrangeas in front of her house. Next door a girl named Kaili sits on a pocket-handkerchief-size lawn and cuts each blade of grass with office scissors. Oblivious of her surroundings, she sits there and smiles. It is a very rare privilege in New York to be able to cut your own blades of grass, right outside your front door. It could be the beginning of a film: You see this little girl sitting there, entirely surrounded by green; the view opens up to reveal a little house with bright blue shutters. Then you see one house after another, one front garden after another and at the end of what you thought was a village street, ugly high-rise apartment blocks with rusty fire-escapes towering up into the sky. It is a powerful image, and a powerful contrast. A rustic retreat in the midst of the monstrous metropolis. At 94th Street you turn off Broadway into an inconspicuous side street and are faced with a locked iron gate. Next to the bell buttons, there are only numbers and no names. The owners need a key to get out into the street. There are no cars. How could there be? Very often, inquisitive people press their noses to the gate and try to get a glimpse of this idyllic garden street. But this is not easy. To start with, there are steps leading up from the street, and from the outside you can only guess which plants are lovingly cared for by the residents of these twenty houses. With only a hundred square feet of garden, every inch counts and every plant is carefully selected and planted; nothing is left to chance. The style is very English, with "mixed borders" designed to ensure that something is in flower throughout the year. Some residents even treat themselves to the luxury of a small lawn. A few years ago, Kaili planted a rose, which is now well above her head, and every June and July the front of the house is decorated with pink petals. Her father Bram Lewis is a stage actor with a long tradition behind him. In 1910 New York saw the production of a play titled *Pomander Walk*. The London suburb of Chiswick was the inspiration for the backdrop. The young Thomas J. Healy, who originally came from Ireland, saw the performance and was particularly impressed by the backdrop. As the owner of cafés and nightclubs, he had amassed considerable wealth in quite a short time, and so was in a position to reproduce this backdrop. He bought a 200-year lease on a steep, irregular plot on the corner of Broadway and 94th Street. His love of the stage led him to encourage theater people to become tenants. In September 1921 the *New York Times* wrote that half of the apartments had already been let, even though the houses were not yet finished. Even then Pomander Walk was a place of nostalgic reminiscence, an anachronism in what was then the most modern city in the world. All around skyscrapers were shooting up, and here was Healy, replicating an English village street. Consulting census archives, you can see that the tenants

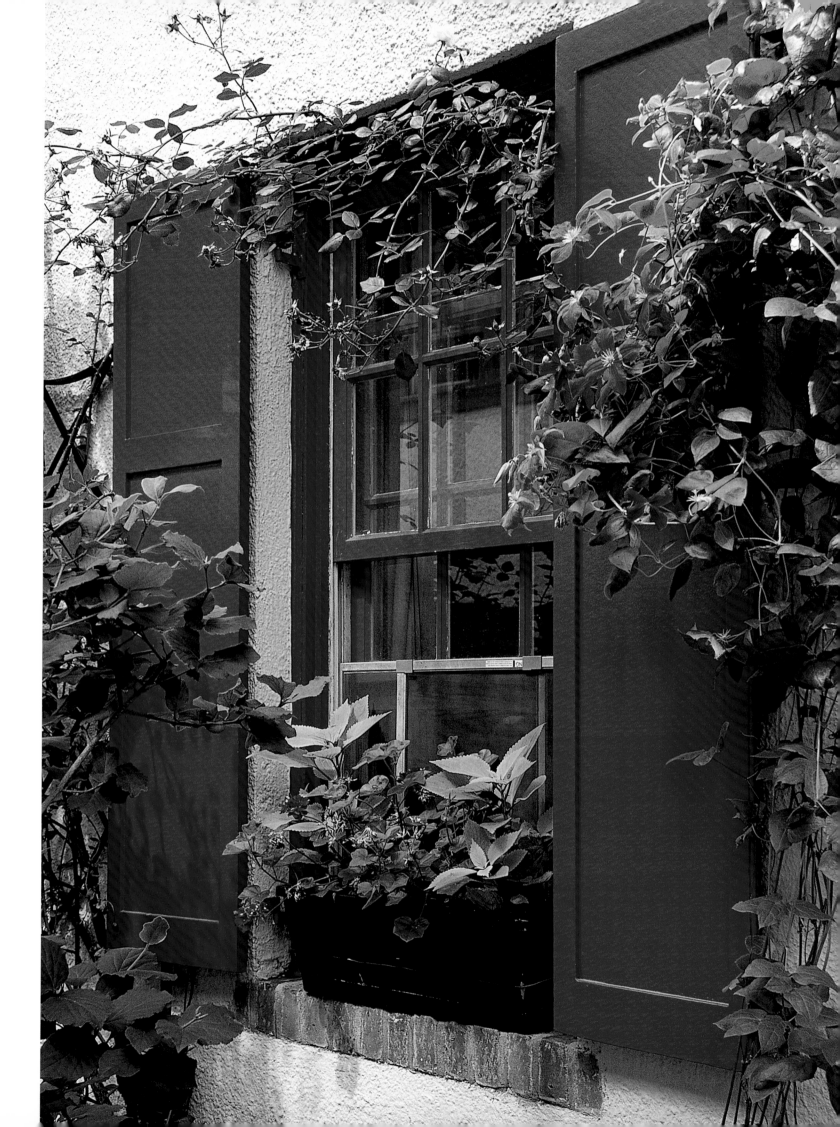

changed frequently. Is this an indication that the income of actors, playwrights, directors, and theatre critics fluctuated then as now? The old saying "temporary measures last longest" certainly applies to Pomander Walk. Built as a temporary crazy idea by a nouveau riche theater freak, it is still in existence. If Healy ever intended to demolish Pomander Walk, he did not get around to it. He died in 1927. For many years the little street was not exactly a luxurious address. But then it was landmarked in 1982, and prices shot up. Nowadays the only members of the acting fraternity who could afford the rents would be Hollywood stars, but given the limited living space, there is no great incentive to do so. Each floor measures no more than some 500 square feet. But do not be deceived: Should a property on Pomander Walk come on the market, which does not happen very often, then it will not be vacant for long. The idyll of a small house with its own garden in the middle of the Upper West Side is too attractive.

Each house is distinctive, as if to create the impression that Pomander Walk evolved over a period of several decades, as one new house after another was added to the row. Some of the fronts are rendered and painted white, others have exposed red brick, and some are whitewashed and decorated with thick wooden beams in what has been described as "Tudorbethan." Every house has red, green or blue shutters, which are most attractive around midday when the sun is directly above and sends its beams onto the narrow street. At other times Pomander Walk is in the shadow of the surrounding high-rise blocks, and such shadows have to be considered when planning a garden. The residents take advantage of these few hours of sunlight and sit on the steps leading to the front doors. Very probably more than half a century ago the street's most celebrated inhabitant sat on these steps at midday, blinked at the sun and coolly puffed the smoke of his cigarette into the daisies. Believe it or not, Humphrey Bogart loved

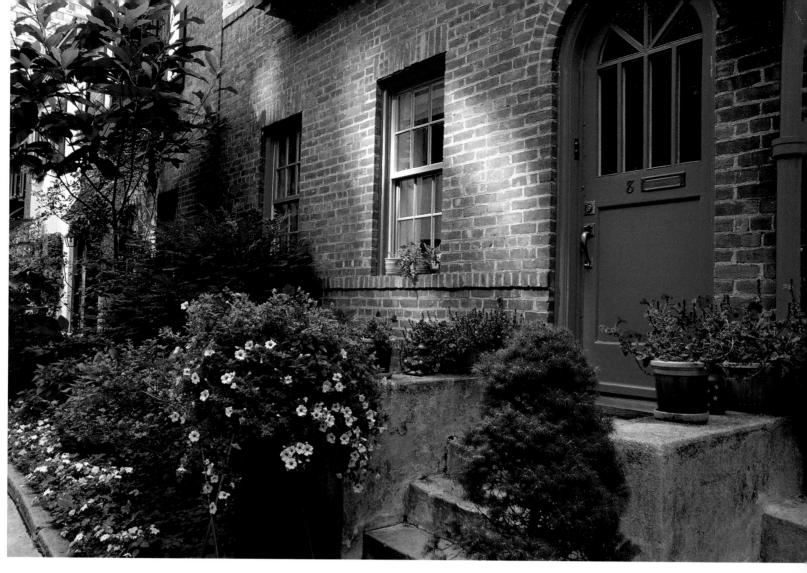

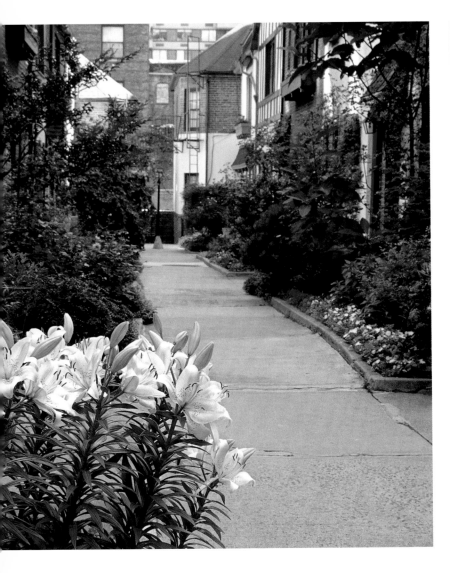

idylls too, and was very much at home in his little garden close to Broadway, between 94th and 95th Streets on Manhattan's Upper West Side.

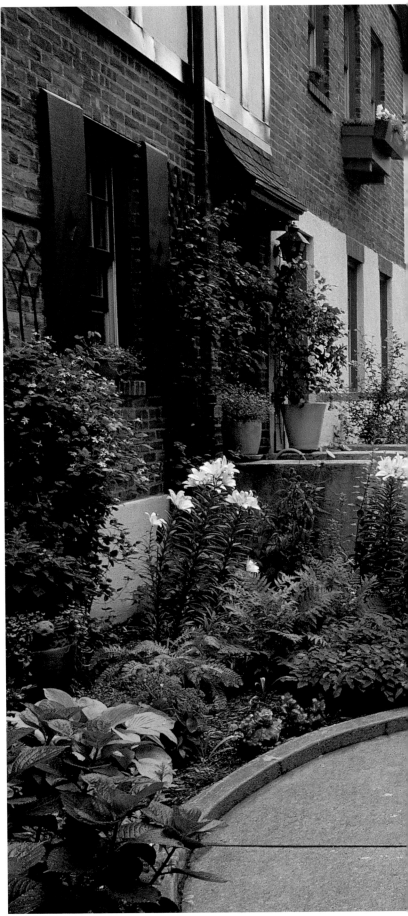

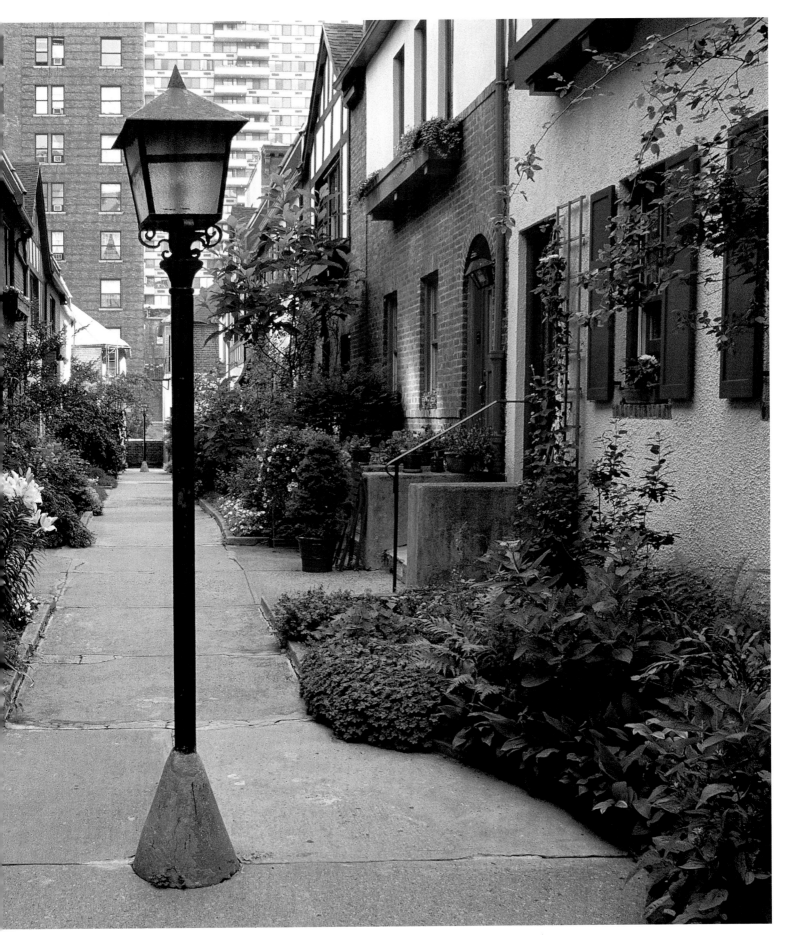

Bauhaus on the Roof

Should you be fortunate enough to be invited to Barry Salzman's roof terrace one evening, not only does a spectacular view of the Manhattan skyline await you, but also a journey into the architectural history of America. It is no coincidence that you will be reminded of the Bauhaus. The reason is as follows. When the architect Brian Sawyer was given the contract to design the terrace, he saw an opportunity to pay homage to the architect Paul Rudolph. Rudolph (1918–1997) was one of the most important representatives of modernism in the USA, and was himself the owner of a town house with a roof terrace on the East River, which Brian Sawyer said was "very architecty" [sic], and one of the coolest roof terraces in the whole of New York. The defining elements of the very sober garden are steel, ivy and concrete. Paul Rudolph studied under Walter Gropius at Harvard University, and trained such famous architects as Norman Foster and Robert A. M. Stern, who in turn taught Brian Sawyer his profession. What all of these people have in common is a serious confrontation with the past and with tradition. Stern sees himself as a "modern traditionalist," and the profile of the company of Brian Sawyer and his partner John Berson states, unusually, that in all of their projects, not only technical criteria, but also the historical background will be intensively researched. And this is why ultimately, Barry Salzman's roof terrace is reminiscent of the formal vocabulary of the Bauhaus tradition.

Before the 2001 modifications, many plant containers and a pavilion graced the roof area. Luckily Brian

Sawyer was a friend of the client, and was able to persuade him that first of all, the terrace needed an architectural framework. He is convinced that the design of the garden and the plants will speak for themselves if the architecture is right; this conceptual way of thinking is not easy to convey to every client. Just as a house needs walls and a roof, a garden follows elementary principles. That is the reason why it is so important to talk about rooms, boundaries, roofing and flooring, to develop an awareness of the fact that this area is to be lived in like a house, and that it must be planned and laid out accordingly. The Salzman terrace is the result of successful communication between client and architect, who in this case is also a landscape architect. The technical requirement for the building of the roof terrace was a steel-framed platform anchored in the building's four load-bearing pillars. Plans for a roof terrace often fail because of structural considerations. When you calculate the weight of the architectural elements—the furniture, the plants and the earth—this can amount to several tons. The property managers required that the roof terrace be designed in such a way that it could be removed for the purposes of roof repair and maintenance.

In total, the terrace is about 1,300 square feet in area, turned into a uniform surface by a floor covering of made-to-measure white concrete tiles. Painted steel supports form the architectural frames, which in the dining area are filled with frosted glass. The barbecue area is separated by perforated stainless-steel sheets. The same materials are used for the plant containers: steel, glass

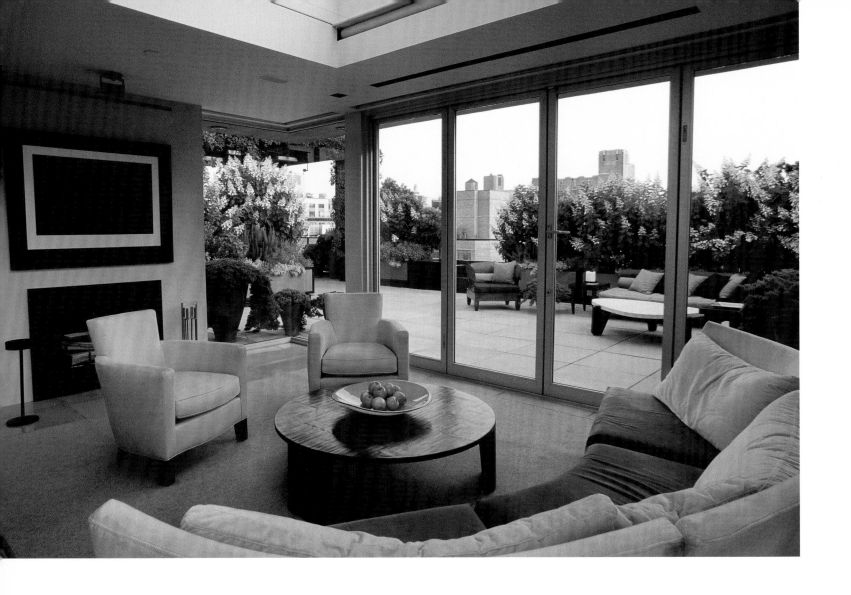

and concrete. This sounds very sober, but the exuberant planting adds a charming, cheerful and elegant aura. You could not describe it as "natural" or "romantic," and the terrace does not intend to be either. It reflects clear architectural lines with a limited and simple vocabulary. The choice of plants shows the expertise and experience of the gardener, who knows exactly how to conform to his client's lifestyle. He is in full-time employment and can normally only enjoy the roof garden in the evening. So what would be more appropriate than choosing white-flowering plants? They are, in themselves, almost a source of light and illuminate the terrace. (By the way, only a short while ago, a night garden was reconstructed on the grounds of the Taj Mahal in India. The Moonlight Garden was planted exclusively with white-blooming plants.) In fall the extravagantly planted hydrangeas form a sea of white flowers. Fall in New York is a season of pleasant temperatures.

It is a time when one likes to be in the open, and can enjoy the terrace. In the barbecue area lavender, thyme, rosemary and sage add Mediterranean flair and supply Brian Sawyer, who is a passionate cook, with sweet smelling herbs. The façades of neighboring houses are reflected by the water in the cubic fountain, which is made from a mosaic of black granite and non-reflecting glass. The surrounding greenery underlines the various black shades of the mosaic structure and lightens what, at first glance, appears to be a black monolith. The colors of the terrace are black and white, if "colors" is the right word in this context. Black provides the accents and white is used for the larger areas. Black furniture stands on the white floor, but the items are mostly covered in white. The asymmetric oval tabletop is also white, and when seen from above it would merge into the floor covering were it not for the projecting black feet. All of the furniture was made so that it can remain

outside throughout the year. Everything has been thought through, both aesthetically and practically, down to the finest detail. The pergola over the dining table, for example, is technically very cleverly conceived: It has, of course, interior lighting and conceals a delicate steel frame for the vine to grow over. The only things which are noticeable are the infrared lamps which warm the guests on cool evenings. On sunny days you can wind over a cover which provides shade for a pleasant lunch on the roof terrace. At night the illuminated frosted-glass wall is like a sculpture and adds pleasant, indirect light. So you always know what you are eating without being blinded by a lamp. Everyone recognizes this problem when you are eating out in the open! It is no surprise that this terrace was awarded the 2007 Residential Design Honor Award by the American Society of Landscape Architects. The citation declared: "Beautifully resolved. It's simple, clean and calm, but with an effective profusion of plants. The details and furnishings are fabulous. It looks like it would be well-used and much appreciated."

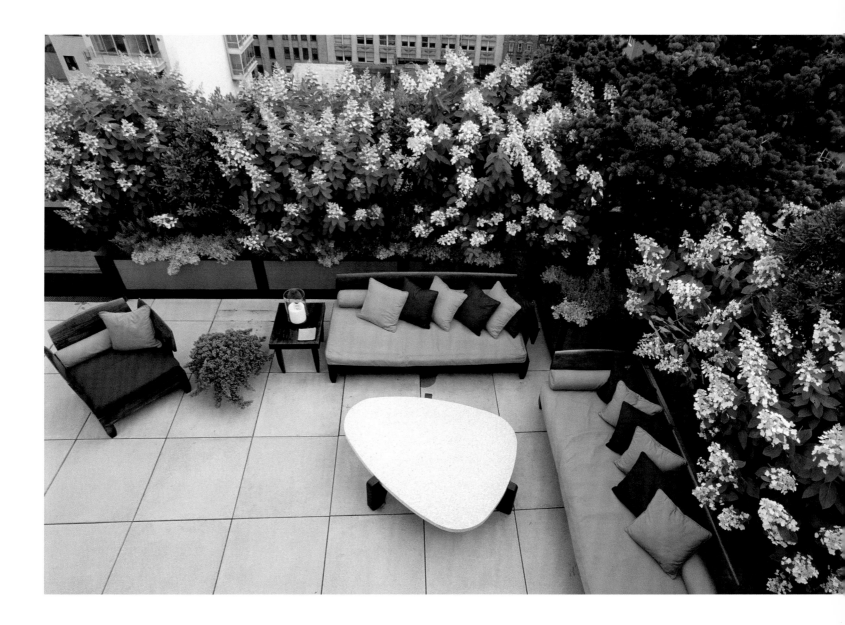

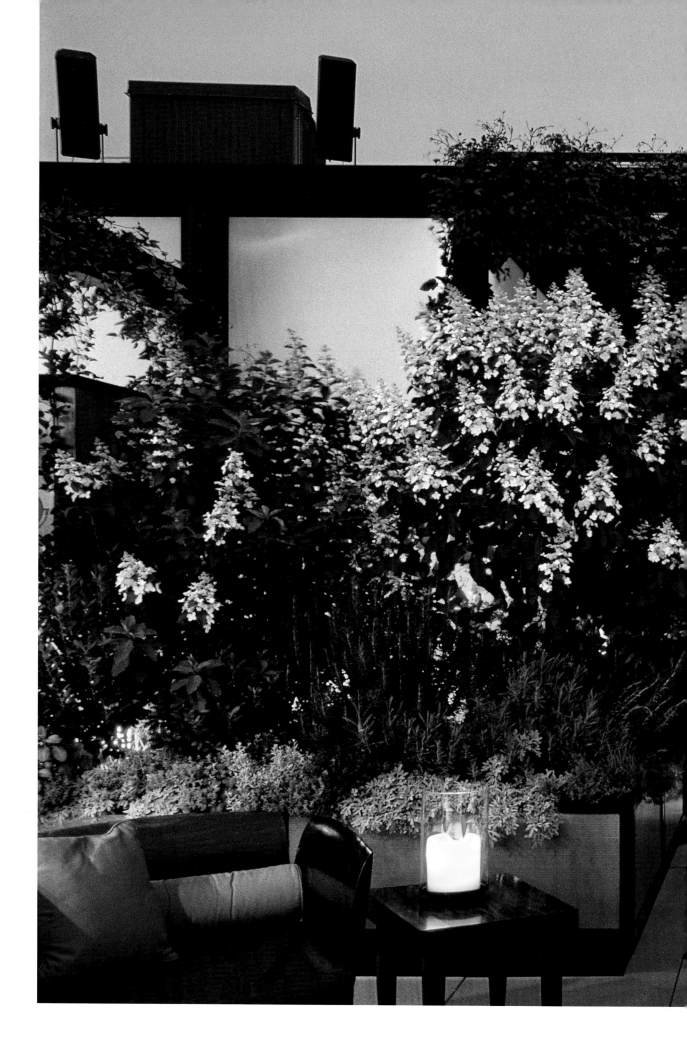

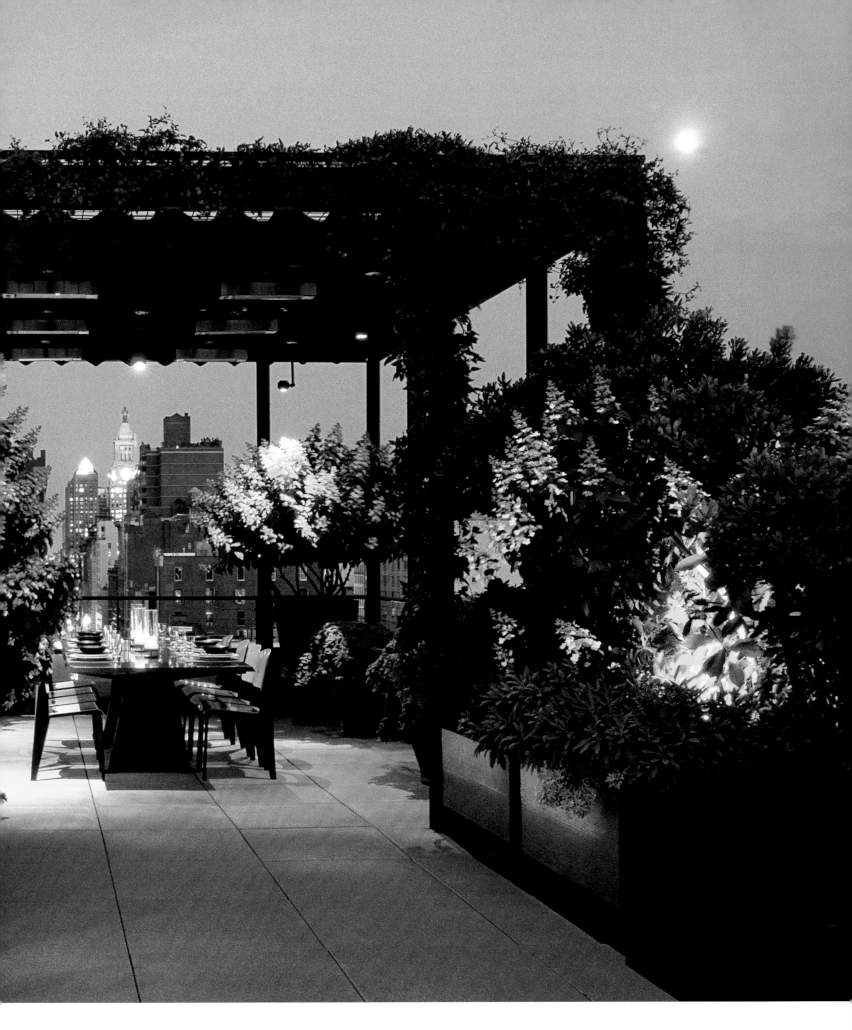

Scholars' Paradise

Dan Kiley (1912–2004), one of the most important landscape architects of the 20th century, must have been a very willful character: He was not at first exactly enthusiastic when he was asked to produce the master plan for the fourteen-acre Rockefeller University Campus in 1956. He was fully occupied with other projects, but in the end agreed to meet the university president, Dr. Detlev Bronk, for a few minutes. Kiley had already decided to turn down the commission, but then the two men found that they both shared similar ideas. After a meeting lasting five and a half hours, Kiley was thrilled by Bronk's vision of turning the university site into a place of retreat in which people would have the chance to experience the rhythm of nature. In these surroundings, the spirit and imagination would be encouraged to flower: For the president of a university dedicated to basic medical research, this was a truly original demand made of the interfaces between the institutes. The campus would be a playground of the Muses to match the research work being done in the laboratories and the clinical tests in the hospitals!

Dan Kiley took the commission, which was more or less finished two years later. The first university buildings were the Founder's Hall, built between 1904 and 1910, and a hospital for clinical research, which was the first of its kind in the United States. This was during the Beaux Arts period when it was normal to plant avenues; the university site had two, both of plane trees along the main entrance way and the north-south axis respectively. Dan Kiley was perfectly happy with the basic lineal structure. He divided the large lawn areas with hedges, trees and stone walls into rectangular garden rooms. Between the creation of the avenues and the 1950s, various new buildings had been erected and Dan Kiley took these into consideration in his design. The landscape architect's challenge was to combine the old and new buildings into a whole. He decided on a simple and elegant plan, based on the principles of symmetry, linearity and geometrical shapes. What sounds rather austere, in reality is of great lucidity, radiating serenity and peace. This is also due to the fact that Kiley limited himself to a narrow range when choosing materials and plants. The paths are of pale marble paving stones, lined on the main routes with white marble gravel. Under the avenue of trees he planted, in the main, dogwood, and andromeda. Parallel to the paths there are low box hedges. The areas behind these are planted with cherry laurels, spyrea and viburnums and between these, pink and white-flowering rhododendrons. The magnificent construction was financed by David Rockefeller, a self-confessed garden-lover and nephew of the founder of the Rockefeller Institute for Medical Research, as it was originally called. The clarity of the design suffered during the following decades, and in 1994 it was decided that the whole area should be restored. Lulu Leibel, who coordinates the work in the garden, says, "Our aim is to get as close to Dan Kiley's original design as possible while taking into consideration some factors which cannot be changed." For example, she cannot influence the microclimate or the

financial constraints. Even the time when you could employ a team of gardeners is long gone. However, the biggest problem is the shade from the increasingly dense leaf coverage of the plane trees. Light and shade were an important element in Dan Kiley's design, but because the trees have grown, they no longer come across as he intended. Lulu Leibel had to look for plants that were compatible with the changed light conditions. She decided on ivy and evergreens. The large lawns, which would not even be considered for a new design today, have to be kept, since they are an important part of the original design. Now that an automatic watering system has been installed, at least having to compete for water with the plane trees is no longer a problem. But the shade problem remains. Sculptures have been placed on some of the open lawn areas, for example

Homage to Piranesi I by the New York sculptor Herbert Ferber (1906-1991). Like a tangle of entwined metal bands it still comes across as linear and recalls the Italian architect, artist and visionary, Giovanni Battista Piranesi, who in the 18th century caused a furore with his views of the ruins of Ancient Rome and his grandiose phantasmagoria, *Carceri*.

In spring, when the crowns of the plane trees are still open and the pale green leaves start to sprout, the light is ideal for the white-flowering rhododendrons. They lie like buds of cotton on the formal lawns with their precisely cut edges. It is contrasts such as this which make the viewer aware of the game of ping-pong between nature and the art of gardening. Nature can unfold, but only as far as the next sharply cut edge. Universities also live by the ideas and creativity of their

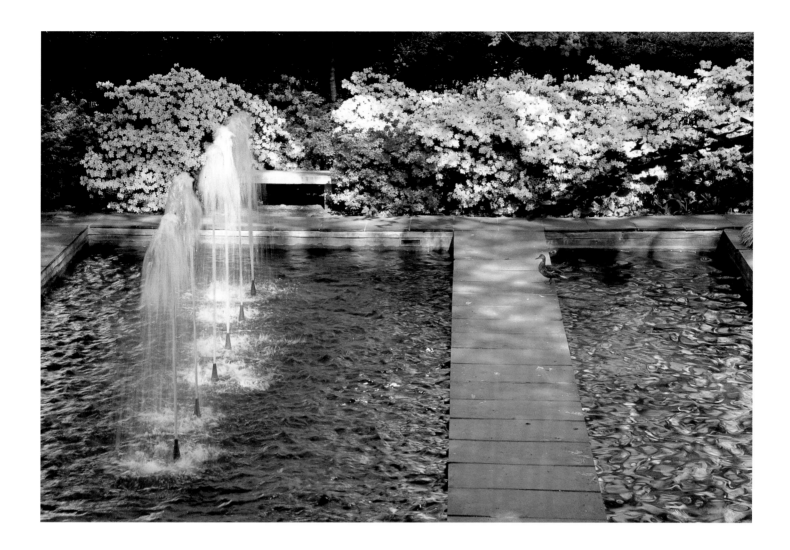

students, but the academic framework is strictly laid down. Dan Kiley's classic-modern ideals come close to the principles of the traditional Oriental garden. With his geometrical shapes and the element of water, Kiley went back to the Philosopher's Garden. In the rectangular water basins the fountains emerge in military formation. Between the basins there is a narrow causeway and when you walk along it, you can feel the spray. The babbling water is a sedative for eyes and ears alike, creating an atmosphere of meditation, cutting out all the noises of the city. It is an ideal place for relaxed contemplation and philosophizing. Immediately behind the sharp edges of the basins, red and pink rhododendron blooms flood the flower beds.

Another approach of the modern movement is the correspondence between interior and exterior which the architect Wallace Harrison and Dan Kiley solved in the Abby Aldrich Rockefeller Hall. The outside café is next to a transparent wall of the building. Two other walls with large rectangular openings provide a view of tall trees. On the pale paved ground, like an island, there is a circular, luxuriantly planted flower bed surrounded by a sort of balustrade. Close by on the lawn there is a sculpture made of filigree wheels titled *Continuità* by the Italian sculptor and painter, Ettore Colla (1899-1968).

On the other side of the building, directly in front of the wall, is the 1978 abstract bronze *Big Twist* by Bryan Hunt, who was born in Indiana in 1947. Against the ornamental shadows of the leaves on the pale wall, this sculpture itself looks like a silhouette.

Dan Kiley's atrium garden for the president's house, designed by the architects Harrison & Abramowitz and

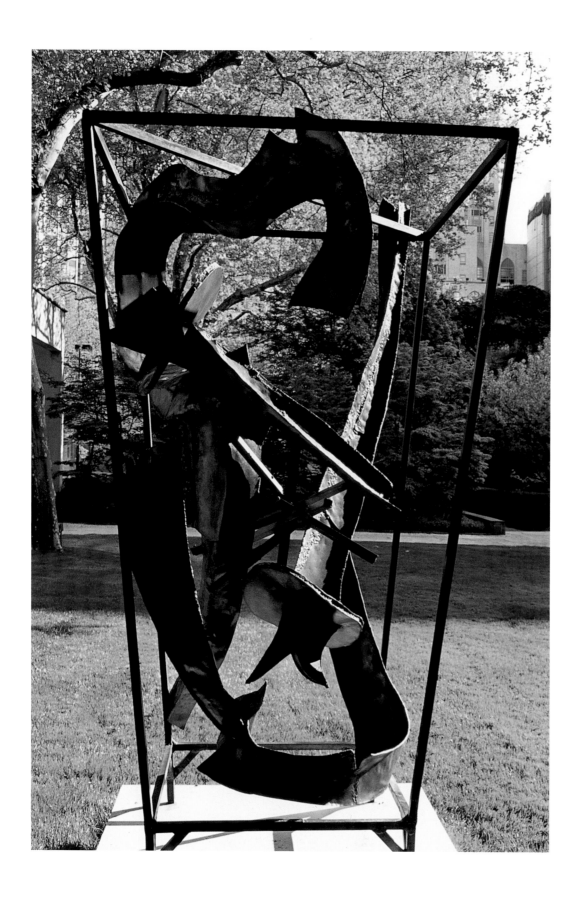

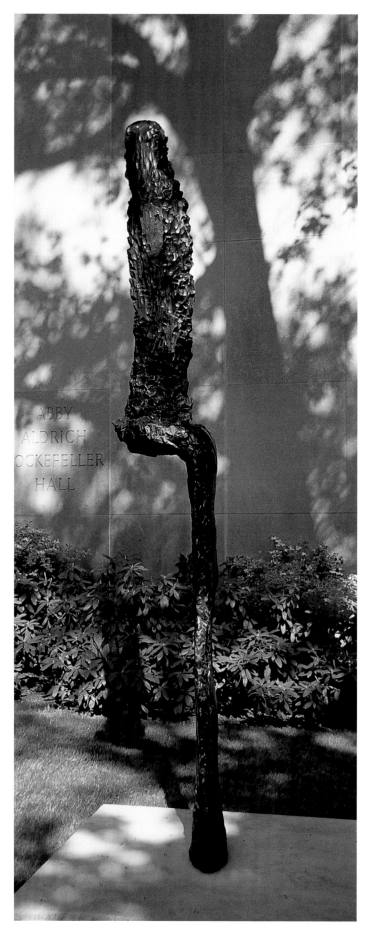

124

built in 1958, is a work of art in itself. This is one of Lulu
Leibel's favorite places on campus, because she consid-
ers the proportions to be absolutely perfect in their ra-
diation of tranquility and harmony. The surrounding
planting is reticent, as is everything in this place, and
consists of evergreens and dwarf hyacinths. The mag-
nolia in the middle is from Dan Kiley's original design.

Nothing is so subject to the principle of change as a
garden. It requires a great deal of circumspection and
sensitivity to maintain the individuality of the Rocke-
feller University campus and yet to allow it the freedom
which keeps it alive. Lulu Leibel is aware of this chal-
lenge, and does it more than justice, since the garden
still maintains a charisma to match Dan Kiley's inten-
tions.

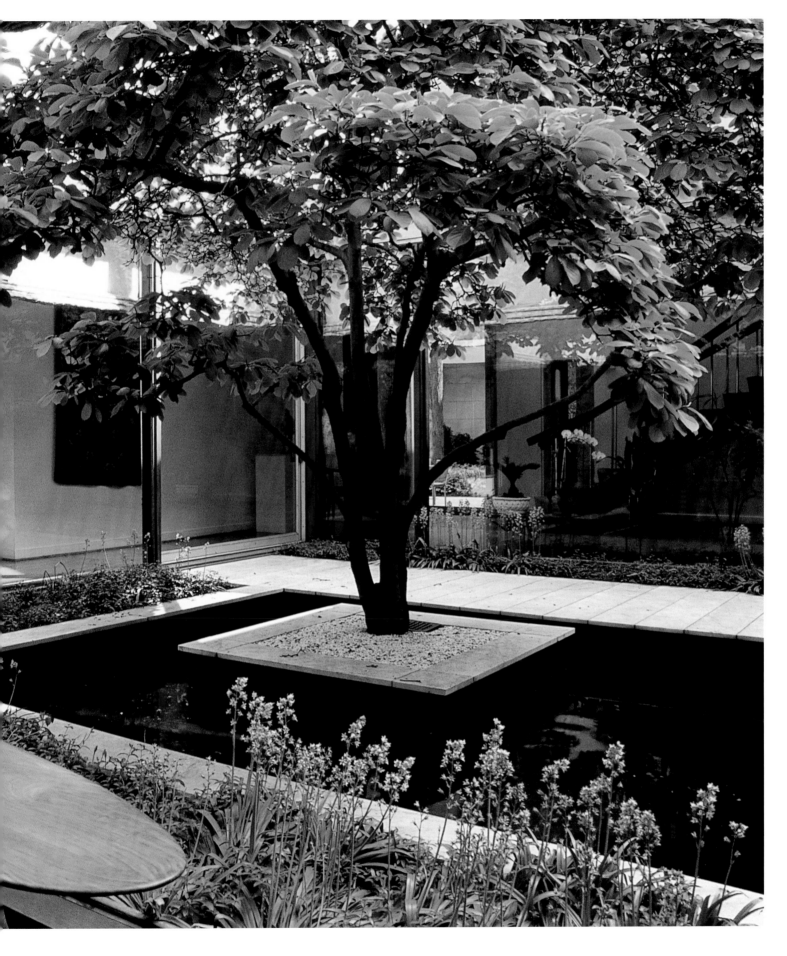

Island of Flowers in a Sea of Buildings

Peter Schulze und Bruce L. Smithwick's roof garden epitomizes one thing above all: the delight in flowers in all their colors. Measuring fifteen hundred square feet on the roof of an eight-story building in Chelsea, this garden is enormous for New York. A sea of pots covers the floor tiles and if you ask how many there are, the answer is that there are too many to count. If you had to water them it would take you several hours a day. Even so, a certain time each day must be devoted to the care of the plants. It is a puzzle how the automatic watering system serves every individual plant pot, no matter how small. Before the owners bought the loft in 1981, they lived in a brownstone in Greenwich Village, which they renovated over a period of seven years. The house did not have a garden, but an outside staircase led up to the roof. This was very important, since without these stairs, carrying plants, pots, earth and furniture would have been extremely laborious and difficult. Peter and Bruce made use of these stairs and created a garden. When everything was finished, they decided to move to a loft in Chelsea with a private roof. The terrace is divided into three areas: the main area with a tent roof shading the dining table, a small garden to the side and a working area with a plant table. A wooden fence hides them from the neighboring houses. The more sensitive plants, such as the palms, spend the winter in a glasshouse. In summer the cacti love the warmth behind glass. When the weather is fine Peter and Bruce spend the months between spring and fall on the terrace. They often invite friends over and together they enjoy New York's glittering skyline accompanied by a glass of wine. Many New Yorkers have a house in the country, but for Peter and Bruce their flower terrace over the roofs of Chelsea is their country house in the city.

Even though the roof garden is filled with hundreds of plants and fully grown trees such as maples, Colorado spruces and a thuja, the location is still very urban. They have not attempted to conceal the outside world and hide themselves in a colorful cocoon of flowers. It is like being on a flowering island in the middle of a sea of brick, stone and concrete, with views of the Empire State and Chrysler Buildings. Seen in this way, it is a very authentic and pleasant New York roof terrace that is quite simply integrated into the city with supreme assurance. The sculptures, accessories and other objects are mementos of trips along the East Coast or journeys to Asia or Europe. Peter Schulze was born in Hamburg and went to New York when he was twenty with the intention of going to college. But his planned return a year later did not materialize. He put down roots in Manhattan. His father had already given him part of the family garden, which he was allowed to design on his own. When he arrived in the States he had to abandon his love of gardens for a few years. He was only able to develop his love of gardening on the roof of the house in Greenwich Village; since 1981 and the move to the roof terrace in Chelsea, he has been able to spread his wings.

Peter Schulze and Bruce L. Smithwick are fortunate that the Greenmarket on Union Square is close by.

Since 1976, on every Monday, Wednesday, Friday and Saturday more than 140 farmers and gardeners from the region have come to the weekly market, which is now the largest of all such (now numerous) markets in New York. It sells fruit, vegetables, plants and flowers. It is a lively world with colorful goods which every week attracts a quarter of a million visitors. "New York goes green" is a new slogan and almost nowhere else do the New Yorkers prove how green their interests are. Peter and Bruce come here to buy plants which have to be re-placed every year. Those perennials which have not survived the winter are also bought here: lilacs, forsythias, rhododendrons, climbing roses, wisterias and many more. The best thing about this market is that the plants which are for sale are sure to thrive in New York, because they began life here. Obviously, on a market such as this the temptation is great to try out new species all the time; and so it is that Peter and Bruce add to the array of plants on their roof terrace every year.

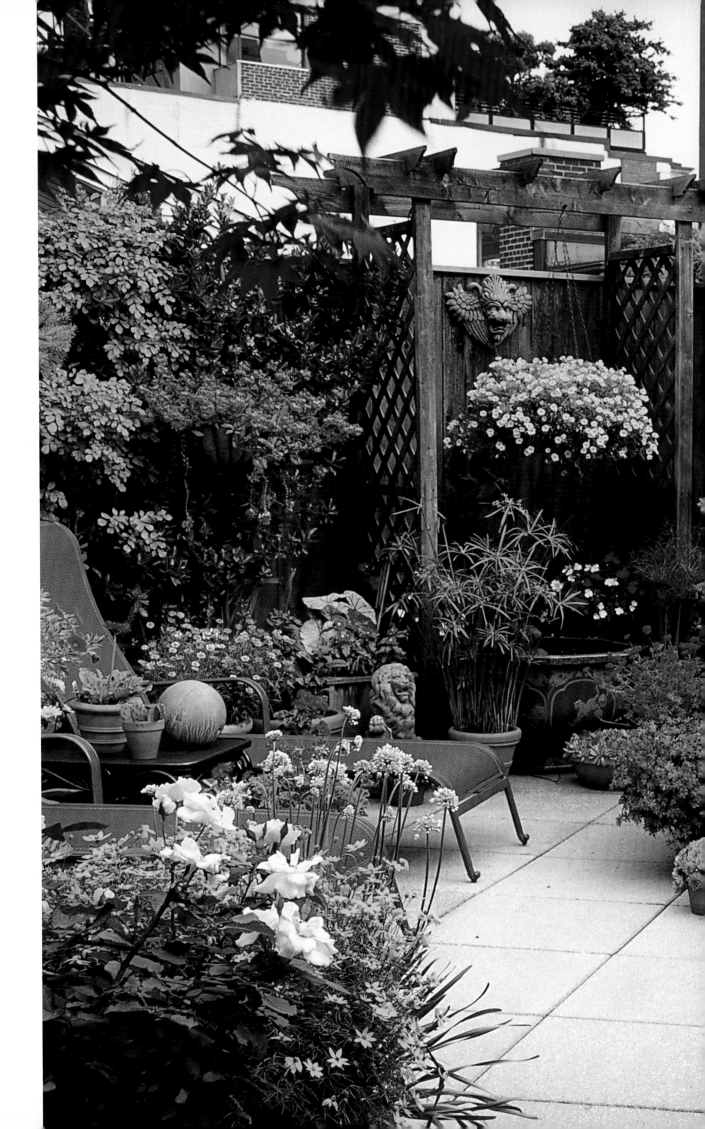

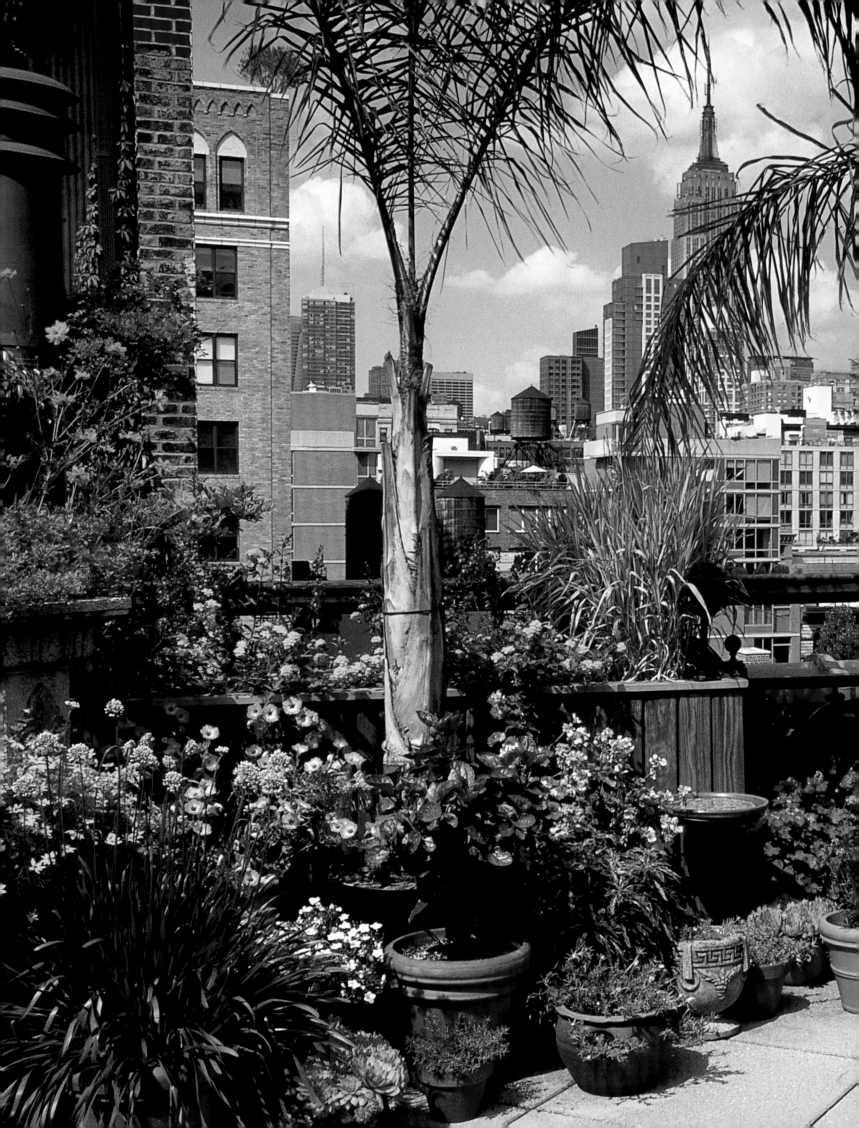

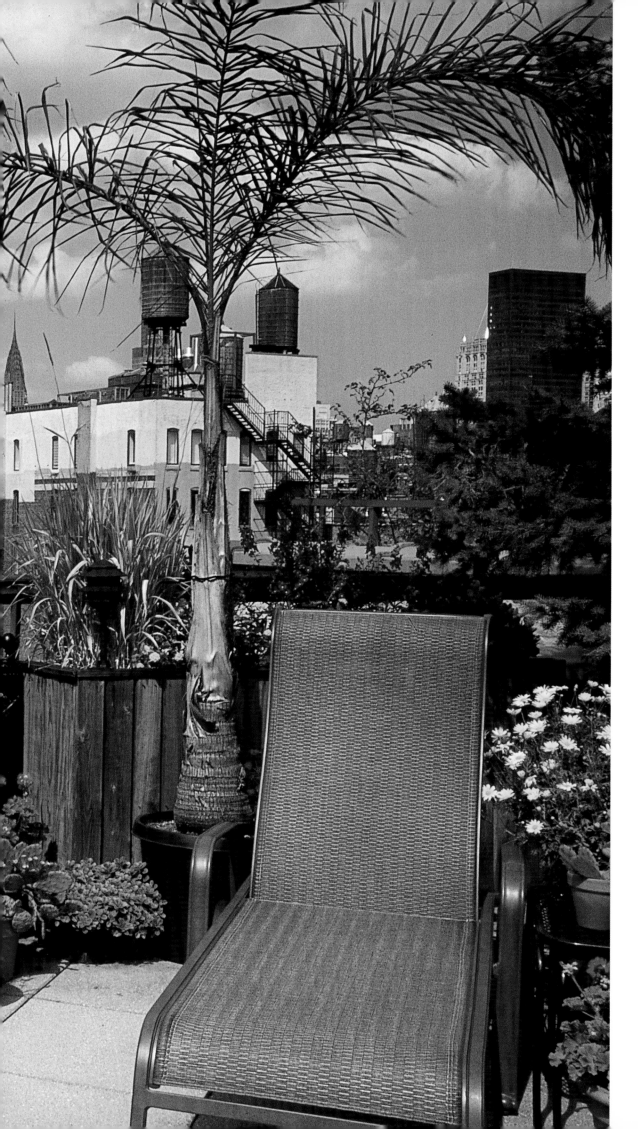

Jewel in Central Park

Calvert Vaux (1824-1895) said that Central Park was a translation of the democratic ideal into trees and earth. Vaux and Frederick Law Olmsted (1822-1903) together designed what is doubtless the most famous park in the world and completed it in 1873. Their aim was to give the city a natural retreat, and they combined this with political ideals; for according to their ideas of democracy, rich and poor, educated and less educated people of all classes, regardless of their origins or incomes, should be able to meet there.

The phrase "the city's green lung" is not modern, but was first used by Olmsted. At that time, residents of the city had to recuperate from heavily polluted industrial air and from their hard physical labor; these days people sit too long in front of their screens and are glad to stroll through the park and breathe comparatively fresh air.

Sometimes, even New Yorkers are unaware that there is a beautiful, classically designed garden in Central Park: the Conservatory Garden. The name comes from the glasshouses which stood in Central Park around 1900 and were used to cultivate flowers and shrubs for public parks. When the maintenance costs could no longer be met, the glasshouses were demolished and in 1937 the garden planted to a design by Betty Sprout and Gilmore Clarke. This garden existed until the 1960s, when it fell into a Sleeping Beauty slumber for more than twenty years.

The *Vanderbilt Gate*, a splendid wrought-iron gate made in Paris and dating from 1894, stands at the north-

ern entrance to the park at the junction of 105th Street and Fifth Avenue, the interface between Manhattan and Harlem. The garden provides a few New Yorkers with an opportunity for particularly healthy exercise: They work there as volunteers, helping to maintain a continuously changing panoply and to keep it spruce, which would otherwise not be affordable. Olmsted and Vaux would have been happy to see their social ideals implemented thus. The volunteers are housewives, retirees, lawyers, nurses, artists and unemployed people. They are all united in their love of the garden, and they all consider it a privilege to be able to contribute to the beauty of the Conservatory Garden. There is a lot to be done in the three sections which together cover about an acre. Every spring a veritable sea of tulips blooms in the north garden; the bulbs are planted during a few days in the fall. Every year more than 45,000 new spring bulbs are bought, to ensure that they flower at the same time and attain the same height. The tulips bulbs from the previous year go into the Community Gardens, which are spread throughout the city. At the center of this carpet of tulips is the Art Nouveau fountain *Three Dancing Girls* by the German sculptor Walter Schott. As late as the 1980s, the lighthearted aspect of the carefree dancing girls seemed a blatant contradiction to what was really happening here: The drug scene had become established in the area. No one who was not involved ventured into the seamy garden. For New Yorkers, this part of Central Park became a no-go area. Now, every year in May, it is the location of one of the

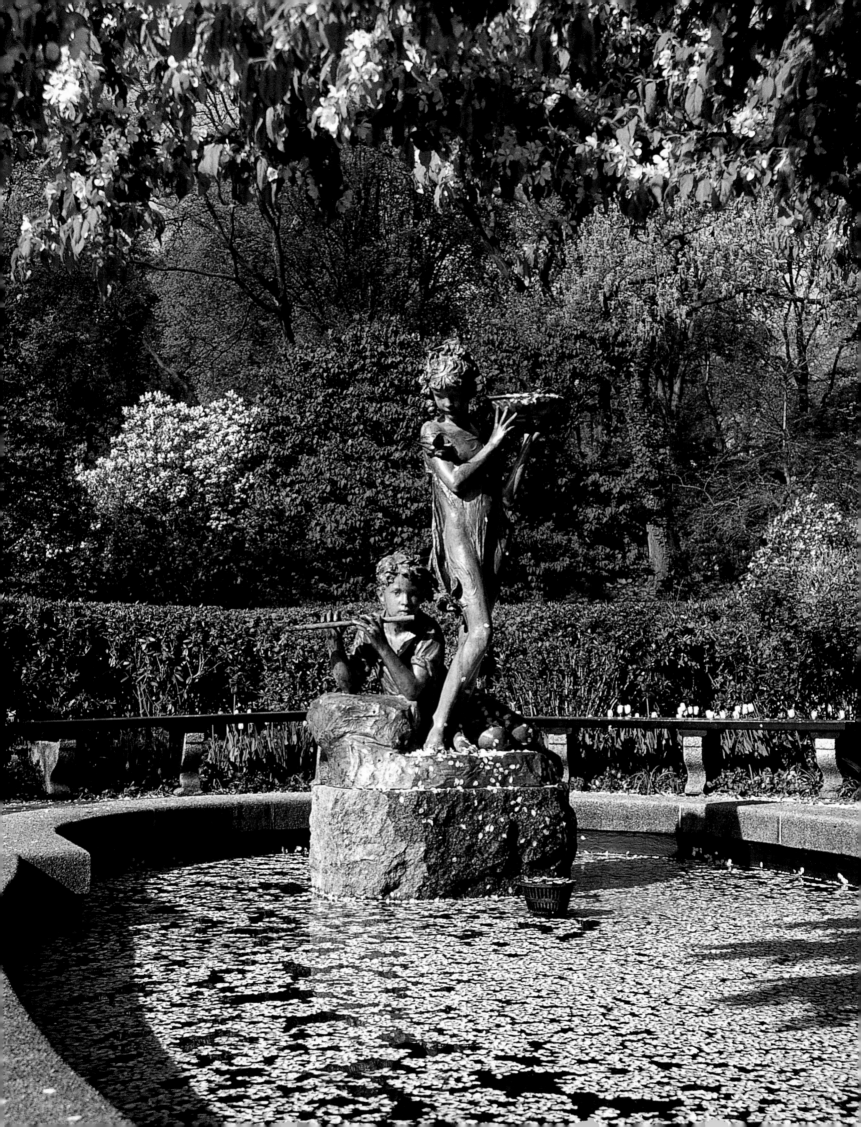

chicest charity events in the city, the Hat Luncheon. The decoration of the ladies' hats is inspired by the magnificent blooms in the Conservatory Garden. Twelve hundred hats in all colors, shapes and sizes ripple through the sea of spring flowers. Every year, at the beginning of May, Betsy Messerschmitt and the Women's Committee of the Central Park Conservancy invite illustrious guests to the garden, and they do not just eat together, but also make donations. In 2009 they collected more than two million dollars for educational programs, as well as the upkeep and care of the plants in the whole of Central Park. Every year the *New York Times* reports on this event and the guest list reads like an extract from the New York *Who's Who?*. Even the mayor keeps his appointment diary free.

Twenty years ago, New York was one of the most dangerous cities in the world, and no one would have thought of investing even one cent in a neglected public garden. Well, almost no one. The landscape gardener Lynden B. Miller was asked by a friend, who was working on the restoration of Central Park, if she would be interested in the restoration of the Conservatory Garden. Miller knew a lot about gardens, but at the time was working as a painter and found the idea absurd. However, she became curious and decided to take a look. The garden was neglected and full of garbage, but she could see its potential. She took photographs of the most beautiful English and French gardens, and with these she attracted sponsors, in spite of the considerable skepticism about a restoration project bordering on the challenging district of Harlem. How-

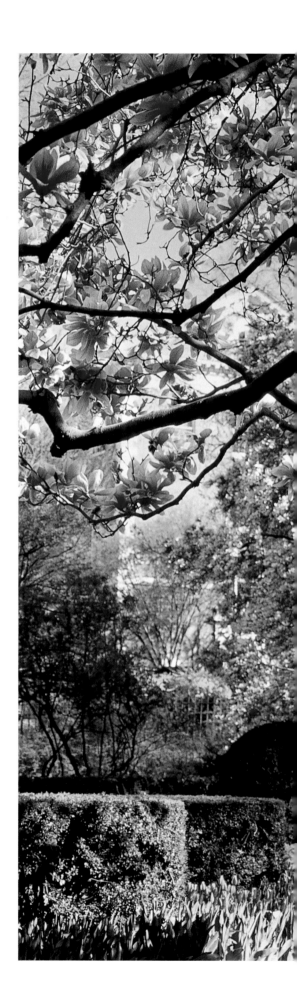

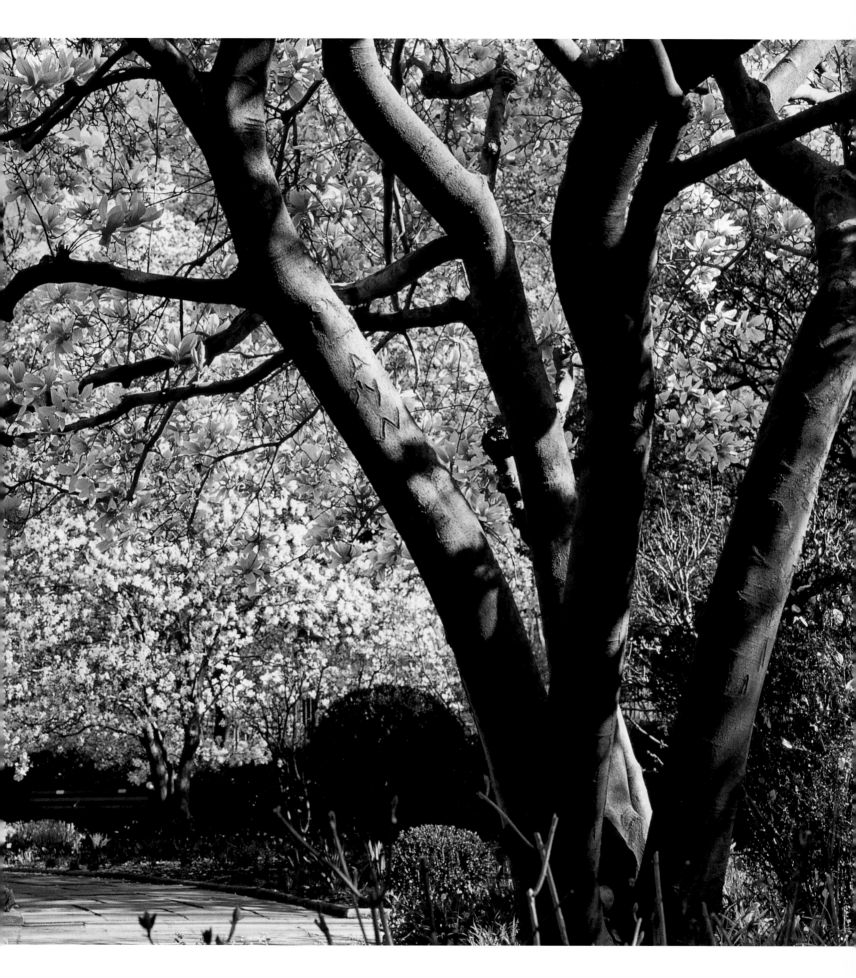

ever, Miller's optimism proved to be correct. "When a public garden is beautiful, then people have the feeling that their city is doing something for them and they are more content. All of us profit from this." Since the Conservatory Garden has been restored, crime has disappeared. The park is populated by strollers and people enjoying their leisure in this atmosphere. The shady magnolia avenues are particularly favored by readers. The central garden is distinguished by its formally clipped hedges and being in the Italian style is all green, except for the mauve spring flowers of the wisterias which grow over a rounded pergola. Very often the fountain at the foot of the pergola takes on all the colors of the rainbow.

It is now an accepted fact that fine public gardens contribute to social cohesion. Lynden B. Miller has helped to revive many neglected areas of the city by planting gardens and parks in such a grand manner "as though they were intended for kings," as she says herself. Since a garden is a living organism, it does not help much to have money only for restoration. The Conservatory Garden was lucky in that it found a patron who makes sure that the garden can be continuously maintained. There are full-time gardeners, and in the background there are the planners and, not least, the volunteers. Every Tuesday, on the dot of nine o'clock in the morning, they meet the gardeners, who tell them what work has to be done and assign the tasks. For more than

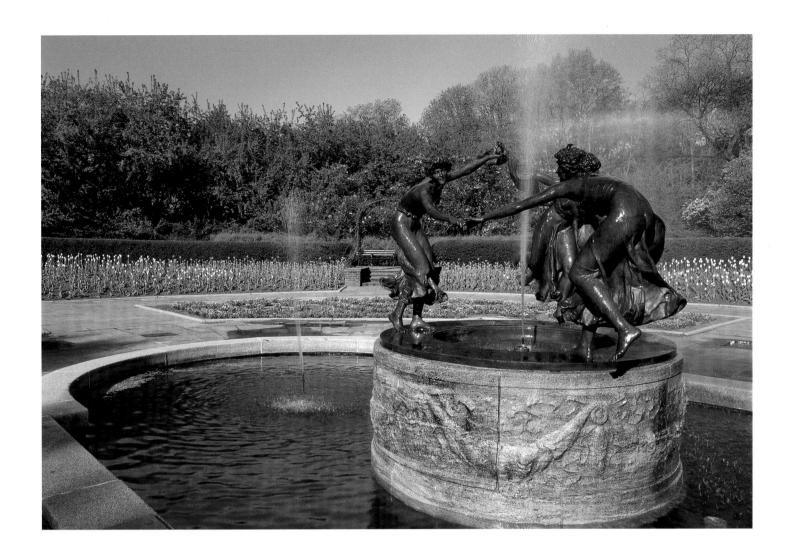

ten years, Nancy has come every Tuesday. This time she is going to prune the roses in the Secret Garden, which takes its name from the fountain sculpted by Bessie Potter-Vonnoh in 1936. It represents the two main characters, Mary and Dickon, of the children's book of the same name by Frances Hodgson Burnett, which is about the healing power of gardens. The fountain is a part of the lily pond and when the surface of the water is covered in flowers, this corner is one of the most romantic in the whole of the garden. The southern part is the least formal area of the garden, whose beds Miller has planted in the English manner, with lavish herbaceous perennials so flowers bloom throughout the year. Many are aware of what this means for the city and its

social framework. As Nancy says, "New York is a city in which it is easy to feel isolated and marginalized, but there are places such as this, where you can meet other New Yorkers and make contacts. That is fantastic in New York, when you consider how different we all are and yet we can still find common ground, and here we are lucky that this common ground is so beautiful." How happy Olmsted and Vaux would be if they knew that the seeds of democracy which they sowed in Central Park more than 130 years ago had come to fruition thus.

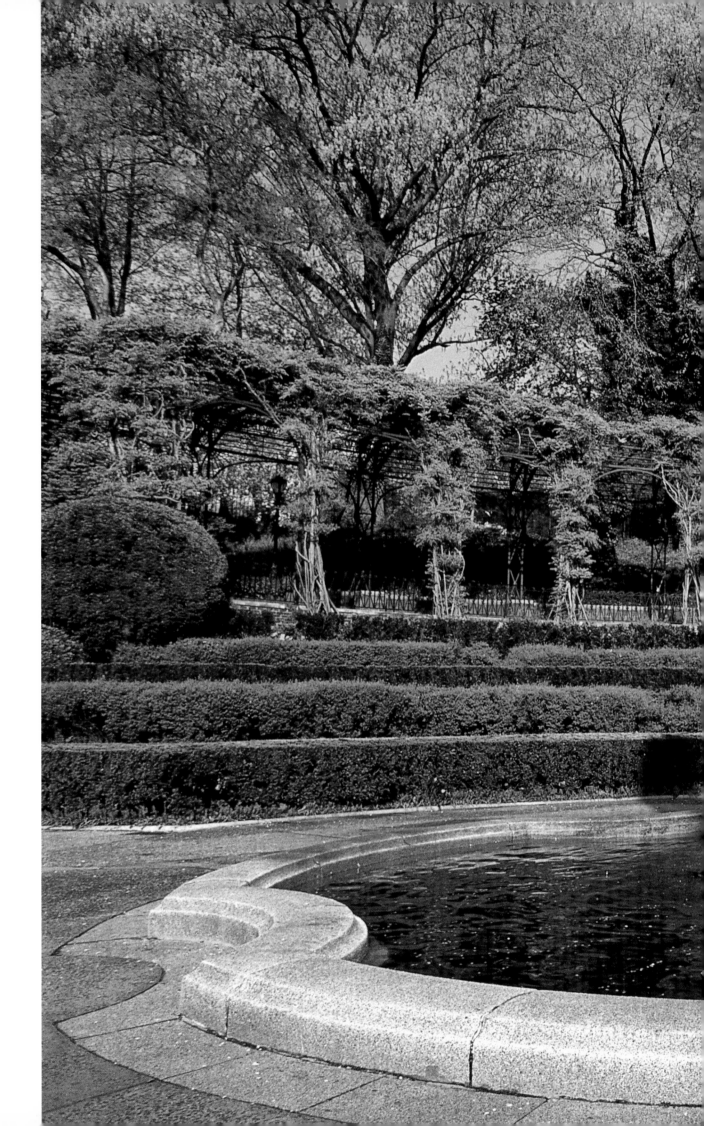

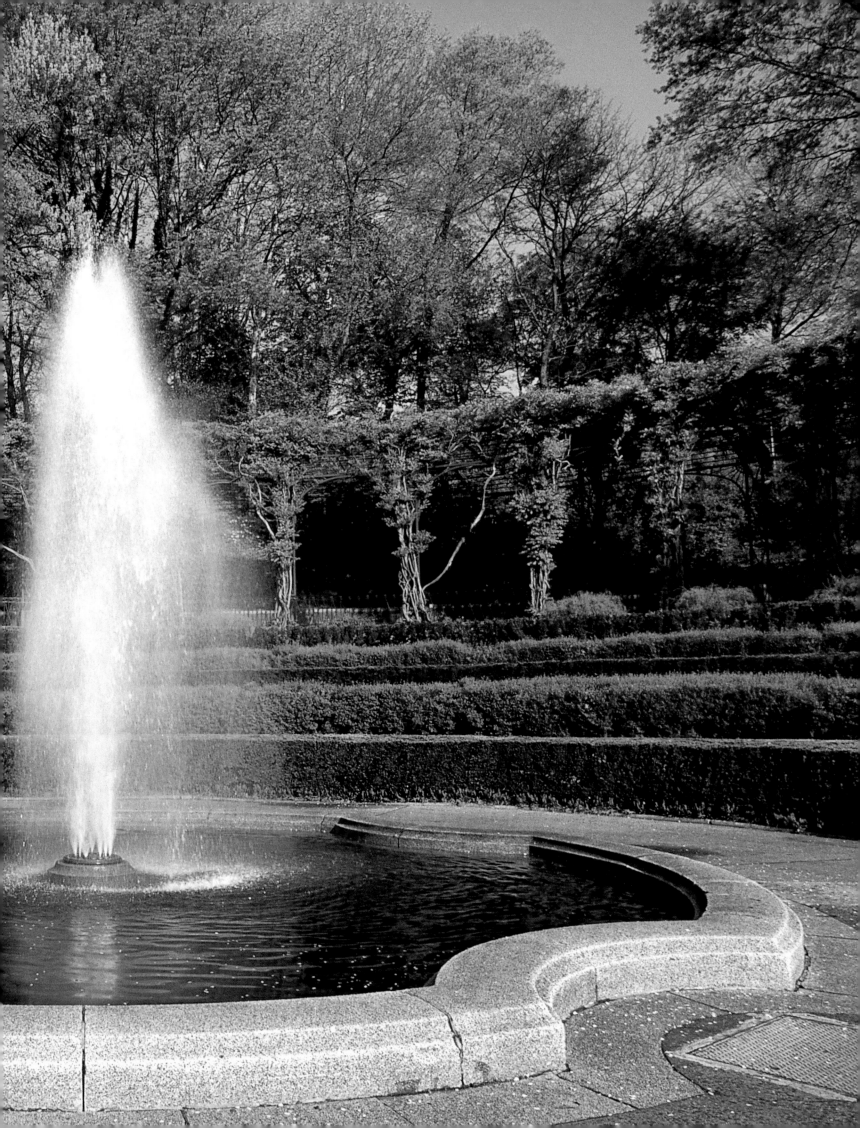

Madison Avenue/Manhattan:

Where Realtors Take a Break

Even roof gardens have weight problems which no dietary adviser can solve: Distributing ninety-eight tons of material on the roof of the real estate company was an enormous engineering feat. The design had to take account of how much weight the roof could support and at which locations. Over a period of six months, construction material was taken up to the twelfth floor using the service elevator, and there used to create a terrace with an area of about 5,000 square feet. It all began when David Michonski, the company's boss, complained to David McAlpin, an architect, that he was fed up with just looking out of the window and seeing ugly tar paper. That is the normal view in Manhattan and the office is in the middle of Manhattan, at the corner of Madison Avenue and 56th Street, the shopping and financial district. The contrast between the friendly

atmosphere in the offices with their modern furniture in pale wood and the black areas outside could not have been greater.

David McAlpin designed the whole interior, including carpets, tables and chairs, from recycled material. The light green tinted glass is intended to smooth out the difference between interior and exterior. At some point, David Michonski says, he discussed with the architect the possibility of building a roof terrace. Since it was not possible to reconstruct the roof, the most important problem was how to distribute the weight on the existing roof. The planning alone took seven months. The trees, for example, were placed according to purely structural considerations. Even the network of paths follows structural necessity. Large angular stones have been placed so that one is encouraged to stay on the path, ensuring that the weight distribution remains within the prescribed limits. Of course this theme also played a role when choosing the furniture. The plastic plant troughs have to be heavy enough to withstand the wind and as light as possible to conform to the weight limits of the roof, and this also applies to the light steel furniture. It was decided that bright colors should be used to contrast with the gray of the city. David Michonski says, "The terrace should make people smile. If you look out of the window in New York, everything is gray, and the colors which you see are not exactly inspiring."

Plants were chosen for their year-round green. Azaleas bloom in spring and for the rest of the year there are

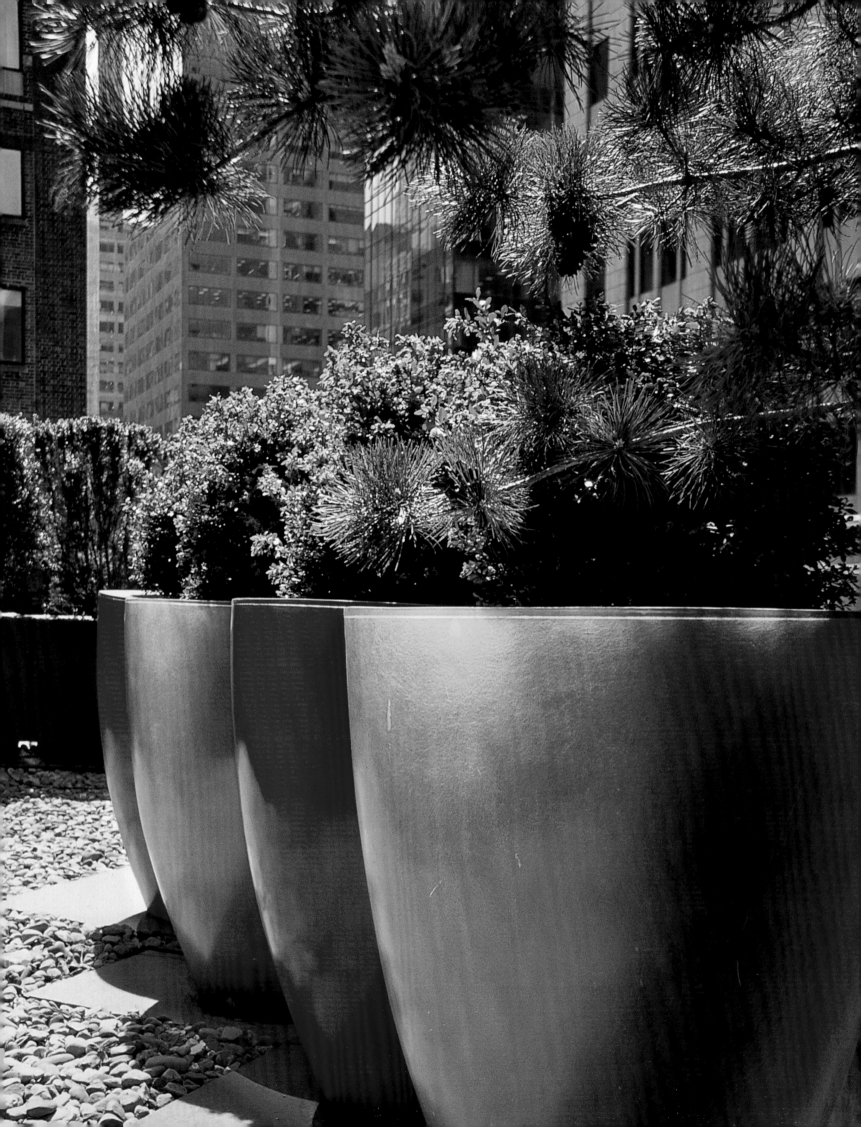

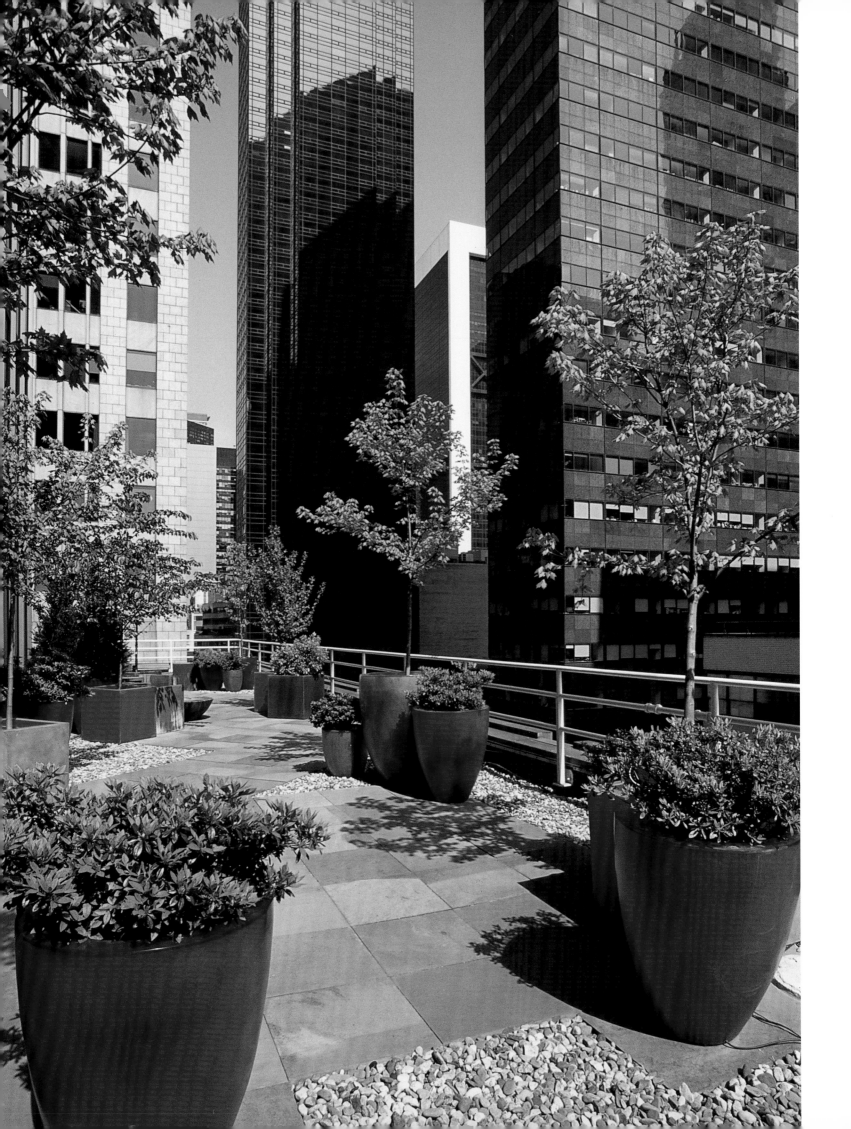

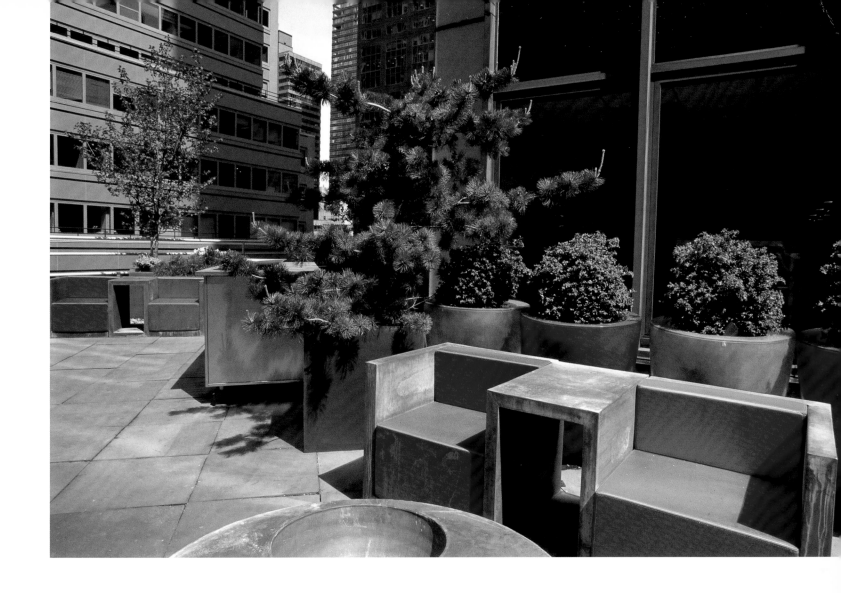

boxwood and conifers. The terrace is used by employees who take their midday break there. Realtors organize evening receptions on the terrace and impress their clients with the glittering Manhattan skyline. The trees are lit from below so that they radiate a romantic and cheerful atmosphere between the brightly colored plant containers. The terrace can also be rented for birthdays and other celebrations, although the load on the roof terrace must not exceed a certain weight. As David Michonski says, the space is designed for a maximum of two hundred people, or there could be weight problems on the terrace, too.

Nostalgia in Pastel

When talking about Pamela Scurry's roof garden on Fifth Avenue, you cannot talk about a definite design. It is more a vision, a life concept. The first glance makes it clear that here beauty means everything. Scurry's favorite word is "pretty." The definition of beauty may well be a question of taste, but for the owner of the garden it means soft shapes, warm colors and creating harmony in all its details. She categorically rejects all hard edges and sharp contrasts. If she could choose an era in which to live, she would choose the 19th century and in art the Impressionists. Her garden looks like a painting which she paints again every year. She takes her main inspiration in New York from the nearby Conservatory Garden.

The location of this Penthouse Garden could not be more romantic: Over the fence there is a view of the Reservoir at the north end of Central Park. The garden, which is about 800 square feet in area, seems much larger because of the water feature. As in an English cottage garden, brick walls are used to effect, for example as the foundation for the surrounding wire-mesh fence. This was a discovery made during a journey into the Midwest, but Pamela Scurry had it painted to fit in with her taste. The connecting pieces and the points shine in a reddish gold and the fence, while black, has a touch of dark green so that the contrast is not too harsh. Every color nuance is important. The noble reproduction garden furniture is painted a dark black-green rather than the pure black of the English or French originals. Although Pamela Scurry is deeply inspired by the classical

English and French styles, she still makes her own decisions on the details. Every accessory, every flower and every pot tells a story about a place she has visited. It could be a flea market in Paris or an antique shop in Massachusetts. She counts herself lucky that she has been able to make her passion her profession. In New York she has a store selling accessories for interior decoration and furniture. Sometimes, when she is driving past an antique shop, she gets the feeling that she must go in. When she gets this feeling it is inevitable that she will find at least something that pleases her. Pamela Scurry likes beautiful things, but above all has to arrange these things so as to bring out their true value. Visitors often praise her garden as a whole, but very few realize how much detailed work has gone into the complete picture. Take the two terracotta urns by the fence, for example. Their warm color corresponds to the color of the building across the lake. The pale apricot was also used for the wall fountains and the cherubs seated below. When the Scurrys bought the penthouse in 1976 the shell-shaped basins and the wall fountains were in a very poor condition. They repaired the walls and restored the fountain. The box trees on either side are in planters, while the white gypsophila planted beneath them accentuates the romantic character.

On one side of the garden the backcloth is made up of gray high-rise buildings. Pamela Scurry's answer to this vertical picture was to plant an apple tree and a cherry tree. Between these she has planted mint and

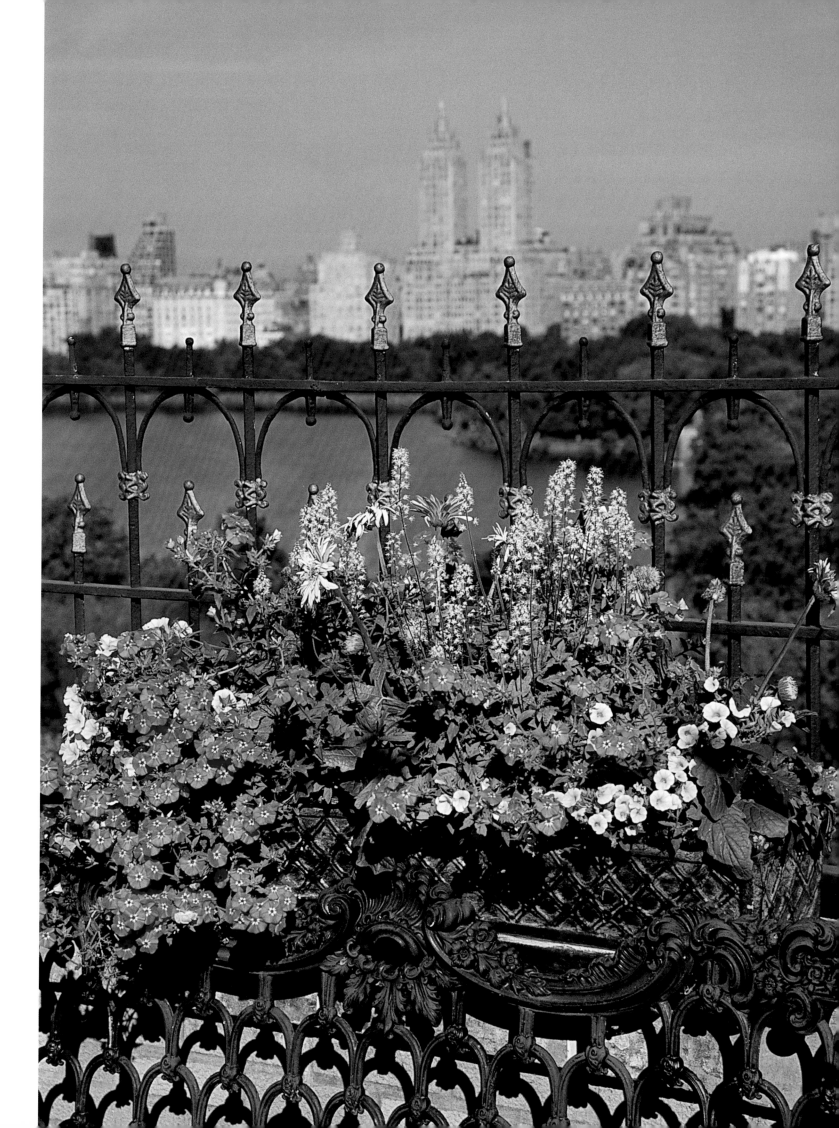

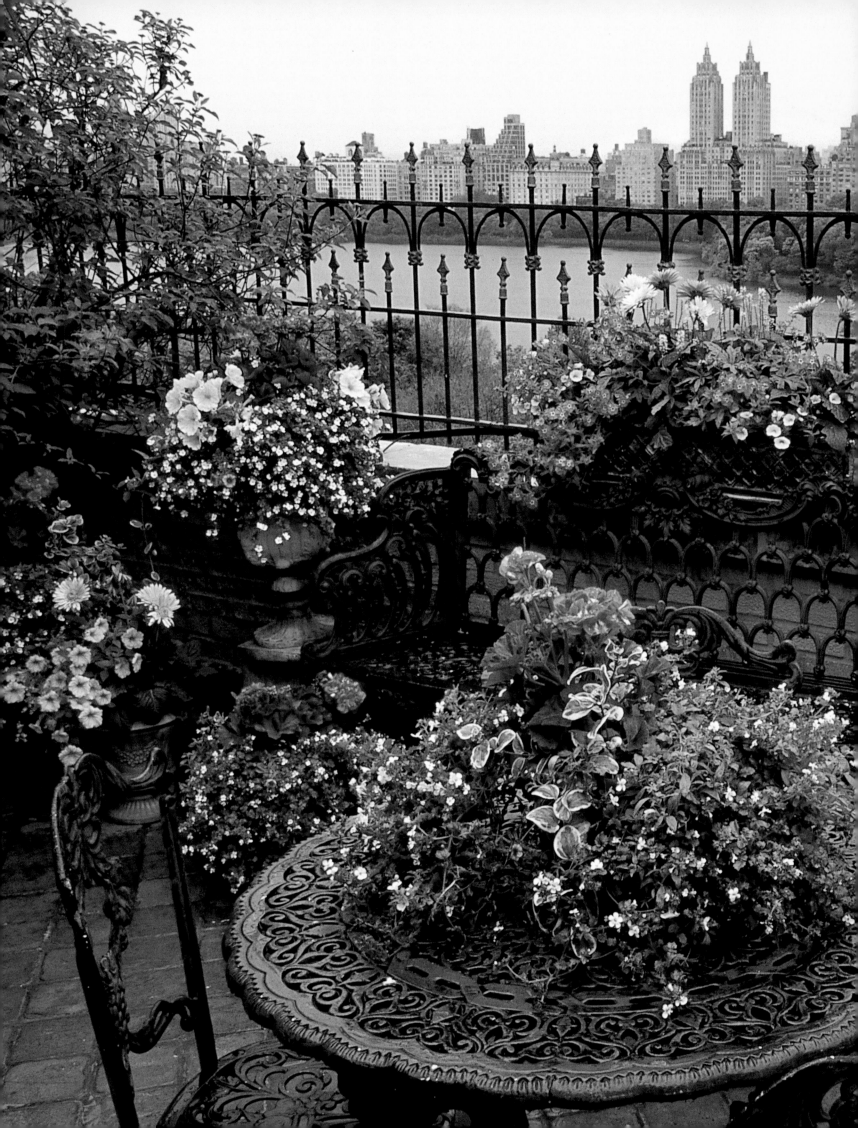

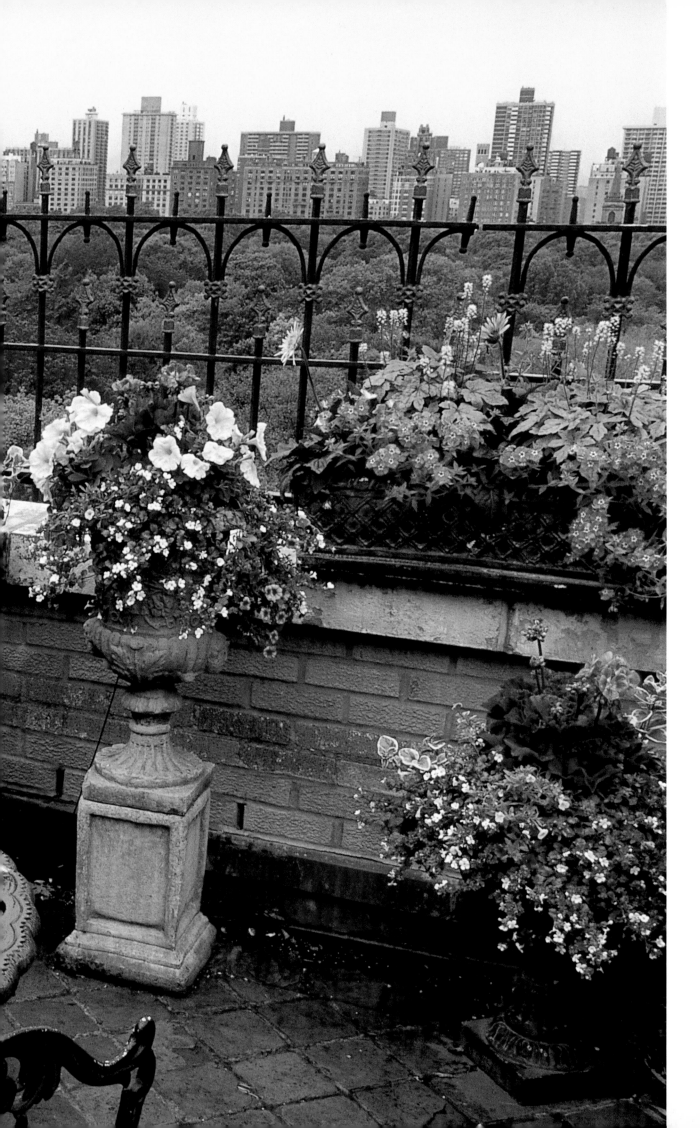

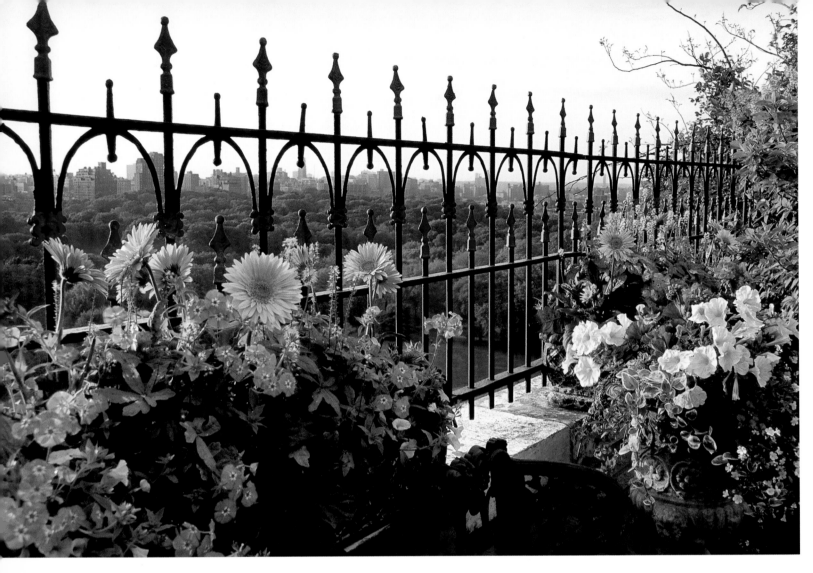

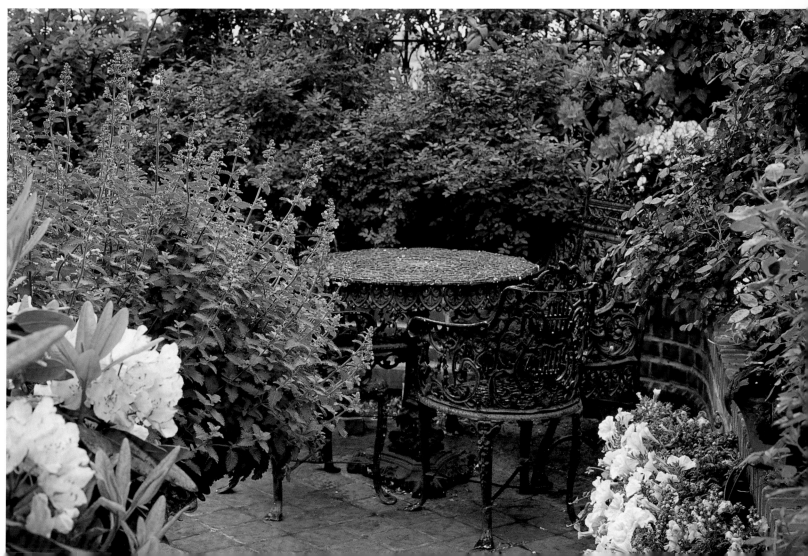

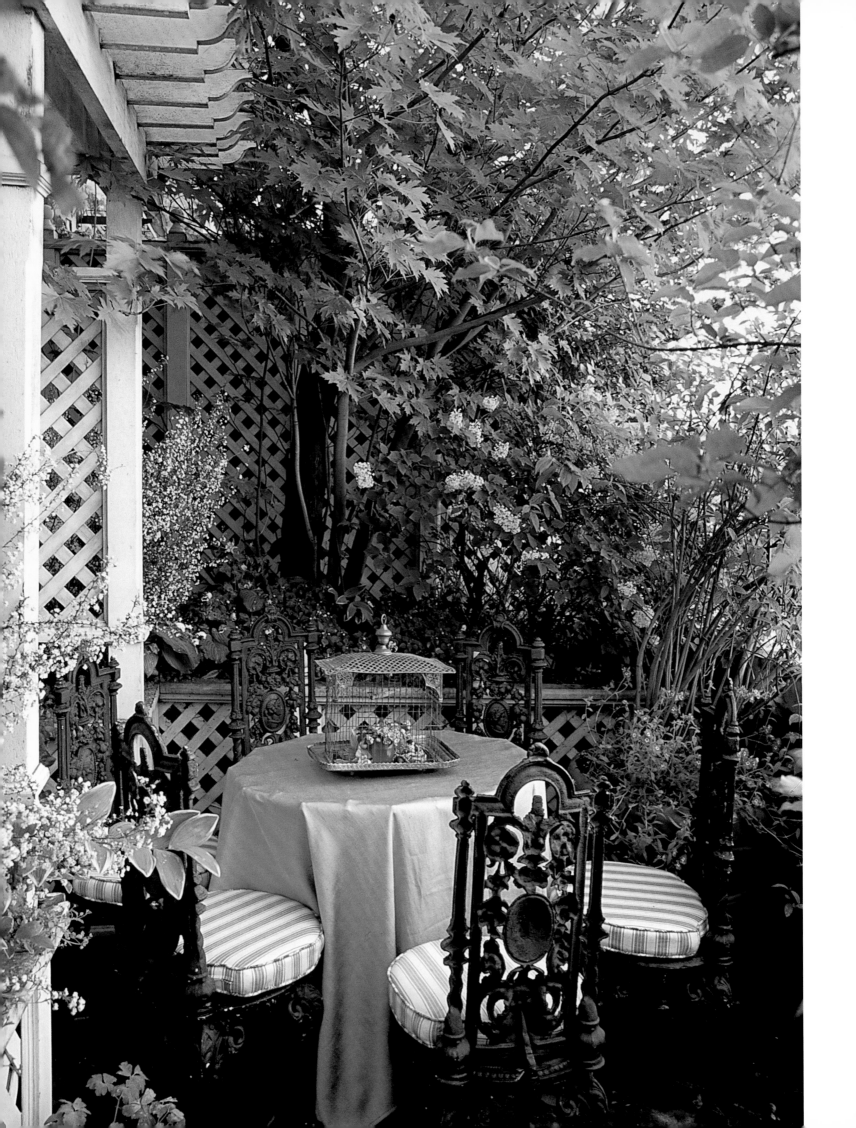

hydrangeas, both flowering pale mauve. Now the high-rise buildings appear to be a continuation of the field of blue and no longer stand there like foreign bodies. The garden rooms are on the same level on the sixteenth floor, but the planting is on different levels. Metal troughs stand on the floor, and there is a raised flower bed, abundantly planted with hanging and climbing plants such as ivy. Frames, raised on feet, furnish the garden. The ledges of the surrounding walls, planted with creamy apricot and pale yellow asters, garnish the view over Central Park. The garden furniture is made of curved metal ornaments. It is futile to look for a sober, clear line unless you accept the round table as such. And should this idyll not be enough, then there is a place which Scurry calls her Secret Garden. This is a group of seats with comfortable cushions, in front of a small white wood alcove, shaded by a maple tree. The striped material was bought at a flea market in Paris. The birdcage on the table found its way here from Italy and of course is filled with a flower arrangement.

In New York the garden owner is famous for her decorative skills, which are displayed to perfection in magazines. She is happy to reveal her tricks about how to make a garden party successful. You should not shy away from using valuable crockery in the open. Glass is particularly spectacular because it glints so well in sunshine. She likes to use various shapes of coffee pots for vases. She like to serve tarts and fancy cakes on raised plates, and the key is that she combines the shape and color of the cakes with those of the decoration and the plate. A tip for hostesses: Leave the baking to the professionals so that you can concentrate on the most important factor, decoration! On normal days the Scurrys usually use their garden in the evening, when daylight is disappearing and the first lights of the skyscrapers are beginning to gleam. This is why the choice of colors is so important to Pamela Scurry: She wants to see and enjoy them at dusk and when it is dark, and this is why she chooses her plants in light, soft, creamy tones. She talks about yellow chiffon, pale, faded lavender blue, creamy beige and soft pink. Should she need more stri-

dent flower colors, then she chooses plants which have a cream-toned center. The rose is her favorite plant, but hydrangeas, geraniums, gardenias and jasmine are also welcome. You have to understand the color concept as a continuation of the interior rooms. All these soft and delicate tones are continued in the apartment, or vice versa, depending on how you view it.

Splendor for All

The New York Botanical Garden in the Bronx is a world in itself. Not simply because it covers about 225 acres, but also because it offers a wide variety of experiences. It is the contrast between untouched nature and artificially created gardens that make a visit so stimulating. Only here, on an area covering fifty acres, can you still encounter the remains of the forest which covered the area before New York City was built. In the 18th and 19th centuries the Lorillard family had a tobacco plantation here, but they were aware of how unusual a feature the forest was, and left a large part of it untouched. In the Lorillard Snuff Mill on the banks of the Bronx River, the family produced snuff and packed tobacco. Today the historic building houses a restaurant which provides a pleasant rest place for visitors to the Botanical Garden who have decided to explore the large area on foot.

At the end of the 19th century the state approved the foundation of a "first class public botanical garden." In 1897 it was decided to use the former Lorillard estate and the foundation stone for the necessary buildings was laid in the same year. Then, as now, the richest people in the country took a large measure of responsibility for projects that would benefit the general public. Many famous names are on the list of sponsors: Andrew Carnegie, Cornelius Vanderbilt II, and J. Pierpont Morgan. They founded a public-private partnership which still exists today. The idea for the botanical garden came from the botanist Nathaniel Lord Britton, who on a visit to England with his wife Elizabeth in 1888 visited the Royal Botanic Gardens at Kew. His position as a famous academic at Columbia University gave him enough influence to bring his plans to fruition. The location and donors were found, and the best-known architect who came to mind for this project was hired. This was Calvert Vaux, who had planned Central Park together with Frederick Law Olmsted. It was due to him that the individuality of this superb landscape was maintained: the river with its marshy areas and also the rocks and pools. In the whole area, there are more than 30,000 trees. About a hundred years ago, 1,500 trees were planted in the arboretum alone.

Even accepting that there was enormous interest in the natural sciences at the end of the 19th century, it is amazing that this institution was able to start its botanical work in the year of its founding, 1891. Today its research work, library and archives are reckoned among the best in the world. However, not only students are intended to profit from this garden: The institution has taken upon itself the task of getting all visitors more involved with the plants in different educational ways.

The Botanical Garden's hallmark is the glasshouse dating from 1902; it is based on the Crystal Palace in London, which was built for the Great Exhibition of 1851. The collection in this glasshouse allows an eco-tour through all the world's climate zones: tropical rain forests, the deserts of America and Africa, sub-tropical and temperate zones. It also features aquatic plants in temperate and tropical basins. Most impressive of all are the palms, which you would not see anywhere else in

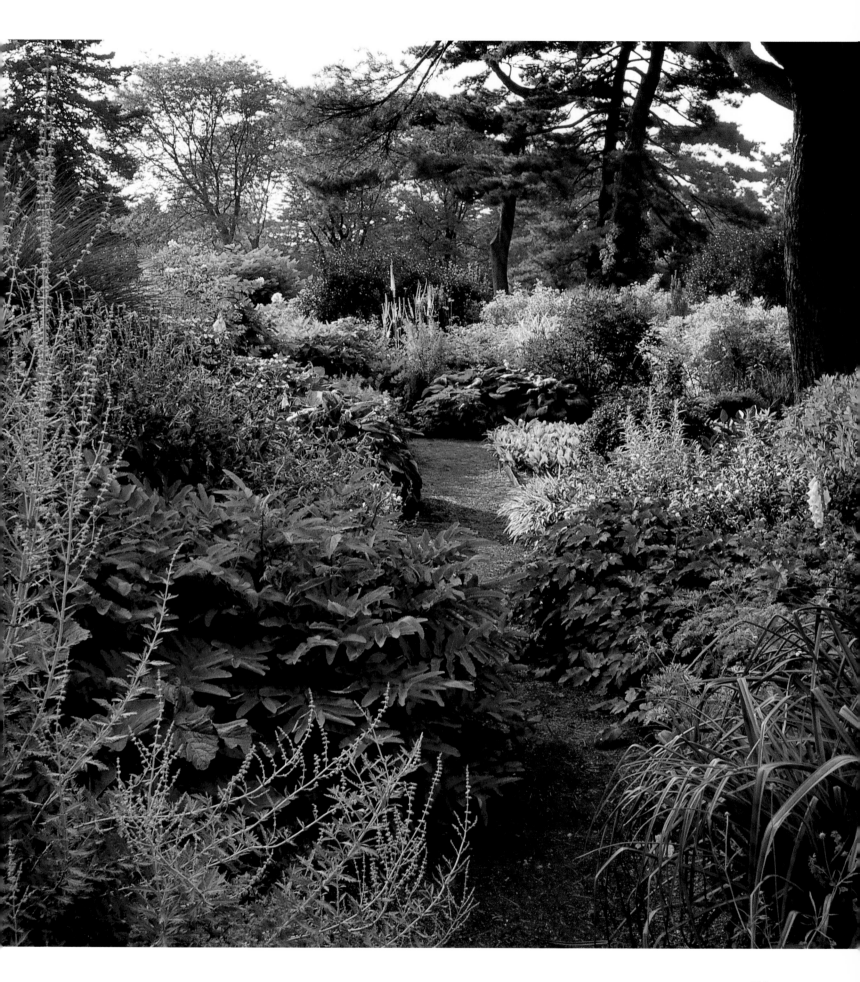

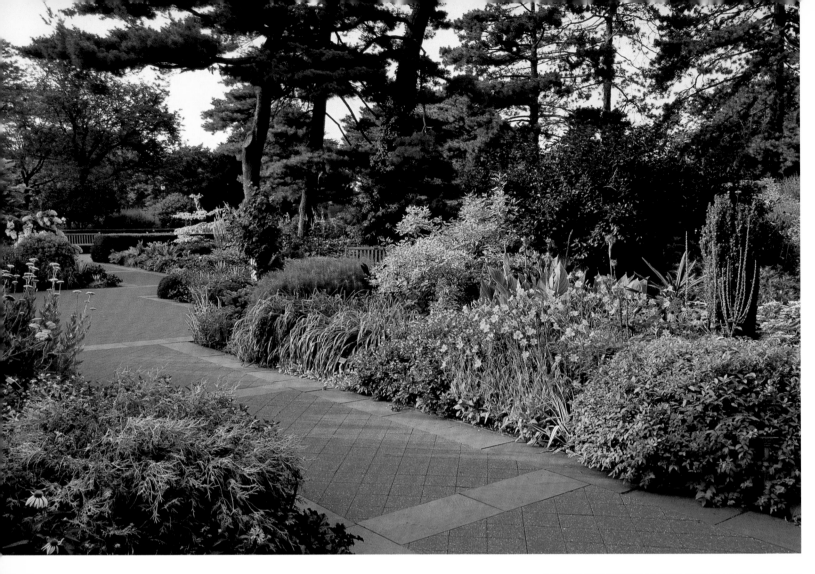

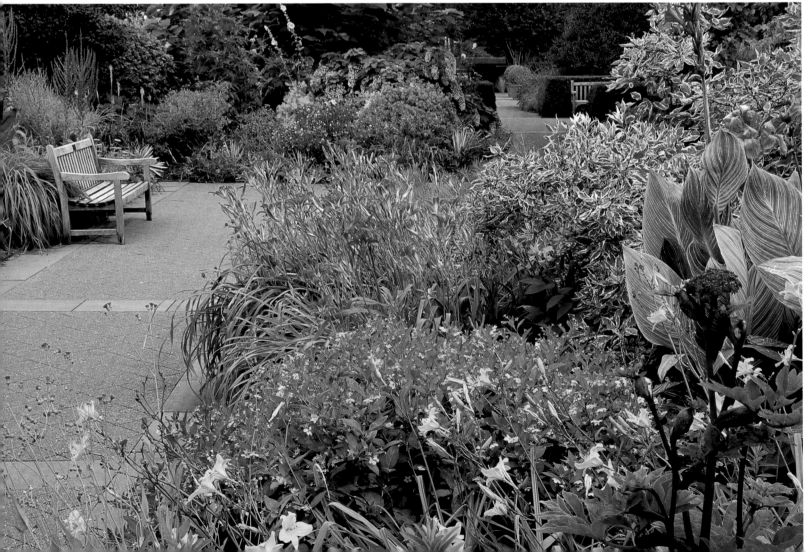

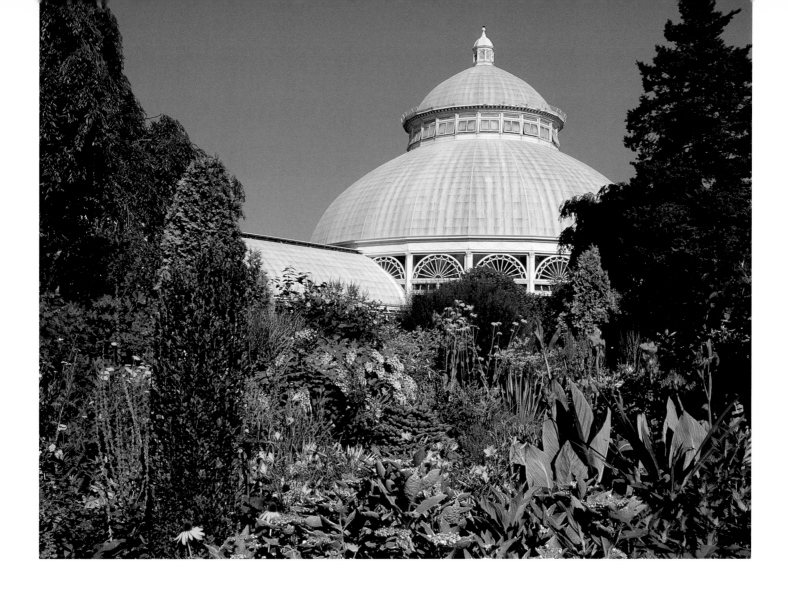

such variety in the western hemisphere. The historical charm of the glasshouse is combined with modern technology installed when the building was totally restored ten years ago. A sultry or else hot, dry climate in each of the separate areas can be created at the push of a button.

Famous garden architects such as Penelope Hobhouse, Susan Child and Patrick Chassé have contributed to the total design of the Botanical Garden. Right in front of the glasshouse there is a garden which shows its full glory in the fall: the Jane Watson Irwin Perennial Garden, shown in these photographs. Through the clever use of hedges, separate rooms have been created in which you have the feeling of privacy, unless, that is, a school class is charging through: nature study programs are very popular! The garden designer Lynden B. Miller, who specializes in public gardens, believes that such a garden cannot be exuberant enough. She

believes in the healing effect of designed green areas and manages, time and again, to persuade sponsors to support her work.

She is able to combine an immense palette of plants in perfect harmony and has an unfailing eye for how leaf shapes, grasses and flower colors fit together; and no matter where your gaze wanders, the aspect is always a pleasure. Doubtless the fact that Miller is a painter with a trained eye for composition plays a role. Nevertheless, when you are standing in front of an immense empty flower bed, it takes a great deal of fantasy, not to mention a vast botanical knowledge, to be able to imagine and plan how it should look one day. The height of the plants in the flowers beds plays an important part, and the way they are staggered reveals a sense for the theatrical which transforms the bed into a stage. In every section there are lead characters, a supporting cast and extras, which provide the entourage for

the star. Tall pines form the backdrop which gives depth to the ensemble. The secret of the balance in her large beds is the regular repetition of grasses, flowers and herbaceous perennials. Luxuriant planting means there is no danger of boredom. All those who think that after summer the garden is past its best have another thing coming when they see Miller's "fall room." At the end of September and the beginning of October the garden overflows with glowing asters, flowering grasses, yellow goldenrod and the red flaming leaves of the oakleaf hydrangeas, backed by sage leaves shimmering blue and silver. When new beds have to be created or existing ones extended, Lynden Miller comes as a consultant and works together with the young gardeners. From Miller they learn a luxuriant garden style, which may not be entirely modern, but which is good for the soul. After all, Miller's credo is that everyone has a right to beauty, particularly in the less privileged areas of the city. The New York Botanical Garden makes an important contribution to the quality of life in the Bronx, a borough which for some time has been increasing in desirability.

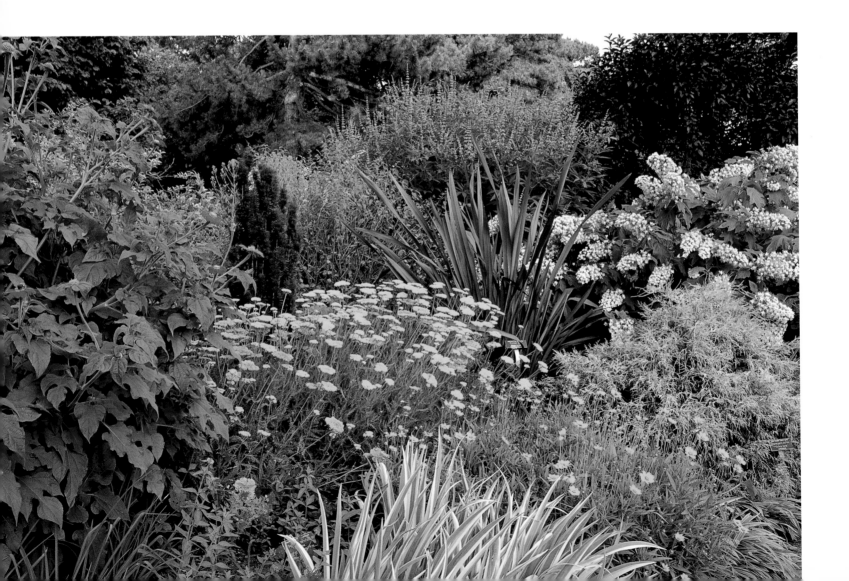

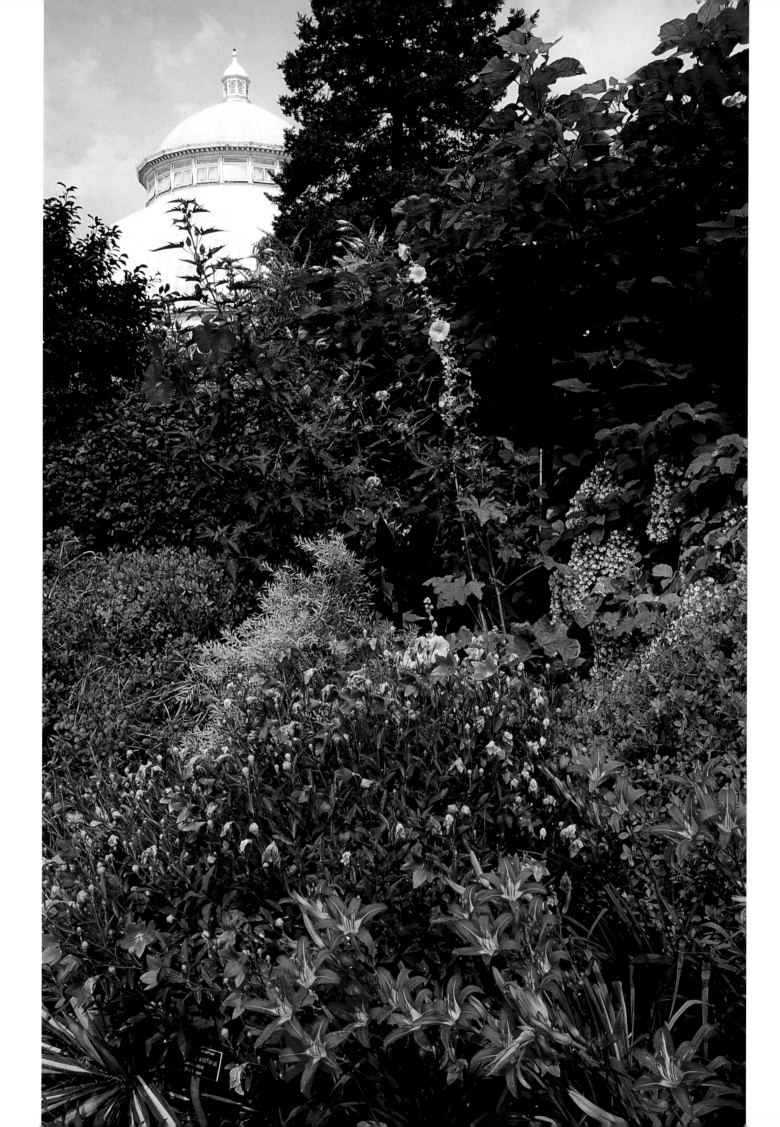

Variations on More Than One Level

The *African Heads*, as the sculptures by Peter Hayes (b. 1946) are called, turn their back on the Manhattan skyline and look into the eleventh floor roof terrace. They watch over an area of about two thousand square feet, a third of which is planted. Steps and paths provide an opportunity not just to sit, but also to stroll around.

The designer responsible, Halsted Welles, says, "One of the most interesting facts about this garden is that it was laid out before the building was finished. This enabled us to specify the flooring and design the balustrades. Had we come later, the whole floor would have been tiled. However, as it was, we were able to control the background for our plants." An additional advantage was that there was enough time for planning. Normally the work has to be done very quickly and the garden architect hardly ever has the chance of ordering materials with a long delivery date. This case was different: Since the construction work for the roof garden was ongoing in any case, paler stones could be chosen which were not immediately available in the warehouse round the corner. The pale limestone, which forms the basis of the terrace, is from a quarry in Jerusalem, as is the material used for the round plant troughs. From Jerusalem it went to Italy for cutting. It was then finished in Florida and transported by ship to New York. Only for the balustrades did Welles choose limestone with a reddish terracotta tinge from Indiana.

Halsted Welles created a second, slightly higher level and linked the two garden rooms using large steps.

Previously the upper level had a five-foot balustrade, over which there was very little view, particularly for those who were seated. Yet when the floor was raised, the wall was too low for safety. As Welles wanted at all costs to do without the solid wall which would have obstructed the view, he had a balustrade built, which compensated for the difference in height. You can now sit up there and enjoy the view of the city and the synagogue. A green band of box hedging runs along the walls and where the two levels join, the box hedges run parallel at different heights. The appearance of the staggered hedges recalls the flower beds in front of Baroque palaces. This impression is enriched by ground-covering white roses.

Even if garden owners never leave their apartments, they can at least enjoy the terrain with its natural-looking different levels. It is like being out in the country. Behind the double glass doors, autumnal yellow and red leaves shine in all their glory. The flap in the door allows the dog to go in and out at will. Household pets are a challenge for garden designers in New York. They have to build barriers against dogs and cats which like to dig, but these barriers must not disturb the overall picture. Filigree, almost invisible, fences enclose the dog's territory—a solution which in this case was respected by the well-trained dog.

The *African Heads* are in sharp contrast to their location. Solid and self-immersed, they bring an oasis of quiet to the tumult of the metropolis. The English artist Peter Hayes lived in Africa for ten years, which changed

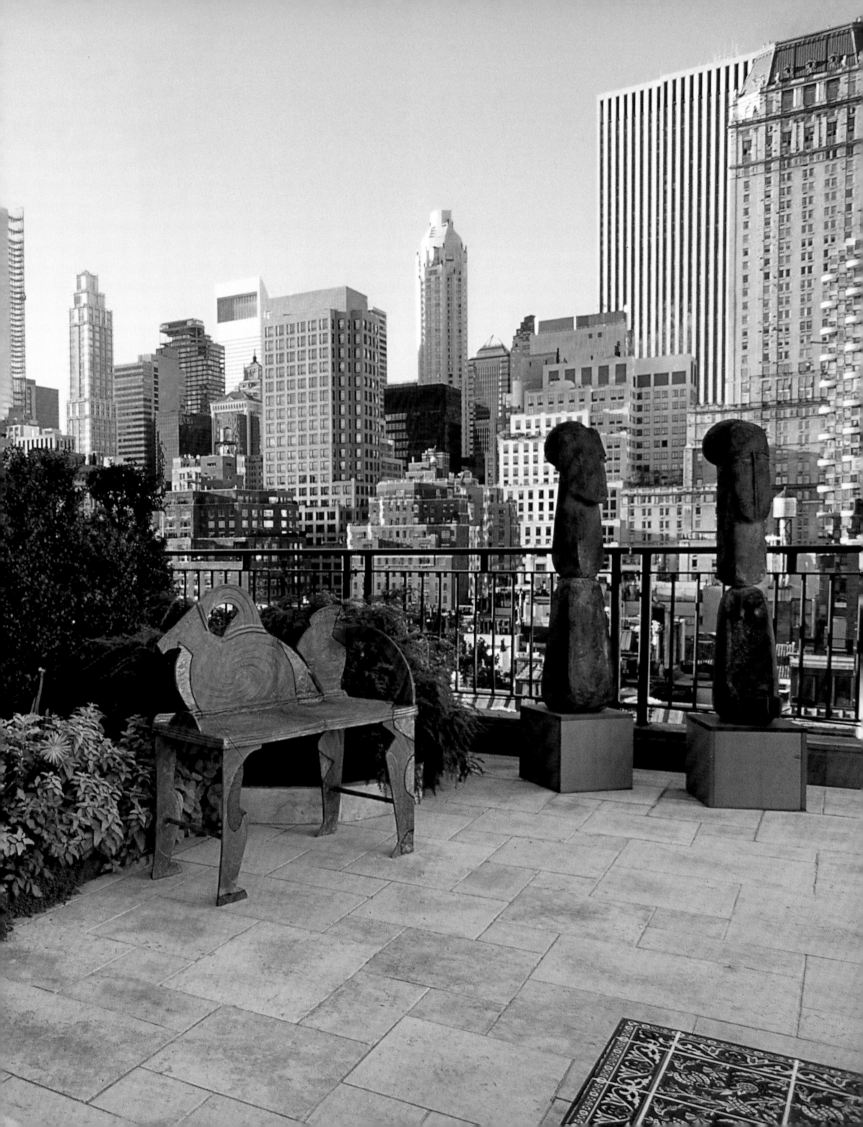

his life and art forever. Artist Betty Woodman's bench with its backrest resembling a bird is in itself a contradiction: The bench is for sitting on, a place of rest, but a bird wants to fly, to be on the wing. Maybe this work truly reflects the garden owner's idea of life: The need for a permanent place to live for a world traveler is matched only by the desire to fly far away.

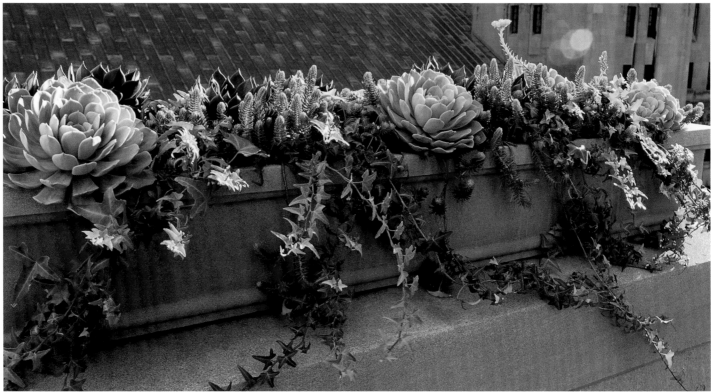

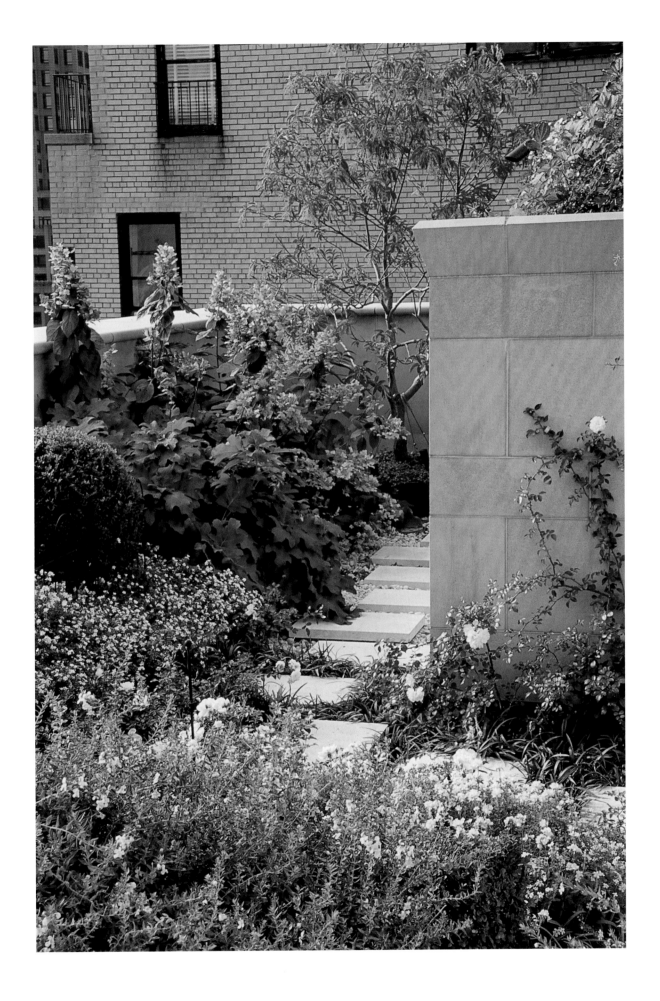

Greenacre Park/Manhattan

A Cozy Place by the Waterfall

"A private park for public enjoyment." This may seem to be a contradiction, but that is what is said about one of the best-loved gardens in midtown Manhattan. A sign saying as much informs visitors to Greenacre Park on 51st Street between 2nd and 3rd Avenues that they are permitted to visit a private garden. The trustee is the Greenacre Foundation, which is also responsible for the excellent care and maintenance.

A little less than one acre in size, Greenacre Park is a "pocket garden." Small it may be, but the Project for Public Spaces has put it on the list of the world's best parks.

Abby Rockefeller Mauzé, a granddaughter of John D. Rockefeller, the founder of Standard Oil, established the Greenacre Foundation to maintain a number of public parks in New York. Her commission for Greenacre Park, which was opened in 1971, was to create "a pocket of serenity filled with nature." Four years earlier, Paley Park had been created close by and is often compared to Greenacre. How much Paley Park was used as an example no one knows, but there are comparable elements in its design. Although Paley Park is favored as a place of retreat with a relaxed atmosphere, it is not nearly so sophisticated as Greenacre: A few unassuming steps take you directly from the street to a roofed entrance area. Along the west wall there is a raised pergola, providing shelter from both cold and heat and there are heating lamps in the roof, which allow you to wile away the time in cold weather. In front there is a garden on a slightly lower level, furnished with small ta-

bles and metal chairs. Particularly at midday, employees from the neighborhood come to sit here and enjoy their lunch.

At the vanishing point of the leather-pod trees is the dramatically staged sensation of the entire garden: a waterfall, which cascades thirty feet over a symmetric granite block in a fine but dense white veil. Right behind the waterfall there is a low redbrick wall half overgrown with ivy, just like the walls to the left and right of the cascade. In the background, the pale skyscraper with its many windows seems to be a continuation of the waterfall above or below: The light, mirrored skyscraper seems to dissolve and flow into the garden in a mighty torrent. The landscape architect Hideo Sasaki recognized and exploited the reality of this location. The way he used an "outside" skyscraper in his vertical scenario can only be described as a stroke of genius. He has added something magnificent to this little oasis surrounded by overpowering buildings without relinquishing its intimacy. The falling water drowns out the noise from the city and also cools and freshens the air. Hideo Sasaki transformed the eastern boundary of the plot into a wall fountain: Low down, the bricks are covered with granite, over whose rough-hewn surfaces the water trickles and collects in a narrow channel. Here, with your eyes, ears and nose, you can be far away from the city. The luxuriant vegetation includes a magnolia, a pine, a cypress, bamboos and a Japanese maple. Azaleas, rhododendrons, snowball bushes and barberries add color and flowers to the garden. The park is well

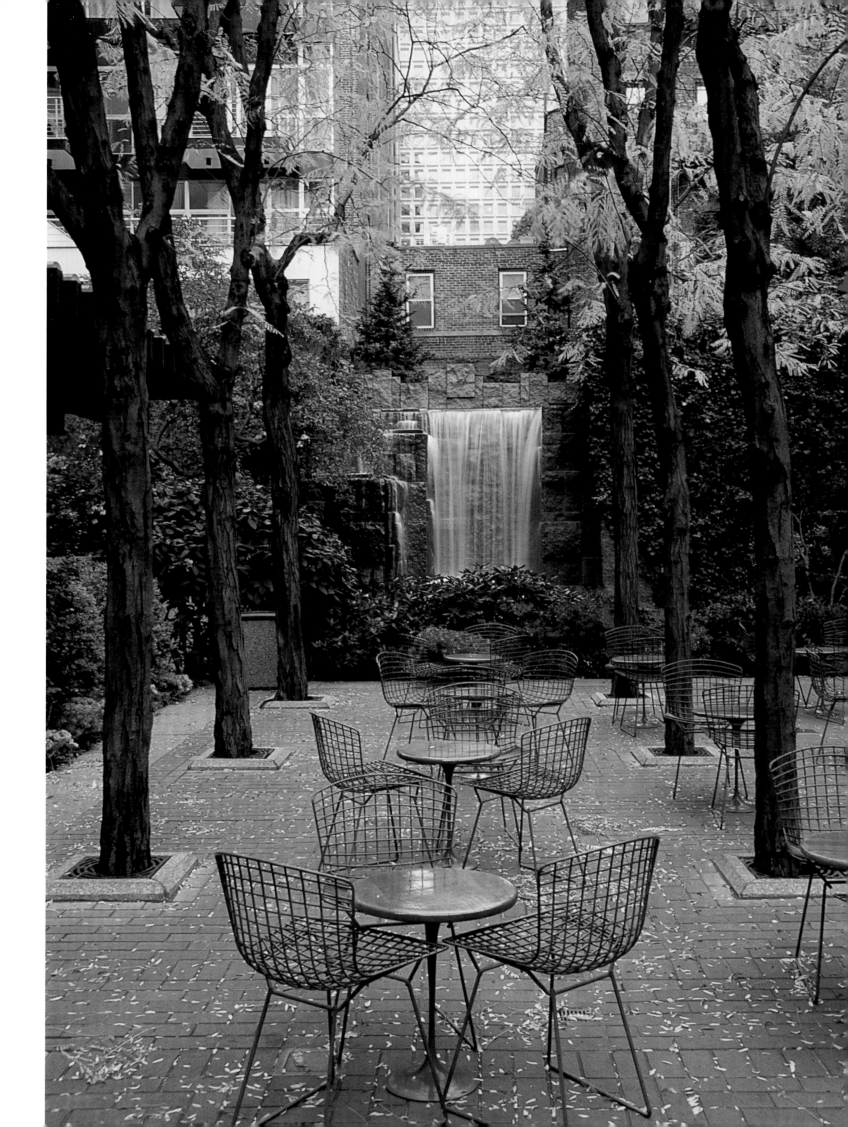

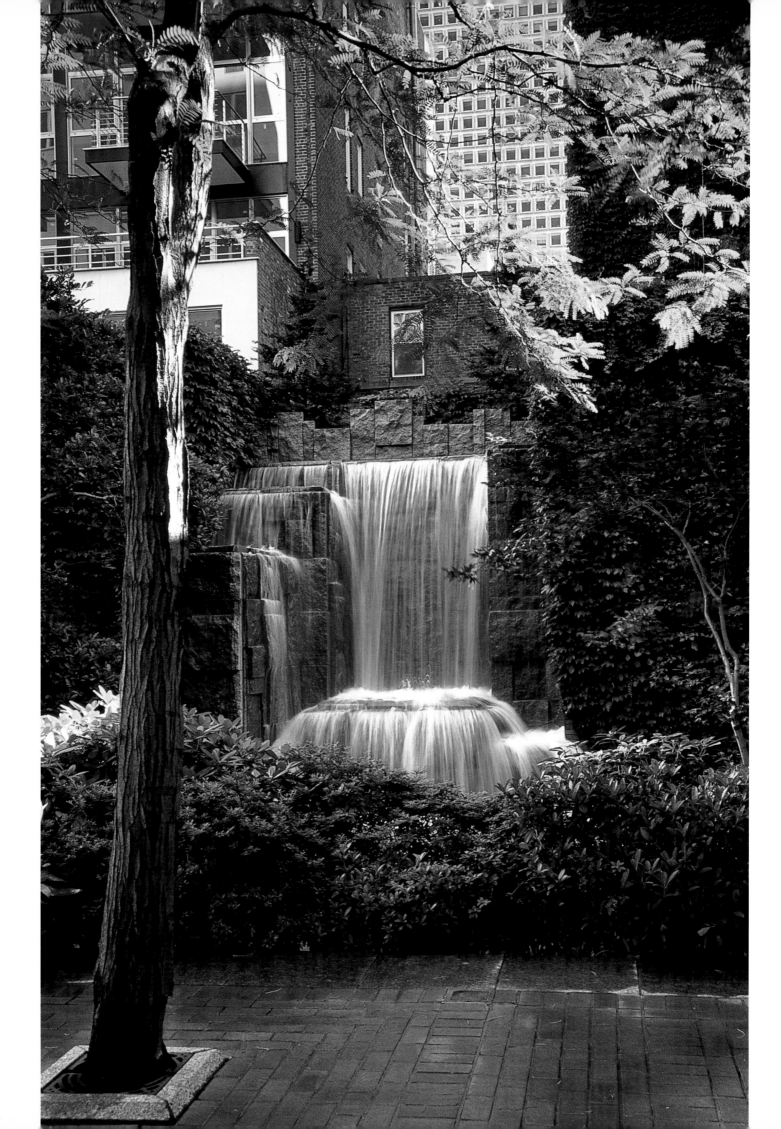

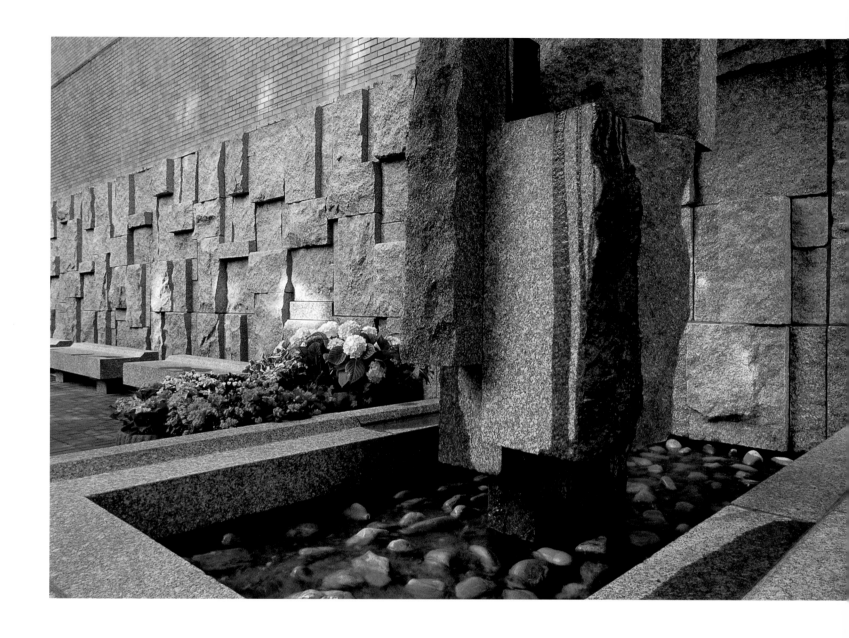

known for its seasonal decorations: The Greenacre Foundation gardening team changes the planting every two weeks. In spring, for example, there are quantities of potted pink hydrangeas and in late fall baskets decorated with all shapes and colors of squash.

For many people, Hideo Sasaki (1919–2000) was one of the most influential landscape gardeners of his generation. From 1958 to 1968 he was President of the Institute for Landscape Architecture at Harvard, where he taught. At the time, landscape architecture as an academic discipline had little influence on everyday life. While others were constructing parking lots, Sasaki was building immense gardens for companies and universi-

ties. He designed courtyards and terraces, groves and artificial lakes whose water cooled the buildings. He was a pioneer in working with engineers, architects, sculptors and city planners. The most important thing for him was not a design idea, but an understanding of natural realities and people's needs. He loved to play with the existing silhouettes and shapes, and to juxtapose "biomorphic" and geometric forms. This is why, when building the waterfall in Greenacre Park, he used the heavy veiling of the water to contrast with the sharp contours of the skyscraper in the background.

If you visit Greenacre Park, you will notice immediately how many people are smiling; even the gardeners

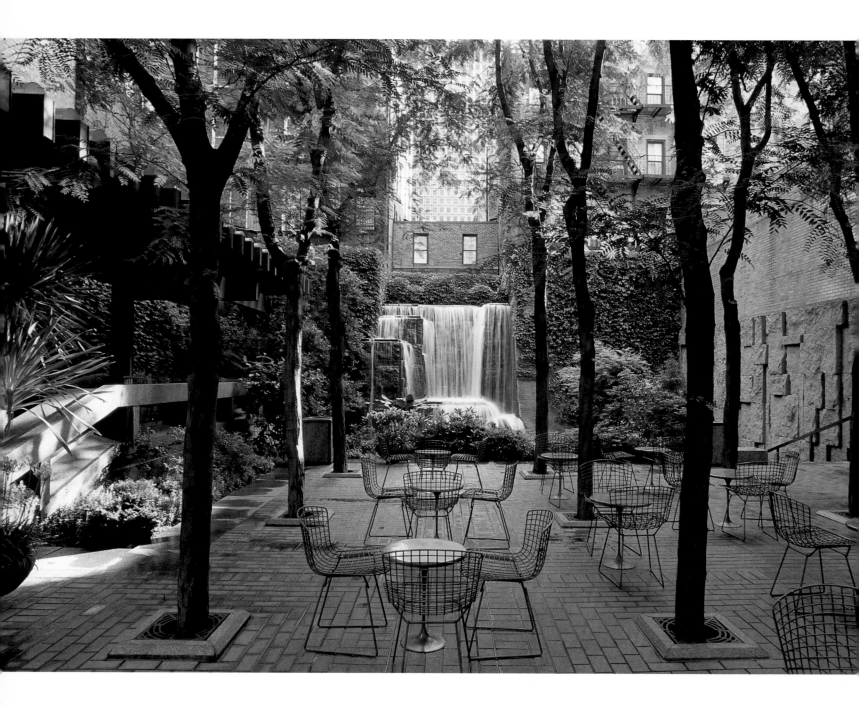

spread an air of happiness. One visitor described how he had taken a chair close to the waterfall, closed his eyes and imagined that he was on a beach. These little moments of escape just a few steps away from the nearest street help you to replenish the energy you need to cope with the challenges of a megacity like New York.

Hospitable Elegance

The brick walls with their white mortar of the high-rise on Park Avenue provide a romantic backdrop for the Biggs family's penthouse garden. Chimneys are a visual irritant, but here they take on the appearance of an adjacent forest: They are covered in evergreen ivy and extend the garden vertically. The garden designer Halsted Welles reinforced this effect by planting a pine tree in front of the chimneys and had white roses and ivy grow up the wall. Over the years, the real tree increasingly blended in with the angular "brick trunks" behind it. Halsted Welles has a great talent for changing urban districts into rural idylls which mirror nature and give them a dream-like flair. When you enter the garden, your first view is of a Gothic wall fountain made of white marble with an opulent basin. According to Friedericke Biggs this came from a French village. As a committee member of The New York Botanical Garden she organized an annual Antique Garden Show, and this is where she found the wall fountain. It must be said that the "marriage" with the basin, which on feast days has goldfish swimming in it, was an arranged one. However, the planting under the basin looks as if it has always been there. The strength of Halsted Welles's design lies in the fact that it appears not to be a design at all. All kinds of grasses support this natural impression, and between these grasses there are mainly white and violet plants, the lady of the house's favorite colors. She is a very successful interior decorator, and this is reflected quite clearly in her apartment. Not even the smallest space is unused. The display cabinets are full of porcelain objects, the furniture exquisite antiques. The walls are covered in fabric hangings and the ceilings are painted with skies and colorful birds. The dominant colors are blue and black, and these colors continue onto the terrace. It is a major handicap for the garden designer to have to drag plant pots, trees and sacks full of earth through to it. When a garden architect is working in Manhattan, planting is the least of his or her worries. Transport alone is a big issue, which begins with finding a parking place in front of the building for the delivery truck. The NYPD shows no mercy for tradesmen. Most gardens in Manhattan are roof gardens, and that is the next problem: How, for example, do you get a fifteen-foot tree in an elevator? With more than forty years' experience Halsted Welles has a few tricks up his sleeve: For example, he removes the ceiling of the elevator and then can take trees up to the twentieth floor. The two birch trees for the Biggs family had an even airier journey. The last time the Biggs moved, they decided that the birch trees were family members that would come with the rest of the family. A crane was organized to lower the birches from one roof garden and raise them onto the other. A low-loader transported the trees expensively between the two buildings. Welles remembers this adventure and also that the thing that worried him most was whether the trees would survive all the disturbance. After all, they could have bought a whole birch copse for the cost of the transport. Thanks to lots of tender loving care, the trees are thriving; let us hope that they do not suffer from vertigo and that they are not

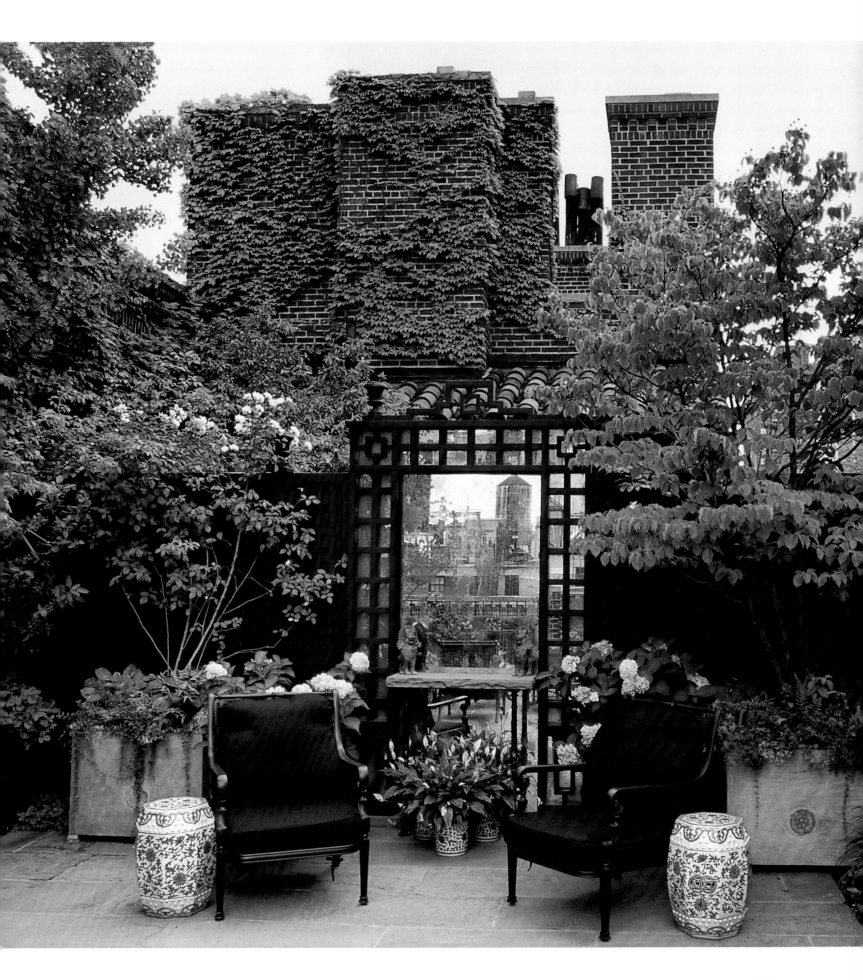

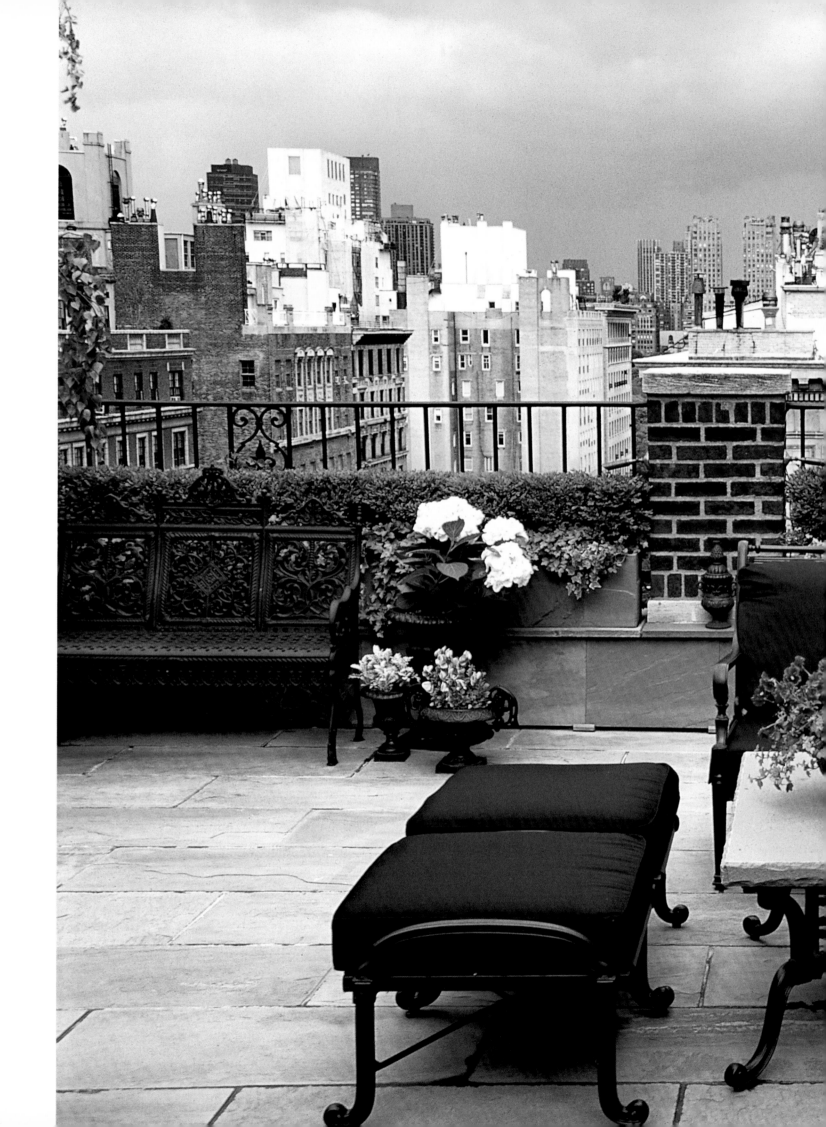

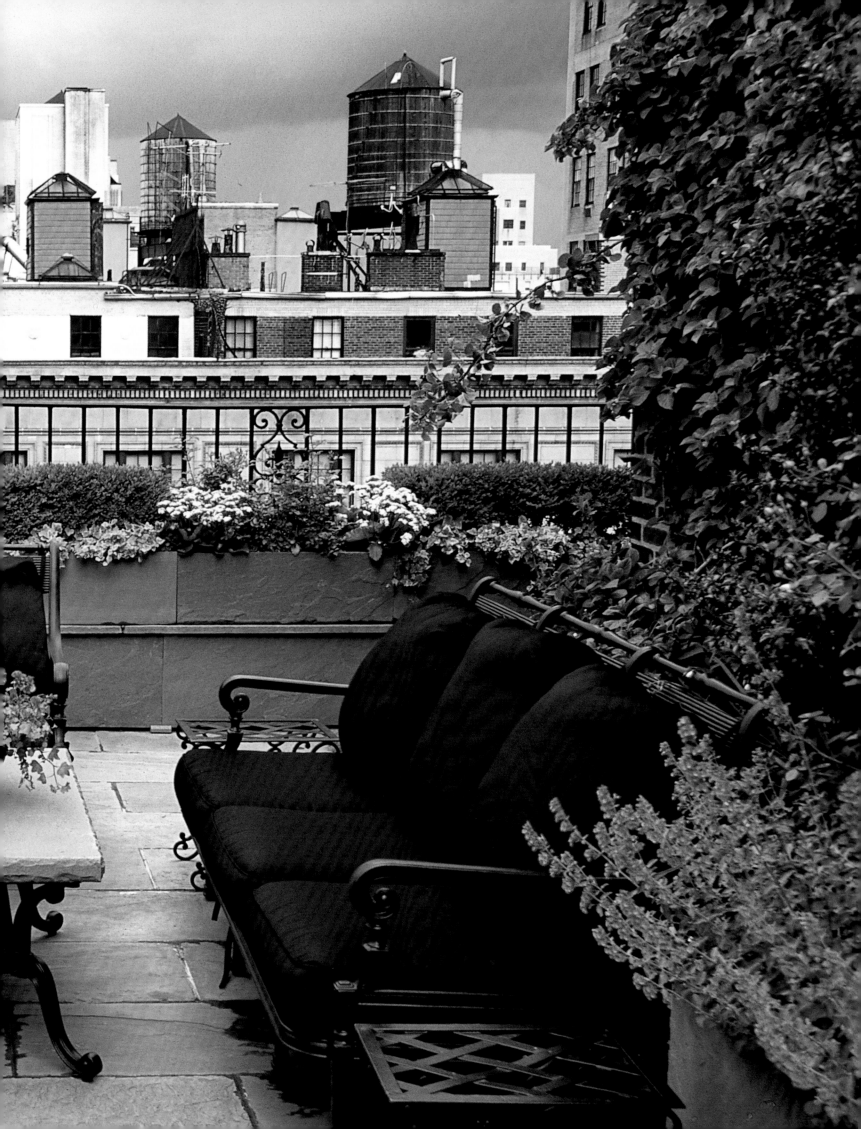

afraid of the canyon of the street below. There is no way that they could fall in, since they are well secured against the strong winds which blow over the rooftops.

Around the terrace there is a low, one might even say cute, box hedge, which is always carefully trimmed. This adds a green frame to the garden. In front of this hedge, the flowers beds are changed regularly so that there are always white or violet blooms. Depending on the season these will be hydrangeas, petunias, tulips or lobelia. The gray plant containers are almost invisible and do not distract from the content. The black garden furniture adds a touch of elegance and the cushion covers are so waterproof that they do not have to be removed in even the heaviest of rainstorms. Halsted Welles may seem to be very pragmatic, but some of his architectural elements reveal how playful he is. He uses a mirror to make the terrace appear larger and to suggest spatial depth. It reflects houses, sky and plants. He chose the location which reflects the most interesting views. A dark lattice, which looks like a trellis, frames the artificial images. The lady of the house placed two blue-and-white Chinese porcelain vases either side of it. There is also a narrow terrace side, which can be accessed from the kitchen. This is the place for the long table where guests can sit. When seated, you can see the luxurious flower beds at eye-level, so those who do not wish to need not look at the surrounding facades. A short time ago, the Biggs family celebrated their son's wedding. It was his wish to have the marriage ceremony in the roof garden. Pale blue silk was rolled out, bows were made from the same material and vases were filled with blue-and-white bouquets. There were blue hydrangeas and white roses everywhere. The couple took their vows in front of the mirror, which doubled as an altar, within earshot of all the assembled guests high in the sky, surrounded by a cozy blue-and-white flowering garden in the middle of Manhattan.

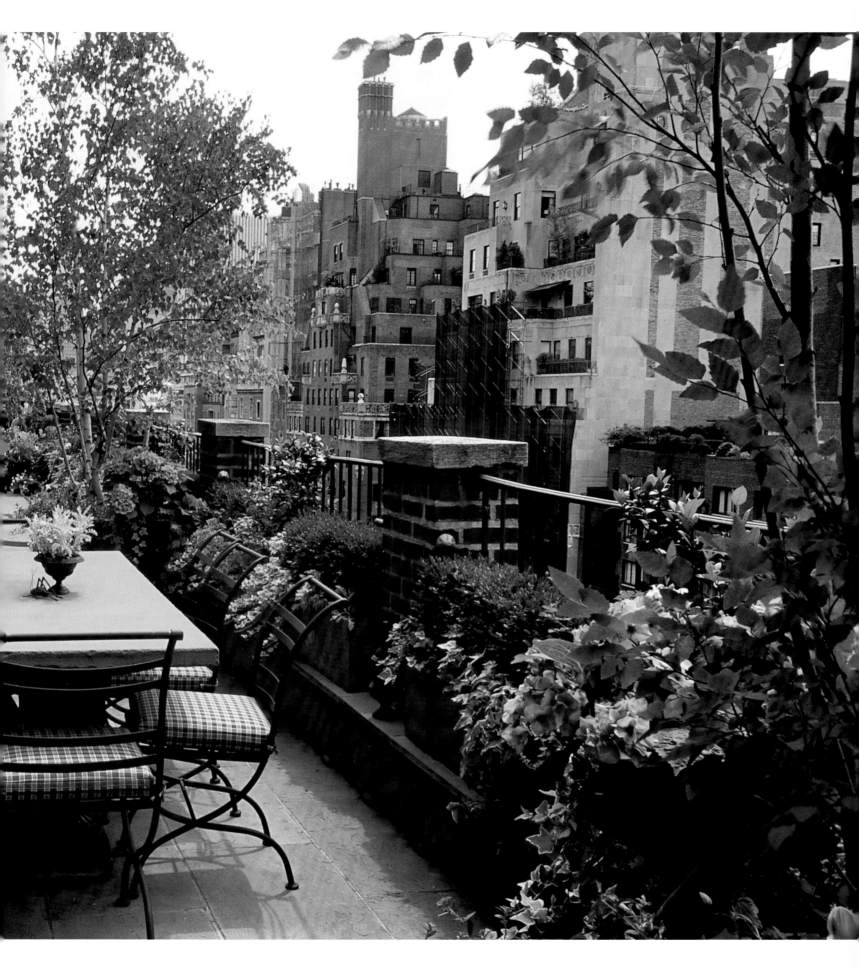

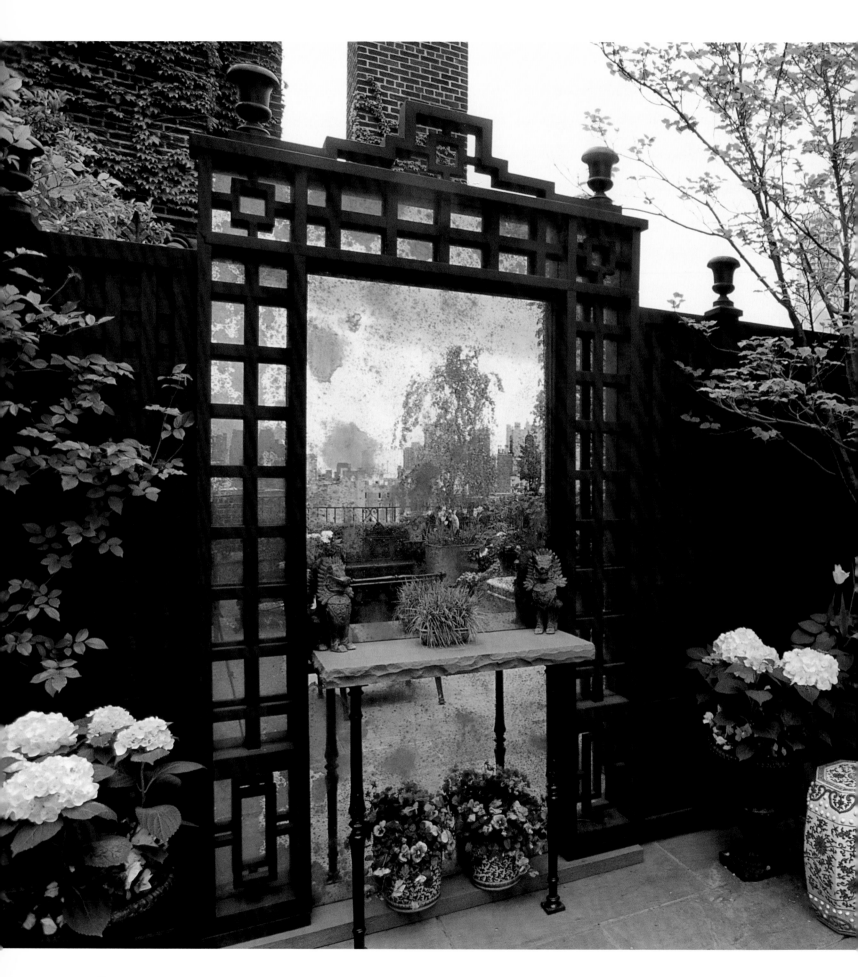

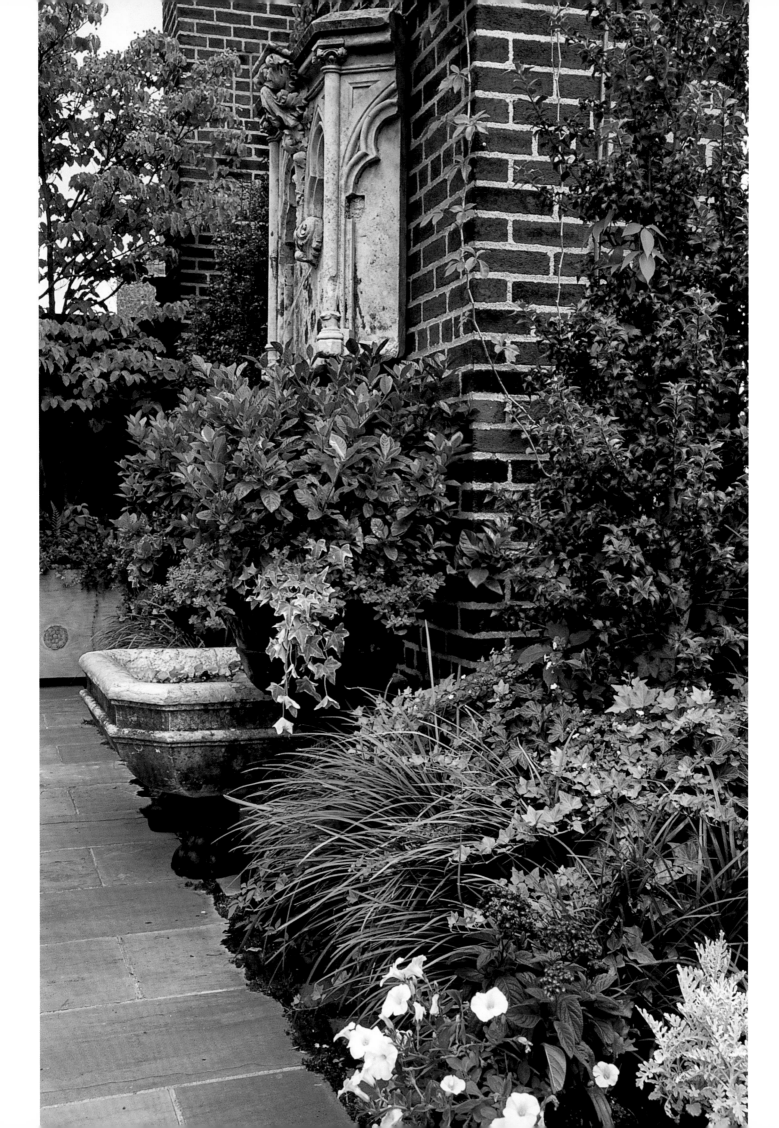

Mirror of the Soul

The Californian landscape architect Topher Delaney speaks of her gardens as works of art which she developed for their owners. In in-depth conversations, she tries to track down her clients' life stories. What is important, what have they experienced, what is their rhythm of life, what is their approach to life? When you commission Topher Delaney to design your garden, it does not just mean showing her a plot of land to work with, but also revealing a good part of your own identity. You must be ready to open up, prepared for an intensive and honest analysis with the artist and with yourself. The more the client reveals, the more personal the finished garden will be: "I see my work as making people stronger. In order for them to have a relationship with their plots, I work their life experiences into them." This results in very individual gardens, all of which, however, bear Topher Delaney's signature.

This was also true of the backyard garden she created on Manhattan's Upper West Side. Many discussions took place before the planning began. The clients are cultured art collectors and the intellectual level of the concept was accordingly high. The garden presents many puzzles and even the first glance into this geometric scene is bewildering. Surrounded by neighboring gardens and three-story brownstone houses, you go down a few steps and lose yourself in a garden which has no clear boundaries. It is surrounded on all sides by seven-foot mirrored walls, which means that the elements reflected in the mirrors go on for ever in all four directions. The oval lattices are placed about a foot in front of the walls, and this also has the effect of veiling the true source of the reflections. The geometry of the lattices is followed by the dark green ivy. The garden is at its most spectacular at night. It is then that the interior lighting concept developed by John Reimnitz Architect P.C. flows out into the garden: It is at its best when the bands of light flame yellow and red, warming the soul on cool evenings. The blue light is just as effective; it seems to transport you to another planet. The mirrored walls amplify their effect. They reflect the colored light in a continuous to and fro. Residents can view this play of light from above or go down a few steps and dive into the dissolving boundaries. What is it like to meet yourself, mirrored so many times? Does it do your vanity good, or does it strengthen your self-criticism? Does it depend on your mood that day whether you can accept your image or find it intolerable? How do you cope with being surrounded by no clear boundaries—do you get the feeling that you are also disappearing? Do you begin to doubt your individuality, or do you enjoy the feeling of being part of a large and continuous whole? Topher Delaney, from her personal experience, tells us, "The experience is one of silence... we are one and we are everything... connected on a cellular level to the entire formation of the cosmos." The fleeting images in the mirrors cause beholders to put their individuality and their lifetime into perspective.

The ground of the "installation" in the rear garden is covered with light terrazzo tiles, the color of greaseproof paper. If you look more closely, then you can see

a seemingly irregular pattern of white circles. These are Braille symbols, the touch alphabet for the blind. The artist says, "These are there to symbolize the irony of this form of communication, which is contrary to their intended use. Why? They are there to question the truthfulness of our supposed perception. Do we really know what we are looking at? Are we blind to the message? Do we even realize that there is a message?"

Ultimately, these signs are of no use to anybody and as a form of communication they are taken ad absurdum. Their duplication in the mirrors is invisible to the sighted and the blind alike, and the latter will hardly kneel down to feel these signs which other people walk on.

Topher Delaney does not make understanding her work easy. Here are lines from a poem written by the garden owner's father:

> Out of my life
> I fashioned a fistful
> Of words when I
> Offered my hand
> They flew away.

Nothing can be captured, life is constantly changing. This is not only the meaning of the poem; it is also Topher Delaney's conviction and doubtless that of the garden owners. It is their sensitive awareness of the fragility of our present existence that characterizes their intimate approach: "In the garden you are a part of the continuum, of life as a dynamic principle. Every moment means change."

The experience behind this viewpoint is related to finality, the theme of death. After Topher Delaney survived a serious illness, she developed a new sense of direction for her gardens and since then her gardens all over America have been conceived as "healing gardens" or "sanctuaries." "It was not my intention to make a healing garden," she says, "I didn't even know what that was. I just decided that I wanted to arrange the plants so that people could become aware of their own selves

190

and could reduce their stress." Since then she has designed more than four hundred gardens for hospitals, therapy centers, or memorials. One of these is the memorial garden in San Francisco which she planted in the middle of the Police Department's parking lot for a policeman who was shot in 2004. Topher Delaney laid out a "blue garden." "Blue is the traditional color of protection, extracted from the roots of the woad plant. Warriors used to paint their faces with this before they went to war." She spent a lot of her own money on this memorial garden. For the police, it remains an important place where they can regenerate and find brief moments of peace.

The backyard garden in Manhattan is only 550 square feet, but the mirrored walls make it look larger. Thanks to Topher Delaney's artistic gardening skills, the owners are able to escape from the constraints of the city, albeit only virtually. Depending on their mood they can be in a protective cocoon or imagine themselves in the multiply reflected expanses. Topher Delaney stresses, "It is so important to understand that things are constantly changing and that our time here is short." Her artistic gardens help people to be aware of this, and, hopefully, to be able to treasure this existence and enjoy it in their gardens.

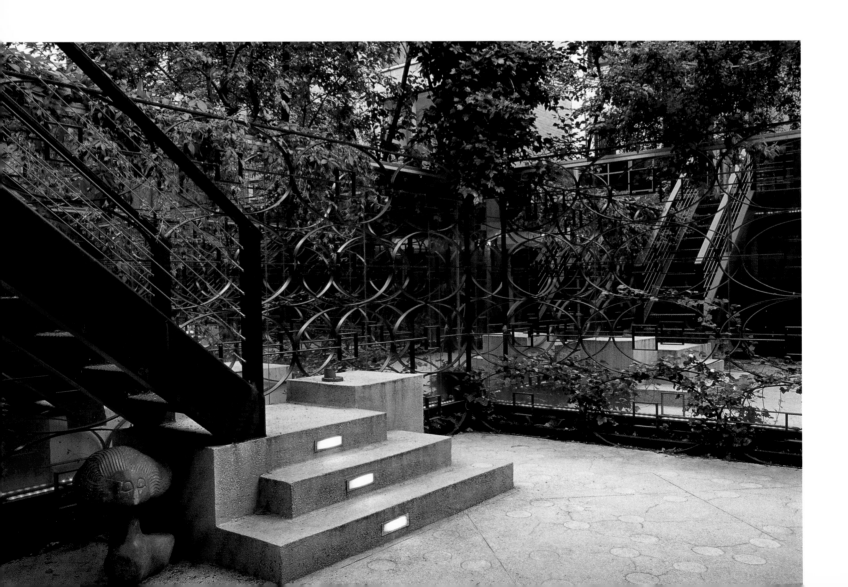

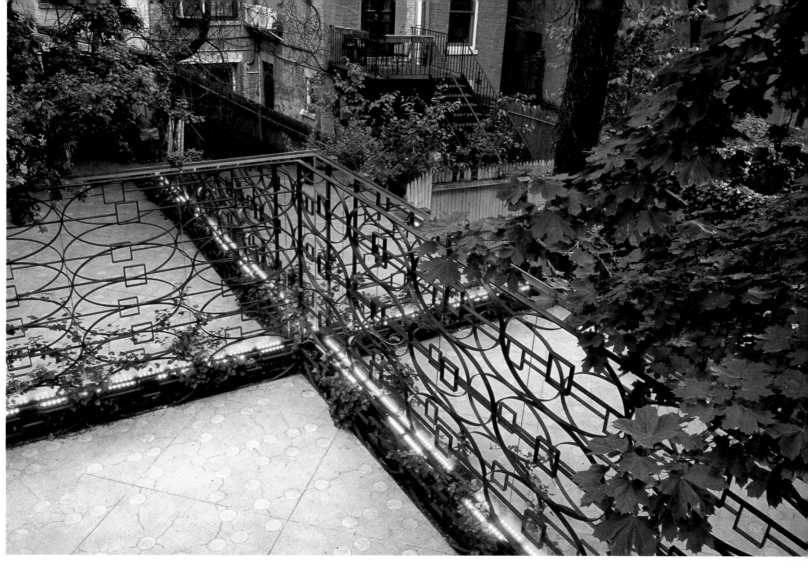
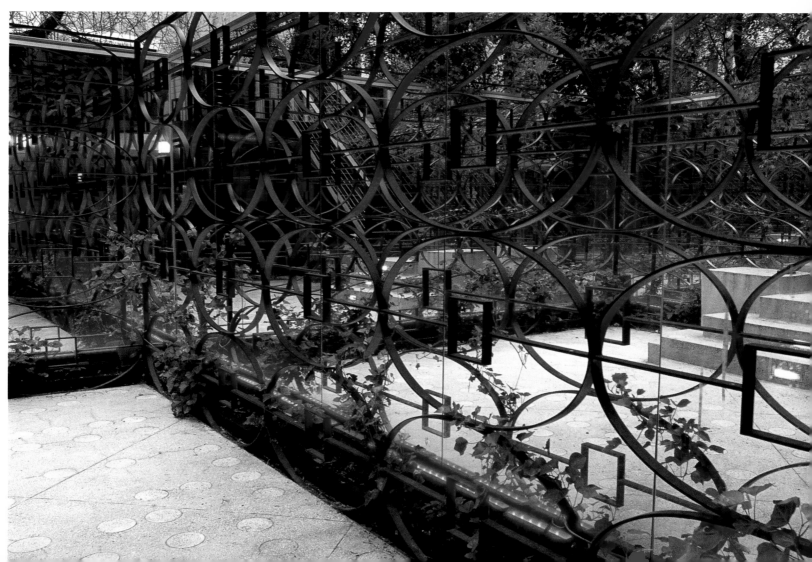

The Ha-ha

We are amused, we are surprised, and we say "Ha, ha!" And believe it or not, this is precisely why "ha-ha" has become a technical term in landscape architecture; it refers to a boundary which cannot be seen from a distance. To transition from a garden into open countryside, you do not build a wall or a fence, but preferably dig a deep ditch. This artifice not only extends the view beyond the enclosed plot, but also (for example on manorial estates) stops wild animals eating the tender rose buds. When looking across the garden, a ha-ha is invisible.

The box hedge surrounding the Iris and Gerald B. Cantor Roof Garden of the Metropolitan Museum could, with a little imagination, be called a ha-ha. It is the link between the museum and Central Park. At the same time, the green hedge forms a barrier, without spoiling the view. The museum's roof terrace is a garden, and the principles underlying its design go back centuries. Gardens were a welcome location for sculptures as early as the Renaissance. Since 1987 the roof of the Metropolitan has been open to the public, weather permitting, from spring to fall. At first, sculptures from the collection were exhibited; in the last ten years, however, the exhibition has focused each year on the work of one artist. In 2008, for example, it was Jeff Koons, born in America in 1955.

Sacred Heart is eleven feet high and more than six feet wide. It balances like a ballet dancer on her points and is extravagantly packed in a glossy red cocoon, tied with a golden ribbon. The red material seems to flutter in the wind and adds lightness to the sculpture, as though it were made of shiny paper rather than chrome. For many visitors it brings to mind happy times from their childhood and this is why they find the heart sculpture so beautiful. That is certainly a result, not least, of the perfect execution. Jeff Koons plans every artwork down to the very last detail, and then hands it over to his assistants (there are more than eighty of them), who are responsible for implementing his design in the workshop. Koons has enjoyed huge success for some time now, and his works fetch vast sums at auction. Nevertheless, he is more controversial than most, and doubtless the controversy is part of his success. Can art be concerned with the banal? Can formally perfect, but kitschy representations of the everyday be called art? Koons himself denies the accusation of irony or kitsch. It is sometimes said he is superficial, that he never delves far beneath the surface of things. But if the surface is as brilliant as in *Sacred Heart*, then so what? The enormous symbolic strength of the heart has its origin in the ubiquity of its banalized form. Just to state the obvious, it represents love, and for Jeff Koons it represents love as a principle of life.

The inspiration for the second sculpture, *Coloring Book*, was a page from a Winnie-the-Pooh coloring book with an outline of Piglet. Koons took thick crayons, colored in the figure and, just as children do, colored over the existing contours. One can just about recognize Piglet's ears in the silhouette, for example. The sculpture is eighteen foot tall and almost thirteen foot

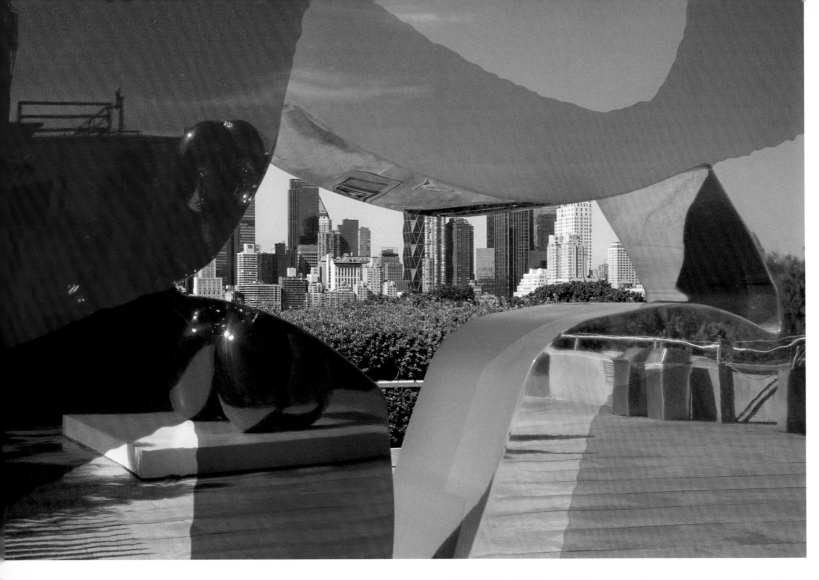

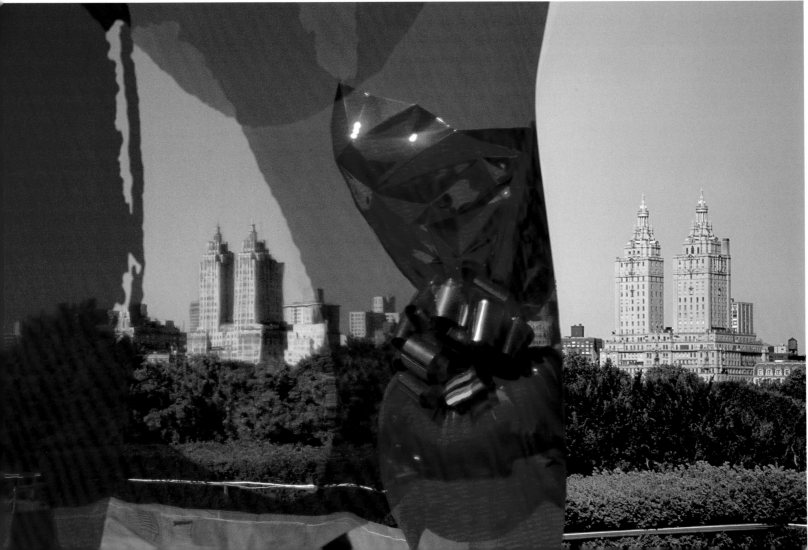

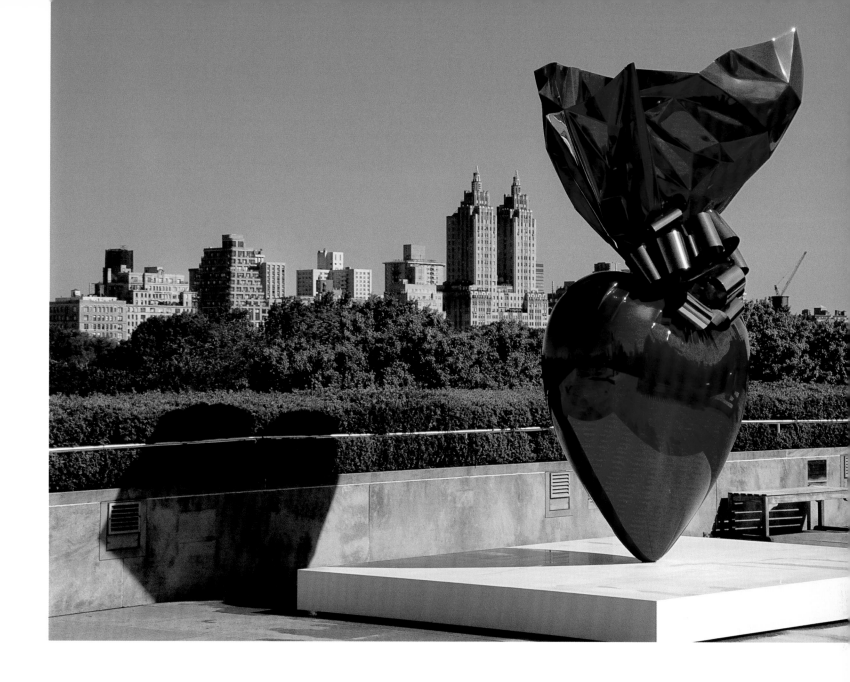

wide. The cutout in the figure forms a vibrant frame for the Upper West Side skyline. Jeff Koons has succeeded in making New York look like some toy town in the background of this colorful Piglet figure. And the shiny surface allows boundaries to be crossed: The city beyond the terrace is present in its reflections, as are parts of *Sacred Heart*. While the heart-shaped chrome sculpture gathers the immediate surroundings of the roofscape together as a panorama, the flat plane of *Coloring Book* with its reflections extends into three dimensions.

Witty optical illusions like these have been part of the entertainment repertoire of the garden since the Renaissance. And here, on the roof of one of the world's most famous museums, passing visitors immortalize themselves for a brief moment as a component of a Koons sculptures—a nice variation on the ha-ha effect.

Flower Frenzy Above the River

The largest public flower garden in the city, Heather Garden, is at the northern end of Manhattan, about 250 feet above the Hudson River. The breathtaking views across the river to the steep banks of the Palisades on the other side are the same as those painted by the artists of the 19th-century Hudson River School. These were the views which established this group of artists as romantic landscape painters. Landscape at the time was the leading genre in America. But one item was missing then: The construction of the George Washington Suspension Bridge linking Manhattan to New Jersey only began in 1927. In the same year Frederick Law Olmsted Jr., the son of the designer of Central Park, was hired to create a seventy-five-acre public park: Fort Tryon Park. It was planned to include a flower garden, the Heather Garden. The client was the philanthropist John D. Rockefeller Jr., one of the richest entrepreneurs in the United States. When Rockefeller took on this project, it was at the time of the Great Depression, and he employed hundreds of workers for eight years. They also built a subway line to connect Washington Heights with downtown New York. Today, 190th Street is the only subway station in New York with any historical look about it. A quick glance in the Olmsted archives of the National Park Service reveals just how important this park was for Rockefeller personally. They confirm that he examined and criticized the plans; he even wrote a letter saying that too many trees were planned for the east of the park. His commitment to the project was truly amazing, bearing in mind that he was at the same time building the Rockefeller Center. Rockefeller set aside part of the park for the Cloisters Museum, a branch of the Metropolitan Museum of Art which houses one of the foremost collections of medieval art.

When you enter the Heather Garden you are overwhelmed by the views over the river below. The topography with its steep slopes determines the character of the garden. The main 200-yard asphalt path on the crest is bordered by flower beds which while at their best in June, are worth seeing from spring to fall; more than a hundred different herbaceous perennials ensure that the colors and shapes change continually. On the western terraces facing the river, Olmsted created a natural-looking landscape with heather and gorse which bejewel the rocky slopes. Thus Olmsted combined two styles, and the contrast enhances the effect. When other gardens are still in hibernation, the gorse begins to bloom at the end of February. In March, 15,000 spring flowers come into bloom, with peonies and irises in May. Luxuriant poppies are scattered throughout the garden. In June, the air is thick with the scent of hundreds of lilies and roses. Even in high summer, not generally an interesting time for gardens, the heather comes into flower. These inconspicuous plants make their impression on the garden all year long. Sometimes they cover it with a carpet of flowers ranging from white to dark red; then the evergreen leaves in shades of gray and red change the atmosphere. The spectacle is particularly attractive in winter, when the golden leaves contrast with the white of the snow.

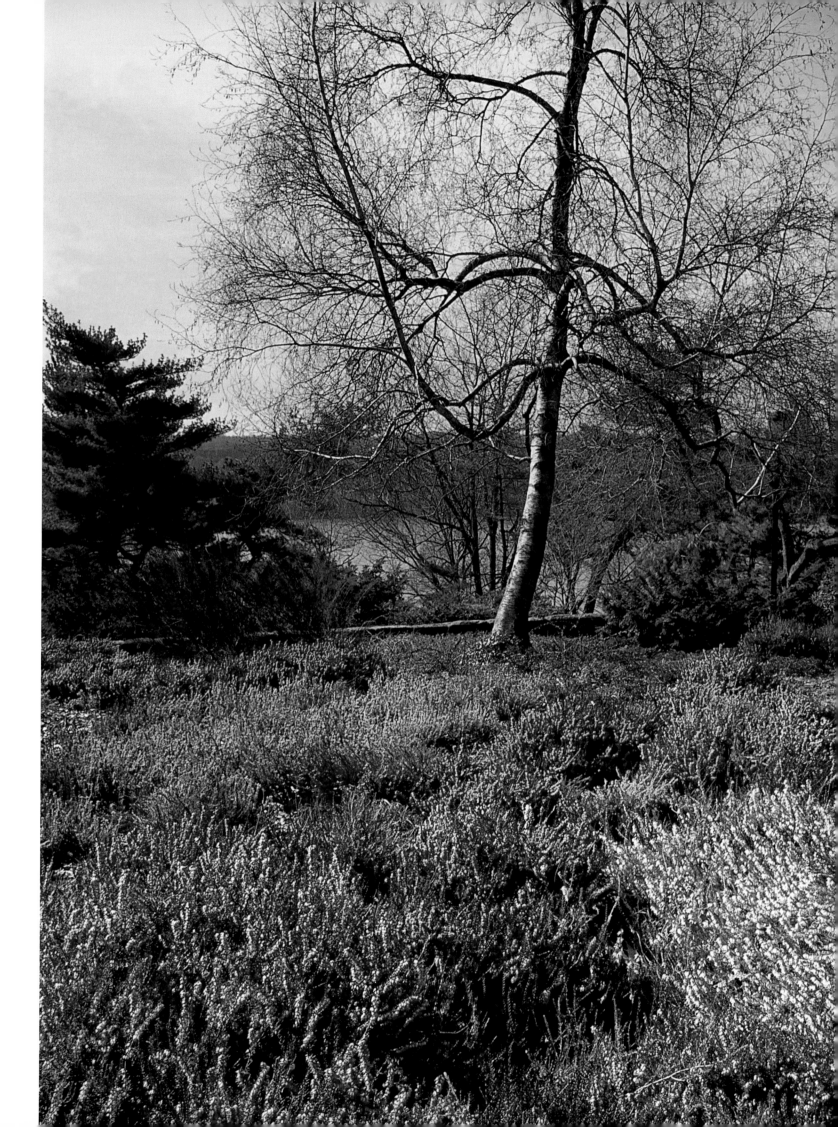

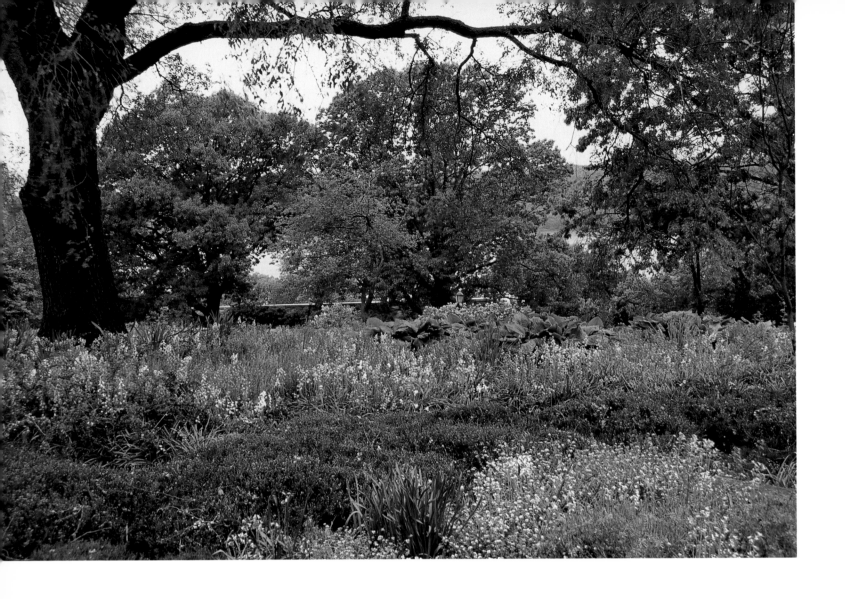

Hundreds of plans and photographs bear witness to landscape designer Olmsted's painstaking work in the Heather Garden. He made lists of plants, paying particular attention to the combination and the number of plants needed. One of the most important criteria in his planning was respect for lines of sight. He had to position plants according to their size and growth rate so that they would not disturb the view. By the way, John D. Rockefeller Jr. made sure that even today, a fifteen-mile stretch of the opposite river bank could not be developed.

After Fort Tryon Park and with it the Heather Garden had been ceremoniously handed over to New York in 1935, Olmsted's duties came to an end and he had to let go of his "baby." Unfortunately, when renovation took place in the 1950s, no one referred back to Olmsted's original design. Thirty years later, this led to

the disappearance of the lines of sight. Wild trees had grown so high that you could no longer see the river. Scrub and weeds had overgrown the cliffs so that nothing of the original garden was recognizable.

In 1983 the Greenacre Foundation decided to restore the garden. This was expected to take three years. Cliffs had to be cleared and wild trees dug up and replanted. The whole area was overgrown with ground-covering ivy, walls and steps had been destroyed by tree roots. Self-seeded trees obstructed the circulation of light and air. The biggest problem was deciding which trees and bushes were in the garden originally and which were not. The experts had to cultivate many plants in order to find out which sorts Olmsted had used. Indeed, over the years, the gardeners, helpers and volunteers have planted thousands of heath plants, gorse bushes and shrubs to restore the Heather Garden to its original

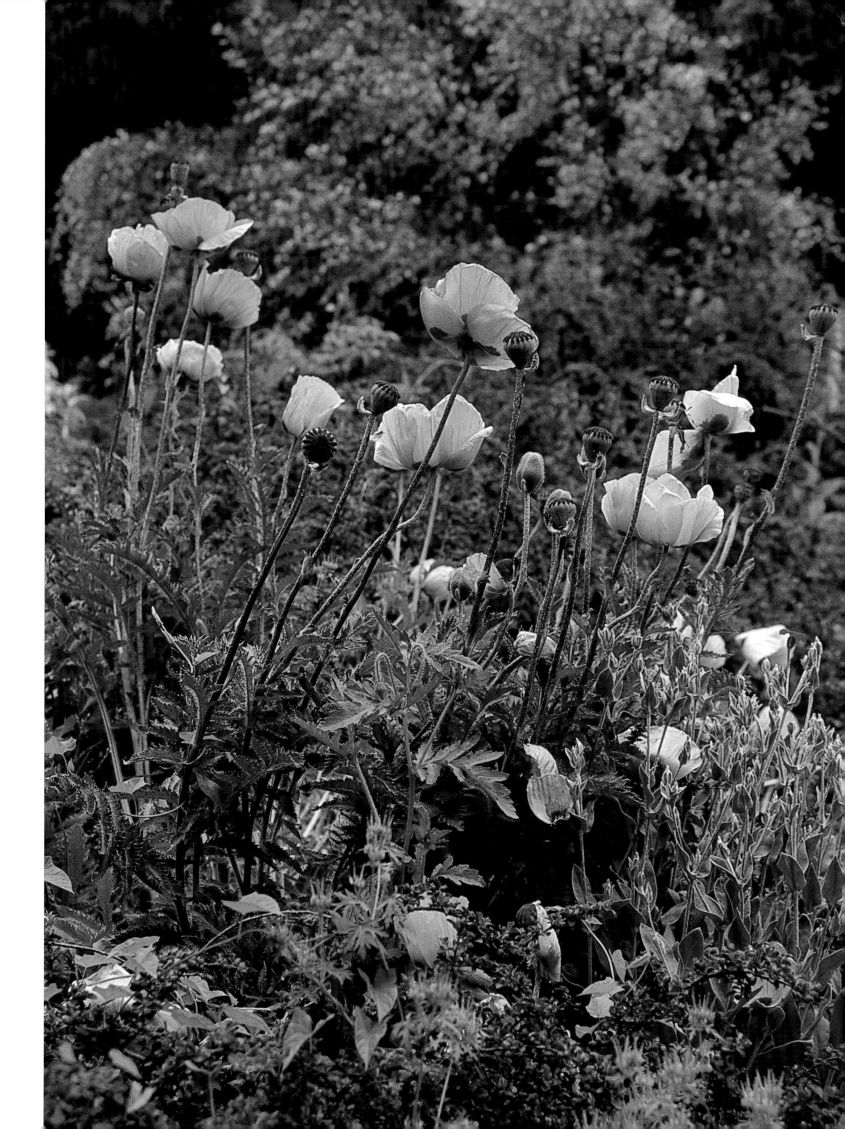

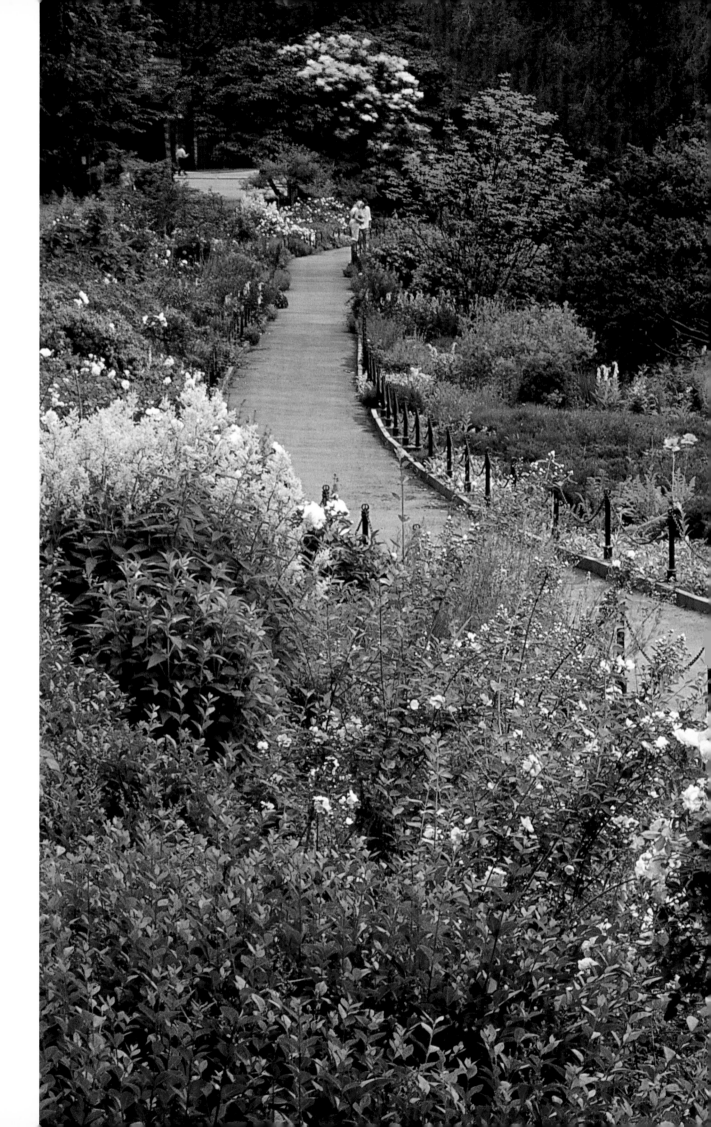

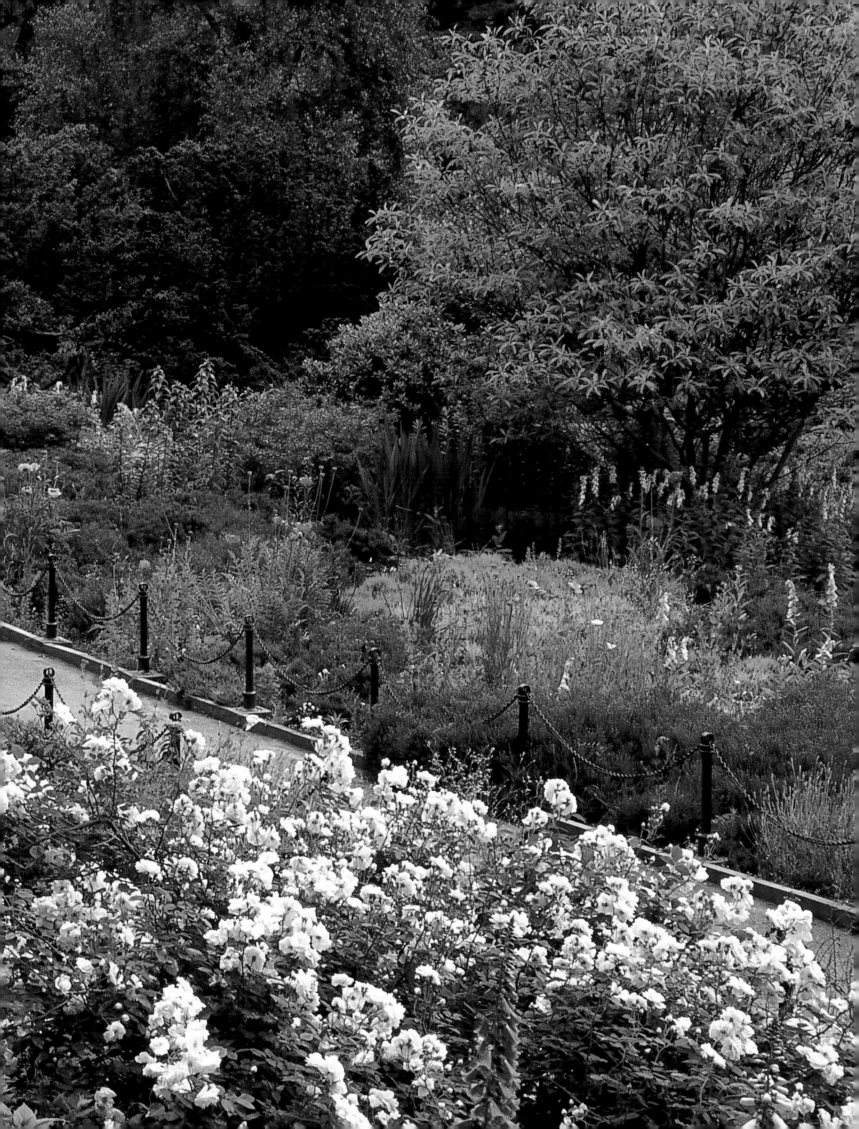

appearance. Even now, it remains a challenge to collect money for the upkeep of this, the largest flower garden in New York. A handful of committed citizens have made it their task to collect donations and support the Heather Garden financially.

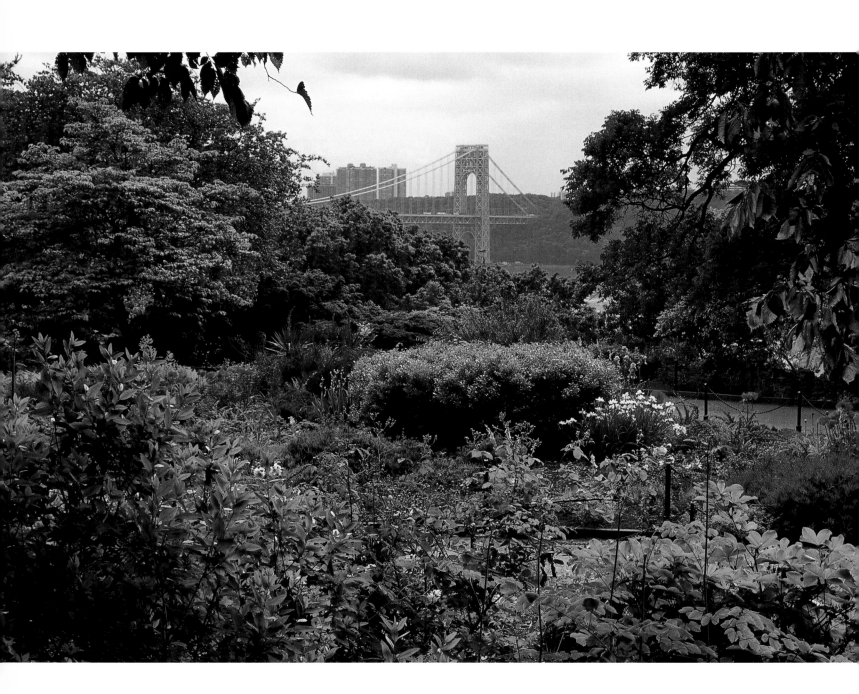

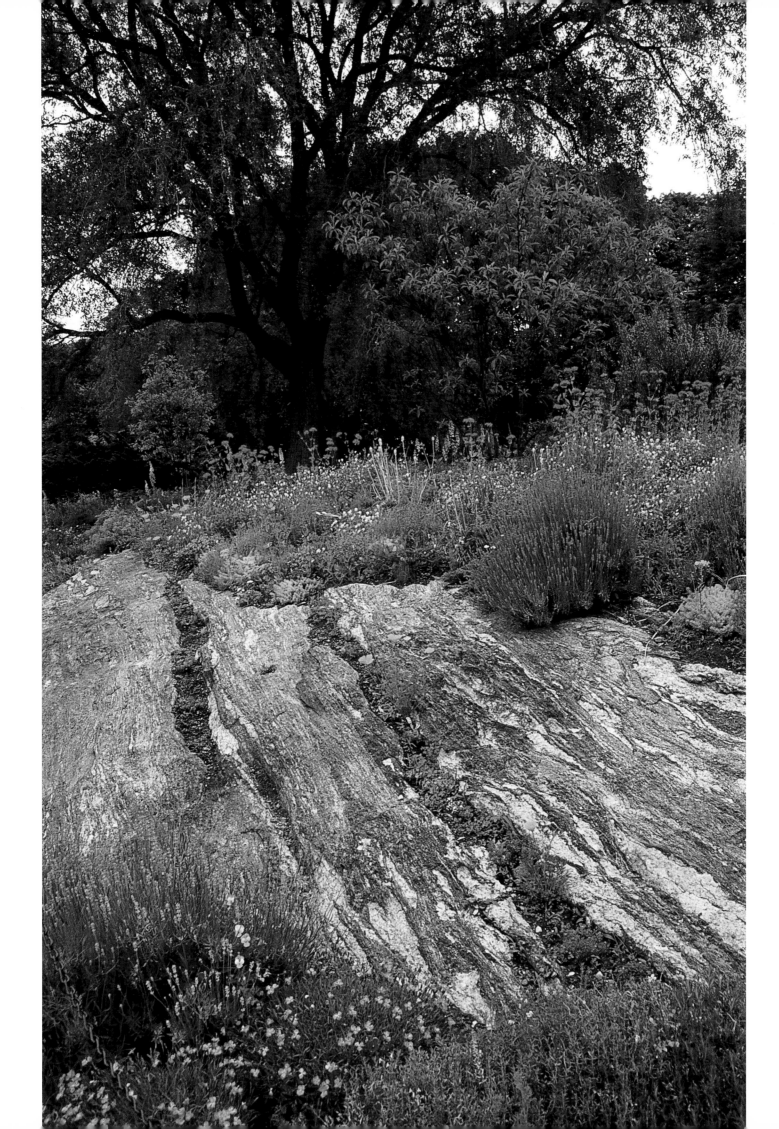

Garden Loft with Skyline Backdrop

When Dagny and Timothy Du Val sit in their garden in the evening, they see a silhouette like a mountain range with summits, crests, canyons and gorges. What looks like a mountain range is the Manhattan skyline, with architectural icons such as the Chrysler Building, the UN headquarters and the Empire State Building. Dagny Du Val raves about sunsets in June, which she considers to be the most beautiful month, when the skyscrapers are bathed in incandescent red. These are magical moments which depict dramatic cloud-and-light moods. Almost thirty years ago, together with her husband, she bought a former metal foundry in Long Island City. This was a collection of buildings dating from the 19th century bordering on three streets. At the beginning of the 1980s, very few people lived here. The area was dominated by industrial and factory buildings. Even though Long Island City is only a short hop over the East River from mid-Manhattan, people think of it as the last place on earth. By now many have discovered that Long Island City is part of the city and closer to the center than many parts of Manhattan itself. Many of the old buildings have been demolished and apartment houses are sprouting out of the ground like mushrooms. Nevertheless, the district has been able to maintain its original raw charm. The most beautiful factory buildings have been redeveloped and now house loft apartments and studios. The Du Vals fear that the building boom will result in nothing being left of the original area. They themselves have taken great care in their restoration to keep the flair of the former foundry. Un-

plastered brick walls, doors with innumerable paint layers, large industrial windows, and rusty metal fittings are combined with modern design. The Du Vals have recognized the potential of this unusual mixture, and hire out the building for weddings, commercials and film productions such as *Sex and the City*.

Three double doors open onto the garden, which was originally the roof of the neighboring ice-cream factory. Here they found gigantic pieces of equipment standing on black tar-paper, which had to be dismantled and removed. The statics of the roof had not been calculated with a garden in mind. The weight of all the individual elements had to be precisely worked out. The plants are housed in variously sized containers made of fiberglass, a very light material, although some are made of plastic or wood. They are all dark green or black, to make them as invisible as possible. In addition, Dagny Du Val chose ground plants that grow over the containers and make them appear as natural as possible.

The first plant was a Japanese maple which the Du Vals brought from their roof terrace in Manhattan. It has been a family member for over thirty years. The 3,200 square feet are divided into single garden rooms. The Du Vals built a pergola of old wooden beams from the foundry and in its shade there is a long dining table. The open areas benefit from the exceptional location, which is very close to the Queensborough Bridge. Particularly on weekends, when no trucks are thundering over the bridge, the garden is a very attractive place to meet friends, or to read and to enjoy the atmosphere

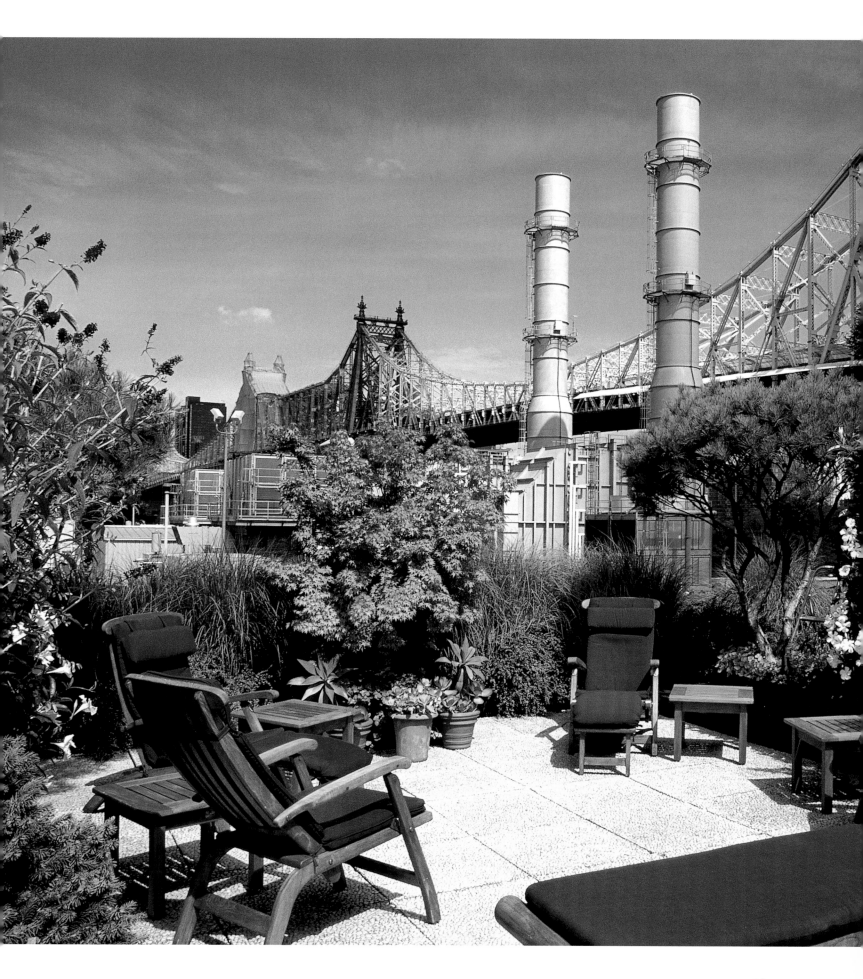

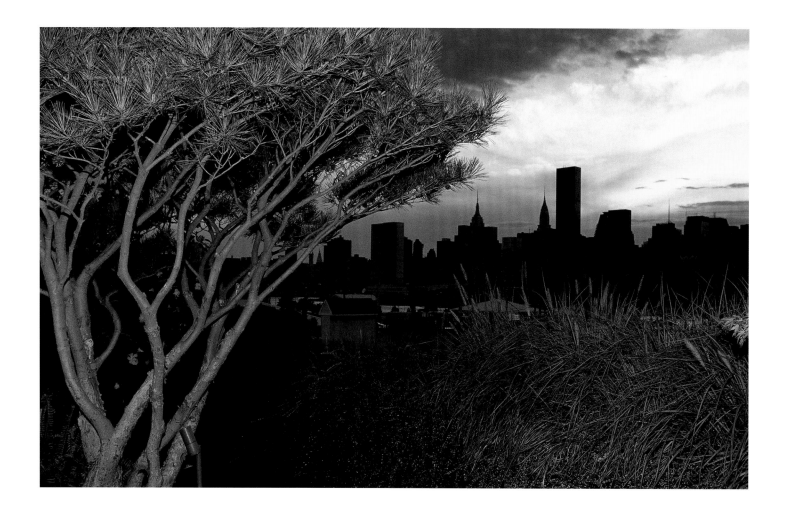

above the city. There are now many evergreen plants in the garden, such as dwarf and black pines, while the grasses in the background look like the natural bank of the East River. Purple loosestrife grows very well in the damp air. The Du Vals are particularly proud of their aspens. Ten years ago the cuttings, only as thick as a thumb, came by post; now they are almost fifteen feet tall. Dagny appreciates it most when, even in a light breeze, their leaves glint and shimmer. She admits that she is privileged to be able to grow flowering plants which normally need a warmer climate: papyrus, jasmine, pigeonberry, snowball bushes, false myrtle and passion flowers. The colors range from white through pale pink to blue; there are no red or orange blooms. The Du Vals have been very clever in their choice of floor covering, which helps to create the impression of different garden rooms. The wooden floor makes the

pergola cozy and comfortable, while the black gravel and integrated paving stones fit in well with the character of the fountain and the bamboo. A cubic table and four chairs in the front garden area are made of slate-gray stone and fit in well with the ground covering. The luxuriant planting has been specifically chosen to contrast with the sober furnishings. Another garden room is defined by large, light gray paving stones, where comfortable sun-loungers with dark green cushions are an invitation to laze in the sun with Manhattan as a backdrop.

The signature of a professional is clearly seen in the optimal use of what is quite a small area. The Du Vals turned their love of nature into a profession and in 1971 started a company for garden design, which they managed until recently. They employed up to seventy-five people and experienced all the ups and downs of the

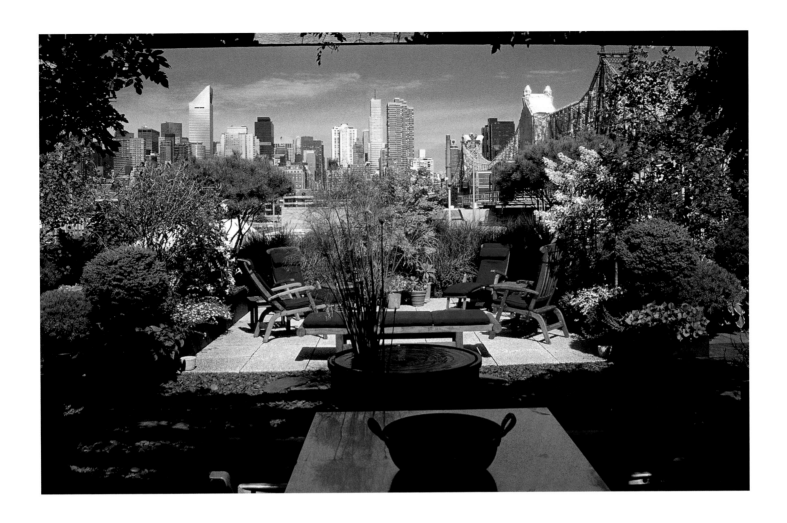

sector. When Wall Street was booming, many stock-brokers realized their dream of having a roof garden; when the stock market went into decline, so did their business. Gardens, then, reflect the economic climate of the city. At the beginning of the recession, the Du Vals called their own garden an "orphanage," because they took back the plants which their clients no longer wanted or could afford. However, that does not mean that their garden has become a hodgepodge. On the contrary: With its imaginative harmony it testifies to the pleasure the Du Vals take in their own work. They have created a place to reflect the identity of life and design.

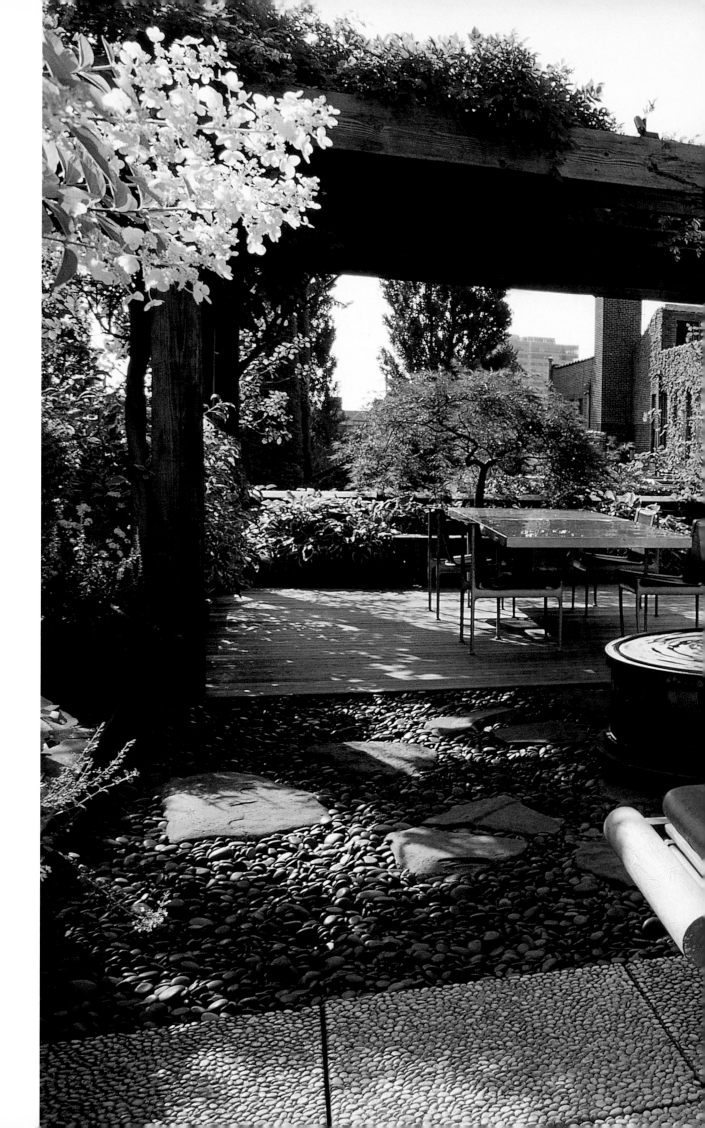

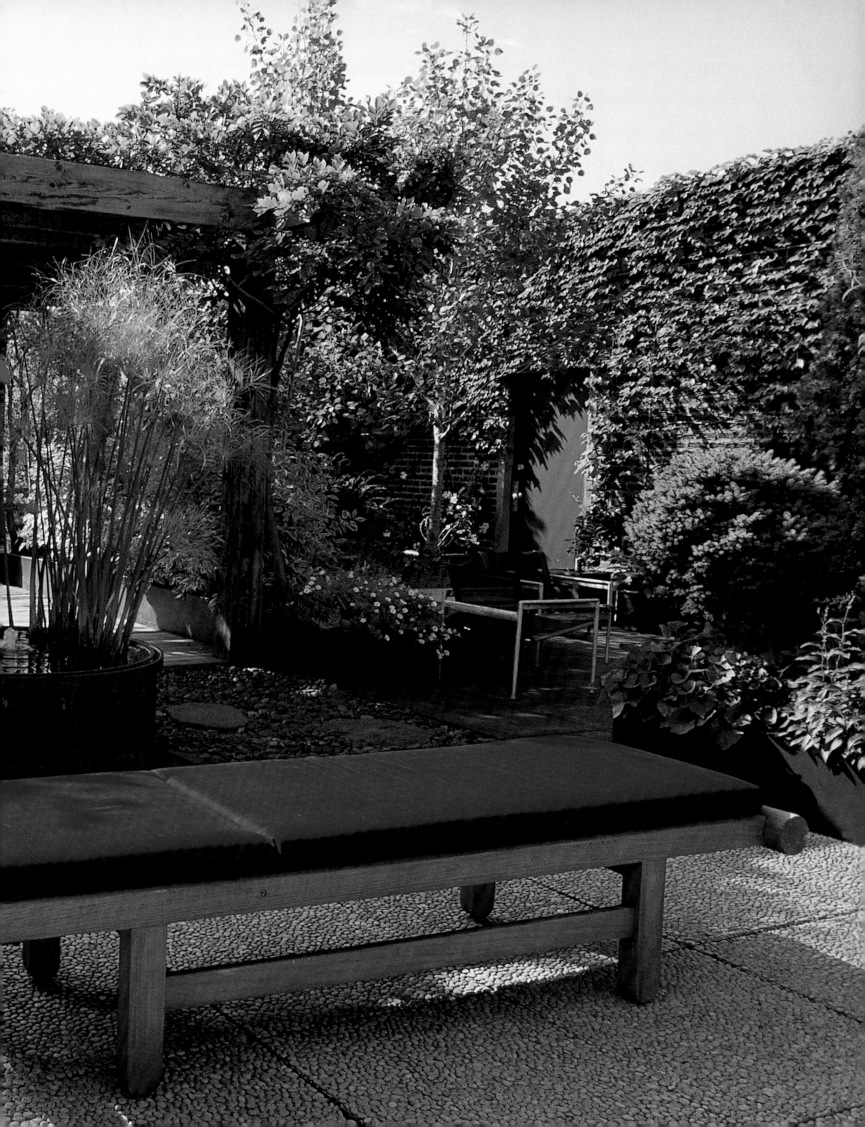

A Walk with Miss Liberty

Battery Park City at the southwest end of Manhattan is the site of the World Financial Center, but it is also a residential area with shops and restaurants. About ten thousand people live here. The new district was built around parks, gardens and squares. The planners concentrated on making the best possible use of the view over the Hudson River and offering residents as much public space as possible for getting together. This concept has obviously proved its worth. Battery Park City has won important prizes. Time Magazine even counts it as one of the ten best designs of the last decade.

Until the 1950s the piers were the heart of the prospering harbor district, but had to relinquish their function to the airports and fell into decay. So it was decided to fill in the Hudson River to create more land. When the building of the World Trade Center began in 1966, some thirty million cubic feet of detritus was used to build Battery Park City. The mouth of the Hudson only got its present shape ten years later. Many of the piers were, quite simply, buried. During the following years the development slowed down, which was largely the result of funding problems. Then, in 1981, construction work for the World Financial Center finally got under way and four years later the first tenants moved in. Cesar Pelli was the architect of Battery Park City, which took its name from the existing Battery Park.

Manhattan's southern shore has been a popular promenade at least since the 17th century and the name "Battery" comes from the fortifications which protected the harbor from 1683 to 1807. Battery Park itself was created by landfill in the 19th century. The 25-acre plot includes parks, squares and gardens and there is a one-and-a-half-mile-long esplanade along the Hudson. What is now one of the most attractive leisure areas in New York City, in the 1980s was one big problem zone, a "no-go area." The residents certainly avoided the most southerly point of Manhattan and tourists were strongly advised not to visit the area, so as to avoid any unpleasant adventures. The park was neglected and attracted people for whom the lack of beauty was the least of their problems. As early as 1986 there was a master plan for the park, but this just gathered dust on some shelf; at that time there was no awareness of how important the configuration of public space can be for social cohesion. It was not until ten years later that the money was made available to guarantee the planning, planting, and ongoing maintenance of the park. Unlike in Europe, where the state can be called on to undertake financial responsibility, in the United States funds for this type of project are collected from companies, banks and private donors. By 2009, three large projects had been completed in this way and seven more projects in the development stage should be finished by 2014. The master plan for the garden was developed by the Dutch garden designer Piet Oudolf, and his signature can be seen in the character of the whole area. He did away with the exclusive planting of annuals in public squares, which unfortunately is still the norm in many cities. Believing it is important to combine ecology and design, he refused to buy new plants every year and throw the old

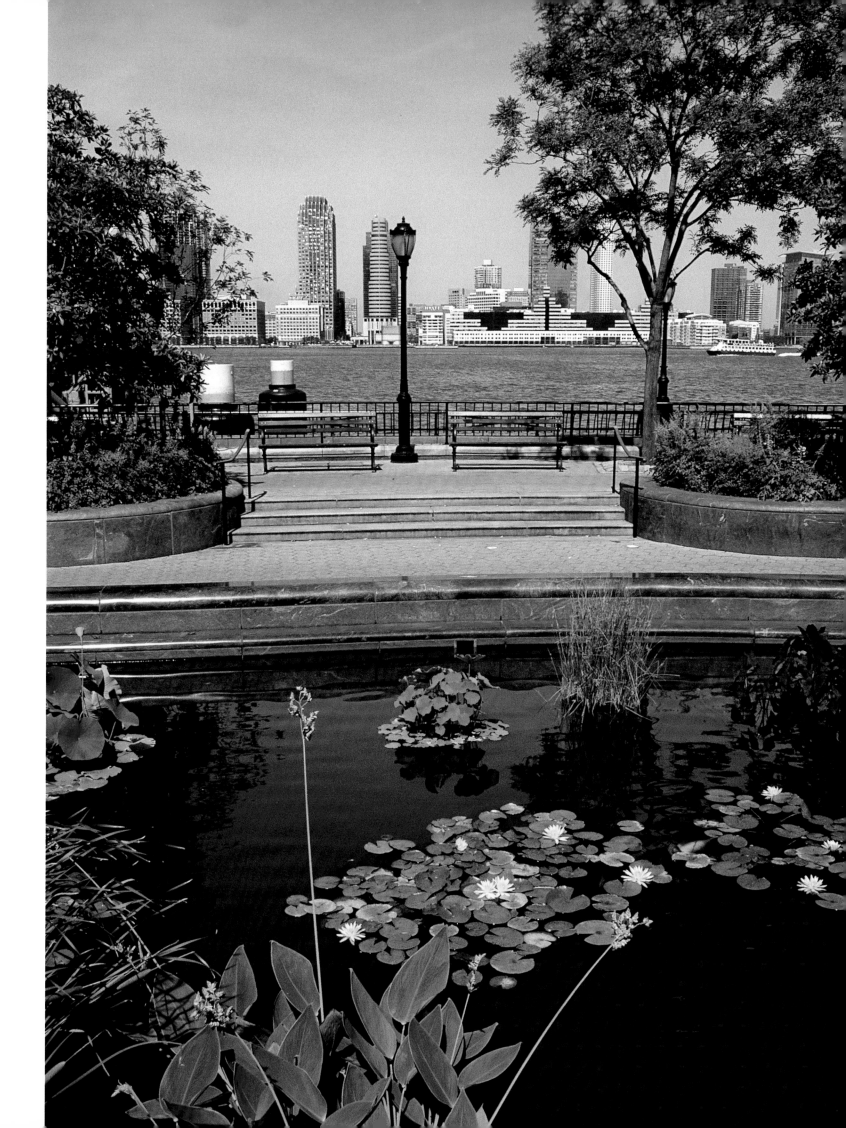

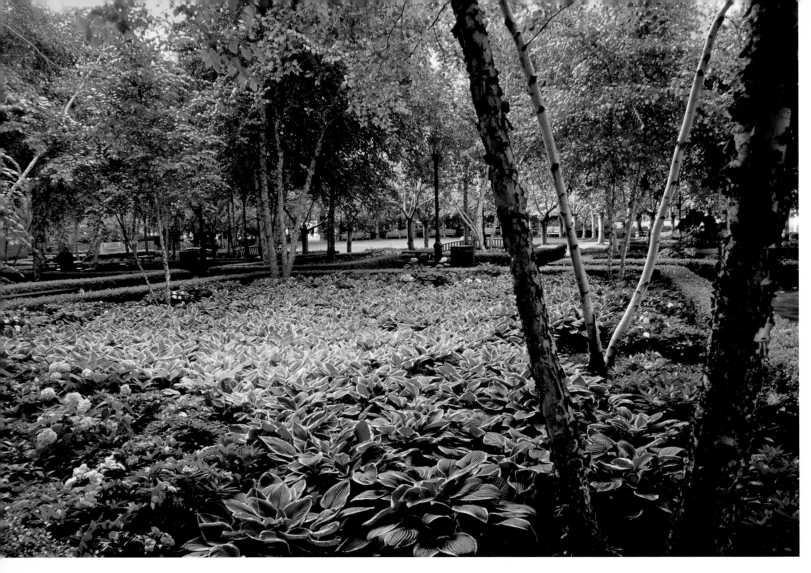
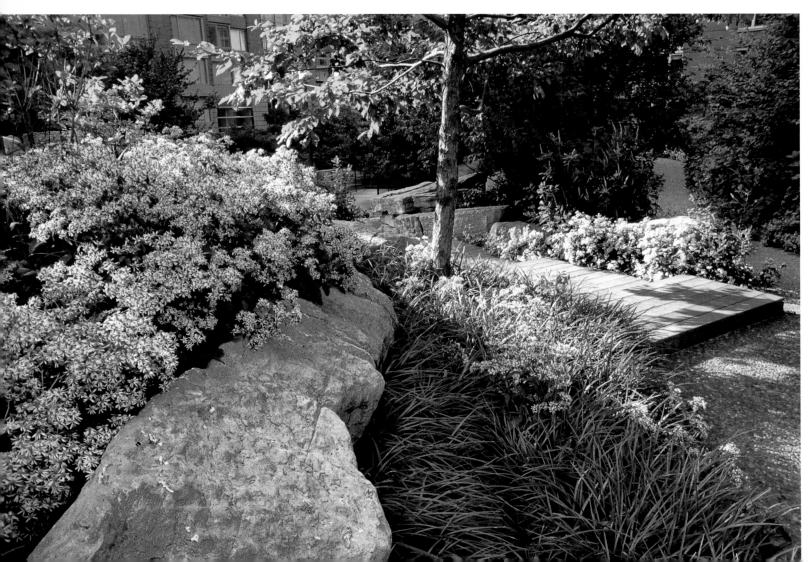

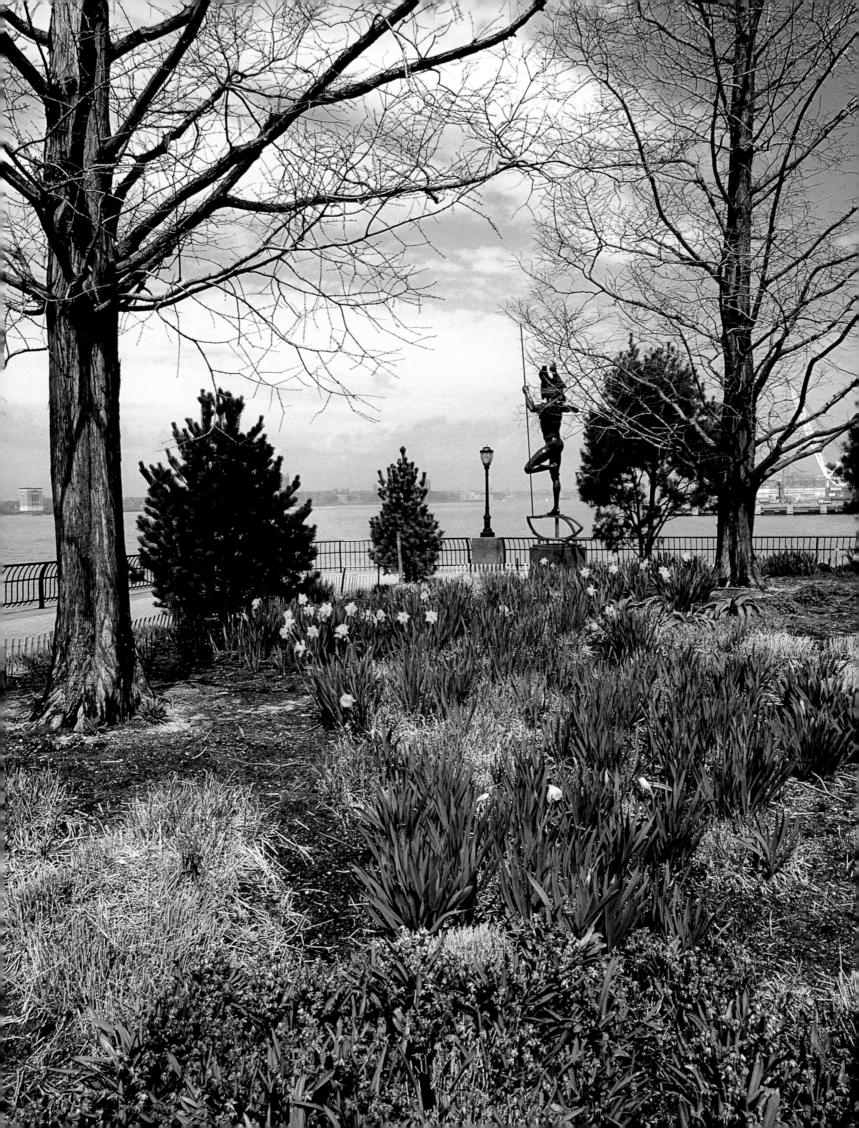

ones away. He therefore concentrates on herbaceous perennials which remain in the ground over winter and come back to life in spring. This means that the plants are more luxuriant and more beautiful every year. In the 1990s, Piet Oudolf founded the New Perennial Movement. The origin of this movement can be traced back to the German gardener and grower, Karl Foerster. Flowers only please the eye for a very short time. And this is why Piet Oudolf is convinced that the structure and shape of a plant is much more important than its color and flowers. He is interested in the life cycle of a plant, how it changes during the period of growth. When he conceives his planting compositions, he makes sure that all the components are equally suitable for the local conditions. The color of the flowers and when they bloom are not the most important elements. This may be foreign to many a flower-lover because taste in flow-

ers is often limited to the moment when the blooms are at their best. However, Piet Oudolf has a great love for all types of grasses, which retain their beauty throughout the year; grasses also flower: some in spring, others in summer and late summer or in autumn. In winter, when their stems and seed pods are frozen, they create bizarre shapes and above all attract birds. Grasses are particularly suited to the garden alongside the Hudson because they create the illusion of a natural river bank. Yet Piet Oudolf stresses that he does not try to copy nature, but rather to impart a feeling for nature. His project was certainly influenced by its proximity to the river. The view extends across the wide stretch of water to New Jersey, Ellis Island and, not least, the Statue of Liberty. The one-and-a-half-mile-long path, the Esplanade, is designed artistically in places. South Cove, for example, if you believe the Battery Park guide, is one of the

most important public artworks in the city. It is the result of collaboration between the environmental artist Mary Miss, the garden architect Susan Child and the architect Stanton Eckstut. It was Stanton Eckstut who presented the master plan for Battery Park City in 1979, for which he received many awards. The wooden constructions in and around the water are seen as a homage to the piers, where once steamers had safe moorage. Leaving the river banks, the path wanders back and forth like swishing water. It is hemmed in by carefully positioned rocks which enclose the carefully chosen plants. Especially at twilight, the blue lanterns add a romantic touch even though it is always said that blue lights are cold. Strolling along the Esplanade, one is immediately aware of the attention to detail. Even the garbage bins fit into the design, as do the benches and lamps. The garden of the World Financial Center, known as the South Garden, is made up of beds of white-edged hostas and red busy lizzies surrounded by boxwood hedges. The birch trees with their sparse leaf coverage provide dappled shade for the flowers. The landscapers M. Paul Friedberg and Partners are responsible for the design.

At the northern end of the park in spring, when the trees are still bare, there is a particularly good view of the bronze sculpture *Ulysses* made in 1997 by Ugo Atardi (b. 1923). Snowdrops bring a hint of spring in spite of the cold wind and clouds. Turning away from the river there is a view of the Nelson A. Rockefeller Park. Here, four symmetrically planted trees break up the view and seem to be much taller than the skyscrapers in the background. When you are in the Battery Park garden, you gladly turn your back on the latter and look out over "man-made nature" to the waters of the Hudson River. For just one moment you forget that you are in one of the most densely populated places on earth; and the gardens facilitate this act of forgetting.

Many-splendored Miniature

Landscape architect Nigel Rollings' personal garden was created in 1980. It still has the same area of about fifteen hundred square feet, but nonetheless has grown, and above all become more mature. It is a garden in which not only the plants have grown, but also the design, which even takes advantage of air space. It is totally amazing what abundance and variety this small plot in Queens displays. Nigel Rollings is a professional garden designer, who came to the USA from England in the 1970s because of the omnipresence of the sophisticated "space age" style. In London he studied at the Architectural Association School of Architecture and Goldsmiths' School of Art, but was also a rock musician who composed. He is still a composer, but now his compositions are not made up of musical notes, but of plants and flowers. For him these activities are closely related, just like cooking. You put various ingredients together and create something new. He says himself that his most successful relationship is with his private garden.

His rented apartment is a long tube, at the end of which there is a window through which he has a view of the green beyond. The door next to the window stands open from spring to autumn and triples his living space. He says he brought the garden in the confined backyard to life in 1980, and since then has perfected it into a habitat for birds, fish, frogs and plants. Directly in front of his apartment he has built a wooden veranda, which is decorated with flower troughs and small water gardens in wide, black earthenware basins. A few steps lead down to the real terrain of the luxuriant garden. It is constructed in two loops, which together form a figure of eight. This means that there is an excellent approach to all the plants along several paths. One made of clinker tiles laid lengthways runs jauntily past blooming beds of perennials. Further back, a wooden walkway leads along a bamboo hedge. For Rollings, the heart of the garden is a small pond, which is home to six fish and the same number of frogs. He rescued the frogs from a pool belonging to one of his clients. His favorite place is a bench under a tree and here, were it not for the continuous city noise, you could really feel that you were in a country oasis.

For privacy, Rollings erected screens made of plastic which he discovered in a DIY store. Using his imagination, he was able to screen his idyllic garden from garbage tips, ugly buildings, and a vacant lot which many residents use as a dumping ground for their various implements and motor vehicles. Previously there was a paint factory here, which has since been demolished. Because of an inheritance dispute, the area has not been built on, and Rollings hopes that this state of affairs will continue for a long time. Young people from the financial world are moving into the once quiet area, and tall apartment blocks are being built all around him. The social climate has become harsher. Next door there was a woman who had lived there for sixty years. The landlord threw her out when she was 94 so that he could raise the rent. She had really enjoyed the garden, particularly because as she grew older, she was not so

224

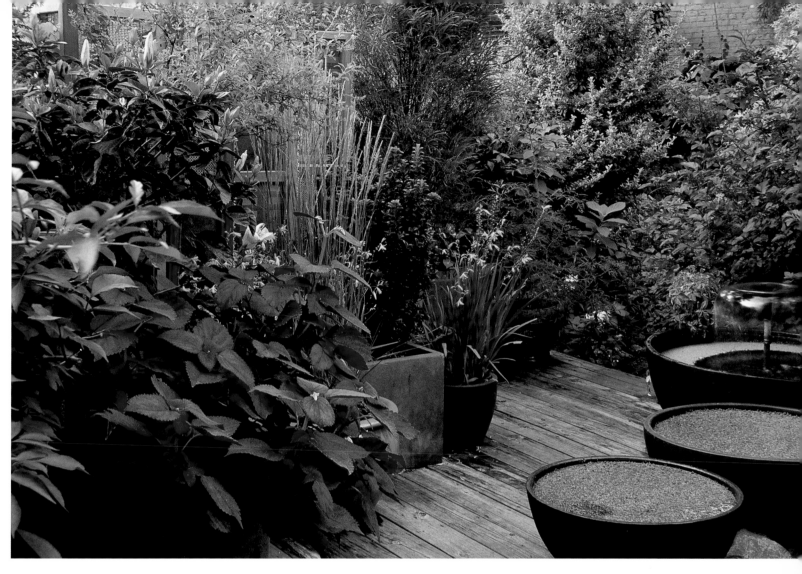
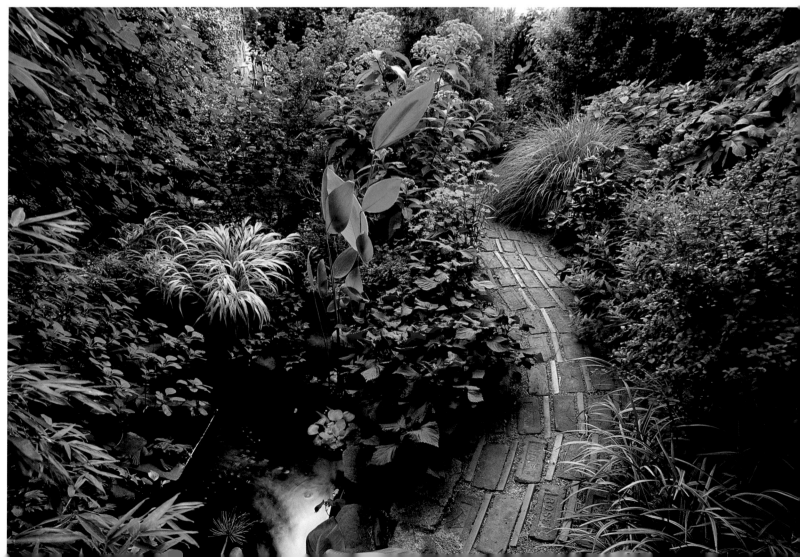

mobile. Today there is a coming and going in this apartment, with young people moving in and out. Rollings believes that if developments in the financial world continue as they are doing, the area will become a ghost town. And he will be able to keep his view: of the Empire State Building, the Chrysler Building and the Trump Tower. Sometimes he invites guests over, but not to a chic cocktail party. He is more interested in bringing people into the garden to enjoy nature. They must be amazed by all the plants even before reaching the party area. There Rollings displays his latest achievement. With pride he says, "Here you can sit on the grass," and folds down from the wall wooden seats which he has covered in artificial grass. He has a talent for making something beautiful and practical out the simplest of things. In the wonderful seclusion of his city garden, one can only hope that he and his great love will not be chased out by greed one day.

Gardens for the View

The four buildings on Fifth Avenue, which are part of the Rockefeller Center, are only seven stories high. Even though the engineers did not have to make calculations for a skyscraper when the building plans were drawn up in 1930, these low buildings presented a particular challenge: Gardens were wanted on the roof, with a two-foot layer of soil, ponds, plants, troughs and pots. Even today, the "Rockefeller Rooftops" are the only roof gardens in New York with a deep layer of earth. Lying parallel on top of the building there are four Art Deco gardens, planned and planted in the 1930s by the English landscape architect Ralph Hancock. They laid the foundation for a classical New York tradition: "gardens for the view." These roof gardens can be marveled at from more than one hundred thousand windows, including the windows of the eighth-floor café of the famous Saks department store on Fifth Avenue opposite. The fantastic view compensates for the high prices. However, there is one view which you can enjoy only from the roof gardens, and that is the neo-Gothic St. Patrick's Cathedral in the background. It is a spectacular setting for gardens and church alike. The garden bejewels the building across the street like a bouquet.

Ralph Hancock's design was geometric and formal, and served to provide a distant view. Details played a subordinate role. The complete picture was the most important. The ground area of each garden is a long, dark, rectangular lawn, with a slight bulge in the middle. This means that when viewed from above, the areas appear larger and the rainwater can drain off. Along the sides, carefully trimmed box hedges separate the grass from the peripheral path. Classical beds with pink flowers (begonias or geraniums, depending on the season) are planted in the recesses formed by the U-shaped hedges. Conically trimmed box trees mark the corners and lend the garden its three-dimensionality. Each of the four roofs has an aquamarine pool with a bronze frog spouting water sitting at the end. The combination of the dark green of the lawns, the intensive pink of the flower beds and the aquamarine of the pools results in a striking "tricolor." The planner Ralph Hancock was aware that in the city, an architect could no more ignore the surrounding roofs than a landscape gardener in the countryside could ignore the plants surrounding the house. And not only in this respect was the Rockefeller Center a pioneering building. When John D. Rockefeller Jr. bought the site in 1928, he wanted to establish a center of culture; he wanted the Metropolitan Opera to be part of it. However, the stock market crash of 1929 ruined his plans and the "Met" withdrew. Rockefeller then decided to build an office complex, which he financed personally. It was the time of the Great Depression and the gigantic building project in the center of Manhattan provided work for 75,000 people. Between 1930 and 1939 fourteen buildings were erected. The principle architect was Raymond Hood. All of these buildings have a long rectangular ground plan so as to take advantage of as much sunlight as possible. No wall was to be more than thirty feet from a window. All

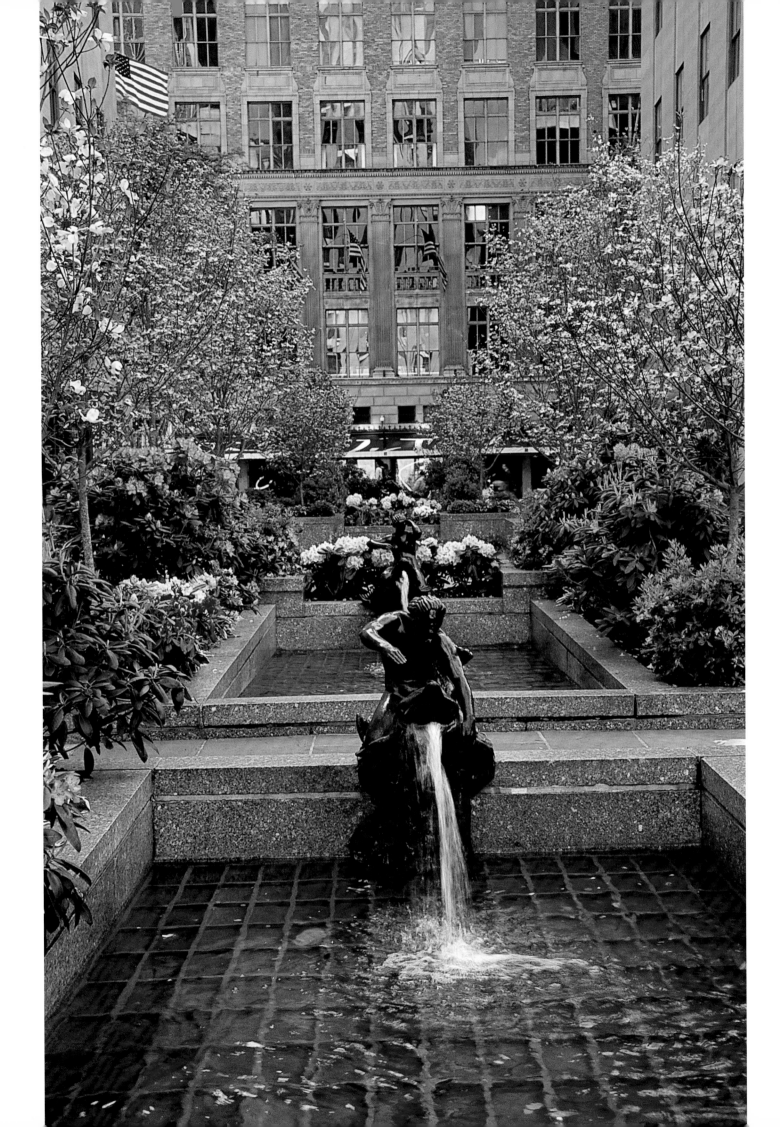

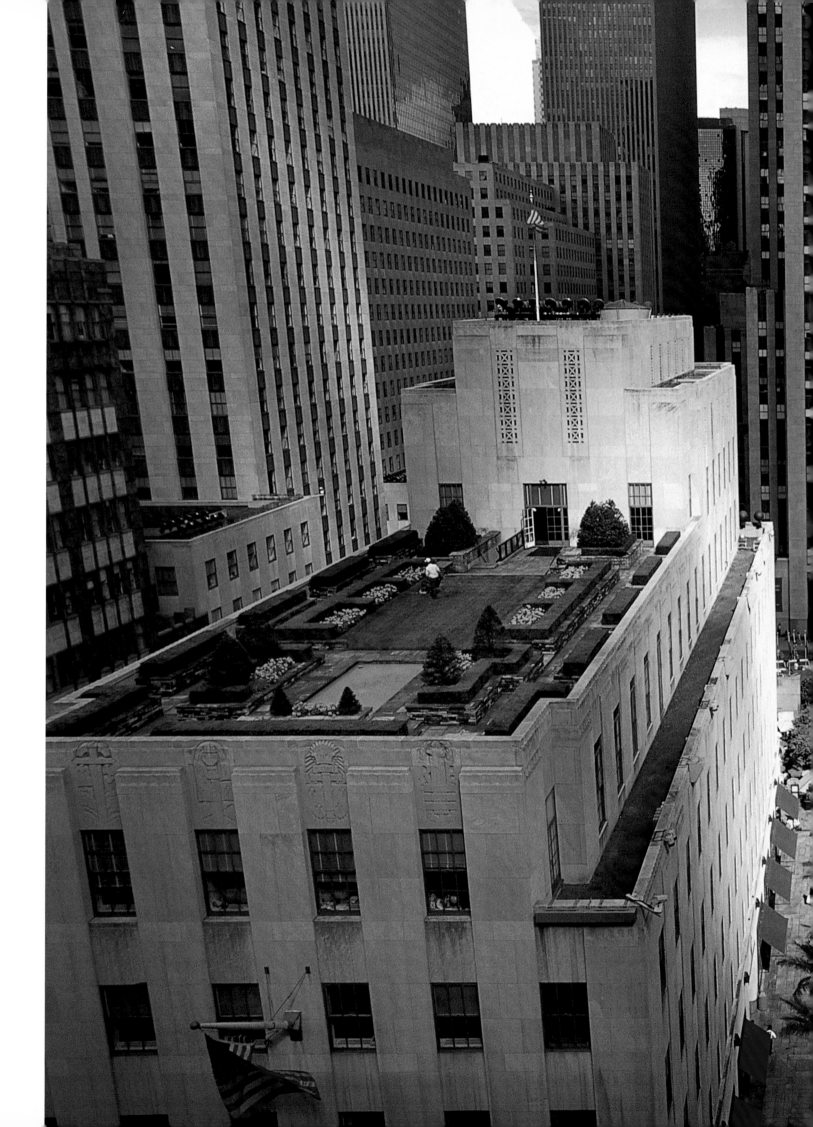

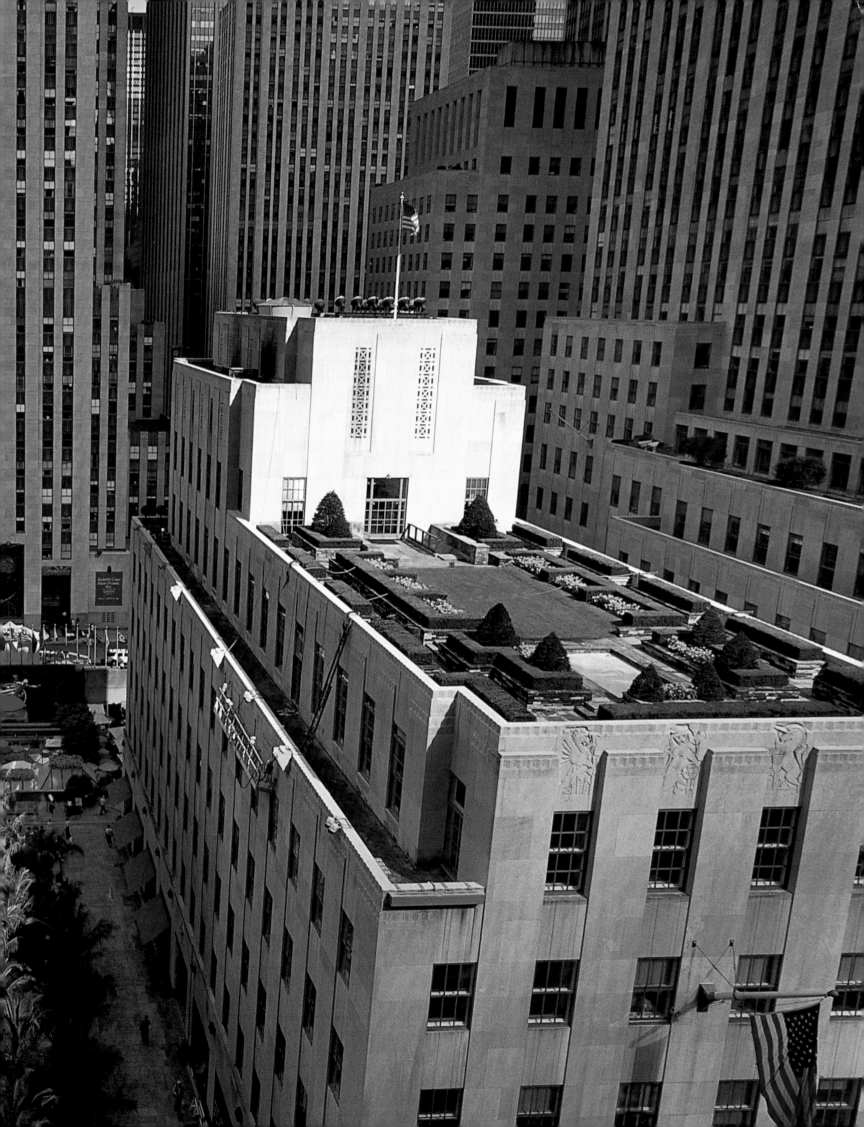

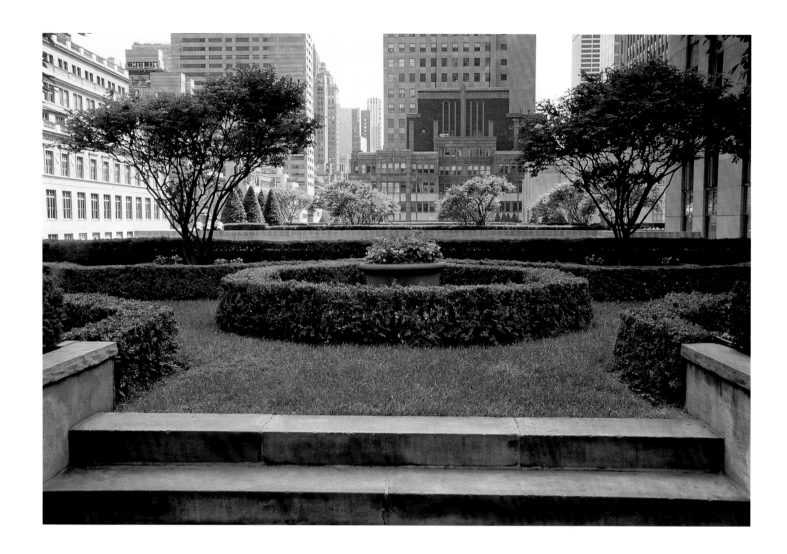

the Rockefeller Center façades are of white limestone, which forms an important unifying element between the buildings. For the first time in history, a coherent architectural ensemble was planned in the center of a city. John D. Rockefeller Jr. did not just have the individual buildings in mind, but a total urban concept. The seventy-story RCA (Radio Corporation of America) Building rose high above the famous Rockefeller Plaza, which every winter since 1936 has metamorphosed into a giant skating rink. In the Christmas season, hordes of tourists come to gaze in wonder at the Christmas tree decorated with thousands of globes. In summer there are free concerts and for more than seventy years the square has been a meeting place for rich and poor, young and old; not just New Yorkers, but also their guests from all over the world.

The Rockefeller Plaza and Fifth Avenue are connected by a small pedestrian precinct called the Channel Gardens. The name comes from the long and narrow site between the British Empire Building and the Maison Française, which are also part of the Rockefeller Center. Officially it is known as the Promenade and is frequented every day by more than 200,000 passers-by. This is partly due to the exclusive shops and shop windows, and partly to the design of the Channel Gardens themselves, which change every two to three weeks. Plants that are no longer needed are given to not-for-profit garden projects, the Community Gardens or the Rikers Island Prison Garden. In spring, pink clouds of cherry blossom float over the narrow basins with their Triton-and-Nereid fountains. Between them white, pink and magenta rhododendrons add a blaze of color.

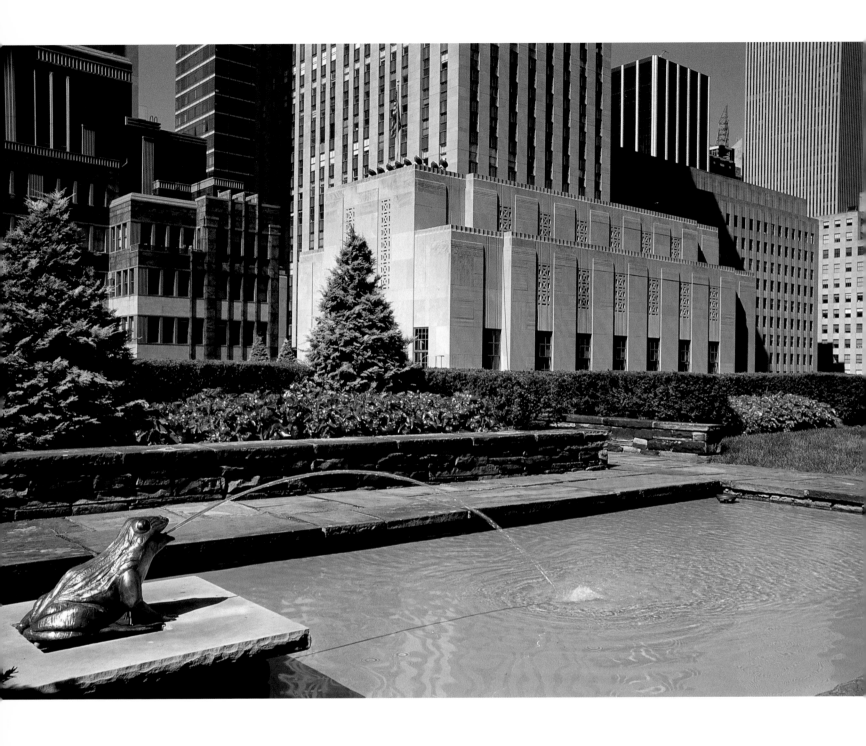

There are weeks which are devoted to particular plants and when the Promenade is transformed into a jungle-like path through palms. But sometimes it can be a simple idea that defines the concept, or an arrangement of colors that stops passers-by in their tracks. The planting always confronts the rigorously geometrical lines of the surrounding architecture with something playful, light, green or colorful. Because in the densely built-up center of Manhattan, almost every blade of grass is a small triumph over the overweening might of the right angle.

236

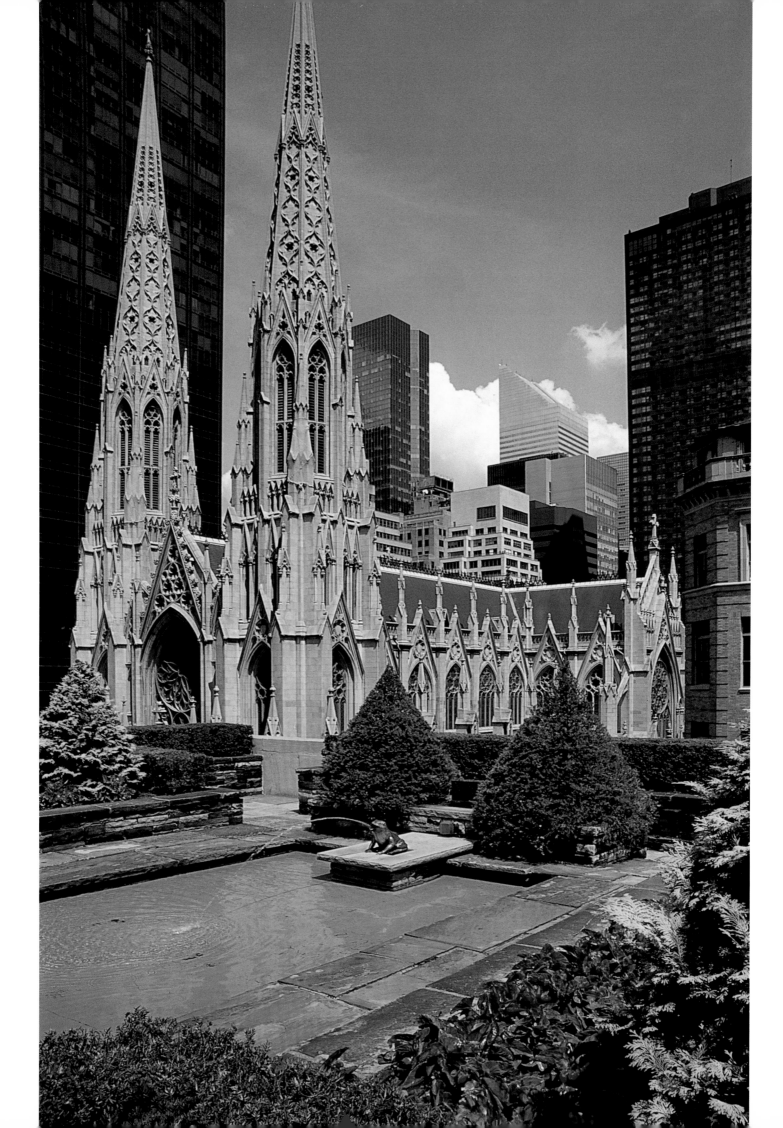

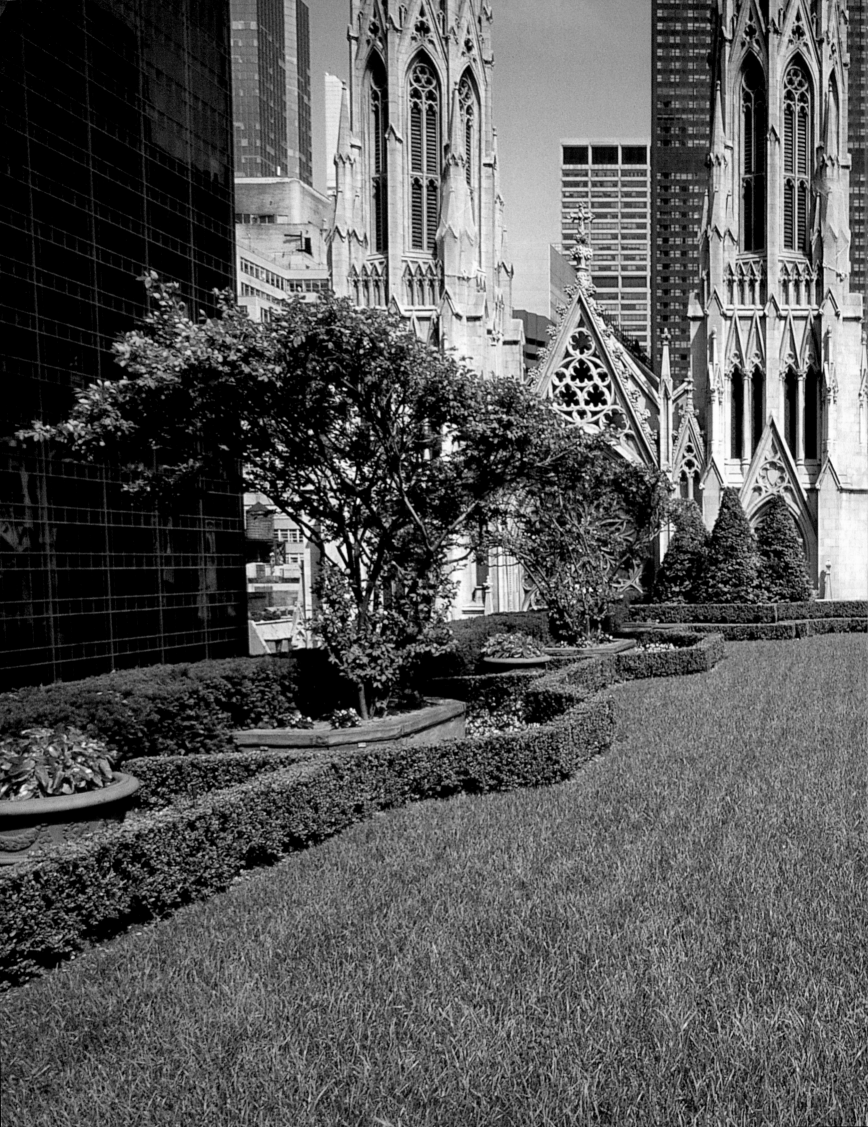

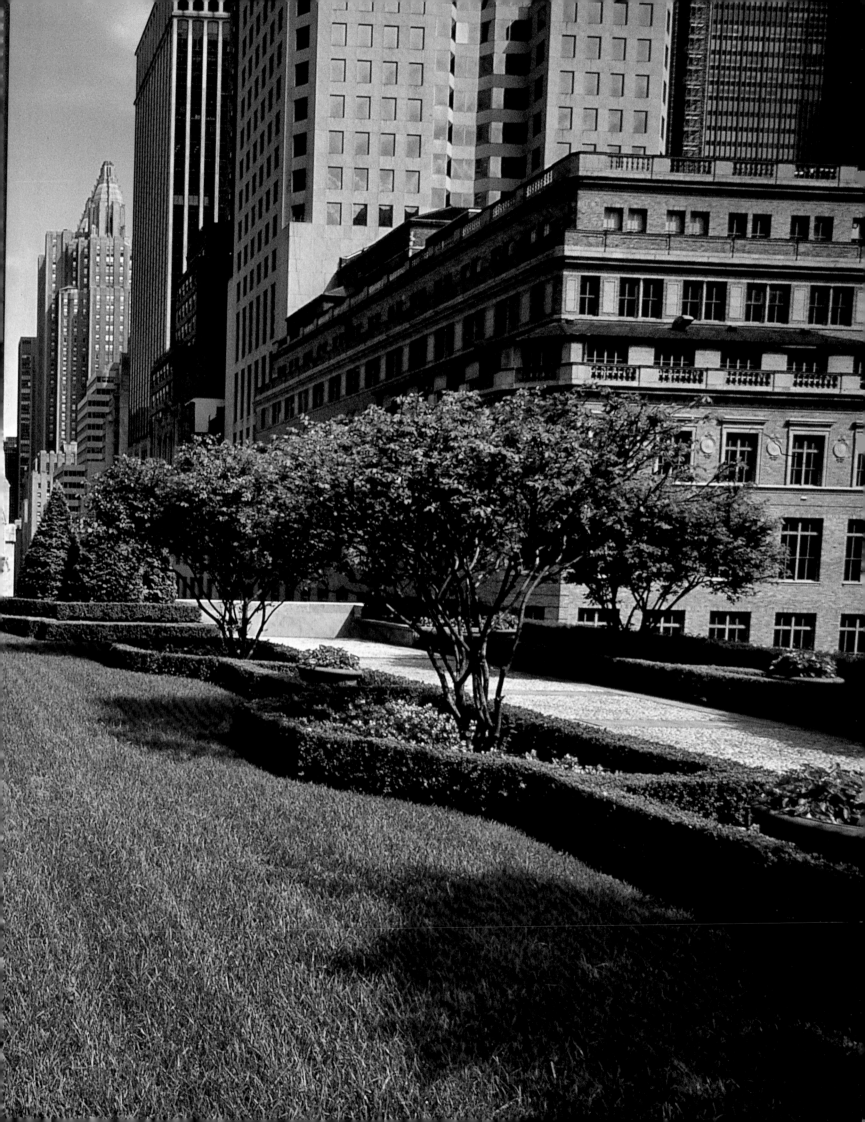

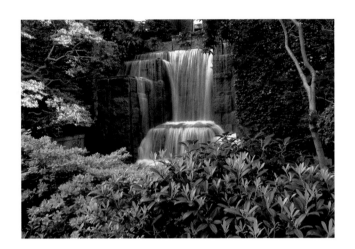

Acknowledgement
This book would not have been possible
without the support of garden-owners,
designers and landscape architects who
granted us entrée, assisted with scheduling
and provided information for the text.
We thank them for the time and patience
they devoted to our conversations and
photography sessions. We hope that all
participants and readers will take pride in
the gardens we have selected to represent
the creativity, beauty and variety that
New York City offers.

Veronika Hofer and Betsy Pinover
Spring 2010

Photography: © Betsy Pinover Schiff
Text: Veronika Hofer
Translation: Michael Scuffil
Proofreading: Bronwen Saunders,
Markus Kersting
Separation: Zanotto/Brisotto, Tezze di Piave
Design and production: Gunnar Musan
Printing and binding: Firmengruppe Appl,
aprinta druck, Wemding
Paper: ProfiSilk, 150 g/qm
Printed in Germany

© 2010 Hirmer Verlag GmbH, Munich;
the authors

Fig. p. 1: Private roofgarden (see p. 66ff.)
Fig. p. 2, 4: New York Botanical Garden
(see p. 156ff.)
Fig. p. 7: Private roofgarden (see p. 150ff.)
Fig. p. 240: Greenacre Park (see p. 172ff.)

ISBN 978-3-7774-2721-8
ISBN 978-3-7774-2731-7 (special edition)
ISBN 978-3-7774-2751-5 (U.S. edition)

www.hirmerverlag.de

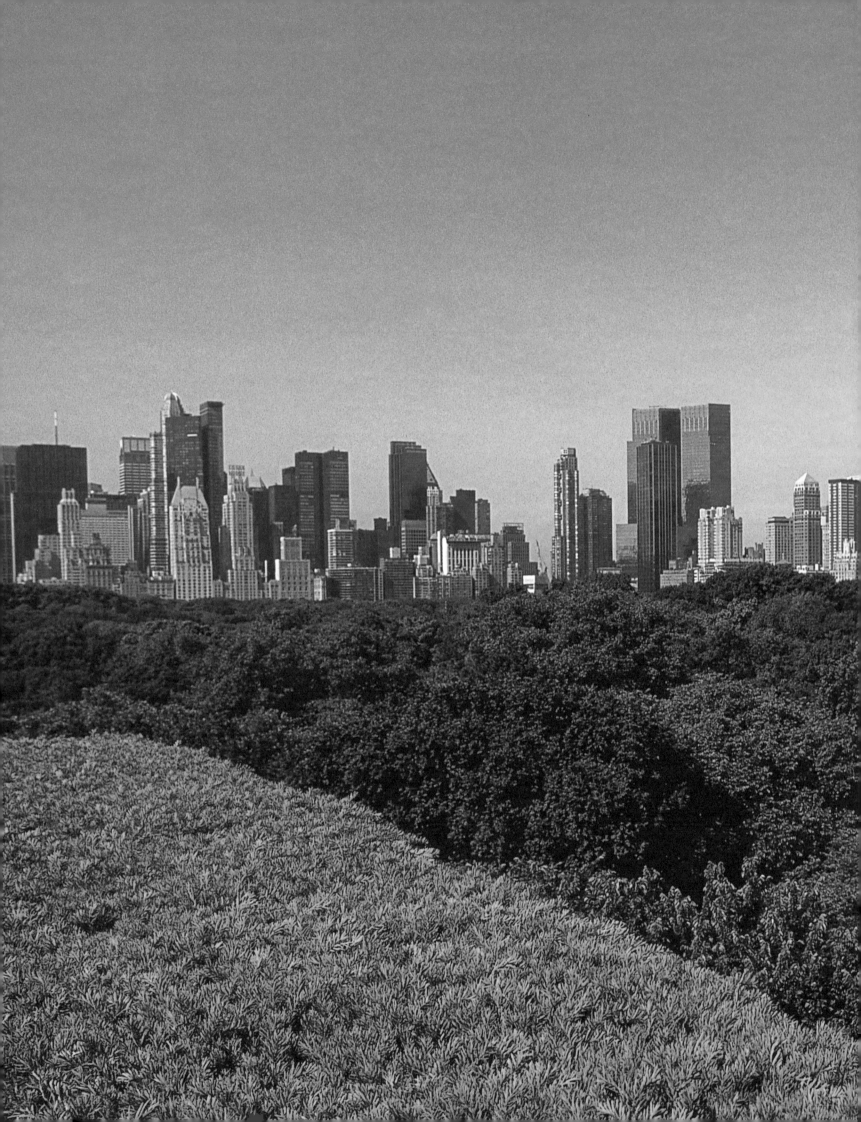